THE SOCIAL HISTORY OF ART
VOLUME I

'As much a work of intellectual history as art history, Hauser's work remains unparalleled in its scope as a study of the relations between the forces of social change and western art from its origins until the middle of the 20th century.'
Johanna Drucker, Professor of Art History, State University of New York

'Harris's introductions to each volume – dealing with Hauser's aims, principles, concepts and terms are extremely useful. . . . This edition should bring Hauser's thought to the attention of a new generation of readers.'
Whitney Davis, Professor of Art History, Northwestern University

First published in 1951 Arnold Hauser's commanding work presents an account of the development and meaning of art from its origins in the Stone Age through to the 'Film Age'. Exploring the interaction between art and society, Hauser effectively details social and historical movements and sketches the frameworks within which visual art is produced.

This new edition provides an excellent introduction to the work of Arnold Hauser. In his general introduction to *The Social History of Art*, Jonathan Harris assesses the importance of the work for contemporary art history and visual culture. In addition, an introduction to each volume provides a synopsis of Hauser's narrative and serves as a critical guide to the text, identifying major themes, trends and arguments.

Arnold Hauser was born in Hungary and studied literature and the history of art at the universities of Budapest, Vienna, Berlin and Paris. In 1921 he returned to Berlin to study economics and sociology under Ernst Troeltsch. From 1923 to 1938 he lived in Vienna where he began work on *The Social History of Art*. He lived in London from 1938 until 1977, when he returned to his native Hungary. He died in Budapest in 1978.

Jonathan Harris is Senior Lecturer in Art History and Critical Theory at the University of Keele. He is the author of *Federal Art and National Culture: The Politics of Identity in New Deal America* (1995), co-author of *Modernism in Dispute: Art Since The Forties* (1993) and co-editor of *Art in Modern Culture: An Anthology of Critical Texts* (1992).

The Social History of Art

Arnold Hauser, with an introduction by Jonathan Harris

Volume I – From Prehistoric Times to the Middle Ages
Volume II – Renaissance, Mannerism, Baroque
Volume III – Rococo, Classicism and Romanticism
Volume IV – Naturalism, Impressionism, The Film Age

THE SOCIAL HISTORY OF ART

VOLUME I

From Prehistoric Times to the Middle Ages

Arnold Hauser

with an introduction by Jonathan Harris

Routledge
Taylor & Francis Group

LONDON AND NEW YORK

First published in two volumes 1951

Second edition published in four volumes 1962
by Routledge

Published 1989, 1995
by Routledge
2 Park Square, Milton Park, Abingdon, Oxon, OX14 4RN
711 Third Avenue, New York, NY 10017, USA

Routledge is an imprint of the Taylor & Francis Group, an informa business

Third edition 1999

British Library Cataloguing in Publication Data
A catalogue record for this book is available from the British Library

Library of Congress Cataloguing in Publication Data
A catalogue record for this book has been requested

ISBN 0–415–19945–X (Vol. I)

ISBN 0–415–19946–8 (Vol. II)
ISBN 0–415–19947–6 (Vol. III)
ISBN 0–415–19948–4 (Vol. IV)
ISBN 0–415–21386–X (Set)

CONTENTS

CONTENTS

CONTENTS

CONTENTS

CONTENTS

ILLUSTRATIONS

GENERAL INTRODUCTION

Jonathan Harris

Contexts of reception

Arnold Hauser's *The Social History of Art* first appeared in 1951, published in two volumes by Routledge and Kegan Paul. The text is over 500,000 words in length and presents an account of the development and meaning of art from its origins in the Stone Age to the 'Film Age' of Hauser's own time. Since its publication, Hauser's history has been reprinted often, testament to its continuing popularity around the world over nearly a half-century. From the early 1960s the study has been reprinted six times in a four-volume series, most recently in 1995. In the period since the Second World War the discipline of art history has grown and diversified remarkably, both in terms of the definition and extent of its chosen objects of study, and its range of operative theories and methods of description, analyses and evaluation. Hauser's account, from one reading clear in its affiliation to Marxist principles of historical and social understanding – the centrality of class and class struggle, the social and cultural role of ideologies, and the determining influence of modes of economic production on art – appeared at a moment when academic art history was still, in Britain at least, an élite and narrow concern, limited to a handful of university departments. Though Hauser's intellectual background was thoroughly soaked in mid-European socio-cultural scholarship of a high order, only a relatively small portion of which was associated directly with Marxist or neo-Marxist perspectives, *The Social History of Art* arrived with the Cold War and its reputation quickly, and inevitably, suffered within the general backlash against political and intellectual Marxism which persisted within mainstream British and American society and culture until at least the 1960s and the birth of the so-called New Left. At this juncture, its first 'moment of reception', Hauser's study,

actually highly conventional in its definition and selection of arte-
facts deemed worthy of consideration, was liable to be attacked
and even vilified because of its declared theoretical and political
orientation.

By the mid-1980s, a later version of Marxism, disseminated pri-
marily through the development of academic media and cultural
studies programmes, often interwoven with feminist, structuralist
and psychoanalytic themes and perspectives, had gained (and
regained) an intellectual respectability in rough and ironic propor-
tion to the loss of its political significance in western Europe and the
USA since the 1930s. Hauser's study was liable to be seen in this
second moment of reception as an interesting, if, on the whole,
crude, antecedent within the development of a disciplinary special-
ism identified with contemporary academic art and cultural histor-
ians and theorists such as Edward Said, Raymond Williams, Pierre
Bourdieu and T.J. Clark. By the 1980s, however, Hauser's orthodox
choice of objects of study, along with his unquestioned reliance on
the largely unexamined category of 'art' – seen by many adherents of
cultural studies as inherently reactionary – meant that, once again,
his history could be dismissed, this time primarily on the grounds of
its both stated and tacit principles of selection. Yet *The Social
History of Art*, whatever its uneven critical fortunes and continuing
marginal place in most university courses, has remained an item, or
an obstacle, to be read – or at least dismissively referred to – within
the study of the history of art. Why should this be the case?

There are several different, though related, answers to this ques-
tion. The sheer extent and relative detail of reference in Hauser's
study – despite the narrowness of selection – has commanded a cer-
tain amount of respect and attention. No comparable study exists in
the English language, though many attempts at a one-volume 'his-
tory of art' have been made since Hauser's *magnum opus* appeared.
Most famous of these and certainly better known, especially outside
the Academy, is Ernst Gombrich's *The Story of Art*, which was actu-
ally published just before Hauser's study.[1] Unlike Hauser, however,
Gombrich, probably aware of the charge of reckless megalomania
likely to be levelled at anyone attempting such a task, shrewdly
adopted the term 'story' for his title which connoted, amongst other
things, a modest declaration of unreliability. Gombrich admitted, by
using the word, that his pithy tale was evidently 'made up', an
invention, and therefore, after a point, 'not to be trusted'. Hauser's
pleonastic *History*, on the other hand, offered no such self-
effacement and its seriousness was liable to be represented, especially

in the Cold War, as another dreary facet of doctrinal Marxism promulgated by one of its apologists in the Free West. And Hauser's text *is* undoubtedly hard-going, unrelieved by regular and frequent section sub-divisions, only sparsely (and sometimes apparently arbitrarily) illustrated, and with no specific references to illustrations in the text. In addition to these failings the text itself was translated from German into English in usually a merely adequate manner by Stanley Goodman, though with Hauser's collaboration. Long Germanic sentences, piling qualifying sub-clause upon sub-clause, within arguments mounted at usually quite high levels of abstraction make reading *The Social History of Art* sometimes seem like the exhausting ascent of a literary Everest, in painful contrast to what amounts to an afternoon skip up Gombrich's sunny and daisified hillock.

If it is the case that Hauser's sheer ambition (megalomaniacal or not) to attempt to write meaningfully on art from the Stone Age to the Film Age almost in itself warrants a certain amount of cautious interest, however, and his command of research materials ostensibly indicates a more than superficial understanding of the dozens of fields of study necessarily implicated in such an account, then there is another reason for taking the history seriously. This is the issue of the significance of his claim, finally stated clearly only in the ultimate volume, that the entire effort is really directed towards trying to understand ourselves and the present. However, Hauser omitted – and this was a serious error – to begin his study with an introduction which might have made the intended purpose and value of his work manifest for readers at the start of their arduous climb. Though it might not have been at all evident from his first pages on cave painting and paleolithic pottery, Hauser was trying, he says retrospectively, to use history to understand the present. 'What else could the point of historical research be?', he asks rhetorically. Although 'we are faced with new situations, new ways of life and feel as if we were cut off from the past', it is knowledge of 'the older works', and knowledge of our alienation from them, which can help us to find 'an answer to the question: How can we, how should one, live in the present age?' (vol. IV: pp. 1–2). One may, relatively productively, simply 'dip into' Hauser – in a way that one can not simply experience a portion of Mount Everest at will (say, the atmosphere and footholds around 20,000 feet) and then return to a temperate and well-oxygenated sitting-room when tired. But reading the whole text, appreciating the historical developments and disjunctions Hauser identifies over the four volumes, ending up with the place of art and

culture after the Second World War, is really necessary in order for the 'ground' of the past to be as clearly visible as possible – be it only fleetingly, obscured by cloud and rain-bursts, from the vertiginous summit of the present. The higher one goes up, or further on, the more there is to see, potentially at least, below, or behind.

Hauser's motivation, from this point of view, was truly sanguine, and reflected a belief held by socialists and Marxists around the world after 1945 that revolutions in society would surely follow those in knowledge brought about by Marxism's purported science of historical materialism. But the development of anti-communism in the USA, Cold War politics there and in Europe, along with Stalinization in the USSR and the Eastern Bloc states, would bring popular disillusionment with traditional notions of socialist revolution and transformation during the 1950s and 1960s, along with loss of faith in the grand vision of history, society and culture exemplified by Hauser's scholarly ambitions. Confidence in Marxism's 'scientific' status, historical understanding and map of the future dissipated gradually, though continuously, during the post-war decades. Although temporarily enlivened, within French academic theory at least, by association with structuralist ideas which themselves claimed objective status for a while during the 1960s, or with socialist-feminists who attempted to theorize the relations between class and gender identity in the 1970s, by the mid-1980s Marxism as a unitary theoretical system, and socialism as a practical political doctrine, was discredited, almost as much by some of its own previous protagonists as by its long-standing and traditional enemies.[2]

Though still a thriving specialism in some university arts and social studies departments, Marxism has been cut off as effectively from civic culture and politics in the West as definitively as Hauser claims in his third volume that German idealist philosophy was in the eighteenth and nineteenth centuries. The loss of the intellectual as 'social activist' paralleled, Hauser argues, in fact, the development of modern aestheticism ('art for art's sake') and the refashioning of the artist as estranged outcast, the artistic persona predominant still in his own time. Hauser's history, from one perspective then, is an account of this transformation or decline, from art as social instrument of authority and propaganda of one sort or another – the Church, the State – into an expensive plaything of the cultured bourgeoisie and philosophical rebus of the academic and critical intelligentsia. Yet Hauser's time is *not* our own: though Marxism certainly has lost its political role and intellectual centrality, many

other forms of politics and modes of analyses of social life and history have become important, both in academia and in the general polity. Feminist, racial, sexual, regional and ecological concerns, for instance, are *not*, singularly or together, a 'false consciousness' that has simply usurped the fundamental and prior place of class analysis and politics in historical and social understanding. Rather, they have provoked and reflected a renewed, though disparate, 'left-libertarianism' in the West – inside and outside the Academy – but have also helped to catalyse a range of art forms, utilizing both traditional and new media, that have restored a variety of social activisms to contemporary culture. Hauser, writing in the late 1940s, could not have predicted this development, although he probably hoped for it. His own perspective inevitably limited what he could see and, from our situation in the late 1990s, his study may seem extremely dated. We are, of course, now further up the mountain than Hauser, although, in one sense, the near half-century since the publication of his study is a mere trifle compared with the ten thousand or more years of history he tried to encompass.

Reasons and strategies for reading

On the other hand, the specifics of the moment in which one writes determine absolutely what we can see and why we want to see it. Ten years later, in 1961, Hauser might have produced a very different book, in the light of, say, the critical hegemony achieved by US-based Abstract Expressionist painters (the full-blown abstractions of whom were claimed to make completely obselete Picasso's still highly mimetic, and in Hauser's sense, *naturalistic* 'modernism'), or the extensive erosion of popular and intelligentsia faith in Marxism and Soviet socialism (though Hauser is implicitly critical of the Soviet state and quietly derisive on the value of socialist realist art). Reading Hauser is important and instructive now, then, also because his text itself has achieved historical significance: it tells us about his values, representative, as they were, of an influential stratum of left-wing intellectuals active in Britain in the early 1950s.[3] On the whole, it is also the case that his account is far less crude, in fact far less straightforwardly 'Marxist' altogether, than many have assumed.

Reading Hauser may also inform us about the current terrain of the discipline of art history, and enable us to register and evaluate, through a process of systematic comparison, the continuities and ruptures in the post-war development and present configuration of the subject. Reading is usually, and certainly most valuably, an active

process: we search for meaning and significance in a text because our reading is specifically motivated, and we have a conscious sense of purpose in mind. Far less attentive and productive readings occur when we have little or no sense of *why* reading a text is worthwhile. In approaching Hauser's study, due to its length and complexity, readers – in addition to sheer stamina – require a particularly clear sense of their own intentions, as well as a knowledge of which parts of the text might be most useful. If a reader wishes to find material relevant to, for example, an essay question on ecclesiastical art commissions in early Renaissance Florence, or on the changing social status of artists in the French revolutionary period, then it is easy enough to find the appropriate sections. This is an entirely valid use of Hauser's text and one he probably envisaged. But a careful reading of the *whole* study produces, and, arguably, was intended to produce, much more than a simple sum of all the separate historical sections. For the study attempts to show us how what is called 'art' began, and how it has become – along with Western society – what it appeared to its author to be in the mid-twentieth century.

Hauser does not make this understanding easy. The book contains no general overview of its aims and methods, nor any succinct account of its values and assumptions, nor a defence or definition of key concepts (such as 'art' or 'style'), nor of its principles of selection. Inclusion of this kind of introductory material has become part of the 'reflexivity' of academic theory in the humanities over the past twenty-five years and constitutes a real advance on the complacency present in earlier traditions of art and cultural history, those identifiable both as 'traditional' or 'radical'. Hauser does not indicate either whether his study is directed at any particular readership and appears almost completely unself-conscious about the general intelligibility of his arguments. Though any person *might* benefit from reading his history, the complexity of his language, assumptions about prior knowledge (particularly knowledge of visual examples), and discussion of a vast range of issues in economic, social, cultural and intellectual history presumes a readership already highly educated and in agreement with Hauser on basic principles, and involved rather in engaging with his abstract 'connective logic' and manipulation of Marxist analytical tools.

The tone and rhetoric Hauser deploys may also appear unattractive, because doctrinaire. Generally he writes, especially in the earlier volumes, in an authoritative and declamatory manner, seemingly with little or no sense of open investigation, or of any doubt over the credibility of his account. Reflexivity in recent theory has

come to value scepticism and 'explanatory modesty' over this kind of authorial certainty. The apparent unassailability of Hauser's argument in large part reflects the character of Marxist history and theory in the late 1940s, its proponents still sure of its 'scientific' basis – philosophically water-tight in its dialectical materialism – and confident that the veracity of its understanding of the world was somehow confirmed by the existence of an 'actual' socialist society erected on its principles. It transpires that Hauser's certitudes, however, are more apparent than real, and begin to break down fundamentally as his account moves through to the nineteenth and twentieth centuries. He not only subjects many *other* theories and traditions of cultural analysis to withering critique – for instance, the 'liberal' concept of the Renaissance, the 'formalist' method of art historians such as Alois Riegl or Heinrich Woelfflin, or the previously mentioned 'social escapism' of German idealism. By the end of the fourth volume Hauser's historicization of Marxism *itself* – part of which locates it as an item alongside other, specifically nineteenth-century symptomatic 'ideologies of unmasking', such as those produced by Nietzsche and Freud – suggests that his, and Marxism's, 'mastery' of history is tentative, corrigible, and inadequate in many ways. This sense partly reflects his understated, though serious, qualms expressed in the final volume over the place of art and culture in the Soviet Union.

Hauser's inclusion of artefacts, or artists, or periods or geographical regions is, necessarily, drastically selective and therefore narrow – after all, how could *any* history of art from the Stone Age be otherwise? Yet some attempt to justify or simply to acknowledge this selection as such would have mitigated the doctrinaire quality to his writing, particularly evident in the first two volumes which deal with many thousands of years of history in little over 500 pages. Presumably he included what he felt was most important, though even this is not said directly and the effect is to feel too often as if one is being lectured at, rather than being invited to engage in an extended explanation. 'Facts', at times, seem to overwhelm his text and its reader, particularly when he includes extensive sociohistorical, contextual material at what seem like relatively arbitrary points in the text, or when he lurches, without clear reasons, from France to England, or from Russia to Germany, in his discussion of the late nineteenth century. Certainly a quite orthodox outline description of the history of art subsists in Hauser's text, despite his Marxist perspective, and this account is squarely based on the use of traditional art-historical terms, methods of description of artworks

(thought these are relatively few and far between), and a defence of the conventional canon of Great Works. Hauser's history of art is also clearly and unapologetically 'Western' or 'eurocentric' – especially, definitively perhaps, in its 'cultural-imperialist' assimilation of Egyptian, Byzantine and Babylonian works to this tradition – and for this reason would count as what Edward Said calls, critically, an 'orientalist' text, despite its Marxism.[4]

Given its massive historical sweep and gross selectivity it should not be surprising that Hauser's study presents little in the way of specific 'technical' information or analysis of particular paintings or sculptures or prints (or any other artefacts). The level of abstraction generally precludes him from discussing anything below, in most cases, what one might call an identifiable 'social style' – that is, a consistent form of representation he claims is characteristic of a group of producers at a certain moment. Hauser, by the way, at no point subjects the term 'style' to any sustained analysis; instead he allows it to proliferate a range of different and sometimes confusing senses which come to co-habit throughout his account. Though he does occasionally discuss individual artefacts, though never for more than a few paragraphs at the most, his narrative is carried forward in terms of a conventional art historical litany of familiar style abstractions, such as 'mannerism' (though he claims to identify several distinct varieties of this), or 'the baroque' (similarly variegated), or 'impressionism' (a term he uses highly promiscuously to discuss an extensive range of painting, literature, music and drama in nineteenth-century France). This analytic and narrative device persists until he moves to the late nineteenth century when he claims that 'social style' in the arts more or less breaks down altogether – for complex historical reasons – and that from this point the 'history of art' becomes really the history of the work of disparate individuals, living in an ostensibly common world, but driven by radically incommensurate motivations and methods. Hints, prefigurations, of this claimed development occur much earlier in the study – within his account of the high Renaissance persona and work of Michelangelo, for instance. Hauser is open to the charge, however, that, given the sheer density of detail available on more recent art cautioning the analytic reduction of such particularity to homogenizing 'social styles', all his earlier abstracted notions (the style-labelling stretching back to the 'gothic' and before) could equally be shown to be untenable if sufficient historical evidence was adduced.

Hauser and the 'New Art History'

If Hauser's narrative of producers and products in large part reproduces that of mainstream art history, the qualification in his superior title for each volume (*The* Social *History of Art*) suggests that the account goes on to offer something different, and presumably better, or truer, than an ordinary, unqualified 'history'. In many respects, however, Hauser's study faithfully – even dogmatically – continues much of art history's traditional descriptive terminology. As noted, he uses the same style labels, both for relatively historically-specific forms of representation (e.g. 'mannerist', 'rococo', 'baroque', etc.), as well as those for 'transhistorical' or 'epochal' depictive modes. These, such as 'naturalistic', 'stylized', 'classicistic', etc., according to Hauser again following art-historical orthodoxy, have remained relatively constant within many centuries of human culture. Hauser's novel analytic extension *beyond* the typical art-historical procedures of what might be called 'style-nomination' and 'style-mutation description', is to attempt to correlate such claimed stylistic features and changes with a range of socio-economic developments. He wishes to see, and attempts to show, that 'development' and 'progress' in art is related, necessarily – though abstrusely – to a corresponding dynamism, a 'historical logic', active in the organization of human societies since the Stone Age. This identification, or correlation, is the basis of his Marxist, 'social', art history.

The traditional, painstaking, 'footsoldier' work of art-historical methods rooted in the careful form of specific 'visual analysis' – connoisseurship, Erwin Panofsky's 'pre-iconographical' and iconographical protocols, reconstructions of artists' intention, etc. – are supplanted in Hauser's account with this work of correlation between style and socio-economic development.[5] Given that the discussion usually takes place at a quite high level of abstraction and involves complex, and sometimes highly questionable, notions of 'equivalence' or 'agreement' between apparently quite disparate economic, institutional, political and artistic phenomena, it should not be surprising that many conventionally trained art historians have quickly run out of patience with Hauser's intentions and arguments. Those art historians indifferent or actually antagonistic to his intellectual and political motivations have found, and continue to find, many of his claims, by turns, either truistic – because pitched at such a high level of abstraction – and therefore banal, or simply empirically unverifiable – given that Hauser's undoubtedly grandiose project

inevitably eschews specific historical detail – and therefore unproductively ineffable.

In the 1960s and 1970s most critiques of Hauser's account were liable to proceed from the assumption that 'authentic' art history meant precisely a kind of detailed descriptive and analytic work on specific works of art, or on an artist's *oeuvre*, or on a group of artists or artefacts thought to constitute an identifiable school or style or tendency. General problems of explanation and evaluation in art history – the meanings of 'romanticism', say, or the question of the figurative 'autonomy' of an abstract painting – were certainly beginning to be taken seriously at the level of conference debate and published diatribe between peer academics. The study of the 'history of art history' had also begun to be taught in universities and this indicated the opening up of debate over the status and value of key assumptions, ideas and values in the subject generally. In the early 1980s the Open University in Britain inaugurated an art history course specifically designed to introduce complex theoretical and philosophical problems relevant to the study of modern art, approached however, and wisely, through a series of specific historical case-studies.[6] One of Hauser's errors in *The Social History of Art* was really not sufficiently to have related his 'meta-historical' and theoretical concerns to specific case-studies that could be recognized as examples of what stood, in the 1950s and 1960s at least, as 'proper' art history. This was, and remains, a very reasonable objection, particularly in relation to the productive use of Hauser's text in undergraduate teaching, where students, with perhaps only scant knowledge of the artworks to which Hauser often anyway only indirectly refers, are expected to follow, and presumably then assess, the highly complicated relations he draws between such empirical material and claimed abstract societal developments.[7]

Hauser's refusal to clarify his aims, objectives, and methods in a general introduction, along with his adoption, generally, of a dictatorial tone (however much subverted in later stages of the account) meant that his study was likely to meet another critical response when the so-called New Art History emerged in the mid-1980s. If previously attacked by traditional art historians for the crudity, or vapidity, of his abstractions and lack of meaningful engagement with specific artworks and their contexts of production and reception, Hauser's text was now, in addition, liable to be judged reactionary, sexist, racist and élitist by recently politicized groups responsible for the New Art History's attempted reconstruction of the discipline over the past fifteen years or so. Once again the charges are, on the

whole, sustainable. Hauser, because of his mid-century gender, class, political and scholarly characteristics and inclinations, manifestly is *not* concerned, for instance, with an investigation of the presence or absence of women as significant or jobbing artists in history, nor with the sociological reasons why they did or did not achieve such positions – perhaps the two most important issues that have pre-occupied feminist art historians for many years now.[8] (He does, however, discuss several times the place of women as part of a changing public for art, or even, occasionally, as patrons, and their status as 'muse'. In addition, and interestingly, the question of a presumed relationship between 'femininity' and creativity crops up in his discussion in volume I of the production of craft artefacts in ancient societies where he is quick to refuse any simplistic relationship.)

Hauser is similarly, though again predictably, 'blind' to the questions or significances of race, of sexual orientation, and of ethnicity in artistic production and reception, all issues core to the 'subject-position' or 'life-style'-oriented politics and theory of many of those involved with New Art History in Europe and the US. But this revisionist phase in the discipline has included not just those representing New Left libertarian politics (including some who believe 'art' is an intrinsically élitist designation which should be replaced by study of those images and artefacts deemed to constitute 'popular culture'). Novel academic techniques of textual or visual analysis – most with French provenances, some claiming to be scientifically objective – also found an important place, initially at least, in New Art History. So-called 'structuralist' and 'post-structuralist' methods and philosophies would make mince-meat of Hauser's Marxism, convicting it endlessly of such analytic crudities as 'reflectionism', 'mechanistic reduction' and 'teleological projection'. However, revivified post-structuralist, academic Marxism itself can play this game as well as (if not better than) the followers of Foucault, Lacan and Derrida, finding Hauser's concepts, analyses and values stranded in the crudities of 'Second International' and 'Third International' Marxist protocols of ideologues such as Karl Kautsky, Franz Mehling, George Plekhanov and even Georg Lukács.[9]

The point, however, is to understand Hauser's text itself *historically* and to assess its significance on this basis. It can not be claimed – though neither can any other single book for that matter – as a viable basis for constructing an entire art-historical method, or for regenerating a 'cultural Marxism', or anything else. Its overleaping ambition certainly tells us, however, that Hauser nursed a belief that Marxism did possess a unique explanatory potential, a set of sureties, and a

cluster of values superior to anything else available in the discipline in 1951. But this confidence becomes systematically and increasingly undermined within his own text and what would now be called Hauser's 'auto-deconstruction' constitutes the book's most interesting feature. The vast text is heterogeneous, uneven, fragmented – composed of many genuine insights and genuine idiocies; full of active and productive revisions and complacent reproductions; it is hectoring and vituperatively authoritiarian, yet also interrogative and prone to dubiety.

Hauser, like Marx himself, is sometimes, when it suits, effectively prepared to declare himself 'not a Marxist'. Many times, actually, throughout his text he will criticize *others* for attempting the same task of correlating art and social development – Wilhelm Hausenstein, for instance, who attempts, illicitly Hauser believes, to claim an identity between ancient art's geometric style and the 'communistic outlook of the early "agrarian democracies"' (vol. I: p. 16). Such fallacious connections Hauser dismisses repeatedly as 'equivocation', the use of ambiguity to avoid or conceal the truth. But his own correlations necessarily perform an identical analytic operation: they draw on one set of features claimed to be immanent in an artwork or group of artworks (for instance, an identifiable 'social style') which are then mapped upon, claimed to organically 'reflect' and partially 'constitute', another set of selected features claimed to be immanent in an identifiable social development. Though Hauser is right to condemn simplistic or 'essentialist' correlations that posit necessary and inevitable relations – such as that of H. Hoernes-O. Menghin, who contends, in contrast to Hausenstein, that 'the geometric style is . . . feminine in its character' (vol. I: p. 19), Hauser's own analytic house – a veritable skyscraper at that – is built fundamentally with the same bricks. Reading his text runs the danger of becoming a game of deciding whether one happens to 'like', or 'find pleasing', the correlation that entertains the author at a particular moment. Is the 'social order' of French revolutionary society under Napoleon justifiably 'correlated' (confirmed) in the formal and narrative 'visual order' of a painting by David? Are both equally 'facts' about French art and society at the time? Is the fractured, reversible space and time of film an 'objective' facet of the 'experiential dimension' to early twentieth century modernity? Such claims, ultimately, can not be either 'proved' or 'disproved'; they become a bit like artworks themselves, which we can admire or not, depending on taste. This is to say, actually, that the credibility of Hauser's account is, to an important degree, a matter of 'faith' in the end, or commitment to a certain

notion of the purpose of history and meaning of culture. If Marxism was still able to command this fidelity in the early 1950s, amongst intellectuals and popular movements in favour of social revolution, it certainly can not recruit such support now. The implications of this are mixed.

The New Art History – at least in its manifest political variants which brought the issues of women, race, sexuality, popular culture and ethnicity into some kind of generally productive relation with the pre-existing discipline of art history – importantly challenges these absences in Hauser's text. But although *The Social History of Art* cannot – should not – be used as the basis for teaching the subject, it can provide many valuable insights and observations. These may be used to support the interests of feminists, scholars concerned with non-Western culture, and gay or lesbian revisionists, as well as those of the dwindling ranks of Marxists still haunting universities – those largely forgotten within the New Art History now, who can similarly integrate some of Hauser's valuable work into their own studies.[10] But the radical fragmentation of the discipline's theoretical bases, along with the loss of faith in Marxism, both as a superior intellectual system, and as a practical means of transforming capitalist societies, has an ambiguous legacy when it comes to assessing Hauser's study. On the one hand, it is definitely an advance for left-liberal scholarship and culture no longer to maintain that 'class' and 'economics' have singularly, or most significantly, determined the social development and value of art. On the other hand, contemporary art history is balkanized and no longer contains *any* kind of what Jean-François Lyotard famously called a 'metanarrative of legitimation' – an accepted overarching principle – able to unite all the theories and methods with putative disciplinary status. To be sure, of course, there was never a time in the past when art history experienced a pristine, transparent, golden age of community and consensus. Methods of description and analysis have always been heterogeneous, in large part reflecting the institutional dualism of its core knowledge-producers, whose interests have been half curatorial and market-oriented (connoisseurial and provenance-hunting), half academic and pedagogic ('style and civilization' studies). But up until the mid-1970s the subject, arguably, exhibited a relative unity based on the general stability of the canon of artworks deemed worthy of study. This quickly broke down in the 1970s and 1980s as media, film and popular-cultural studies burgeoned.

Hauser's text, in large part manifestly Marxist and therefore 'radical' in method was also, as noted, traditional, and therefore

'conservative', in its selection of cultural artefacts. 'Cultural Marxism' in the 1980s was, in contrast, highly sceptical of 'aesthetic value' understood either as a defensible analytic category or as a datum of human experience believed to 'guarantee' the canon, and saw both as examples of ideological delusion or 'false consciousness'. Canons were claimed to be simply duplicitious; partisan preferences masquerading as neutral and objective categories. Such extreme relativism over the issue of cultural value was characteristic of parallel forms of structuralist, post-structuralist and reception theory. Relativism of this kind had found no place at all in the writings of Marxists active before the 1970s and Hauser's text is full of judgements, asides and reflections which indicate his highly conventional taste and values (often labelled 'bourgeois' by the ideologues of academic Cultural Studies), identical or close to those of earlier influential Marxist critics and cultural commentators including Theodor Adorno, Herbert Marcuse, A.S. Vasquez, Lukács, and Marx and Engels themselves.[11] Hauser, whatever his declared 'sociological method', will repetitively uphold a mysterious phenomenon called the 'human spirit', reiterate his belief in the ineffability of quality in art, and even, by the end of the fourth volume, seem to sometimes replace his Marxist 'objectivity' with a variant of judgemental subjectivism reminiscent of the kinds found in the prose of Marcel Proust, the philosophy of Henri Bergson, or the paintings of the Surrealists.

In addition to this reliance on conventional canonical selection, advocacy of the 'autonomy of the aesthetic' in art in matters of experience and evaluation, Hauser also often attacks the crudity of others claiming to mobilize Marxist principles and methods. As we have seen, this is sometimes a criticism of those exhibiting 'essentialist' tendencies (such as those who Hauser thinks reduce analytic complexity to a single sociological or psychological determinant), or of those who claim correlations between style and socio-economic developments based on what he regards as 'equivocations'. Though Hauser several times attacks historians such as Riegl or Woelfflin for reliance on a 'formalist' notion of 'internal laws' operating in art styles, Hauser himself mobilizes a variant of this idea when it seems necessary. For instance, reflecting on the complexity of interpretation involved with assessing broad style designations, such as 'naturalistic' or 'classicist', he remarks:

> The greater the age of an art, of a style, of a genre, the longer
> are the periods of time during which the development
> proceeds according to immanent, autonomous laws of its

own, unaffected by disturbances from outside, and the longer these more or less autonomous episodes are, the more difficult it is sociologically to intepret the individual elements of the form-complex in question.

(vol. I: p. 21)

Hauser's own 'equivocation' here – what does he really mean by 'immanent' or 'autonomous'? – exemplifies the nature of his text as a whole, which does not present a single or unified argument, or a stable set of concepts and ideas, or a homogeneous sense of value or purpose. Its semantic openness, in fact, makes it in many ways definitively 'post-modern': it is best read as fragmented, split, undecided. Its ambitions and claims are unbalanced, unreasonable and unverifiable, evidenced in a lurch from a discussion of ten thousand years of art in two volumes, to the last two hundred years in another 500 or so pages, often at a level of rarefied and quite suffocating abstraction. Yet its rhetoric and grand historical sweep, often overblown, at the same time is quite magisterial. Hauser's study is an excitedly written history of the world, of ideas, of human social development, as well as of art and culture more broadly. From one perspective his sources and selections are narrow and highly partial, yet from another quite extensive and diverse, and the treatment belies his ostensible Marxist method. The text tells us as much about Hauser's own intellectual and class formation (in all its gender, ethnic and other specificities) as it does about art and its history.

We may read *The Social History of Art*, then, for all this which it offers, from our own very different moment, which it also throws into relief. Lapsing, or rising, often into the present tense, as he races through the Stone Age, the Renaissance, the Romantic movement and the dawn of the Film Age, Hauser above all communicates a sense of urgency and commitment to understanding the past as a means of knowing about the present. The medium of film itself, to which he refers many times in his text – often when its use as a comparison seems virtually historically meaningless – indicates his excitement precisely with the dynamism of the present, signified in film, and partly explains the 'teleology' or sense of 'necessary development' which permeates his narrative. For Hauser the past – in art, in social organization and change generally – has 'made' the present what it is, made us what we are. If one exhaustedly closes *The Social History of Art* with this insight, which we may then decide to qualify as much as Hauser himself does, then a reading of his account has surely been worthwhile.

Notes

1 *The Story of Art* (London: Phaidon, 1950). See Gombrich's review of Hauser's study, 'The Social History of Art', in Ernst Gombrich, *Meditations on a Hobby Horse and Other Essays* (London: Phaidon, 1963), pp. 86–94. This article was originally published in *The Art Bulletin*, March 1953.

2 See Ernesto Laclau and Chantal Mouffe, *Hegemony and Socialist Strategy: Towards a Radical Democratic Politics* (London: Verso, 1985) and Stanley Aronowitz, *The Crisis in Historical Materialism: Class, Politics and Culture in Marxist Theory* (New York: Praeger, 1981).

3 See Tom Steele, *The Emergence of Cultural Studies 1945–1965: Cultural Politics, Adult Education and the English Question* (London: Lawrence & Wishart, 1997).

4 See Edward Said, *Orientalism: Western Conceptions of the Orient* (Harmondsworth: Penguin, 1991), Martin Bernal, *Black Athena: The Afroasiatic Roots of Classical Civilization* (London: Vintage, 1991) and Edward Said, *Culture and Imperialism* (London: Chatto & Windus, 1993).

5 See Eric Fernie, *Art History and its Methods: A Critical Anthology* (London: Phaidon, 1995) and Marcia Pointon, *History of Art: A Students' Handbook* (London and New York: Routledge, 1994).

6 *Modern Art and Modernism: Manet to Pollock* (Milton Keynes: The Open University, 1983). Thirteen course books and associated materials.

7 See, in contrast, however, Hauser's *Mannerism: The Crisis of the Renaissance and the Origin of Modern Art* (London and New York: Routledge & Kegan Paul, 1965).

8 See Rozsika Parker and Griselda Pollock, *Old Mistresses: Women, Art and Ideology* (London: Pandora, 1987) and Griselda Pollock, *Vision and Difference: Femininity, Feminism and the Histories of Art* (London and New York: Routledge, 1988)

9 See Raymond Williams, *Marxism and Literature* (Oxford: Oxford University Press, 1977).

10 See A.L. Rees and F. Borzello (eds), *The New Art History* (London: Camden Press, 1986).

11 See Roger Taylor, *Art: An Enemy of the People* (Brighton: Harvester, 1978).

INTRODUCTION TO VOLUME I

Jonathan Harris

Content and concepts

Hauser's first volume deals with the beginnings of human settlement in paleolithic or 'Stone Age' times and progresses – breathlessly, in about 250 pages – up to the end of the Middle Ages. He includes discussion on the nature and place of art in the 'old' and 'new' Stone Ages, Egyptian, Mesopotamian, Cretan, Greek and Roman times. The second half of the volume divides the notoriously homogenized Middle Ages into three distinct historical periods. Needless to say, the truncation and brevity of treatment, in all respects, is inevitable, though, in comparison with later volumes, the number of illustrations of 'ancient' art (that is, everything before the Middle Ages) is reasonably helpful. Because, as previously noted, Hauser never refers to any specific illustrations bound with his text, the reader is encouraged to begin the habit of flicking back and forth from text to pictures, as many of his major arguments correlating style and socio-economic development are exemplified. Hauser's end notes, as a glance indicates, reference sources which now appear almost archaic themselves – the vast bulk published before 1940 and many in the late-nineteenth century. Most of them are the work of middle-European scholars and indicate Hauser's own genesis and heritage in an art and cultural history if not specifically 'Marxist', then certainly committed to the general belief that all the elements of human society, including its manifest forms and means of visual and semantic communication, necessarily share a commonality and interdepend-ence, at the levels of their material production and consumption.

The purpose of this introduction to the first volume is to suggest a path through the text and signposts along the way to major themes, claims and problems. It does not, however, provide a comprehensive synopsis of Hauser's narrative. Rather it offers a set of contexts –

historical, political, intellectual – for interpreting its shape and assessing its value, for Hauser's text, like that of the artworks he discusses, is an artefact produced in a particular time and place, and for specific reasons. Hauser's descriptions and analyses often depend upon a set of key concepts whose meaning and significance he usually takes for granted. Notions of 'class' and 'class interests', of 'ideologies' or 'value-systems' and of 'culture' and 'society' are four of the most important. The ideas of 'class' and 'class struggle' must for Hauser become significant within the earliest societies because they are an essential component of Marxism's claim to offer the most profound understanding of the determinants of all human history. By the 'new' Stone Age, then, according to Hauser, differentiation of society into 'strata and classes, privileged and underprivileged, exploiters and exploited' (vol. I: p. 9) has already taken place. From the beginning of his first section on the 'old' Stone Age, however, he also assumes that 'art' is the most applicable and obvious term to use to describe the kinds of cultural products – paintings on dwelling walls, pots and all other decorative, functional or 'magical' images or artefacts – made by human beings. While he recognizes that early human societies were extremely 'simple' in organization compared with later ones and that 'class' could not mean the same thing in both, his perennial and unexamined use of 'art' is analytically indefensible. The term simply carries with it too many meanings generated only in the past three or four centuries, and therefore confuses, rather than clarifies the status and purpose of the earliest human images and artefacts.

Hauser's notion and use of the category of 'ideology', like class, is crucial, though unlike that developed by Marxists influenced by structuralist ideas in the 1960s, its definition remains unclear and relatively uncomplicated.[1] Throughout his account he maintains that ideas and values are straightforwardly 'class-specific', that is, that they reflect or embody the interests of certain social groups – though he understands that different classes, confusingly, may sometimes adopt similar, or even identical, 'world-views' or 'value-systems', such as Christianity in the late Roman period. He argues that even in the 'old' Stone Age a kind of 'primitive individualism' was already in existence, conditioned, he claims, by lack of belief in gods, or in a world and life beyond death (vol. I: pp. 3–4). By the time of the complex society of Egypt's New Kingdom, characterized by division of power and labour, Hauser claims an extensive stratification of interests has occurred. Artists within it, he contends, already belonging to the 'higher social classes', developed a 'comparatively

advanced class-consciousness' (vol. I: p. 28). Though certainly not interested particularly in the place of woman as an identifiable 'social class' of their own (a pressing concern of 1970s feminist-socialists), Hauser *is* attentive to aspects of their status within the ancient societies, and in his discussion of the theme of love in Greek poetry claims that Euripides's saga of the heroine Medea includes, perhaps for the first time, 'something like a domestic drama of married life' (vol. I: p. 84). In addition to this an extended and interesting discussion of gender takes place in a later section on chivalric culture and the 'cult of love' in the Gothic period (vol. I: pp. 175–210).

Hauser's text, though radically selective in terms of visual art discussed, ranges widely beyond this facet of culture to include extensive discussions of poetry, prose, philosophy, and – in later volumes – drama, music, opera and, finally, film. *The Social History of Art* may also be seen, therefore, as a 'history of ideas' and even contains the basis of a kind of historical 'cultural studies', though it is sometimes tempting to read much of the discussion as 'background' to the account of visual art's development. It is possible, however, to discern an emergent dualism in Hauser's argument which continually sets 'art' (as an ahistorical category or 'common sense' reality) against an increasingly constricting and complicating 'culture' or 'society', although he is, of course, trying specifically to show the interpenetration and interdependence of these phenomena. Several times in the first volume, though, Hauser appears to equate 'culture' with a rigidification of artistic values and practices, claiming to find such a development in the 'new' Stone Age (vol. I: p. 14), intensified later in the aristocratic social orders of Egypt and Mesopotamia (vol. I: p. 45), and later in the homogeneity and self-contained outlook found in the 'entirely "authoritarian and coercive culture"' of the Romanesque (vol. I: p. 165).

As important to Hauser's argument as the notion that styles in art are necessarily related to the ideologies or world-views of particular social classes, is his belief that all styles are developmentally linked. Like classes in history, styles, such as that which he calls 'prehistoric naturalism' (vol. I: pp. 1–2), make sense – in fact become substantively intelligible – only in relation to what has come before and what will follow. He is careful, however, *not* to argue that a clear and uni-directional 'progression' (connoting 'improvement') takes place in such stylistic change. The relationship of style to class, in increasingly complex societies, is too opaque for such a judgement or belief to be possible or necessary. Stone Age cultures are particularly important for the sociology of art, he claims, though, because their

art can be linked much more unambiguously to social conditions, in comparison with 'later cultures in which forms that have already become partially ossified are dragged along from an earlier age and are often amalgamated undistinguishably with the new and still vital forms' (vol. I: pp. 20–1) Developments in social class formation and struggle, in contrast, because they *are* so central to Marxism's understanding of history and the future of society, are, for Hauser, necessarily 'progressive', leading, he believes, to the creation of the modern proletariat which has the potential to usher in socialism.

The first stylistic change in art occurs, Hauser says, when 'old' Stone Age 'naturalism' is replaced by the 'geometric stylization' of the 'new' Stone Age. This change accompanies the shift from a hunting-based society to an agrarian one, in which the need (and capacity) to depict, for instance, 'actual' deer, that were needed for food and clothing, began to disappear (vol. I: pp. 8–12). Hauser equates 'naturalism' with the depiction of 'empirical reality' and he contrasts this with a deliberate abstraction and simplification of visual form. Between the 'new' Stone Age and the end of the ancient period with the decline of the Roman empire, art will oscillate many times, he claims, between the attempt to depict 'empirical reality' and to stylize and simplify. This 'oscillation' implies no sense of progress or improvement, although Hauser says that skills and aptitudes at times sometimes *are* actually lost in history, and the implication of this is surely that the occurrence of such incapacity is regressive. Somewhat confusingly, as we have become conditioned to understanding some sequences of stylistic development as 'necessary' and 'progressive' (a 'teleological' view Hauser puts down to nineteenth-century views of the Renaissance and the Enlightenment), terms such as 'baroque' or 'rococo' or 'impressionist', normally associated only with post-sixteenth-century culture, he will use to describe phases of ancient art (for example, 'late Roman impressionist' wall-painting), a usage which scrambles the received art-historical narrative of phase-development.

Hauser's account of 'naturalism' and its relationship to the culture and society of the earliest peoples is open to serious dispute on many grounds. If his use of 'art' to describe their visual representations and artefacts is misleading analytically and historically (after all, the term only emerged with its modern meanings in the Renaissance), then his account of the relationship between the putative perceptions of Stone Age people and their ability to represent these visually and semantically is based on sheer unevidenced presupposition and tautology (for example, 'the Paleolithic artist still paints what he

originated precisely in the most totalitarian, illiberal societies, such as those in Egypt and Mesopotamia (vol. I: p. 24). Though there was no urge to 'express or communicate aesthetic emotion' in the 'old' Stone Age, he contends, without providing any definition of this term or any evidence (vol. I: p. 6), by the sixth and seventh centuries BC artistic forms had become 'independent', 'purposeless', and 'to some extent autonomous', functioning as 'spiritual resources' (vol. I: p. 69). 'Art for art's sake', then, normally associated only with the development of modern art in the late nineteenth century, has already emerged, Hauser claims, hundreds of years even before the Dark Ages. The quality of great art, he goes on to say, can not be deduced from a 'simple sociological recipe'; the most sociological study can do is 'trace some elements in the work of art back to their origin' (vol. I: p. 81).

Hauser's assertions about the 'best' art from the past share the same lack of explanation as his stipulations on what he regards as the 'average' or 'mediocre': Cretan 'artistic means are too complaisant and obvious to leave behind a deep and lasting impression' (vol. I: p. 47); peasant art in the Dipylon style of Attica between 900 and 700 BC degenerated into a 'pseudo-tectonic decoration' (vol. I: p. 59); while culture generally, in the period after the Barbarian invasions in the West, 'sank to a low-water mark unknown in classical antiquity and remained unproductive for centuries' (vol. I: p. 132). Even if one accepts the partial mitigation that Hauser could not afford space to defend all these judgements properly, the rhetorical tone he adopts suggests a reluctance to submit these evaluations to outside scrutiny. His authoritative voice becomes authoritarian at many points, his scholarly superiority presented as unassailable. Along with his orthodox reproduction of the canon, his non-reflexive use of most traditional art historical terminology, Hauser's belief in Great Art and its essential ineffability identifies him much more with the traditional élitism of art history than against it.

These aesthetic judgements *appear* to have little or nothing to do with the correlations between style and socio-economics that constitute Hauser's Marxist method. The activities of analysis and evaluation in Hauser inhabit antinomic, unconnected worlds, it often seems. Yet his restatement of the canon of great artworks, with their abstracted stylistic characteristics, are the ones chosen for this work of correlation, the ones regarded as worthy of consideration in the first place. Though ancient history for Hauser is the development of, and oscillation between, styles of art and the related modes of socio-economic organization in which they have been produced, he

actually sees . . . ', vol. I: p. 3). Later research published on visual perception and its relation to both cognition and graphic representational capacities has rendered Hauser's account naive and highly unreliable.[2] He also attempts to draw a comparison between Stone Age art and the 'artistic production of comtemporary primitive races', claiming similar social and cultural conditions, in which 'everything is still bound up directly with actual life, where there are still no autonomous forms and no differences in principles between the old and the new, between tradition and modernity . . . ' (vol. I: p. 21). Predictably, he suggests that there are substantive links between the 'unity of visual perception' characteristic of such 'primitivism' and the expressionism of modern art achieved 'only after a century long struggle' (vol. I: p. 3).These assumptions and evaluations, stock-in-trade of an influential tradition of modernist art history, based jointly on anthropological idealizations and poor or non-existent scholarship, reveal Hauser's conventional European ethnocentrism.[3] The dogmatism and crudity of these assertions – however 'well-intentioned', given Hauser's Marxist and therefore presumably anti-imperialist perspective – unhappily accompany his declaratory tone in the first volume, though he begins to ask serious questions about methods in art history when he approaches, for instance, the issue of the meaning of the so-called 'gothic' conception of art developed in the late period of the Middle Ages (vol. I: p. 175).

Values and modes of evaluation

Hauser's reliance on the unexamined term 'art' throughout his study is symptomatic of his belief in a transcendent and 'spiritual' core to human life. The 'highest' art produced throughout history embodies and signifies, he believes, this potential for creativity and depth of expression. Though art is always the product of particular societies, necessarily conditioned by specific economic and social relations between classes, its achievement can symbolize values and meanings true of all people at all times. Though this view would be regarded as a mystification by many adherents of New Art History, many earlier Marxists had shared Hauser's 'humanist' view, though perhaps not expressed it so clearly and often.

Hauser is definitive on this judgement at many points in his account. The 'aesthetic quality' of a work, he remarks in a discussion of culture in ancient oriental societies, has little or nothing to do with 'the alternative presented by political freedom and compulsion' (vol. I: p. 25). Some of the 'most magnificent works of art', he claims,

establishes certain features in culture as virtually permanent elements of this, and all subsequent history. For instance, by the end of the Paleolithic Age, he claims, all three basic forms of pictorial representation – the imitative (naturalistic), the informative (pictographic sign) and the decorative (abstract ornament) – have developed, and will have varying presences in culture until the twentieth century (vol. I: p. 15). Style nominations usually associated with post-Renaissance art, as noted, he asserts, may also be applied, adjectively, to much earlier culture – so, for instance, Cretan court-based art is described as having a 'rococo' element (vol. I: p. 46), Hellenistic art as having baroque, rococo and classicistic phases (vol. I: p. 94), while the stylistic ideals of gothic art – 'truth to nature and depth of feeling, sensuousness and sensitivity' – continue, he says, to be powerfully active in the modern art of the early twentieth century (vol. I: p. 175). Hauser's view of great art's 'transhistorical' – if not 'superhistorical' – character is summed up in his statement, while discussing the epic Greek poets, that every 'cultural epoch has its own Homer, its own "Nibelungenlied" and "Chanson de Roland"' (vol. I: p. 151).

Such a view, implying belief in the undeniable permanencies of cultural value, the transcendence of the human spirit and mystical nature of creativity, constantly finds a place within the extensive accounts of the embeddedness of artistic style in societal organization which constitute the bulk of Hauser's account. These range from the naturalism of the art of the 'new' Stone Age that Hauser relates to the development of 'individualistic and anarchistic social patterns' (vol. I: p. 16) to the 'less changeable, less dynamic character' of the art of Mesopotamia, compared with that of Egypt, which he finds hard to understand given the former society's outward-going and dynamic trade and finance-based economy (vol. I: p. 42). Hauser stresses difficulties of correlation as well as the identification of clear relationships, and the greater value of his account perhaps lies in these problematizations which become increasingly common and more profound. For instance, one such difficult problem is, he says, the fact that 'the liberalism and individualism of democracy would seem to be incompatible with the severity and regularity of the classical style' found in Greek society (vol. I: pp. 72–3). The meanings of 'classicism' will go on to preoccupy Hauser intermittently for most of his account, as it is a 'style' or set of motifs constantly returned to, and manipulated, by many social groups in different historically specific societies, most notably of all, perhaps, that in which the French Revolution occurred.

The development of societies characterized as 'democratic', in fact, presents a major challenge, he says, to the sociology and social history of art, for it is within such complex and differentiated cultures that 'individualism and community spirit can no longer be looked upon as alternatives but are seen to be indissolubly connected. In this complex condition of things, the correct sociological estimation of stylistic factors in art becomes more difficult' (vol. I: p. 73). Hauser, however, must offer a set of answers, as well as an acknowledgement of the range of analytic difficulties encountered in correlating art and socio-economic development. His declarative and authoritative tone in these passages represents that of the Marxist confident in his analytic protocols and epistemological certitudes. As 'rhetoric', however – that is, a means of arguing convincingly – these interpretations of the socially shaped nature of art generally share the same stipulatory character as his summary judgements on aesthetic quality. Both sets of statements are 'notificatory' rather than 'interrogative'; we are required to 'believe' instead of invited to 'consider'. Usually pitched at a high level of abstraction and with cursory or no reference to specific empirical materials, Hauser's claims are presented as truths rather than carefully evidenced arguments. Here are some examples:

> The Neolithic peasant no longer needs the hunter's sharp senses; his sensitivity and gifts of observation decline; other talents – above all the gift of abstraction and rational thinking – attain importance both in his methods of production and in his formalistic, strictly concentrated and stylizing art.
>
> (vol. I: p. 12)

> The historic significance of Hesiod's work is due to its being the very first literary expression of social tension and of class antagonism . . . it is the first time that the voice of the working people is heard in literature.
>
> (vol. I: p. 58)

> Plato's theory of Ideas fulfils the same social function for Athens of the fourth century as 'German idealism' did for the nineteenth century; it furnishes the privileged minority with arguments against realism and relativism. . . . Such an attitude always works out ultimately in favour of dominating minorities, who rightly see in realism an approach to reality that might be dangerous to them,

whereas a dominant majority has nothing to fear from realism.

(vol. I: p. 89)

The sheer range of Hauser's discussion tends to make the reader feel subordinate in the face of his apparent mastery of so many facets of culture and social history. Who, except another Hauser, could assess competently the credibility of so many interpretations and analyses? Specialists in particular fields may develop a view on Hauser's treatment of, for example, Romanesque architecture, Greek epic poetry or Egyptian burial chambers, but the substance – the significance – of his text is the threading together of *all* these academically discrete subjects into an apparently continuous historical and analytic narrative. Insights and profundities may leap off virtually every page, as one reviewer remarked – but seeing his claims as such surely requires that we already accept his account to be 'truthful' in its detail. *Wanting* to believe in it all, however, is probably all that is really possible.

If the truthfulness of this detail remains, in practical terms, questionable, then adoption of Hauser's principles of analysis and interpretation, like agreement with his aesthetic judgements, is also more a matter of faith than of evidence. Sympathy, or lack of it, towards the Marxist view of history as the progressive development of class struggle and culture as an embodiment of conflicting ideologies will ultimately determine one's attitude towards *The Social History of Art*. Many will be impatient, for instance, with his occasional resort to the hackneyed notion of the 'time-lag' to excuse the lack of a development of a style, such as ancient naturalism, believed necessarily or normally to 'correspond' to a change in social organization (vol. I: p. 42). Similarly, for Hauser, over four volumes and 10,000 years of history, whatever happens in art, part of the explanation will be that 'the bourgeoisie is always rising'. Again, because Marxism believes that only a future communist society could be authentically 'democratic', all actual societies that have claimed to offer freedom (those contemporary or past, such as Athens) have really masked structural and oppressive inequalities, Hauser notes (vol. I: p. 74). But any and every form of analysis eventually generates its lexicon of explanatory clichés such as these, which continue, presumably, to appear as objective truths for those who share the same values as their perpetrators.

It is important to remember, however, that Hauser's Marxism is not simply, or primarily, an academic or intellectual procedure. In

later volumes he includes numerous parentheses in his art-historical narrative directly about the state of politics and culture in contemporary society. References to film, symbolic of a concern with the present day and his need to return to it as a sign of the continuing relevance of his narrative, occur earlier, initially in the first volume's discussion of 'frontality' and theatricality in Egyptian art (vol. I: pp. 35–6). Later comparisons between late Roman art and filmic representation indicate Hauser's tenacious desire to connect the past to the present, even when the links seem analytically weak (for example, vol. I: pp. 99–100). The category of 'artist' for Hauser also, arguably, attains a submerged symbolic significance in the first volume, concerned as it is with art and societies so apparently distant from those of his own time and place. Although he is actually very attentive to the shifts in the social status and function of producers in ancient and medieval societies (this aspect of his account is very valuable), at the same time he exhibits a tendency to abstract and idealize 'the artist' into a kind of personified proletarian. For instance, culture and society in ancient Egypt were oppressive, he says, and therefore the artist had to work against such 'resistances to their achievement – resistances represented by inadmissable motifs, social prejudices and faulty powers of judgement of the public, and aims which have either already assimilated these resistances or stand openly and irreconcilably opposed to them' (vol. I: p. 24). If this depiction of the artist as a heroic antagonist of convention by no means typifies his often careful and differentiated account of transformations in the personas of producers and their relationship with the institutions in which training took place, Hauser's investment in the unexamined notion of 'art', the value of which he holds to be ineffable and transcendent, is romantically idealist, as is the Marxist notion of a single class uniquely possessing the power to bring social emancipation to all.

The first volume concludes with the end of that epoch known as the Middle Ages, an historical cliché in itself which Hauser does his best to undo by trying to show clear differentiations in the economic, social, intellectual and artistic character of the millenium or so of this period. His account of the development of 'gothic naturalism' and the beginnings of modern artistic individualism is, however, whatever its Marxist perspective, in general accordance with art-historical orthodoxy. This observation is not meant as a criticism: Hauser's social history of the rise of mercantile capitalism and its relationship with the redevelopment of naturalist motivations and capacities in the thirteenth and fourteenth centuries in southern

Europe is best understood as a complement to or extension of art history's general account, not as an intended subversion or critique of it. Though Hauser's Marxism is centred on the ambitious task of showing the complex links between style in art and socio-economic development and change, as well as with pointing out the potential difficulties and pitfalls of such analyses, he also develops several other important aspects of art's social history. The development and significance of social institutions for the training and work of artists, and their role in the organization of society as a whole, such as the monasteries of the Catholic Church in the late Middle Ages, is an obvious, and very important, example. It is closely related to another – the development and gradual expansion of a 'public' for art, along with particular fractions of this which acquired certain expertise, such as the Ancient-Orient's 'experienced and fastidious élite of connoisseurs' (vol. I: p. 23), forerunners, Hauser claims, of the Renaissance humanists.

His attention, as previously noted, to what might be called the 'institution' of the artist as a category of producer is also a highly significant facet of this social history. Hauser claims that what are often regarded as entirely novel developments in the late Middle Ages and Renaissance are actually historically-specific 'reinventions' of types, ideals and values present in much earlier art and societies. The 'artist as alienated outcast' is an example. The ancient Euripides, he claims, was actually the first 'modern' poet, for he lacked real success and exhibited a genius-like aloofness from the world, refusing to take a public role (vol. I: p. 86); in short, he was a proto-Romantic.

The most important development in the history of art, however, he says, is the development of 'art for art's sake' – the stage reached when images and sculptures are no longer made simply, or mainly, for ritual or propaganda reasons – a change which first occurred, Hauser believes, in Ionia in the sixth and seventh centuries BC (vol. I: pp. 69–70). The audacity of this claim exemplifies the best and worst of Hauser's account: on the one hand, the excitement and dynamism of his narrative, the generation of almost countless striking claims; on the other, the sense that such an assertion could probably never be sufficiently grounded in evidence to become really believable. Hauser's social history of art seems as often like a kind of art-historical Narnia – a fantasy world to enjoy – as much as an actual past that might be corroborated.

Acknowledgement

In the preparation of this introduction I have realized how much my own biography is implicated in my account of Hauser's text and the history of art history since 1951. I would like to acknowledge and thank two individuals influential within this biography: Eric Fernie was prepared to give me my first proper job as an art historian. Marcia Pointon first pointed out to me that the bourgeoisie was, indeed, always rising!

Notes

1 See, in contrast, Louis Althusser, 'Ideology and Ideological State Apparatuses', in his *Lenin and Philosophy and Other Essays* (New York: Monthly Review Press, 1971) and Nicos Hadjinicolaou, *Art History and Class Struggle* (London: Pluto Press, 1979).

2 See Ernst Gombrich, *Art and Illusion* (Princeton, NJ: Princeton University Press, 1969).

3 See Flora E.S. Kaplan (ed.), *Museums and the Making of 'Ourselves': The Role of Objects in National Culture* (Leicester: Leicester University Press, 1994).

CHAPTER I

PREHISTORIC TIMES

1. OLD STONE AGE
MAGIC AND NATURALISM

THE legend of the Golden Age is very old. We do not exactly know the sociological reason for reverence for the past; it may be rooted in tribal and family solidarity or in the endeavour of the privileged classes to base their privileges on heredity. However that may be, the feeling that what is old must be better is still so strong that art historians and archaeologists do not shrink even from historical falsification when attempting to prove that the style of art which appeals to them most is also the oldest. Some of them declare the art based on strictly formal principles, on the stylization and idealization of life, others that based on the reproduction and preservation of the natural life of things, to be the earliest evidence of artistic activity, according to whether they see in art a means of dominating and subjugating reality, or experience it as an instrument of self-surrender to nature. In other words, corresponding to their particular autocratic and conservative or liberal and progressive views, they revere either the geometrically ornamental art forms or the naturalistically imitative forms of expression as the older.[1] The monuments of primitive art that survive suggest quite clearly, anyhow, and with ever increasing force as research progresses, that naturalism has the prior claim, so that it is becoming more and more difficult to maintain the theory of the primacy of an art remote from life and nature.[2]

But the most remarkable thing about prehistoric naturalism is not that it is older than the geometric style, which makes so much more of a primitive impression, but that it already reveals

1

all the typical phases of development through which art has passed in modern times and is not in any sense the merely instinctive, static, a-historical phenomenon which scholars obsessed with geometric and rigorously formal art declare it to be. This is an art which advances from a linear faithfulness to nature, in which individual forms are still shaped somewhat rigidly and laboriously, to a more nimble and sparkling, almost impressionistic technique. It is a process which shows a growing understanding of how to give the final optical impression an increasingly pictorial, instantaneous and apparently spontaneous form. The accuracy of the drawing rises to a level of virtuosity which takes it upon itself to master increasingly difficult attitudes and aspects, increasingly fleeting movements and gestures, increasingly bold foreshortenings and intersections. This naturalism is by no means a fixed, stationary formula, but a mobile and living form, which tackles the rendering of reality with the most varied means of expression and performs its task sometimes with lesser, sometimes with greater skill. The indiscriminately instinctive state of nature has long been left behind, but there is still a far journey yet to that state of culture in which rigid artistic formulae are created.

We are the more perplexed by what is probably the strangest phenomenon in the whole history of art, because there are no parallels whatever between this prehistoric art and child art or the art of most of the more recent primitive races. Children's drawings and the artistic production of contemporary primitive races are rationalistic, not sensory: they show what the child and the primitive artist know, not what they actually see; they give a theoretically synthetic, not an optically organic picture of the object. They combine the front-view with the side-view or the view from above, leave nothing out of what they consider worth knowing about the object, increase the scale of the biologically and practically important, but neglect everything, however impressive in itself, which plays no direct part in the context of the object. The peculiar thing about the naturalistic drawings of the Old Stone Age is, on the other hand, that they give the visual impression in such a direct, unmixed form, free from all intellectual trimmings or restrictions, that we have to wait until modern impressionism to find any parallels in later art. We discover

2

motion studies which already remind us of modern instantaneous photographs, the like of which we do not find again until we come to the pictures of a Degas or a Toulouse-Lautrec, so that for the eye unschooled by impressionism there must appear to be something badly drawn and unintelligible about these pictures. The painters of the Palaeolithic age were still able to see delicate shades with the naked eye which modern man is able to discover only with the help of complicated scientific instruments. Such ability had already gone by the time of the New Stone Age when the directness of sensations had been replaced to some extent by the inflexibility and stability of conceptualism. But the Palaeolithic artist still paints what he actually sees, and nothing more than he can take in in one definite moment and in one definite sight of the object. He still knows nothing about the optical heterogeneousness of the various elements of the picture and rationalistic methods of composition, stylistic characteristics with which we are so familiar from children's drawings and the art of primitive races, nor does he know above all about the technique of composing a face from the silhouette in profile and the eyes *en face*. Palaeolithic art apparently takes possession without a fight of the unity of visual perception achieved by modern art only after a century-long struggle; it certainly improves its methods, but does not change them, and the dualism of the visible and the invisible, of the seen and the merely known, remains absolutely foreign to it.

What was the reason and purpose behind this art? Was it the expression of a joy of life insistent on being recorded and repeated? Or the satisfaction of the play-instinct and delight in embellishment—of the urge to cover empty surfaces with lines and forms, patterns and ornament? Was it the fruit of leisure or had it some definite practical purpose? Have we to see in it a plaything or a tool, an opiate and a luxury or a weapon in the struggle for a livelihood? We know that it was the art of primitive hunters living on an unproductive, parasitic economic level, who had to gather or capture their food rather than produce it themselves; men who to all appearances still lived at the stage of primitive individualism, in unstable, almost entirely unorganized social patterns, in small isolated hordes, and who believed in no gods,

in no world and life beyond death. In this age of purely practical life everything obviously still turned around the bare earning of a livelihood and there is nothing to justify us in assuming that art served any other purpose than a means to the procuring of food. All the indications point rather to the fact that it was the instrument of a magical technique and as such had a thoroughly pragmatic function aimed entirely at direct economic objectives. This magic apparently had nothing in common with what we understand by religion; it knew no prayers, revered no sacred powers and was connected with no other-worldly spiritual beings by any kind of faith, and therefore failed to fulfil what has been described as the minimum condition of an authentic religion.[3] It was a technique without mystery, a matter-of-fact procedure, the objective application of methods which had as little to do with mysticism and esoterism as when we set mouse-traps, manure the ground or take a drug. The pictures were part of the technical apparatus of this magic; they were the 'trap' into which the game had to go, or rather they were the trap with the already captured animal—for the picture was both representation and the things represented, both wish and wish-fulfilment at one and the same time. The Palaeolithic hunter and painter thought he was in possession of the thing itself in the picture, thought he had acquired power over the object in the portrayal of the object. He believed the real animal actually suffered the killing of the animal portrayed in the picture. The pictorial representation was to his mind nothing but the anticipation of the desired effect; the real event had inevitably to follow the magical sample-action, or rather to be already contained within it, as both were separated from each other merely by the supposedly unreal medium of space and time. It was, therefore, by no means a question of symbolical surrogatory functions but of really purposive action. It was not the thought that killed, not the faith that achieved the miracle, but the actual deed, the pictorial representation, the shooting at the picture, that effected the magic.

When the Palaeolithic artist painted an animal on the rock, he produced a real animal. For him the world of fiction and pictures, the sphere of art and mere imitation, was not yet a special province of its own, different and separate from empirical

4

reality; he did not as yet confront the two different spheres, but saw in one the direct, undifferentiated continuation of the other. He will have had the same attitude to art as Lévy-Bruhl's Sioux Red Indian, who said of a research worker whom he saw preparing sketches: 'I know that this man has put many of our bisons into his book. I was there when he did it, and since then we have had no bisons.'⁴ The conception of this sphere of art as a direct continuation of ordinary reality never disappears completely despite the later predominance of a conception of art as something opposed to reality. The legend of Pygmalion, who falls in love with the statue which he has created, comes from this attitude of mind. There is evidence of a similar approach when the Chinese or Japanese artist paints a branch or a flower and the picture is not intended to be a summary and idealization, a reduction or correction of life, like the works of Western art, but simply one branch or blossom more on the tree of reality. Chinese anecdotes and fairy tales about artists' relation to their works and the relationship between picture and reality, appearance and being, fiction and life, convey the same idea—fairy tales in which it is related, for example, how the figures in a picture walk out through a gate into a real landscape, into real life. In all these examples the frontiers between art and reality are blurred, only in the art of historical times the continuity of the two provinces is a fiction within the fiction, whilst in the painting of the Old Stone Age it is a simple fact and a proof that art is still entirely in the service of life.

Any other explanation of Palaeolithic art, as, for example, decorative or expressive form, is untenable. A whole series of indications argues against such an interpretation, above all the fact that the paintings are often completely hidden in inaccessible, absolutely unilluminated corners of the caves where they would have been quite impossible as 'decorations'. Their palimpsest-like superposition, destroying any decorative effect from the very outset, also argues against such explanations. After all, the painters were not forced to paint their pictures one over the other. They had space enough. This very superposition of one picture over another points to the fact that the pictures were not created with any intention of providing the eye with aesthetic

enjoyment but were in fulfilment of a purpose in which the most important element was that the pictures should be accommodated in certain caves and in certain specific parts of the caves— obviously in definite spots considered particularly suitable for magic. There could be no question of a decorative intention or of an urge to express or communicate aesthetic emotion, since the pictures were more hidden away than exhibited. There are in fact, as has been noted, two different motives from which works of art are derived: some are produced simply in order to exist, others to be seen.[5] Religious art created purely to the honour of God, and more or less all works of art designed to lighten the burden that weighs on the artist's heart share this working in secret with the magical art of the Old Stone Age. The Palaeolithic artist who was intent solely on the efficacy of the magic will nevertheless have derived a certain aesthetic satisfaction from his work, even though he considered the aesthetic quality merely as a means to a practical end. The situation is mirrored most clearly in the relationship between mime and magic in the religious dances of primitive peoples. Just as in these dances the pleasure in make-believe and imitation is fused with the religiously motivated action, so the prehistoric painter will have depicted the animals in their characteristic attitudes with gusto and satisfaction, despite his surrender to the magical purpose of the painting.

The best proof that this art was concerned with a magical and not an aesthetic effect, at least in its conscious purpose, lies in the fact that the animals in these pictures were often represented as pierced by spears and arrows or were actually shot at with such weapons after the completion of the work. Doubtless this was a killing in effigy. That Palaeolithic art was connected with magical actions is finally proved by the representations of human figures disguised as animals of which the majority are obviously concerned with the performance of magical-miming dances. In these pictures we find—as for instance in Trois-Frères—combined animal masks which would be quite unintelligible without a magical intention.[6] The connection of Palaeolithic painting with magic also helps us best to explain the naturalism of this art. A representation the aim of which was to

create a double of the model, that is to say, not merely to indicate, imitate, simulate, but literally to replace, to take the place of, could not have been anything else but naturalistic. The animal which was to be conjured into life was intended to appear as the counterpart to the animal in the painting—but it could only come into existence if the copy was faithful and genuine. It was precisely the magic purpose of this art that forced it to be naturalistic. The picture which bore no resemblance to its object was not merely faulty but senseless and purposeless.

It is assumed that the magical age, the first in which we have evidence of works of art, was preceded by a pre-magical phase.[7] The age of fully developed magic, with its fixed ritual and wonder-working technique already crystallized in formulae, must have been prepared for by an epoch of unregulated, groping practical activity and mere experimentation. The magical formulae had to prove themselves effective before they could be schematized. They cannot have been the result of mere speculation; they must have been found without conscious seeking, and been developed step by step. Pre-magical man probably discovered the connection between the copy and the original by accident, but this discovery must have had an overwhelming effect on him. Perhaps the whole sphere of magic, with its axiom of the mutual dependence of things similar, first grew out of this experience. The two basic ideas which, as has been emphasized, are the pre-conditions of art may have developed in the age of pre-magical experimentation and discovery, namely the idea of similarity and imitation, and the idea of producing something from nothing, in fact the very possibility of creative art.[8] The hand silhouettes which have been found in many places near the cave paintings, and which apparently arose through the impress of actual hands, probably first gave man the idea of creating —of *poiein*—and made him aware of the possibility that something lifeless and artificial could be perfectly similar to the living and genuine original. This mere playing about had, of course, at first nothing at all to do with either art or magic; it had first to become an instrument of magic and could only then become a form of art. For the gap between these hand-impressions and even the most primitive animal representations of the Old Stone

Age is so immense and there is such a complete lack of records of
a possible transition between the two that we can hardly assume
a direct and continuous development of art forms out of pure
play forms, but must infer the existence of a connecting link
coming from outside—and in all probability this will have been
the magical function of the copy. Yet even those playful, pre-
magical forms had a naturalistic tendency, imitating reality,
however mechanically, and can in no way be considered the
expression of an anti-naturalistic, decorative principle.

2. NEW STONE AGE
ANIMISM AND GEOMETRISM

The naturalistic style prevailed until the end of the Palaeo-
lithic age, that is to say, during a period of many thousands of
years; no change took place until the transition from the Old to
the New Stone Age, and this was the first stylistic change in the
whole history of art. It was not until then that the naturalistic
attitude, open to the full range of experience, yielded to a
narrowly geometric stylization, in which the artist tended rather
to shut himself off from the wealth of empirical reality. Instead of
representations true to nature, with loving and patient care
devoted to the details of the object, from now on we find every-
where schematic and conventional signs, indicating rather than
reproducing the object, like hieroglyphs. Instead of the concrete-
ness of actual living experience, art now tries to hold fast the idea,
the concept, the inner substance of things—to create symbols
rather than likenesses of the object. The Neolithic drawings
merely indicate the human figure by two or three simple geo-
metric patterns, as for instance by a vertical straight line for the
body and two semicircles, one facing upwards, the other down-
wards, for the arms and legs. The Menhirs, in which some
scholars have claimed to see abbreviated portraits of the dead,[9]
show an equally far-reaching abstraction in the modelling. On
the flat stone surface of these 'tombs' the head, which is not
similar to the natural shape even to the extent of being round, is
separated from the body, that is, from the oblong of the stone

itself, only by a stroke; the eyes are indicated by two dots; the nose is combined either with the mouth or the eyebrows in one simple geometric figure. A man is characterized by the addition of weapons, a woman by two hemispheres for the breasts.

The change in style which leads to these entirely abstract forms of art is conditioned by a general turning-point in culture and civilization which represents perhaps the deepest incision in the history of the human race. The material environment and the spiritual constitution of prehistoric man undergo such a thorough change at this time that everything that lies before it can easily appear to be merely animal and instinctive and everything that happens afterwards as a continuous, purposeful development. The decisive and revolutionary step consists in man's no longer living parasitically on the gifts of nature, no longer gathering and seizing his daily food but producing it for himself. With the domestication of animals and plants, with cattle-breeding and agriculture, he begins his triumph over and conquest of nature and makes himself to some extent independent of the vagaries of fate and chance. There begins the age of the organized supply of the material needs of life; man begins to work and to practise husbandry; he provides for future needs and cultivates the basic forms of capital. With these rudiments—the possession of arable land, domesticated animals, tools and food provisions—there is no doubt that the differentiation of society into strata and classes, into privileged and under-privileged, exploiters and exploited, also begins. The organization of labour, the division of functions, professional differentiation begin: cattle-rearing and cultivation of the land, primary production and handicraft, specialized trades and domestic crafts, male and female labour, farming and the defence of the land, all these gradually become separate.

With this transition from the stage of food-gathering and hunting to that of cattle-breeding and planting not only the content but the whole rhythm of life is changed. The nomadic hordes are transformed into settled communities; socially inarticulate and disintegrated groups yield to organized, locally amalgamated social bodies. Gordon Childe is quite right to warn us against seeing this change to settled community life as an all too precisely

demarcated turning-point and thinks that, on the one hand, even the Palaeolithic hunter dwelt in the same cave sometimes probably for generations, and, on the other hand, that primitive land-economy and cattle-rearing were connected in the early stages with a periodical change of domicile, since fields and pasture became exhausted after a certain time.[10] But one must not forget that, first, the exhaustion of the soil became more and more rare with improvement in agricultural techniques, and that, secondly, the farmer and the cattle-breeder, however short or long the time he stayed in one place, must have had a quite different relationship to his home, to the piece of land to which he felt himself attached, from that of the nomadic hunter, however regularly he returned to his cave. With this attachment to his home there developed a style of life completely different from the restless, unstable, piratical existence of Palaeolithic man. The new form of economy brought in its train, as opposed to the anarchic irregularity of food-gathering and hunting, a certain stability; in place of a planless economy of depredation, of just managing to exist from one day to the next, of living from hand to mouth, there now appears a planned economy, regulated for long periods in advance and prepared for various eventualities; the development moves from the stage of social disintegration and anarchy to that of co-operation, from the 'stage of the individual search for food'[11] to that of a collectivistic—though not necessarily communist—co-operative group-economy, to a society with common interests, common tasks, common undertakings; from the condition of unregulated power-relationships the individual groups develop into more or less centralized, more or less uniformly governed communities, from a centre-less existence with no settled institutions of any kind, to a life that revolves around home and farm, field and pasture, settlement and sanctuary.

Religious rites and acts of worship now took the place of magic and sorcery. The Palaeolithic age represented a phase marked by the absolute absence of worship-cults; man was full of the fear of death and starvation, endeavoured to defend himself against the assaults of enemies and material want, against pain and death by magic practices, but did not connect the good

and evil fortune which befell him with any power behind events. Not until he begins to breed plants and cattle does he also begin to feel that his fate is directed by powers endowed with reason and with the ability to determine human destiny. With the awareness of man's dependence on good and bad weather, on rain and sunshine, lightning and hail, plague and famine, on the fertility or infertility of the earth and abundance or meagreness of litters, arises the conception of all kinds of demons and spirits —beneficent and malignant—distributing blessings and curses, and the idea of the unknown and mysterious, of the higher powers, of huge, supramundane and numinous forces beyond human control. The world is divided into two halves; man himself seems divided into two halves. This is the phase of animism, of spirit-worship, of belief in the survival of the soul and the cult of the dead. With belief and worship, however, there arises also the need for idols, amulets, sacred symbols, votive offerings, burial gifts and burial monuments. The distinction between sacred and profane art, between an art of religious representation and the art of secular ornamentation, now appears. On the one hand, we find the remains of idols and of a sepulchral art, and, on the other, those of secular ceramics, with decorative forms, partly developed in fact, as Semper pointed out, directly from the spirit of handicraft and its techniques.

For animism the world is divided into a reality and a super-reality, a visible phenomenal world and an invisible world of spirits, a mortal body and an immortal soul. The burial customs and rites make it quite clear that Neolithic man was already beginning to conceive the soul as a substance divided from the body. The magic view of the world is monistic, it sees reality in the form of a simple texture, of an uninterrupted and coherent continuum; but animism is dualistic, it forms its knowledge and beliefs into a two-world system. Magic is sensualistic and holds fast to the concrete; animism is spiritualistic and inclines to abstraction. In the one case thought is centred on the life of this world, in the other on that of the world to come. That is the main reason why Palaeolithic art reproduces things true to life and reality, whilst Neolithic art opposes a stylized and idealized super-world to ordinary empirical reality.[12] But this is the beginning

of the process of intellectualization and rationalization in art: the replacement of concrete pictures and forms by signs and symbols, abstractions and abbreviations, general types and conventional tokens; the suppression of direct phenomena and experiences by thought and interpretation, accentuation and exaggeration, distortion and denaturalization. The work of art is no longer purely the representation of a material object but that of an idea, not merely a reminiscence but also a vision; in other words: the non-sensory and conceptual elements of the artist's imagination displace the sensuous and irrational elements. And thus the picture is gradually changed into a pictographical sign-language, the pictorial abundance is reduced to a non-pictorial or almost non-pictorial shorthand.

In the final analysis, the Neolithic change of style is determined by two factors: first, by the transition from the parasitical, purely consumptive economy of the hunters and food-gatherers to the productive and constructive economy of the cattle-breeders and tillers of the soil; secondly, by the replacement of the monistic, magic-dominated conception of the world by the dualistic philosophy of animism, that is, by a conception of the world which is itself dependent on the new type of economy. The Palaeolithic painter was a hunter, and as such he had to be a good observer, he had to be able to recognize animals and their characteristics, their habitats and their migrations, from the slightest tracks and scents; he had to have a sharp eye for similarities and differences, a fine ear for signs and sounds; all his senses had to be directed outwards to concrete reality. The same attitude and the same qualities are also important in naturalism. The Neolithic peasant no longer needs the hunter's sharp senses; his sensitivity and gifts of observation decline; other talents— above all the gift of abstraction and rational thinking—attain importance both in his methods of production and in his formalistic, strictly concentrated and stylizing art. The most fundamental difference between this art and naturalism is that it represents reality not as a continuous picture of complete homogeneity, but as the *confrontation* of two worlds. With its formalistic urge, it opposes the normal appearance of things; it is no longer the imitator, but the antagonist of nature; it does not add a further

continuation to reality, but opposes it with an autonomous pattern of its own. It is the dualism that came into the world with the animistic creed and has since found expression in hundreds of philosophical systems, which is expressed in this opposition of idea and reality, soul and body, spirit and form, and from which it is no longer possible to separate our conception of art. However much these opposing factors may displace each other from time to time, the tension between them is felt in every period of Western art—just as much in the formally rigorous as in the naturalistic periods.

The formalistic, geometrically ornamental style enters on a long period of undisputed dominion with the Neolithic age such as has never been attained again in historical times by any trend in art, least of all by that of formalism itself. Apart from Cretan-Mycenean art, this style dominates the whole period of the bronze and iron and of the Ancient-Oriental and archaic Greek ages, that is to say, a period of world history reaching from approximately 5000 to 500 B.C. In relation to this period of time all later styles seem short-lived and the later geometric and classicistic styles mere episodes. But what determined the age-long predominance of this conception of art which was so strictly controlled by the principles of abstract form? How was it able to outlast so many different economic, social and political systems? The uniform conception of art of the period dominated by the geometric style corresponds to an equally uniform sociological characteristic, which exerts a determining influence on this whole age, despite individual variations, namely the tendency towards a homogeneous organization of economy, towards an autocratic form of government and a hieratic outlook in the whole of society, an outlook dominated by cultus and religion, as opposed both to the still unorganized, primitively individualistic nomadic existence of the hunters and to the differentiated, consciously individualistic social life of the ancient and modern bourgeoisie based on the idea of competition. The outlook of the parasitical hunting community, living from one day to the next, was dynamic and anarchistic, and its art was correspondingly devoted to expansion, to the extension and differentiation of experience. The outlook of the productive peasantry, striving to assure and

preserve the means of production, is static and traditionalistic, its forms of life are impersonal and stationary and its art forms are correspondingly conventional and invariable. Nothing is more natural than that there should develop along with the essentially collective and traditional methods of work in peasant societies solid, inflexible and stable forms in every field of cultural life. Hoernes was one of the first to emphasize the obstinate conservatism 'which is peculiar both to the style itself as well as to the economic nature of the lower peasantry',[13] and Gordon Childe refers, in his characterization of this spirit, to the remarkable fact that the pots of a Neolithic village are all alike.[14] The rural culture of the peasantry, which develops away from the fluctuating economic life of the towns, continues to remain faithful to the strictly regulated patterns of life handed down from one generation to another, and even in the peasant art of modern times shows certain features which are still related to the prehistoric geometric style.

The change of style from Palaeolithic naturalism to Neolithic geometrism is not achieved entirely without intermediary stages. As early as the age of the naturalistic style itself, we find side by side with the South French and North Spanish trend, striving in the direction of 'impressionism', an East Spanish group of paintings which are more expressionistic than impressionistic in character. The producers of these works seem to have given their whole attention to physical movements and their dynamics, and, in order to give more intensive and suggestive expression to them, they intentionally distort the proportions of the limbs, draw ludicrously long legs, impossibly thin upper parts of the body, distorted arms and dislocated joints. Nevertheless, this expressionism no more represents a principle opposed to naturalism than does any later expressionism. The exaggerated emphasis and the features simplified by exaggeration merely afford a more convenient starting point for stylization and schematization than absolutely correct proportions and forms. But the gradual simplification and stereotyping of contours, which Henri Brueil notes in the last phase of Palaeolithic development and defines as the 'conventionalization' of naturalistic forms,[15] represents the first real transition to the geometrism of the Neolithic

age. He describes the process in the course of which the naturalistic drawings are executed more and more carelessly, with ever increasing abstraction, formal rigidity and stylization, and bases on this observation his theory of the development of geometric forms out of naturalism, a process which, although it may have proceeded without any internal caesurae, could not have been independent of external conditions. The schematization takes two directions: on the one hand, it pursues the search for clear and easily understood forms of communication and statement; on the other, it creates simple and appealing forms of decoration. And so we already find at the end of the Palaeolithic age all three basic forms of pictorial representation developed: the *imitative*, the *informative* and the *decorative*—in other words, the naturalistic likeness, the pictographic sign and the abstract ornament.

The transitional forms between naturalism and geometrism correspond to the intermediary stages which lead from an exploitative to a productive economy. The beginnings of agriculture and cattle-breeding probably developed even in certain hunting tribes from the preserving of bulbs and the sparing of pets—later on perhaps totem animals.[16] The change is not a sudden revolution either in art or in economics, but will have taken place gradually in both spheres. And the same mutual interdependence will have existed between the transitional phenomena in both fields as between parasitical hunting and naturalism, on the one hand, and the productive peasantry and geometrism, on the other. Incidentally, we have an analogy in the economic and social history of modern primitive races, which gives us reason to conclude that this relationship is typical. The bushmen, who are hunters and nomads like Palaeolithic man, are at the stage of development which we have called that of the 'individual search for food', who have no knowledge of social co-operation, believe in no spirits and demons and are devoted to crude magic and witchcraft, produce a naturalistic art which is surprisingly similar to Palaeolithic painting; again, the negroes of the West African coast, who carry on productive agriculture, live in village communities and believe in animism, are strict formalists and have an abstract, geometrically devised art, like Neolithic man.[17]

15

It is hardly possible to say anything more concrete about the economic and social conditions of these styles than that naturalism is connected with individualistic and anarchistic social patterns, with a certain lack of tradition, the lack of firm conventions and a purely secular outlook, whilst geometrism, on the other hand, is connected with a tendency to uniformity of organization, with stable institutions, and a very largely religiously orientated outlook on life; anything beyond the mere statement of these relationships is based mostly on equivocation. Such ambiguously applied concepts also underlie the correlation which Wilhelm Hausenstein attempts to establish between the geometric style and communistic outlook of the early 'agrarian democracies'.[18] He finds an authoritarian, egalitarian and planning tendency in both phenomena, but overlooks the fact that these conceptions do not mean the same in the two distinct fields of art and society and that—by taking such a flexible view of these concepts—on the one hand, the same style can be connected with very different social forms and, on the other, the same social system can be connected with the most varied styles of art. What is understood by 'authoritarian' in the political sense can be applied both to autocratic as well as to socialistic, to feudal as well as to communist orders of society, whilst the limits of the geometric style are much narrower; they do not even entirely embrace the art of autocratic civilizations, let alone that of socialism. The concept of 'egality' is likewise narrower in its range when applied to society than to art. From the social-political point of view, it is opposed to autocratic principles of every kind, but in the sphere of art, where it has merely the sense of the superpersonal and the anti-individual, it is compatible with the most varied orders of society—it is, however, precisely the spirit of democracy and socialism to which it corresponds least of all. In the final analysis, there is no direct relationship between social and artistic 'planning'. Planning as the exclusion of free, unregulated competition in the field of economics and planning as the strictly disciplined execution of an artistic plan, elaborated to the last detail, can at the very most be brought into a metaphorical relationship with one another; in themselves they represent two absolutely different principles, and it is perfectly conceivable that

in a planned economy and society a formally individualistic art, revelling in variety and improvisation, might well come to the fore. There is scarcely any greater danger for the sociological interpretation of cultural structures than such equivocations and none to which it is easier to fall victim. For there is nothing easier than to construct striking connections between the various styles in art and the social patterns predominating at any particular time, which are based on nothing but metaphor, and there is nothing more tempting than to make a show of such daring analogies. But they are just as fateful traps for truth as the illusions enumerated by Bacon and they might well be put on his list of warnings as *idola aequivocationis*.

3. THE ARTIST AS MAGICIAN AND PRIEST
ART AS A PROFESSION AND DOMESTIC CRAFT

The creators of Palaeolithic animal drawings were to all appearances themselves 'professional' hunters—one can assume as much with almost absolute certainty from their intimate knowledge of animals—and it is improbable that as 'artists', or however they were called, they would have been exempt from the duties of food-providing.[19] But certain signs definitely indicate that some vocational differentiation—although perhaps only in this particular calling—had already taken place. If, as we assume, the representation of animals really did serve the purposes of magic, then it can hardly be doubted that the persons who were capable of producing such works were simultaneously regarded as gifted with the power of magic and venerated as such, a status which brought with it, however, certain privileges and at least a partial emancipation from the duties of food-seeking. Incidentally, the elaborate and refined technique of Palaeolithic paintings also argues that these works were done not by dilettanti but by trained specialists who had spent a considerable part of their life learning and practising their art and who formed a professional class of their own. The many 'sketches', 'rough drafts' and corrected 'pupils' drawings', which have been found alongside the other surviving pictures, even make it seem highly probable

17

that there was an organized educational activity at work, with schools, masters, local trends and traditions.[20] The artist-magician, therefore, seems to have been the first representative of specialization and the division of labour. At any rate, he emerges from the undifferentiated mass, alongside the ordinary magician and medicine-man, as the first 'professional' and is, as the possessor of special gifts, the harbinger of the real priestly class, which will later lay claim not only to exceptional abilities and knowledge but also to a kind of charisma and will abstain from all ordinary work. But even the partial exemption of one class from the tasks of direct food-seeking is evidence of comparatively advanced conditions; it means that this society can already afford the luxury of specialists. As far as those conditions are concerned in which man is still dependent on providing for his own daily sustenance, the doctrine of the artistic productivity of wealth is perfectly valid; at this stage of development the existence of works of art is in fact the sign of a certain abundance of the means of subsistence and of a relative freedom from immediate anxiety as far as food is concerned. But it cannot be applied to more highly developed conditions without some qualification, for even though it may be right that the very fact that painters and sculptors are able to exist at all argues a certain degree of material plenty, which society must be prepared to share with these 'unproductive' specialists, this principle must by no means be applied according to the method of that primitive sociology which makes the golden ages of art simply coincide with the epochs of economic prosperity.

With the separation of sacred and profane art, artistic activity in the Neolithic age probably passed into the hands of two different groups. The tasks of sepulchral art and the sculpture of idols, as well as the execution of religious dances, which—if one may apply the results of anthropological research to prehistorical conditions—now became the leading art in the age of animism,[21] were in all probability entrusted exclusively to men, above all to magicians and priests. Profane art, on the other hand, which was now restricted to craft and had to solve merely decorative problems, probably lay entirely in the hands of women and may have formed a part of the activity of the home. Hoernes connects the

18

whole geometric character of Neolithic art with the female element. 'The geometric style is primarily a feminine style'—he thinks—'it is feminine in its character and at the same time bears the marks of discipline and order.'[22] The observation may be correct but the explanation is based on an equivocation. 'The geometric ornament seems', he says in another place, 'more suited to the domestic, pedantically tidy and at the same time superstitiously careful spirit of woman than to that of man. It is, considered purely aesthetically, a petty, lifeless and, despite all its luxuriousness and colour, a strictly limited mode of art, but within its limits healthy and efficient, pleasing by reason of the industry displayed and its external decorativeness—the expression of the feminine spirit in art.'[23] If one must express oneself in this metaphorical fashion, one might just as well connect the geometrical style with the strictness and the domineering spirit of the male.

The partial absorption of art by domestic industry and by domestic female crafts, that is to say, the fusion of artistic activity with other activities, is a retrogression from the standpoint of the division of labour and professional differentiation. For a functional division now occurs at the most between the sexes, but not between professional classes. Therefore, although agricultural civilizations promote specialization in general, they bring the professional artist class to an end for the time being. And this change is all the more complete because in fact not merely those branches of artistic activity practised by women but also those retained by man are now practised as side-lines. It is true that at this stage all artisan activity—with the possible exception of the art of the armourer—is a 'side-line' of this kind,[24] but one must not forget that artistic production, in contrast to all other manual labour, can already look back on an independent development of its own, and only now becomes a more or less dilettante leisure occupation. It is difficult to say whether the end of the independent artist class is one of the reasons for the simplification and schematization of artistic forms or is one result thereof. Certainly the geometric style, with its simple and conventional motifs, does not require anything like the thorough training required by the naturalistic style; but then the dilettantism, which it makes

possible, probably contributes much to the simplification of art forms.

Agriculture and cattle-breeding bring long periods of leisure in their train. Farm work is limited to certain seasons; the winter is long and allows for long rests from labour. Neolithic art bears the marks of a 'peasant art', not only because it corresponds with its impersonal and traditionalistic forms to the conventional and conservative spirit of the peasantry, but also because it is the product of this leisure-time. But it is by no means at the same time a 'folk art' like the peasant art of today. At any rate, it is not a folk art so long as the differentiation of peasant societies into classes has not been completed—for 'folk art' only has a meaning, as has been said, in contrast to the 'art of a ruling class'; the art of a mass of people which has not yet divided into 'ruling and serving classes, high and fastidious and low and modest classes' cannot be described as 'folk art', for one reason because there is no other kind of art at all.[25] And the peasant art of the Neolithic age is no longer a 'folk art' once this differentiation has been completed, for the works created by the fine arts are then destined for the possessing upper class and are executed by that class, that is to say, usually by the women of that class. When Penelope sits at the loom beside her maids, she is still, to some extent, the rich peasant woman and the heiress of the female art of the Neolithic age. Manual labour, which is later looked down on, is still regarded here as a perfectly honourable activity, at least in so far as it is carried out by women in the home.

The surviving works of art of the prehistoric age are of quite outstanding importance for the sociology of art—not because they were perchance to a higher degree dependent on social conditions, but because they allow us to see the relationships between social patterns and art forms more clearly than the art of later ages. At any rate, there is nothing in the whole history of art which illuminates so clearly the connection between a change of style and the simultaneous change in economic and social conditions as the transition from the earlier to the later Stone Age. Prehistoric cultures show the marks of their derivation from social conditions more distinctly than later cultures in which forms that have already become partially ossified are dragged

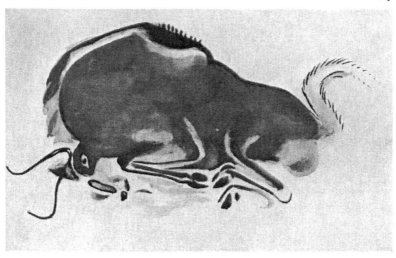

1. BISON. *Sketch by Fauconnet after a cave painting in Altamira.—Example of the naturalism of the Paleolithic hunters who make art, as an instrument of magic, subservient to the needs of everyday life.*

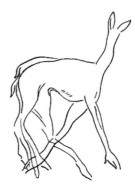

2. HIND. *Drawing by Henri Breuil after an engraving on limestone found in Bout-du-Mont near Les Eyzies in France. —Example of the impressionism of movement into which the naturalism of the North Spanish and South French cave paintings develops.*

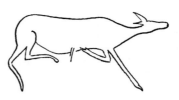

3. FAWN. *Drawing by O. Moszeik after a bushman painting. —The anthropological parallel to the naturalism of the Old Stone Age. This, too, is an example of the art of hunters who believe in magic.*

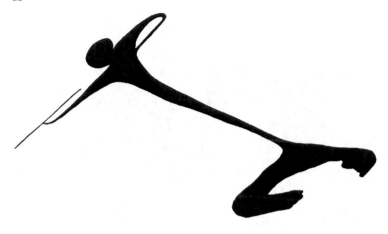

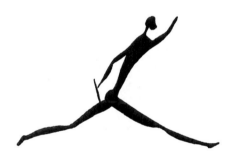

1. HUNTER. *From a Mesolithic painting in the so-called East Spanish style which transforms the naturalism of the Franco-Calabrian trend into a stylizing expressionism.*

2. HUNTER. *Rock painting from the Orange Free State after a copy by G. W. Stow.—The anthropological parallel to the expressionism of the later Palaeolithic age.*

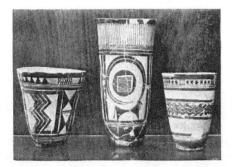

3. PAINTED EARTHEN VESSELS. *Paris, Louvre. About 4000 B.C. From the necropolis of Susa.— Example of early Mesopotamian art on the level of Neolithic geometrism.*

along from an earlier age and are often amalgamated undistinguishably with the new and still vital forms. The more developed the level of culture is whose art we are examining, the more complicated is the network of relationships and the more obscure the social background with which they are related. The greater the age of an art, of a style, of a genre, the longer are the periods of time during which the development proceeds according to immanent, autonomous laws of its own, unaffected by disturbances from outside, and the longer these more or less autonomous episodes are, the more difficult it is sociologically to interpret the individual elements of the form-complex in question. Thus the epoch immediately following the Neolithic age, in which the peasant cultures change into more dynamic urban cultures based on trade and industry, reveals such a relatively complicated structure that no particularly satisfactory sociological interpretation of certain phenomena is possible. The tradition of geometric-ornamental art is already so consolidated by this time that it can hardly be uprooted and remains predominant apparently for no particular sociological reason. But where, as in prehistorical times, everything is still bound up directly with actual life, where there are still no autonomous forms and no differences in principle between the old and the new, between tradition and modernity, there the sociological explanation of cultural phenomena is still comparatively simple and plainly feasible.

CHAPTER II

ANCIENT-ORIENTAL URBAN
CULTURES

1. STATIC AND DYNAMIC ELEMENTS
IN ANCIENT-ORIENTAL ART

THE end of the Neolithic age betokens almost as universal a re-orientation of life, almost as profound a revolution of economy and society, as its beginning. Then the break was marked by the transition from mere consumption to production, from primitive individualism to co-operation, now it is marked by the beginning of independent trade and handicrafts, the rise of cities and markets, and the agglomeration and differentiation of the population. In both cases we see before us a picture of complete change, although in both cases it takes place more as a gradual alteration than as a sudden subversion. In most of the institutions and customs of the Ancient-Oriental world, the autocratic forms of government, the partial maintenance of a natural economy, the permeation of daily life by religious cults and the rigorously formalistic trend of art, Neolithic customs and traditions continue side by side with the new urban way of life. In Egypt and Mesopotamia the peasantry continues its own traditionally defined existence, independent of the restless bustle of the cities, in its village settlements, within the framework of its domestic economy, and even though its influence is constantly on the decline, the spirit of its traditions is still discernible even in the latest and most advanced manifestations of the highly differentiated city cultures of these countries.

The decisive change in the new way of life is expressed above all in the fact that primary production is no longer the leading, historically most progressive occupation, but that it now enters

the service of trade and handicraft. The increase in wealth, the accumulation of arable land and freely available food supplies in comparatively few hands, creates new, more intensive and more varied needs for trade products and leads to an increased division of labour. The maker of pictures of spirits, gods and men, of decorated utensils and jewels emerges from the closed milieu of the home and becomes a specialist whose trade is his livelihood. He is no longer either the inspired magician or the merely nimble-fingered member of the household, but the craftsman, carving sculptures, painting pictures, shaping vessels, just as others make axes and shoes, and he is hardly more highly esteemed than the smith or the shoemaker. The craftsmanlike perfection of the work, the assured control of difficult material and the flawless care of execution, which is especially noticeable in Egypt,[1] in contrast to the genius-like or dilettante carefreeness of earlier art, is a result of the professional specialization of the artist, of city life with the growing competition of contending forces and of the training of an experienced and fastidious élite of connoisseurs in the cultural centres of the city, in the temple precincts and at the royal court.

The city, with its concentration of population and the intellectual stimuli produced by close contact between the different levels of society, its fluctuating market and its anti-traditionalist spirit, conditioned by the peculiar nature of the market, its foreign trade and the acquaintance of its merchants with foreign lands and peoples, its money economy, rudimentary as it may be at first, and the displacements of wealth promoted by the nature of money, inevitably had a revolutionary effect in every field of cultural life, and brought about a more dynamic and more individualistic style in art, more free from the influence of traditional forms and types than the geometrism of the New Stone Age. The well-known and often inordinately emphasized traditionalism of Ancient-Oriental art, the slowness of its total development and the longevity of its individual tendencies, merely restricted the mobilizing influence of the new urban ways of life, but did not arrest it. For if one compares the course of Egyptian art with those conditions in which 'all the pots of a village were alike' and the distinct stages of cultural develop-

23

ment could only be expressed in terms of millennia, one becomes aware of stylistic phenomena, whose differences one from another are often overlooked merely as a result of their foreignness, which makes it more difficult to differentiate their distinct characteristics. But to attempt to derive this art from one single principle and to disregard the fact that it bears within itself the polarity of static and dynamic, conservative and progressive, strictly formal and form-destroying tendencies, is to falsify its very essence. In order to understand it properly, one must feel the living forces of experimenting individualism and expansive naturalism behind the rigid traditional forms, forces which flow from the urban outlook on life and destroy the stationary culture of the Neolithic age; but one must not on any account allow oneself to be led by this impression to underestimate the spirit of conservatism at work in the history of the ancient East. For apart from the fact that the schematic formalism of the Neolithic peasant culture not only continues to exert an influence but produces constantly new variants of the old pattern, at least in the early stages of the Ancient-Oriental epoch, the leading social forces, above all the royal house and the priesthood, contribute to the preservation of the *status quo* and the traditional forms of art and worship as far as possible.

The compulsion under which the artist has to work in this society is so relentless that according to the theories of modern liberalistic aesthetics all genuine cultural achievement should have been fundamentally impossible from the outset. And yet some of the most magnificent works of art originated precisely here in the Ancient Orient under the most dire pressure imaginable. They prove that there is no direct relationship between the personal freedom of the artist and the aesthetic quality of his works. For it is a fact that every intention of an artist has to make its way through the meshes of a closely entwined net; every work of art is produced by the tension between a series of aims and a series of resistances to their achievement—resistances represented by inadmissible motifs, social prejudices and faulty powers of judgment of the public, and aims which have either already assimilated these resistances or stand openly and irreconcilably opposed to them. If the resistances in one direction are impossible

24

to overcome, then the artist's invention and powers of expression turn to a goal the way to which is not obstructed, and it is very unusual for him even to be aware of the fact that his achievement is a substitute for the real thing. Even in the most liberal democracy the artist does not move with perfect freedom and unrestraint; even there he is restricted by innumerable considerations foreign to his art. The different measure of freedom may be of the greatest importance for him personally but in principle there is no difference between the dictates of a despot and the conventions of even the most liberal social order. If force in itself were contrary to the spirit of art, perfect works of art could arise only in a state of complete anarchy. But in reality the presuppositions on which the aesthetic quality of a work depends lie beyond the alternative presented by political freedom and compulsion. Therefore the other extreme, namely, the assumption that the ties which restrict the artist's freedom of movement are profitable and fruitful in themselves, that the freedom of the modern artist is consequently responsible for the inadequacies of modern art and that compulsion and restrictions could and should be produced artificially as the supposed guarantees of true 'style', —such an assumption is just as wrong as the anarchist point of view.

2. THE STATUS OF THE ARTIST
AND THE ORGANIZATION OF ARTISTIC PRODUCTION

The first and for a long time the only employers of artists were priests and princes and their most important workshops during the whole period of Ancient-Oriental culture were in temple and palace households. In the workshops of these households they worked either as voluntary or compulsory employees, as labourers able to move about freely or as lifelong slaves. Here far the greatest and most valuable part of the artistic production of the time was accomplished. The first accumulation of land fell into the hands of warriors and robbers, conquerors and oppressors, chieftains and princes; the first rationally administered property may well have been the temple estates, that is to say, the properties of the gods founded by the princes and managed by the

priests. Therefore, it is highly probable that the priests were the first regular employers of artists, the first to give them commissions; the kings will merely have followed their example. Ancient-Oriental art was restricted in the first place, apart from domestic industry, to the carrying out of the tasks set by these patrons. Its creations consisted for the most part in votive gifts to the gods and royal memorials, in the requisites of either the cult of the gods or the ruler, in instruments of propaganda designed to serve either the fame of the immortals or the posthumous fame of their earthly representatives. Both the priesthood and the royal house were part of the same hieratic system, and the tasks which they set the artist, of securing their spiritual salvation and endowing them with lasting fame, were united in the foundation of all primitive religion, the cult of the dead. Both demanded that the artist should provide solemn, stately and lofty representations, both encouraged the artist to remain static in his outlook and subjected him to the service of their own conservative aims. Both did all they could to prevent innovations in art, as well as any kind of reform, since they feared any alteration in the prevailing order of things and declared the traditional rules of art to be just as sacred and inviolable as the traditional religious creeds and forms of worship. The priests allowed the kings to be regarded as gods so as to draw them into their own sphere of authority and the kings allowed temples to be built for the gods and priests so as to increase their own fame. Each wanted to profit from the prestige of the other; each sought to enlist the help of the artist in the fight for the preservation of royal and priestly power. Under such circumstances there could be no more question of an autonomous art, created from purely aesthetic motives and for purely aesthetic purposes, than under those of the prehistoric era. The great works of art, of monumental sculpture and wall-painting, were not created for their own sake and their own beauty. Sculptures were not commissioned in order to be set up in front of temples and on the market place—as in classical antiquity or the Renaissance; most of them stood in the dark interior of the sanctuary and in the depth of the sepulchre.[2]

The demand for pictorial representations, for works of sepulchral art in particular, was so great in Egypt from the very

beginning, that one must assume the profession of the artist to have become distinct and self-supporting at a fairly early date. But the rôle of art as a subordinate servant was emphasized so strongly and its absorption in practical tasks was so complete that the person of the artist himself disappeared almost entirely behind his work. The painter and sculptor remained anonymous craftsmen, in no way obtruding their own personalities. We know only very few names of artists from Egypt and as the masters did not sign their works[3] it is impossible to connect even these few names with any definite body of work.[4] We possess, it is true, pictures of sculptors' workshops, above all from El Amarna, and even that of a sculptor working at an identifiable portrait of the Queen Tyi,[5] but the person of the artist and the attribution of the extant works of art is doubtful in every case. If the wall-decoration of a tomb occasionally represents a painter or sculptor and gives his name, we may assume that the artist intended to immortalize himself,[6] but this is neither wholly certain, nor can we derive much benefit from the information in view of the scarcity of other details of the history of Egyptian art. It is impossible to form any clear outline of the personality of these artists. These self-portraits do not even give any satisfactory information about what the artist in question thought about himself and the value of his work. It is difficult to say whether we must interpret them simply as an attempt by the artist to record his everyday routine or whether, driven, like the kings and the great ones of the kingdom, by the urge to secure immortal fame for himself, in the shadow of their fame, he wished to set up a monument which would allow him to survive for ever in the memory of man.

It is true that we are acquainted with the names of master-builders and master-sculptors in Egypt, and special social honours will have been bestowed on them as high court officials, but on the whole the artist remains an undistinguished craftsman, esteemed at the most as such, and not as a personality in himself. An idea like Lessing's notion of a 'Raphael without hands' would have been quite inconceivable. Only in the case of the master-builder is it possible to speak of a dividing-line between intellectual and manual work; the sculptor and the painter are

27

nothing but manual workers. The school-books of the learned scribes give the best idea of the subordinate social position of the artist in Egypt: they speak with contempt of the artist's banausic profession.[7] Compared with the position of these scribes, that of the painter and sculptor does not seem very honourable, particularly in the earlier periods of Egyptian history. This is evidence of that underestimation of the arts in favour of literature which is so familiar from the records of classical antiquity. And here, in the ancient East, the dependence of social status on the primitive conception of prestige, according to which manual labour was regarded as dishonourable,[8] will have been even more close than with the Greeks and Romans. At all events, the esteem in which the artist was held grew as general progress developed. In the New Kingdom many artists already belong to the higher social classes, and in some families several generations hold fast to the profession of artist without a break, which can be regarded in itself as a sign of a comparatively advanced class-consciousness. But even now the rôle of the artist in the life of society is still rather subordinate, compared with the presumable function of the prehistoric artist-magician.

The temple and palace workshops were the greatest and most important, but they were not the sole workshops; such establishments were also to be found on the great private estates and in the bazaars of the bigger cities.[9] These latter united several small independent workshops which, in contrast to the routine of the temple, palace and estate households, used exclusively free labour. The purpose of such amalgamation was, on the one hand, to facilitate co-operation between different craftsmen, and, on the other hand, to produce and sell goods in one and the same place in order to become independent of the merchant.[10] In the temple, palace and private workshops the craftsmen still worked within the framework of self-contained and self-sufficient households, whose only difference from the peasant households of the Neolithic age was that they were incomparably bigger and were based entirely on foreign, often forced labour; structurally there was no essential difference between them. As opposed to both of these, the bazaar system, with its separation of workshop routine from the household, is a revolutionary innovation: it contains

the germ of the independent industry, producing goods systematically, which is no longer restricted to occasional commissions, but, on the one hand, is carried on as an exclusive professional activity, and, on the other, produces its goods for the free market. This system not only turns the primary producer into a manual worker, but removes him from the closed framework of the household. The probably equally old putting-out system, which leaves the worker in his home but separates him from the household spiritually by making him work for a customer rather than for himself, has the same effect. The principle of the household economy, in which production is limited to immediate internal needs, is thereby broken.

In the course of this development the man gradually takes over even those branches of manual labour and art which were formerly the special province of the woman, such as the making of ceramic products and of textiles.[11] Herodotus remarks with amazement that in Egypt men—albeit forced labourers—sit at the loom; but this phenomenon was merely in accordance with the general trend of development, which finally led to manual crafts becoming the exclusive province of the male. This is in no way—as in the parable of Heracles at Omphale's spinning-wheel —the expression of the enslavement of the male, but of the separation of manual crafts from the household and the increasingly difficult manipulation of tools.

The great workshops attached to the royal palace and the temples were the schools in which young artists were trained. It is usual to regard especially those workshops connected with the temples as the most important transmitters of tradition—an assumption the justification for which is not generally acknowledged, however, just as doubt has sometimes been cast on the whole predominant influence of the priesthood on the practice of the arts.[12] At all events, the educational importance of a workshop was all the greater the longer it was able to maintain its tradition and in this respect some temple workshops will probably have been superior to the palace workshop, although, on the other hand, the court, as the intellectual centre of the country, was in a position to exercise a kind of dictatorship in matters of taste. Incidentally, both in the temple and in the palace work-

shops the whole practice of art had the same academic-scholastic character. The fact that from the very beginning there existed universally binding rules, universally valid models and uniform methods of work, points to a system directed from only a few centres. This academic, somewhat pedantic and strait-laced tradition led, on the one hand, to an excess of mediocre products, but, on the other hand, it secured that comparatively high average level which is so typical of Egyptian art.[13] How great was the care and pedagogical skill the Egyptians expended on the education of the rising generation of young artists is shown even by the teaching materials which have been preserved, the plaster casts from nature, the anatomical representations of individual parts of the body intended for instructional purposes and, above all, those specimen showpieces, which demonstrated to the pupils the development of a work of art in all the phases of its production.

The organization of artistic work, the procuring and the varied employment of assistants, the specialization and the combination of individual achievements, was so highly developed in Egypt that it reminds one in a way of the methods of the medieval cathedral workshops and in some respects puts all later, individualistically organized art activity in the shade. From the very beginning, the whole development strove towards a standardization of production, and this tendency was from the outset in accordance with the routine of a workshop. Above all, the gradual rationalization of craft-processes exerted a levelling influence on artistic methods. With increasing demands the custom grew of working according to sketches, models and uniform patterns and an almost mechanically stereotyped technique of production was developed which enabled the different objects simply to be constructed from separate uniform components.[14] The application of such rationalistic methods to art production was, of course, possible only because it was usual to set artists the same task over and over again, commissioning the same votive gifts, the same idols, the same sepulchral monuments, the same type of royal images and private portraits. And as originality of subject-matter was never very much appreciated in Egypt, in fact was generally tabooed, the whole ambition of the artist was concentrated on thoroughness and precision of

execution, which is so conspicuous even in the less important works and which compensates for the lack of interest and piquancy in the invention. The demand for a clean, polished finish also explains why the output of the Egyptian workshops was comparatively small in spite of the rationalistic organization employed there. The fondness of the sculptors for works in stone, in which merely the rough hewing of the figure out of the block could be left to the assistants, but the finer detailed work and the final completion was reserved for the master, imposed narrow limits on production from the very outset.[15]

3. THE STEREOTYPING OF ART IN THE MIDDLE KINGDOM

The fact that the art of the earlier periods is less 'archaic' and stylized than that of the later periods is the clearest evidence of how untypical conservatism and conventionalism are of the racial character of the Egyptian people, and of how this characteristic is rather a historically conditioned phenomenon changing as the total situation develops. In the reliefs of the last predynastic and of the first dynastic epoch there prevails a freedom of form and composition which is lost later on and is only won back again in the wake of a general cultural revolution. Even the masterpieces from the later period of the Old Kingdom, such as the 'Scribe' in the Louvre or the so-called 'Village-Mayor' in Cairo, make such a fresh and vital impression that we do not find their equal again until the days of Amenhotep IV. Perhaps there never was so much freedom and spontaneity in Egyptian art as in this early stage of development. The special conditions of life in the new urban civilization, the differentiated social relationships, the specialization of the manual crafts and the emancipation of trade contributed more directly to the spread of individualism than later when this influence was obstructed and often frustrated by forces fighting for the maintenance of their own authority. Not until the onset of the Middle Kingdom, when the feudal aristocracy comes into the foreground with its strongly emphasized class-consciousness, do the rigid conventions of courtly-religious

31

art develop, which suppress any further emergence of spontaneous forms of expression. The stereotyped style of cultic representations was well known as early as the Neolithic age, but the stiffly ceremonial forms of courtly art are absolutely new and come into prominence here for the first time in the history of human culture. They reflect the rule of a higher, superindividual social order, of a world which owes its greatness and splendour to the favour of the king. They are anti-individualistic, static and conventional, because they are the forms of expression of an outlook on life, for which descent, class, membership of a clan or a group represents a higher degree of reality than the character of the particular individual, and the abstract rules of conduct and the moral code are much more directly in evidence than whatever the individual may feel, think or will. All the good things and the charms of life are connected, for the privileged members of this society, with their separation from the other classes, and all the maxims which they follow assume more or less the character of rules of decorum and etiquette. This decorum and etiquette, the whole self-stylization of the upper class, demand among other things that one does not allow oneself to be portrayed as one really is, but according to how one must appear to conform with certain hallowed conventions, remote from reality and the present time. Etiquette is the highest law not merely for the ordinary mortal, but also for the king, and in the imagination of this society even the gods accept the forms of courtly ceremonial.[16]

In the end, the portraits of the king become purely representative images; the individual characteristics of the early period disappear from them without a trace. Finally there is no longer any difference between the impersonal turns of phrase in their eulogistic inscriptions and the stereotyped character of their features. The self-glorifying autobiographical texts which the kings and the great landlords have inscribed on their statues and the portrayal of events from their lives are from the very beginning infinitely monotonous; in spite of the abundance of monuments which have survived, we seek in them in vain for individual characteristics and the expression of personal life.[17] The fact that the sculptures of the Old Kingdom are richer in individual features than the biographical records of the same period is

32

to be explained, among other things, by the circumstance that they still have a magical function reminiscent of Palaeolithic art, which the literary works lack. For in the portrait the *Ka*, that is, the guardian-spirit of the deceased, was supposed to find the body in which he had dwelt on earth in its true and genuinely lifelike form again; this magical-religious aim is partly the explanation of the naturalism of the portrayals. But in the Middle Kingdom, in which the representative function of works of art gains the upper hand over their religious significance, the portraits lose their magical and, therefore, also their naturalistic character. For just as the autobiographical inscriptions reflect in the first place the traditional forms in which a king expresses himself, when he is talking about himself, so the portrait-sculptures of the Middle Kingdom chiefly express the ideal appearance which belongs to a king according to courtly convention. But the king's ministers and courtiers now strive to make just as solemn, calm and measured an impression as the king himself. And just as the autobiography of a loyal subject only mentions what has reference to the king, only the light shed by his gracious favour, so in the pictorial representations everything revolves around the person of the king as in a solar system.

The formalism of the Middle Kingdom can scarcely be explained as a natural stage of development following on continuously from its predecessor; the fact that art returns to the archaism of primitive forms deriving from the Neolithic age is attributable to external reasons which are only intelligible sociologically and cannot be explained purely in terms of the history of art.[18] In view of the naturalistic achievements of the early period and the abiding talent of the Egyptians for accurate observation and the faithful reproduction of nature, we must discern a quite definite purpose in this deviation from empirical reality. In no other period in the whole history of art is the choice between naturalism and abstraction more a question of intention and not merely of aptitude, than here—of intention in the sense that the artist's purpose is determined not only by aesthetic considerations and that aesthetic intentions must be in accordance with practical desires. The well-known plaster-casts—possibly slightly touched-up death masks—which have been discovered in the workshop of

33

the sculptor Thutmosis in El Amarna prove that the Egyptian artist was also able to see things differently from the way he was in the habit of representing them, and we may assume that he in most cases deliberately deviated from the image which he saw in the way shown by these masks.[19] One only needs to compare the shaping of the different parts of the body with one another to see clearly that there was a conflict of purpose here and that the artist was moving in two different worlds—an artistic and an extra-artistic world—at the same time.

The most striking characteristic of Egyptian art, and indeed not only in its strictly formalistic, but to a greater or lesser degree in its naturalistic phases of development as well, is the rationalism of the technique. The Egyptians never freed themselves completely from the 'conceptual picture' of Neolithic art, of primitive pictorial representations and child drawings, and never overcame the influence of the so-called 'completing' technique, by which a picture is composed from several elements which are certainly interrelated in the artist's mind but which are optically incoherent and often even mutually contradictory. They forgo producing the illusion of the unity and uniqueness of the visual impression; they renounce perspective, foreshortenings and intersections in the interests of clarity, and this renunciation leads to a strict taboo which proves stronger than any desire they may have to conform faithfully to nature. How lasting the effect of such a purely external and abstract prohibition can be, and how easily it can be reconciled at times even with a less inhibited aesthetic purpose, is shown by the East Asiatic painting, which is in many respects more similar to our conception of art and in which, even today, shadows, for example, are taboo because they are regarded as making an all too brutal impact on the beholder. The Egyptians must have had to some extent this feeling that all attempts to deceive the observer contain an element of brutality and vulgarity, and that the methods of abstract, strictly formal art are 'more refined' than the deceptive effects of naturalism.

Of all the rationalistic formal principles in Ancient-Oriental and especially in Egyptian art that of 'frontality' is the most conspicuous and the most characteristic. By 'frontality' we mean that law governing the representation of the human figure, discovered

by Julius Lange and Adolf Erman, according to which, in whatever position the body is depicted, the whole chest surface is turned to the onlooker so that the upper part of the body is divisible by a vertical line into two equal halves. This axial approach, offering the broadest possible view of the body, obviously attempts to present the clearest and least complicated impression possible, in order to prevent any misunderstanding, confusion, or concealment of the elements of the picture. The attribution of frontality to a basic lack of technical skill may be justified to some extent, but the stubborn retention of this technique, even in periods in which there can no longer be any question of such an involuntary limitation of artistic purpose, demands another explanation.

In the frontal representation of the human figure, the forward turning of the upper part of the body is the expression of a definite and direct relationship to the onlooker. Palaeolithic art, in which no kind of notice is taken of the public, also knows nothing of frontality; its illusionism is merely another form of its ignoring of the onlooker. Ancient-Oriental art, on the other hand, makes a direct approach to the receptive subject; it is an art which both demands and shows public respect. Its approach to the beholder is an act of reverence, of courtesy and etiquette. All courtly and courteous art, intent on bestowing fame and praise, contains an element of the principle of frontality—of confronting the onlooker, the person who has commissioned the work, the master whom to serve and delight is the artist's duty.[20] The work of art makes its direct approach to him as to a connoisseur, who would not be taken in by the artful deceptions of vulgar illusionism. This attitude finds a late but still abundantly clear expression in the conventions of the classical court theatre, in which the actor, quite regardless of the demands of stage deception, addresses the audience directly, apostrophizes it, as it were, with every word and gesture, and not only avoids 'turning his back' on the audience but emphasizes by every possible means that the whole proceeding is a pure fiction, an entertainment conducted in accordance with previously agreed rules. The naturalistic theatre forms the transition to the absolute opposite of this 'frontal' art, namely the film, which, with its mobilization of the

audience, leading them to the events instead of leading and presenting the events to them, and attempting to represent the action in such a way as to suggest that the actors have been caught red-handed, by chance and by surprise, reduces the fictions and conventions of the theatre to a minimum. With its robust illusionism, its forthright and indiscreet directness, its violent attack on the audience, it expresses a democratic conception of art, held by liberal, anti-authoritarian societies, just as clearly as the whole of the courtly and aristocratic art—by its mere emphasis of the stage, the footlights, the frame and the socle—is the unmistakable expression of a highly artificial, specially commissioned occasion, from which it is obvious that the patron is an initiated connoisseur who does not need to be deceived.

Apart from frontality, Egyptian art displays a whole series of standing formulae, which, although they are less obvious, express the conventionality of most of the stylistic principles governing this art, especially that of the Middle Kingdom, just as acutely. Foremost among them is the rule that the legs of a figure are always to be drawn in profile, and that *both* of them are to be shown from the inside, that is, looking from the big toe; then there is the regulation that the moving leg and the outstretched arm—probably first of all in order to prevent disturbing overlappings—must be farther away from the onlooker; finally there is the convention that it is always the right side of the figures portrayed which is turned to the onlooker. These traditions, laws and regulations were observed with the utmost strictness by the priesthood and the court, the feudal aristocracy and the bureaucracy of the Middle Kingdom. The feudal lords were all little kings trying to surpass the real Pharaoh in formality wherever possible, and the higher bureaucracy, which still kept itself strictly secluded from the middle class, was deeply imbued with the hieratic spirit and felt along thoroughly conservative lines. Social conditions did not change until the advent of the New Kingdom which arose out of the turmoil of the Hyksos invasion. Isolated, self-contained traditional Egypt became not only a materially and culturally flourishing country but became possessed of a wider vision, creating the beginnings of a supernational world-culture. Egyptian art not only drew all the

marginal lands of the Mediterranean and the whole of the Near East into its sphere of influence, but adopted suggestions from all parts and discovered that there was also a whole world beyond its own borders and outside its own traditions and conventions.[21]

4. NATURALISM IN THE AGE OF AKHENATON

Amenhotep IV, with whose name the great cultural revolution is connected, is not only the founder of a religion, not only the discoverer of the idea of monotheism, as he is generally known to be, not only the 'first prophet' and the 'first individualist' in world history, as he has been called,[22] but also the first conscious innovator in art: the first man to turn naturalism into a programme and oppose it to the archaic style, as a newly attained achievement. Bek, his chief sculptor, adds to the titles which he bears, the words: 'the pupil of His Majesty'.[23] What art owes to him and artists learnt from him is obviously a new love of truth, a new sensibility and sensitiveness which leads to a kind of impressionism in Egyptian art. The overcoming of the stiff, academic style by his artists is in harmony with his own fight against pedantic, empty and meaningless traditions in religion. Under his influence the formalism of the Middle Kingdom yields both in religion and art to a dynamic and naturalistic approach which encourages men to delight in making new discoveries. New themes are chosen, new symbols sought out, the portrayal of new and unusual situations is favoured and the attempt is made not only to depict intimate individual spiritual life but, even more than that, to carry an intellectual tension, a heightened sensitivity and an almost abnormal nervous animation into the portraits. The rudiments of perspective in drawing, attempts at more coherent group-composition, a more lively interest in landscape, a fondness for representations of everyday scenes and happenings, and, as a result of the aversion from the old monumental style, a marked pleasure in the delicate and dainty forms of the minor arts—all these begin to show themselves. The only surprising feature is how thoroughly courtly, ceremonial and formal this art remains in spite of all the innovations. The themes are the

expression of a new world, in the faces a new spirit is mirrored, a new sensibility, and yet frontality, the 'completing' method, proportions drawn in accordance with the social rank of the person portrayed and with a complete disregard for the facts, still prevail along with most of the rules of correct form. In spite of the naturalistic trend of the time, this is still a courtly art the structure of which is in some respects reminiscent of the rococo, a style, as is well known, equally dominated by anti-classical, individualistic and form-disintegrating tendencies and yet still a thoroughly courtly, ceremonial and conventional art. We see Amenhotep IV in his family circle, in scenes and situations of daily life, with a human intimacy exceeding all previous conceptions, and yet he still moves in rectangular planes, turns the whole of his chest surface to the onlooker and is still twice as big as ordinary mortals; the picture is still the product of a seigniorial art, intended to serve as a memorial to the king. It is true that the ruler is no longer portrayed as a god, completely free of all earthly trammels, but he is still subject to the etiquette of the court. There are pictures in which a figure stretches out the arm which is nearer, not the arm more distant from the onlooker, and we also find everywhere hands and feet drawn with greater anatomical accuracy and joints which move more naturally, but in other respects this art seems to have become even more precious than it was before the great reform.

The means of expression employed by naturalism in the age of the New Kingdom are so rich and subtle that they must have had a long past, a long period of preparation and perfecting. Where do they come from? In what form did they keep themselves alive, before they emerged under Akhenaton? What saved them from destruction during the rigorously formal period of the Middle Kingdom? The answer is simple: naturalism had always been latent as an undercurrent in Egyptian art and left unmistakable traces of its influence, alongside the official style, at least in the non-official branches of art. The Egyptologist W. Spiegelberg separates this current from the rest of art, sets up a special category for it and calls it Egyptian 'folk art'. But, unfortunately, it is not clear whether he means by that an art by or for the people, a peasant art or an urban art designed for the people, and

whether, in any case, when he speaks of the 'folk' he means the broad masses of the peasants and artisans or the urban, mercantile and official middle class. The people who remained in primary production and within the framework of a peasant economy can be considered a creative element in the later phases of Egyptian history at the most in the field of the applied arts, that is, in a branch of art whose influence on the development of style becomes constantly less and was probably not very important even in the Old Kingdom. The artisans and artists of the palace and temple households come from the people, it is true, but, as the art-producers of the upper class, they have practically nothing in common with the outlook of their own social class. The common people, who are excluded from the privileges of property and power, cannot be reckoned among the public interested in art in the Ancient-Oriental despotisms any more, in fact even less, than in the later epochs of history. Painting and sculpture, being such a costly pursuit, were always and everywhere the exclusive preserve of the privileged classes and probably even more exclusively in the ancient East than in later times. The common people had not the slightest chance of being able to employ artists and to acquire works of art. They buried their dead in the sand without erecting permanent memorials. Even the more moneyed middle class could hardly be said to be of any decisive importance as consumers and patrons of art compared with the feudal lords and the high bureaucracy; they were in no sense a factor which could have had any appreciable influence on the destinies of art as opposed to the tastes and wishes of the upper class.

We may assume that there was, even in the Old Kingdom, a manufacturing and trading middle class alongside the nobility and the peasantry. In the Middle Kingdom, this class gains in strength very remarkably.[24] The official careers which now become open to its members offer good, though, to start with, comparatively modest prospects of rising in the social scale. In trade and industry it becomes a tradition for the son to take up the father's calling and this contributes materially to the formation of a more sharply defined middle class.[25] It is true that Flinders Petrie doubts whether there was a well-to-do middle

class as early as the Middle Kingdom, but he does accept the existence in the New Kingdom of an already very wealthy lower bureaucracy.[26] The fact is that in the meantime Egypt had become not only a military state offering a highly promising career in the army to the new elements which were working their way up from the lower levels of society, but also a bureau-cratically-controlled state which was becoming more and more rigidly centralized and which had to replace the vanishing feudal aristocracy by an endless number of crown officials, that is to say, to form a middle official class from the ranks of the old trading and manufacturing classes. From this subordinate soldiery and officialdom arose, for the most part, the new urban middle class which now also began to play some part among those taking an active interest in art. But it will hardly have had essentially different tastes or demanded anything different from art than the upper class which it was emulating, although it already possessed houses and tombs adorned with works of art; it will have had, however, to be satisfied with less pretentious works. In any case, we have no monuments surviving from the dynastic period which could possibly be regarded as examples of an in-dependent popular art, distinct from the art of the court, the temples and the aristocracy. The urban middle class will probably have had some influence on the ideas about art held by the upper class, in spite of its state of intellectual dependence—perhaps we may even connect the individualism and naturalism of the age of Akhenaton with this influence of the lower levels of society—but the common people and the middle class neither produced nor enjoyed the products of an art distinct from the official style of the upper class.

There are, therefore, in no sense two different types of art in Egypt; there is no 'folk art' alongside the art of the court and the nobility. A division can be traced running through the whole of Egyptian art, it is true, but it does not separate the works into two distinct groups, it runs rather through the individual works themselves. Besides the severely conventional, stiffly ceremonial, solemnly monumental style, we also find everywhere signs of a less restrained, more spontaneous and natural approach. This dualism is expressed most distinctly where two figures in the

same composition are portrayed in the two different styles. And such works as, for instance, the well-known interior showing the mistress in the conventional court style, that is to say, in a strictly 'frontal' position, but a servant in a wholly unaffected attitude, taken from the side-view, with frontal symmetry partly abandoned, make it abundantly clear that the style varies purely according to the nature of the subject itself. Members of the ruling class are portrayed in the official style of the court, whereas members of the lower classes are shown often in the plebeian naturalistic style. The two styles are differentiated not by the class-consciousness of the artist, who was in any case quite unable to give expression to his class-consciousness even if he had any, nor by the class-consciousness of the public, which was still completely under the influence and spell of the court, the nobility and the priesthood, but, as we have said, the style used was determined exclusively in accordance with the nature of the subject. The little scenes of labour, showing craftsmen, servants and slaves at their daily work, which form part of the burial adjuncts of the aristocracy, are kept within the limits of thoroughly naturalistic, un-monumental and playful forms, but the statues of the gods, however unpretentious they may be, are worked in the style of official court art. In the course of the history of art and literature we repeatedly meet this stylistic differentiation according to subject-matter. For example, the dual manner of characterization employed by Shakespeare, according to which his servants and clowns speak in everyday prose but his heroes and lords in elaborately artistic verse, corresponds to this 'Egyptian', thematically determined alternation of style. For Shakespeare's characters do not speak the different language of the various classes as they exist in reality, like the characters in a modern drama, for instance, who are all drawn naturalistically, whether they are of high or low degree, but the members of the ruling class are portrayed in a stylized manner and express themselves in a language non-existent in real life, whereas the representatives of the common people are described realistically and speak the idiom of the street, the inns and the workshop.

Another scholar thinks that the observance or violation of the principle of 'frontality' does not depend on whether the char-

acters portrayed belong to aristocratic circles or to the common people, but on whether they appear in action or in a resting position.[27] Even if this observation is correct to some extent, one must not forget that the kings and lords are in fact normally shown in an attitude of solemn quiet and rest, whereas the common folk are shown almost always moving about their daily work. But the representatives of the ruling class preserve—and this refutes the theory—the forms of frontality even when they appear in action, as in battle or hunting scenes.

There is far more solid justification for speaking of the existence of a provincial art alongside the art of the residence than of a folk art alongside that of the court. The important artistic achievements originate again and again, and more exclusively as progress continues, at the royal court or in the precincts of the court—first in Memphis, then in Thebes and finally in El Amarna. What takes place in the provinces, far away from the capital and the great temples, is comparatively unimportant and lags slowly and laboriously behind the general development.[28] It represents a culture that has merely percolated down from the upper class, it is in no sense a culture which has risen from the depth of folk-life. This provincial art, which it is impossible to consider as the continuation of the old peasant art, is also intended for the land-owning aristocracy, and owes its very existence to the separation of the feudal nobility from the court, a process which had been taking place since the 6th dynasty. The new provincial nobility with its backward regional culture and its derivative provincial art is formed from these elements which had broken away from the capital.

5. MESOPOTAMIA

The real problem of Mesopotamian art consists in the fact that, despite an economy based predominantly on trade and industry, finance and credit, it has a more rigidly disciplined, less changeable, less dynamic character than the art of Egypt, a country much more deeply rooted in agriculture and a natural economy. The code of Hammurabi, which dates from the third

millennium B.C., shows that trade and manual crafts, book-keeping and the granting of credit were highly developed in Babylonia even at that time, and that comparatively complicated bank transactions such as payments to third parties and the mutual adjustment of accounts were carried out.[29] Commerce and finance were so much more highly developed here than in Egypt that, in contrast to the Egyptian, it was possible for the Babylonian to be called quite simply the 'business man'.[30] The greater formal discipline of Babylonian art alongside the more mobile and more directly urban economy refutes, however, the otherwise normally valid sociological thesis according to which the strict geometric style is connected with traditionalistic agriculture and unrestrained naturalism with a more dynamic urban economy. Perhaps the more rigid forms of despotism and the more intolerant spirit of religion in Babylonia set themselves against the emancipating influence of city life, that is, assuming that the mere circumstance that there was only an art of the court and temple here, and no one besides the ruler and the priests could exert any influence on the practice of art, had not nipped all individualistic and naturalistic efforts in the bud. Peasant art and the more popular minor forms of art played an even smaller part in the land of the Two Rivers than in the other civilized lands of the ancient East,[31] and artistic activity was even more impersonal here than in Egypt, for example. We know almost none of the names of Babylonian artists and we divide up the history of Babylonian art purely according to the reigns of the kings.[32] No distinction was made here either terminologically or in actual practice between art and craft; the code of Hammurabi names the master-builder and the sculptor alongside the smith and the shoemaker.

Abstract rationalism is practised even more consistently in Babylonian and Assyrian art than in Egyptian. The human figure is shown not only in strict frontality with the head turned to show the revealing side-view, but the characteristic parts of the face, the nose and eye, are considerably magnified, whilst the less interesting features, such as the forehead and chin, are greatly reduced.[33] The anti-naturalistic principle of frontality is nowhere clearer in evidence than in the so-called 'Doorkeepers', the winged

lions and bulls, in Assyrian architectural sculpture. There is hardly a branch of Egyptian art in which the supremely stylizing approach, renouncing all illusionism, was put into practice so uncompromisingly as in these figures, which have, from the side-view, four moving, and from the front view, two stationary feet, five altogether, and which really represent the mixture of two animals. The striking contravention of natural law is here due to purely rational motives: the creator of this genre obviously intended that the beholder should obtain from all sides a self-contained, complete and formally perfect picture of the subject.

Assyrian art passes through something like a naturalistic development very late, certainly not until the eighth and seventh centuries B.C. The battle and hunting reliefs of Ashur-bani-pal are, at least as far as the animals represented are concerned, excitingly natural and alive, but the human figures are still portrayed just as rigidly and still appear in the same stiff, decorated and old-fashioned hair and bear dress as 2,000 years before. This is a similar case of stylistic dualism as in Egypt in the age of Akhenaton and shows the same difference in the treatment of the human and animal figures as was observed as early as the Old Stone Age and which can be seen again and again in the course of the history of art. The Palaeolithic age portrayed animals more naturalistically than man because in that world everything revolved around the animal; later ages often do the same because they do not consider the animal worthy of stylized treatment.

6. CRETE

Cretan art presents the sociologist with the most difficult pro-blem in the whole field of Ancient-Oriental art. It not only holds a special position of its own beside Egyptian and Mesopotamian art, but it is an exceptional case in the whole development from the end of the Palaeolithic age until the beginning of the classical age in Greece. In all this vast period in which the abstract geo-metric style predominated, in this unchanging world of strict traditionalism and rigid forms, Crete presents us with a picture

of colourful, unrestrained, exuberant life, although economic and social conditions are no different here than anywhere else in the surrounding world. Here too despots and feudal landlords are in power, here too the whole culture is under the aegis of an aristocratic social order, exactly as in Egypt and Mesopotamia—and yet what a difference in the whole conception of art! What freedom in artistic life in contrast to the oppressive conventionalism in the rest of the Ancient-Oriental world! How can this difference be explained? There are several possible explanations, but there is no one perfect, compelling explanation, no doubt owing, first of all, to the hitherto undecipherable nature of Cretan writing. Perhaps the difference lies partly in the comparatively subordinate rôle which religion and religious worship played in public life in Crete. No temple buildings and no monumental statues of gods of any kind have been found here; the small idols and cultic symbols which have been found suggest that religion exerted a much less deep and comprehensive influence than elsewhere in the ancient East. But the freedom of Cretan art can also be partly explained by the extraordinarily important rôle which city life and commerce played in the island's economy. It is true that we find a similar predominance of commercial interests in Babylonia without any observable influence on the world of art, but city life was probably nowhere so highly developed as in Crete. There was a great variety of urban community-types: beside the capital and the seat of the court, Cnossus and Phaestus, there were typical industrial cities like Guernia and little market towns like Praesus.³⁴ But the special character of Cretan art must be seen first of all in relation to the fact that, in the Aegean, in contrast to other areas, trade, above all foreign trade, was concentrated in the hands of the ruling class. The unstable spirit of the trader, fond of making innovations, was able to make its way less hampered than in Egypt or Babylonia.

Of course, even this art is still the art of a court and an aristocracy. It expresses the *joie de vivre*, the good living and the self-indulgence of autocrats and a small upper class. The monuments which have come down to us bear witness to luxurious ways of life, to the glories of the royal household, splendid country seats, wealthy cities, great latifundia and also to the misery of the

broad masses of an enslaved peasantry. It has, as in Egypt and Babylonia, a thoroughly courtly character, but the rococo element, the delight in the sophisticated and the amusing, the delicate and the elegant, comes more to the fore. Hoernes is right to emphasize the chivalrous features of Minoan culture by drawing attention to the part played by festive processions and festival plays, public combats and tournaments, by women and their coquettish manners in Cretan life.[35] This courtly-chivalrous style makes it easier for less rigid, more spontaneous and more flexible forms of life to develop, in contrast to the strict mode of life of the old predatory land-owning barons—a process which recurred in the Middle Ages—and produces, to accord with these new patterns of life, a more individualistic, stylistically freer art expressing more unprejudiced delight in nature.

But according to another interpretation, Cretan art is really no more naturalistic than, for example, Egyptian art; if it makes a more natural impression, then, presumably, it is not so much the stylistic methods employed which are responsible as the bold choice of subject-matter, the abandonment of the officially solemn subjects and the fondness for more secular and episodic, everyday and dynamic motifs.[36] The 'chance arrangement' of the elements of the composition, which is mentioned in the same connection as an essential characteristic of the Cretan style, shows, however, that it is not merely a question of the choice of subject-matter. This 'chance arrangement', this freer, looser, more pictorial composition, is the expression of a freedom of invention which may perhaps best be described as 'European', in contrast to the Oriental restrictions of Egyptian and Babylonian art, and of a conception which, in contrast to the principle of concentration and subordination, favours an accumulation and abundance of thematic material.[37] The fondness for mere juxtaposition goes so far in Cretan art that we find everywhere a widely luxuriant growth of scattered motifs not only in the scenic compositions but also in the ornamental paintings on vases, instead of geometrically arranged decorations.[38] And this freedom from formal constraint is all the more significant, since the Cretans were in fact, as we know, very well acquainted with the productions of Egyptian art; if they, therefore, abandoned its monumentality, solemnity and severity,

that is evidence that the grandeur of Egypt was not in accordance with their own taste and artistic aims.

Nevertheless, Cretan art also has its anti-naturalistic conventions and abstract formulae: it almost always neglects perspective, there is a complete lack of shadow, colouring is mostly limited to local colours and the forms of the human figure are always more stylized than those of animals. The relationship between the naturalistic and anti-naturalistic elements is, however, by no means predetermined from the outset, but changes with the historical evolution of the art.[39] Always keeping close to nature, Cretan art returns from a predominantly geometrical formalism, probably still influenced by Neolithic tendencies, by way of an extreme naturalism, to an archaistic and somewhat academic stylization. Not until the middle of the second millennium, at the close of the middle Minoan period, does Crete discover its own naturalistic style and reach the climax of its development in the sphere of art. Then, in the second half of the millennium, Cretan art loses much of its freshness and naturalness, its forms become more and more schematic and conventional, stiff and abstract. Those scholars who incline to racial explanation of historical phenomena like to attribute this geometrization to the influence of the Hellenic tribes invading the Greek mainland from the North, that is to say, of the same people who also created the later geometric style in Greece.[40] Others dispute the need for such an ethnic explanation and see the reasons for this change in style in the historical evolution of form.[41]

It is a common habit to draw attention to the 'modernity' of Cretan art as its special characteristic when compared with Egyptian and Mesopotamian art; this is, however, its most problematical feature. The taste of the Cretans was not particularly fastidious and stable, for all their originality and virtuosity. Their artistic means are too complaisant and obvious to leave behind a deep and lasting impression. Their frescoes remind us, with their watery colours and straightforward drawing, of the decorations in modern luxury steamers and swimming baths.[42] Crete not only stimulated 'modernist' art, it even anticipated certain aspects of modern industrial art. The 'modernity' of the Cretans was probably connected with their factory-like pursuit of art and their

mass production for an enormous export market. On the other hand, the Greeks avoided the danger of standardization despite an equally advanced industrialization—but this only proves that in the history of art the same causes by no means always have the same effects or that the causes are perhaps all too numerous to be completely exhausted by scientific analysis.

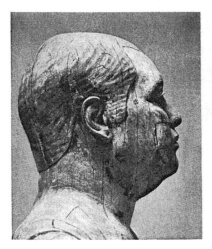

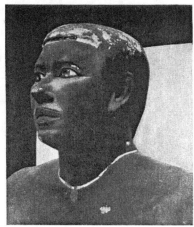

1. 'THE VILLAGE MAYOR'
(Detail). *Cairo, Museum. Early
Vth dynasty.—The classical
example of the naturalism of the
Old Kingdom.*

2. PRINCE REHOTEP (Detail).
*Cairo, Museum. IIIrd dynasty.—
From the burial place of King
Snefru who may have been
related to the Prince. Even the
memmorial of a person so closely
connected with the court shows a
directness in the representation
which is unthinkable in similar
works later on.*

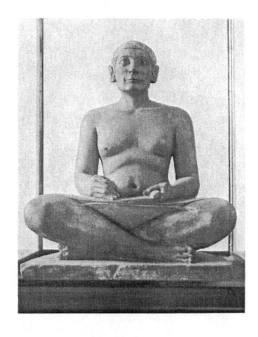

3. SCRIBE. *Paris, Louvre. Vth
dynasty.—Here, too, naturalism
is the predominant element,
but formal principles are
already more obtrusive and
make a perfect balance with the
naturalistic factors.*

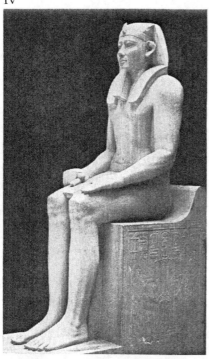

1. SENUSERT I. *Cairo, Museum. XIIth dynasty.—A work typical of the official conception of art of the Middle Kingdom and consisting of nothing but purely stereotyped features.*

2. AMENHOTEP IV. *Berlin, Altes Museum. XVIIth dynasty.—The portraits of the great reformer are the best examples of the new 'impression-istic' style which breaks up the lifeless rigidity, if not the whole conventionality of the old courtly-religious art.*

3. PLASTER MASK. *Berlin, Altes Museum. Age of Amenhotep IV.— From the workshop of the sculptor Thutmosis in El Amarna. The work possibly represents a slightly touched up death mask.*

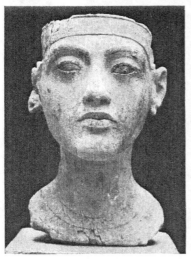

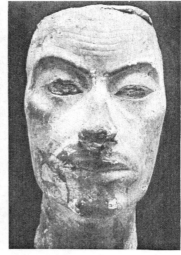

V

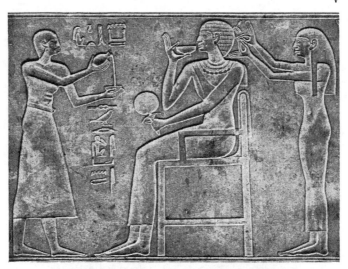

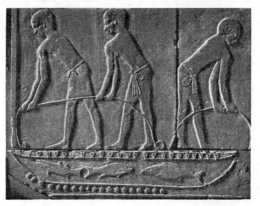

1. PRINCESS KAWIT WITH TWO SERVANTS. *Cairo, Museum. Middle Kingdom.—The representation combines the frontal and the non-frontal conception. The mistress is depicted in the conventional court style, whereas one of the maidservants is shown from the side with frontal symmetry partly abandoned.*

2. DRAUGHT OF FISH. *Berlin, Altes Museum. About 2800 B.C.—The work shows the complete abandonment of frontality typical of the representation of scenes of work.*

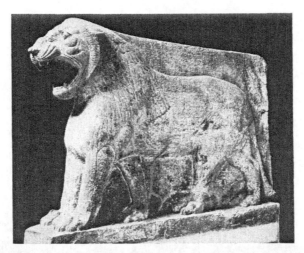

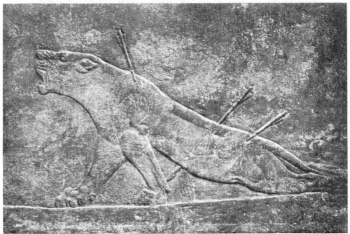

1. LION. *London, British Museum. 9th century B.C.—Example of the so-called 'Doorkeepers'—well known from Assyrian architectural sculpture—which, with their two stationary legs from the front-view and four moving legs from the side-view, give the most intense expression to the anti-naturalistic principle of frontality.*

2. WOUNDED LIONESS. *London, British Museum. 7th century B.C.— Alabaster relief from the palace of Ashur-bani-pal in Nineveh. The battle and hunting reliefs of the palace represent the animals with a thrilling naturalness, in contrast to the human figures.*

CHAPTER III

GREECE AND ROME

1. THE HEROIC AND THE HOMERIC AGES

THE Homeric epics are the oldest poems in Greek that survive, but certainly not the oldest there were. It is not merely that their structure is too complicated and that we can point to contradictions in their contents; the legend of Homer himself contains many features incompatible with the portrait of the poet which we should construct from the sophisticated, sceptical and even frivolous spirit of the poems. The traditional picture of the blind old singer of Chios is largely made up of memories that go back to the time when a poet was a *vates*— a priestly and God-inspired seer. His blindness is merely the outward sign of the inward light that fills his being and enables him to see things others cannot see. This bodily infirmity expresses— as does the lameness of the divine smith Hephaestus—a second idea that was current in primitive times, that a maker of poems, ornaments and other products of handicraft can only come from the ranks of those who are unfit for war and foray. But apart from this feature, the legendary 'Homer' is an almost perfect example of the mythical poet who was still half-divine, a wonder-worker and a prophet. We find the clearest embodiment of this idea in Orpheus, the primeval singer who had his harp from Apollo and instruction in the art of song from the Muse herself; with his music he could move not merely men and beasts but even rocks and could reclaim Eurydice from the bonds of death. 'Homer' no longer boasts such magical power, but still retains the features of an inspired seer and remains conscious of a mysterious and sacred intimacy with the Muse whom he so confidently invokes.

49

We can be sure that the poetry of the earliest Greeks, like that of all other peoples at a primitive stage, consisted of magic formulae, oracular sayings, prayers and charms, songs of war and work. All these types have something in common; they may be termed the ritual poetry of the masses. It never occurred to the makers of charms and oracular verses, the composers of dirges and war-chants, to create anything individual; their poetry was essentially anonymous and intended for the whole community; it expressed ideas and feelings that were common to all. In the visual arts we find on the level corresponding to this impersonal ritual poetry the fetishes, stones and tree-trunks, which the Greeks revered in their temples from the earliest times and which can hardly be called sculptures, so slight are the vestiges of human shape. These, too, like the oldest charms and hymns, are primitive community art, the rude and clumsy artistic expression of a society that knows scarcely any differentiation of classes. We know nothing about the social position of their makers, the part they played in the life of the group or the repute they enjoyed with their contemporaries; but the probability is that they were less highly esteemed than the artist-magicians of the Palaeolithic or the priestly singers of the Neolithic age. It may be remarked that the sculptors also had their mythical ancestors. Daedalus, we are told, could bring wood to life and make stones walk; that he made wings for himself and his son to fly over the sea appears to the narrator of the legend no more miraculous than his power of carving figures and designing labyrinths. He is by no means the only artist-magician, but it may be that he was the last important one, since the conception of Icarus' wings and his falling into the sea seems to symbolize the ending of the age of magic.

With the beginning of the heroic age, the social function of poetry and the social position of the poet changed completely. The secular and individualistic outlook of the warlike upper class gives poetry a new content and assigns new tasks to the poet. He now abandons his anonymity and his priestly aloofness and poetry loses its ritual and collective character. The kings and nobles of the Achaean principalities of the twelfth century B.C., the 'heroes' who gave its name to this age, are robbers and pirates—they are

proud to call themselves 'plunderers of cities'—and their songs are worldly and profane; the tale of Troy, the crown of their fame, is nothing more than the poetical glorification of freebooting and piracy. Their lawless and irreverent spirit is the outcome of the continuous state of war in which they found themselves, of the train of victories which they achieved and the abrupt changes of cultural level which they experienced. Victors over a more civilized folk than themselves and exploiters of a far more advanced culture than their own, they became emancipated from the ties of their ancestral religion while despising the religious precepts and prohibitions of the conquered people, just because they are the conquered.[1] Thus the life of these restless warriors becomes one of unruly individualism which sets itself above all tradition and all law. Everything for them is a prize to be fought for, an object for personal adventures, since in their world everything depends on personal strength, courage, skill and cunning.

From a sociological point of view, the age is characterized by the decisive turn which is now taken away from the primeval clan organization and towards the social system of a feudal monarchy relying on the personal loyalty of vassals to their lord. This system, so far from depending upon, actually ran counter to kinship relations and in principle overrides the duties of the kin to one another. The social ethics of feudalism reject the solidarity of blood and race; the moral ties become individual and rational.[2] The gradual dissolution of the tribal unit is strikingly shown in the conflicts between kin which seem to be more and more frequent as the heroic age advances. The loyalties of vassals to their lord, of subjects to their king and of citizens to their city emerge gradually and finally become stronger than the voice of the blood. This process continues over several centuries and finds its conclusion, though with some interruptions from aristocracies basing themselves on family solidarity, only with the victory of democracy. Classical tragedy is still permeated with the conflict between the clan state and the popular state; the *Antigone* of Sophocles revolves round the very same problem of loyalty which was central to the *Iliad*. In the heroic age this problem does not rise to the level of tragic conflict since it is not linked with any crisis in the current order of society; what we see is a revaluation

51

of moral standards and ultimately the victory of a ruthless individualism for which the freebooters' code of honour is the only valid standard.

In consequence, the poetry of the heroic age is no longer folk poetry for the masses; we do not find songs or hymns for groups, but individual songs about the fate of individuals. Poetry no longer has the task of rousing men to battle but rather of entertaining the heroes after the battle is over; it has to sing their praises, to name them by name, to spread and perpetuate their glory. In fact the heroic lay owes its origin to the warlike nobles' thirst for glory; to satisfy this is its principle task—any other merits are of secondary importance in the eyes of the audience. To a certain extent it must be recognized that all ancient art is a response to a desire for fame and to the wish to be renowned in the eyes of contemporaries and posterity.[3] The story of Herostratus who set fire to the temple of Diana at Ephesus to make his name immortal gives an idea of the undiminished power, even in later times, of this passion, which, however, was never so creative as in the heroic age. The poets of the heroic songs are bestowers of praise and fame; this is the basis of their existence and the source of their inspiration. The subjects of their poetry are no longer hopes and wishes, magical ceremonies or animistic rites, but tales of successful encounters and bloody war. With the disappearance of its ritual function, poetry loses its lyrical character and becomes epic; in this mood it gives birth to the oldest European poetry we know of, which is secular and independent of religion. In fact these poems originate in a kind of war report, a chronicle of how the war is going. At first they probably confined themselves to the 'latest news' of the successful warlike enterprises and the profitable forays of the tribe. 'The newest song gets the loudest applause', says Homer (*Od.* I, 351, 2)and makes his Demodokos and Phemios sing of the latest events of the day. But his singers are no longer mere chroniclers, for the war report has meantime become a mixture of history and saga and taken on the style of the ballad, mingling dramatic and lyric elements with the epic. No doubt this was already the case with the heroic lays, the bricks of which the epics are built, though in their case the epic element was the characteristic one.

52

The heroic lay not merely recounts the deeds of an individual person, it is also recited by an individual person, not by a community or chorus.[3a] Originally it was probably composed and recited by the warriors and heroes themselves; that is to say, both audience and author belonged to the master caste and were noble, sometimes even princely amateurs. The scene portrayed in *Beowulf*, in which the Danish king calls on one of his thanes to sing a song about the fight they have just been through, no doubt holds generally good of conditions in the Greek heroic age.[4] But the rôle of the noble amateur is soon taken over by a professional—the court poet and singer or bard—who through long practice can give a more artistic and so more effective rendering of the heroic lay. Like Demodokos at the court of the Phaeacian king and Phemios ih the palace of Odysseus, they sing their lays at the common tables of the kings and their chieftains. They are professional singers, but at the same time vassals and retainers of the king, and though employed for reward they hold an honourable position. They belong to the court society and are treated as equals by the heroes. They live the secular life of the court, and though they still sometimes claim that the God put these songs into their soul (*Od.* XXII, 347,8) and cherish memories of the divine origin of their art, they are as well versed in the rough trade of war as their hearers are; in fact they have more in common with them than with their own spiritual ancestors, the seers and magicians of an earlier age.

The picture of the social position of the poet which we get from the Homeric poets is not consistent. One singer belongs to the retinue of the prince while the other is something between a court singer and a folk singer.[5] It would seem that there is a confusion between the conditions of an earlier age and of the 'Homeric Age' itself, when the poems were compiled and edited. At any rate, we may suppose that even in the early days there were, besides the bards of the aristocratic court society, wandering singers as well, who entertained folk in the market places and round the fires in the λέσχαι with songs of a less heroic and dignified character.[6] We can form no notion of these, unless we assume that anecdotes such as the adultery of Aphrodite originated in this way.[7]

In the plastic arts, the Achaeans continue the Cretan and Mycenean tradition, and the social position of the artist cannot have been very different from that of the artist-craftsman in Crete. At any rate, it is inconceivable that a sculptor or painter could ever have sprung from the nobility or belonged to court society. In fact, the essays of princes and nobles in poetry and the familiarity of the professional poets with the practice of war were bound to increase the social distance between the artist who worked with his hands and the poet who worked with his brains. This new circumstance is the chief cause of the higher social standing of the poet in the heroic age, compared with that of the scribe in the ancient East.

The Dorian invasion brings the end of the age in which war-like enterprises and adventures are immediately translated into song and saga. The Dorians were a rude and sober-minded peasant folk who made no songs about their victories, and the 'heroic' people they drove out are no longer so keen on adventure after they have settled on the coast of Asia Minor. Their military monarchies become peaceful agricultural and commercial aristo-cracies in which the former kings are merely great landlords, and whereas formerly the princes and their retinues could lead expensive lives at the cost of the rest of the community, wealth is now more widely distributed and the display of the upper classes is correspondingly diminished.[8] They are content with a more modest style of living and the commissions which they give to sculptors and painters in their new homeland are at first no doubt on a quite petty scale. All the more splendid is the poetical pro-duction of the time. The refugees took their heroic lays with them to Ionia where, in the midst of foreign peoples and under the influence of foreign cultures, the epic emerges over the course of three centuries. Under the final Ionic form, we can still detect the older Aeolic material, can distinguish the various sources and note the varying quality of the different parts and the abruptness of some of the transitions, but we do not know just how much of its artistic quality the epic owes to the heroic lay nor how the merit of this incomparable achievement should be apportioned between individuals, schools and generations of poets. Above all, we do not know whether some one person or

other deliberately took up the collective work and stamped it with its final shape, or whether, on the contrary, it is just the embodiment in the poems of so many distinct *trouvailles* and the constant recapitulation of and improvement upon tradition which gives them their special, indeed unique character as products of 'collective genius'.

Poetical creation, which in the heroic age, through the differentiation of the poet from the priest, had taken on a more personal form and was the work of separate and independent individuals, now once again shows a decided tendency towards the collective. The epic is no longer the work of individual poets but of whole schools and even, it may be said, of guilds. It is the creation, not indeed of a folk community, but at least of group work, that is, of a group of artists who recognize their spiritual solidarity and are united by common traditions and methods of working. Thus there begins a new kind of organization which hitherto had only been found in the visual arts and which was quite alien to the older poetry: division of labour between pupils and teachers, masters and assistants now enters the field of literature.

The bard sang his songs in the king's hall before a princely and noble audience; the rhapsode recites from the epics at the seats of the nobility and the great houses, and also at festivals and fairs, in workshops and in the λέσχαι. As this poetry becomes more popular and addresses itself to a wider public, so the style of delivery becomes less and less formal and approaches that of everyday speech; the staff and recitation take the place of the harp and singing. This process of popularization only reaches its completion when the saga, in its new epic form, returns to the mainland and is there spread abroad by the rhapsodes, embellished by the epigoni and finally transmuted by the tragedians. Recitation of the epics becomes a regular custom with the age of the Tyrants and the beginnings of democracy. Already, in the sixth century, a law required the recitation of the complete poems of Homer—presumably by relays of rhapsodes—at the four-yearly festival of the Panathenaeas. The bard declared the glory of the kings and their vassals, the rhapsode that of the nation's past. The bard sang of current events while the rhapsode con-

jured up the events of history and saga. The composition of poetry and its recitation were still not separate, specialized callings, but the reciter was not, as formerly, necessarily the poet.[9] The rhapsode is something between a poet and an actor; the many dialogues which are put in the mouths of characters in the epics, and which necessarily required some histrionic skill in the reciter, form the bridge between the recitation of an epic and the performance of a drama.[10] The Homer of the legend is somewhere between Demodokos and the Homeridai, between the bards and the rhapsodes. He is at once a priestly seer and a wandering minstrel, son of the Muse and mendicant. His figure lacks definition and is nothing but a summing-up and personification of the development from the heroic lay of the Achaean princes to the Ionian epic.

In all probability the rhapsodes could write; for though at a much later date there were still people who could recite the whole of Homer by heart, recitation alone without any written basis would have gradually brought about complete dissolution of the epics. We must imagine the rhapsodes rather as trained and accomplished literary men who were more concerned to preserve than to add to the store of their poetry. The very fact that they are called 'sons of Homer' and clung to the legend of their descent from the master shows the conservative and clannish character of their school. It has, indeed, been asserted that the titles of the guilds, such as Homeridai, Asklepiadia, Daidalidai, etc., are to be regarded simply as arbitrary symbols, and that their members neither themselves believed, nor expected anyone else to believe in a common descent;[11] others have maintained that guilds generally have their origin in kinship and that the various trades were all originally the monopoly of different clans.[12] However that may be, the rhapsodes formed a closed profession, marked off from other groups, of highly specialized literati, trained in an ancient tradition and having nothing to do with any such thing as 'folk poetry'. Greek 'folk epic' is a pure invention of romantic philologists; the Homeric poems are anything but 'popular', whether in their final or even in their earlier stages. The finished epics are no longer court poetry, while the heroic lay was just this: its motifs, style and audience and everything

else about it are of a courtly or knightly character. It is even open to question whether the Greek heroic lay ever became folk poetry as the *Nibelungenlied* did, which after its birth and early development at court was taken among the people by the wandering minstrels and so passed through a folk poetry stage before ultimately taking on the final courtly form in which we know it.[13] On this view, the Homeric epics were the direct continuation of the poetry of the heroic age;[14] Achaeans and Aeolians took to their new homes not merely the heroic lays but also singers who transmitted direct to the poets of the epics the songs they had formerly sung. The kernel would thus consist, not of popular Thessalian ballads, but of courtly panegyrics intended not for the masses but for the sophisticated ear of connoisseurs, and the heroic lay would have reached the mass of the people only at a very late date, in the form of the completed epic—the first form in which, on this view, it becomes known to the Hellenic people generally. It upsets all romantic conceptions of the nature of art and the artist —conceptions which are the very foundation of nineteenth-century aesthetics—to have to think of the Homeric epics, in all their perfection, as being the product neither of individual nor of folk poetry, but, on the contrary, as an anonymous artistic product of many elegant courtiers and learned literary gentlemen, in which the boundaries between the work of different personalities, schools and generations have become obliterated. This view certainly sets the poems in a new light, but still without yielding the secret of their beauty. The puzzling element in the poems was what the romantics called 'naïve folk poetry'; for us, it is the creative power of producing out of so many disparate elements— vision and erudition, tradition and inspiration, the original and the borrowed—this unbroken flow of sweet cadences, this solid and consistent world of images, this complete unity of being and meaning.

The atmosphere of the Homeric poems is still thoroughly aristocratic, but no longer strictly feudalistic; it is only the older portions that reflect the age of feudalism. The heroic lay was addressed exclusively to princes and nobles and shows no interest but in them, their manners and ideals. Though the world of the finished epics is no longer so narrowly restricted, the ordinary

man of the people is still never named and the common soldier is of no consequence. In the whole of Homer there is not a single case of a non-noble rising out of the class he was born in.[15] There is no real criticism in the epics either of kings or aristocracy; Thersites, the only character who rails against the kings, is the very epitome of the boorish person, lacking all cultivation of manners and all the graces of social intercourse. Thus, the outwardly 'bourgeois' features that have been observed in Homer's similes[16] do not, on the whole, reflect any bourgeois spirit. Yet the heroic ideals of the saga are already impaired in the epic. There is already a marked tension between the outlook of the humane poet and the behaviour of his rough heroes. Nor is it only in the *Odyssey* that we meet with the 'unheroic Homer'. It is not merely that Odysseus belongs to a different world from Achilles and one more akin to the poet's own. There are signs that the noble, kindly and generous Hector has displaced the fierce hero of the *Iliad* in the poet's affections.[17] All this merely shows that the outlook of the nobility was changing, not that the poet of the epic derived his moral standards from a new, non-noble public; in any case, they are not written for a warlike landed nobility, but for an unwarlike, town-dwelling aristocracy.

Only when we come to Hesiod do we get a poetry that moves in the world of the peasant. This is not real folk poetry either— it is not a poetry that passes from mouth to mouth, nor such as could compete with bawdy anecdotes round the fire. Still its subjects, standards and ideals are those of the peasants—of people oppressed by the land-owning nobility. The historic significance of Hesiod's work is due to its being the very first literary expression of social tension and of class antagonism. It is true that it advocates conciliation, seeks to calm and console—the time of class warfare is still far off—but it is the first time that the voice of the working people is heard in literature, the first voice to speak up for social justice and against arbitrariness and violence. In short, a poet for the first time takes up a political and educational mission instead of the task which religion and court society had assigned to him, setting up to be a teacher, philosopher and champion of an oppressed class.

It is not easy to establish the historical relationship between

Homeric poetry and the contemporary geometrical art. The refined and elegant conventions of the epics seem to have no obvious resemblance to the sober and schematic style of this geometrical art. Attempts to find the principles of this art in Homer[18] have hitherto been quite unsuccessful. Apart from the fact that symmetry and repetition, the sole 'geometrical' elements in poetry, can only be found in particular episodes of the Homeric poems, these elements represent but the outermost layer of poetry, whereas in geometrical painting and sculpture they are the very kernel of the whole composition. The explanation of this discrepancy lies in the fact that the epics developed in Asia Minor, the melting pot of the Aegean and Oriental cultures and the centre of world trade at that time. The home of the geometrical style, on the other hand, was on the mainland of Greece, among the Dorian and Boeotian peasants. The style of the Homeric poems is rooted in the speech of an urban and cosmopolitan population; whereas geometrical art is the expression of a country people, a people of farmers and shepherds who have rigorously shut themselves off from foreign influences. Subsequent art is a synthesis of these two tendencies; this, however, is only achieved with the economic unity of all the coasts of the Aegean, at a level of development not attained during the geometrical era.

The early geometrical style at the end of the tenth century, after two centuries of stagnation and barbarism, initiates a new line of development in the West. At first we find everywhere the same heavy, awkward and ugly forms, the same summary and schematic mode of expression, until little by little differentiated local styles everywhere emerge. The best known of these, and that which has most artistic merit, is the Dipylon style which flourished in Attica between 900 and 700—a style already refined and almost mannered, delicate and fluent. It shows how even peasant art, through long and uninterrupted practice, can achieve a sort of preciousness, and how an organic type of ornament, based upon the structure of the object to be decorated, can degenerate into a 'pseudo-tectonic decoration'[19] whose abstract character, arbitrarily or playfully distorting nature, no longer makes any pretence of being derived from the form of the object. For example, there can be seen upon a fragment of a

Dipylon vase in the Louvre a 'death-bed scene', with the corpse
laid out, weeping women around or rather on top of the bed,
where they have to form a border, and sorrowing men on each
side and below the main picture, which is square and bears no
relation to the round form of the vase. All these figures can be
taken as you will, either as belonging to the picture or as mere
ornament. Finally, the whole is squeezed into a net of crochet-
work pattern. The figures are all alike; they are all making the
same gesture with their arms, crossing them to form a triangle
whose bottom point is the waist of these wasp-waisted and long-
legged figures. There is no trace either of depth or of spatial
order; the bodies are without volume or weight; all is just surface
pattern and play of lines which are frozen into stripes and bands,
fields and friezes, squares and triangles—undoubtedly the most
violent and uncompromising stylization of reality since Neolithic
times, and far more uniform and consistent than anything in
Egyptian art.

2. THE ARCHAIC STYLE AND ART AT THE COURTS OF THE TYRANTS

Not until 700 B.C., when urban forms of life begin even on
the mainland to supplant those of a peasant society, does the
rigidity of the geometrical forms begin to relax. The new archaic
style, which now succeeds the geometrical, originates in a syn-
thesis of the styles of East and West, of urbanized Ionia, on the
one hand, and the still almost completely agricultural mainland,
on the other. Between the end of the Mycenean and the begin-
ning of the archaic period in Greece, neither palaces nor temples
were erected, nor is there monumental art of any kind; we possess
nothing from this period but the slight remains of an art that was
wholly restricted to the field of pottery. But with the archaic
style, the product of a flourishing commerce and wealthy towns
and successful colonization, a new period of monumental sculpture
and architecture begins. This is the art of a society whose élite
has risen from the level of peasants to that of city magnates, of
an aristocracy which is beginning to spend its rents in the towns

and take part in industry and trade. This art shows nothing of the narrow and static outlook of the peasant. It is urban, not merely in the monumental tasks it undertakes, but in its distaste for tradition and its susceptibility to foreign influences. Admittedly, it is still governed by a number of formal principles, above all the principles of frontality and symmetry, of cubic form and the 'four fundamental aspects' (E. Loewy), so that the geometrical style can hardly be said to have completely ended until the classical style has begun. But within these limitations, the trends of the archaic style are very varied and make a big step towards naturalism. Both the elegant, clever, artistic style of the Ionian Korai and the massive, powerful, dynamic forms of early Dorian sculpture, in spite of all their archaic clumsiness, are aiming all the time at an expansion and differentiation of the means of expression available to the artist. In the East, the Ionic element prevailed; all the development is in the direction of refinement, virtuosity and formalism; its ideal is realized in the courtly art of the Tyrants. Woman is here, as in Crete, the main subject; the art of the Ionian coasts and islands finds its complete expression in those votive statues of maidens, elegantly clad, with hair carefully dressed, richly bejewelled and decorously smiling, with which, judging by the wealth of finds, the temples must have been filled. It is to be noted that the archaic artists, like their Cretan forerunners, never represent woman naked; they seek their plastic effects not in the nude, form but in costume and in an intimation of the body under its clinging robes. The aristocracy disliked representations of the nude which is 'democratic like death' (Julius Lange); at first even the male nude was tolerated only, it seems, as propaganda for the athletic games, for their cult of the body and their myth of blood. Olympia, where these statues of young men were put up, was certainly the most valuable propaganda site in Greece, since it was here that the public opinion of the whole country and the sense of national unity promoted by its aristocracy were formed.

The archaic art of the sixth and seventh centuries B.C. is the art of a nobility which was still very rich and in complete control of the machinery of government, but whose political and economic position was already threatened. The process by which it was

deposed from its economic leadership by the urban bourgeoisie, and its rents in kind devalued owing to the huge profits made in the new money economy, was going on continuously during the archaic era. Only in this critical situation does the artistocracy first become conscious of its essential characteristics;[20] it now begins to emphasize its special traits of character as a compensation for its evident inferiority in the economic struggle. Racial and class characteristics, which hardly came into its consciousness because they were simply taken for granted, are now claimed to be special virtues and excellences justifying special privileges. It now sets out, in the hour of danger, a programme of life which would never have been laid down so positively or indeed followed out so strictly in times when this manner of life was still materially secure. It is now that the foundations of the ethics of nobility are laid: the conception of *areté* with its dominant traits of physical fitness and military discipline, built up on a tradition, birth and race; of *kalokagathia*, the ideal of a right balance between bodily and spiritual, physical and moral qualities; of *sophrosyne*, the ideal of self-restraint, discipline and moderation.

While the epics still find appreciative audiences and eager imitators on the mainland as well as in the islands, the native choral and reflective lyric, with its direct bearing upon the problem of the hour, naturally had a greater appeal to a nobility that was fighting for its existence than the old-fashioned heroic saga. From the outset, gnomic poets such as Solon, elegists such as Tyrtaeus and Theognis, composers of choral works like Simonides and Pindar, offered the nobles earnest moral teachings, advice and warnings, instead of amusing tales of adventure. Their poetry is at once the expression of personal feelings, political propaganda and moral philosophy, and the poets are not entertainers but spiritual leaders both of the nobility and of the nation. Their task is that of keeping the nobles alive to their perilous position and not allowing them to forget their former greatness. Theognis, the enthusiastic panegyrist of the ethics of noblesse, is perhaps the poet who expresses the deepest disgust for the new plutocracy, contrasting its plebeian meanness with the noble virtues of magnificence and generosity; but even in his work we can note the crisis which the *areté* ideal was facing, for, though with pro-

found distaste, he advises his hearers to adapt themselves to the requirements of the new commercial society, and so undermines the whole fabric of aristocratic morality. The crisis which now looms is at the bottom of Pindar's tragic outlook on the world. It is the source from which this greatest of the noble poets draws his inspiration—indeed, the source of Greek tragedy itself. The tragedians, it is true, could only take possession of Pindar's estate after they had purged it of its dross—his narrow cult of the great families, his one-sided ideal of sport, his 'compliments to gymnasts and grooms'[21]—had freed the tragic conception of life from Pindar's narrowness so that it could appeal to their wider and more composite public.

Pindar still writes for the exclusive circle of his fellow nobles, whom, though unquestionably earning his living as a professional poet, he still treats as his equals. By pretending that he is merely speaking his mind and that, though he may desire reward, he could equally work without it, he gives the impression of being an amateur who composes poetry simply for his own pleasure and with the welfare of his fellow nobles at heart. Due to this fictitious amateurishness, it may seem at first sight as if the trend towards professionalism in poetry was being reversed, whereas in reality it is just at this time that the decisive step towards literary professionalism is taken. Simonides writes poetry to order for a definite sum and for anyone who will pay him; he offers his gifts for sale exactly as the Sophists later did their arguments—their forerunner in the very particular for which they were most despised.[22] There were, it is true, among the aristocrats some real amateurs who occasionally composed and took part in the choral performances, but in general both the poets and the performers of the choral lyrics were professional artists, and these two classes were more sharply differentiated than was the case in former times. Whereas the rhapsodes were both poets and reciters, these functions are now separated—the poet no longer sings and the singer is no longer the author. Perhaps the most striking result of this division of labour is to show how the singer is looked upon merely as a skilled workman; no vestige of amateur status attaches to him as it does to the poet, who is still supposed to believe in what he writes. The choral singers

form a widespread and well-organized profession so that poets can send out for performance lyrics they have been commissioned to write on the assumption that this will not meet with undue technical difficulties anywhere. Just as today a conductor can expect to find a tolerable orchestra in any big town, so in Greece at that date a poet could count upon finding a trained choir, whether for public or private festivities. These choirs were maintained by the noble families and were an instrument that was completely under their control.

The forms of contemporary sculpture and painting are equally determined by the ethics of nobility and the aristocratic ideal of bodily and spiritual beauty, even if this is perhaps not so evident as in the poetry. The statues, usually catalogued as 'Apollos', of young nobles who had won a victory in the Olympic Games, or the figures such as those of the Aegina pediments, with their pride of bodily vigour and their noble carriage, are the perfect counterpart of the aristocratic heroizing style and the old-fashioned aloofness of Pindar. The same manly ideal based on the conception of life as a contest (agon), the same typical product of aristocratic breeding and all-round athletic training, forms the subject of sculpture and poetry alike. Participation in the Olympic Games was a preserve of the nobles; they alone possessed the means required for the training and for the competition itself. The first list of victors dates from the year 776 B.C., but the first statue of a victor, according to Pausanias, was dedicated in 536 B.C. Between these dates the aristocracy was at its best. May we conclude that the statues of victors were introduced to spur on the weaker, less ambitious, less spirited generations that succeeded them?

The statues of athletes do not aim to be individual likenesses; they are idealized portraits whose sole purpose, it seems, was to preserve the memory of the particular victory and to make propaganda for the games. Probably in many cases the artist had never seen the victor and had to base his portrait upon a cursory description of the subject;[23] Pliny's remark that athletes had a claim to have a portrait-likeness after their third victory must refer to later times. There is no reason to think that any of the statues erected during the archaic period were ever 'likenesses'; but later on it is quite possible that the Greeks made the same

distinction that we make today, when a small prize is usually something quite impersonal but a big prize is engraved with the name of the winner and the details of the competition. In any case, the notion of a portrait in our sense was quite unfamiliar during the archaic period of Greek art, in spite of the considerable progress towards individualism which was made during this period.

With the development of commerce and of urban society, and with the triumph of the idea of competitive economy, individualism becomes prominent in all fields of cultural life. It is true that the economy of the ancient East had also developed along urban lines and was also based in the main upon trade and industry, but this was either the monopoly of the royal and temple treasuries or was controlled in such a way as to leave little room for individual competition. In Ionia and mainland Greece, on the other hand, there was free competition, at least between the free citizens. The beginning of this economic individualism marks the end of the compilation of the epics and the beginning of a subjective trend in poetry, with predominance of the lyric. This trend shows itself not merely in the subject matter, which in the lyrics is normally of a more personal character than in epic, but also in a new claim of the poet to be recognized as the author of his poems. The idea of intellectual private property now appears on the scene and takes root. The poetry of the rhapsodes was a collective achievement, the common and indivisible possession of school, guild or group. None of them ever regarded the poems he recited as his own personal property. The poets of the archaic era, not merely those, like Alcaeus and Sappho, who wrote lyrics of personal feeling, but also the writers of reflective and choral lyrics, addressed their public in the first person. The established types of poetry now dissolve into a host of individual styles; in each work it is the poet expressing his own feelings directly or making a direct address to his public.

At about the same time, 700 B.C., we find the first signed works of visual art—beginning with the vase of 'Aristonothos', which is the oldest signed work of art in existence. In the sixth century a type of man appears on the scene who was hitherto practically unknown—the artist with a markedly individual

personality.[24] Neither in the prehistoric nor in the early Oriental epochs, nor during the geometrical period of Greek art, was there anything like an individual style or personal ideals or ambitions —at any rate, there is no sign whatever that the artist cherished any feelings of this sort. Soliloquies such as the poems of Archilochus or Sappho, the claim to be distinguished from all other artists which is advanced by Aristonothos, attempts to say something already said in a different, though not necessarily better fashion—all this is quite new and heralds a development which now proceeds without a set-back (apart from the early Middle Ages) to the present day.

There was, however, strong opposition to be overcome in the Dorian lands. Aristocracy in general does not favour individualism; it bases its claim to privilege upon virtues which are common to the whole class or at least to whole clans. And the Dorian nobility of the archaic period was specially disinclined to individualistic impulses and ideals, in contrast, in particular, with the nobility of the heroic age or of the Ionian commercial centres. The hero covets fame, the trader gain; both are individualistic; but for the Dorian landed gentry the former heroic ideals had lost their power while the pursuit of money and profit inspired in them fear rather than hope. It is thus only natural that they should have retired behind the traditions of their class and tried to hold up the onrush of individualism.

The Tyrants who, at the end of the seventh century, had everywhere gained control, first in the leading Ionian states and then on the mainland, signify a decisive victory for individualism over the ideology of kinship. In this respect, as in others, they form the bridge to democracy, many of whose conquests they anticipate, for all their own undemocratic character. Though their system of centralized monarchy harks back to pre-aristocratic days, they set themselves to undermine the clan state. They set limits to the exploitation of the people by the noble families and they completed the transformation of the old home production for subsistence into commercial production for sale— so completing the triumph of the tradesman over the landlord. The Tyrants themselves are wealthy and usually well-born merchants who take advantage of the ever more frequent conflicts

between the possessing and the proletarian classes, oligarchy and peasantry, in order to seize political power by the adroit use of their wealth. They are merchant princes who maintain a court as splendid as that of the pirate princes of the heroic age, and even richer in artistic attractions. They are connoisseurs, and as such have properly been called the forerunners of the Renaissance princes and the 'first of the Medici'.[25] Like the usurpers in the Italian Renaissance, they seek to gloss over the illegitimacy of their rôle by offering tangible advantages and making a fine show;[26] that explains their economic liberalism and their patronage of the arts. They employ art not merely as a means to fame and a propaganda instrument but also as an opiate to soothe the opposition. The fact that their art policy is often accompanied by a true love and understanding of art does not affect its social basis. The courts of the Tyrants are the most important cultural centres of the age and its greatest repositories of artistic production. Almost all the important poets are in their service—at the court of Hiero at Syracuse we find Bacchylides, Pindar, Epicharmus and Aeschylus; Simonides is with Pisistratus in Athens; Anacreaon is the court poet of Polycrates of Samos; Arion, of Periander of Corinth. Yet in spite of this activity at the courts, the art of the age of the Tyrants is not entirely a product of the court; the rationalistic and individualistic spirit of the age hindered the development of that solemn pageantry and those conventional forms which are characteristic of a court style. The only features in this art that we can ascribe to the court are its joy in the senses, its refined intellectuality, and its somewhat artificial elegance of expression—all features to be found in the older Ionian tradition but developed to a still higher degree at the courts of the Tyrants.[27]

If we compare the art of the Tyrants with that of former ages, the most striking thing about it is the slightness of religious motive. Its creations seem to have shaken off all hieratic connections and to stand in a merely external relationship to religion. They may be called cult statues, votive offerings or funeral monuments, but their ritual employment is the merest pretext for their existence. Their real aim and object is to achieve the perfect presentation of the human body, an interpretation of its beauty,

67

a comprehension of its sensible form, free of all magical or symbolic implications. The setting up of the statues of athletes may have had some connection with religious ritual, the Ionian maidens may have served as votive offerings, but one only needs to look at them to convince oneself that they have nothing to do with religious feeling and very little with cult traditions. Compare them with any work of Ancient-Oriental art and you will realize the freedom, even the wilfulness, of their conception. In the ancient East a work of art, be it in the form of God or man, is a requisite of religious ritual. Illustrations of the most trivial everyday scenes are intimately related to faith in immortality and worship of the dead. This relationship between art and cult, though never so intimate, is found for a while in Greek art; the most ancient Greek works may really have been just votive offerings, as Pausanias surprisingly remarks of the Acropolis sculptures in general.[28] But in the late archaic period, the former intimate relationship between art and religion is dissolved and the production of secular works is constantly on the increase at the cost of religious. Religion lives and has its influence, even though art is no longer its servant; in fact, the age of the Tyrants is the scene of a religious renaissance which on all sides throws up new ecstatic confessions of faith, new secret cults and new sects; but at first these develop underground and do not as yet reach the light of art. Thus we no longer find art being commissioned and stimulated by religion, but, on the contrary, we find in this period religious zeal being inspired by the increased skill of the artist. The custom of offering to the Gods representations of living beings as votive gifts draws new life from the artist's new power of making these more imposing, more attractive and truer to nature, and so more pleasing to the Gods.[29] The temples now begin to be filled with sculptures, but the artist is no longer dependent upon the priests, is not under their tutelage, and does not receive commissions from them; his patrons are now the cities, the Tyrants and, for less expensive works, wealthy private individuals also. The works which he executes for them are not expected to have magical or saving power, and even when they serve a sacred purpose, they make no claim whatever to be sacred themselves.

We here meet a completely new conception of art; it is no longer a means towards an end, but an end in itself. At its origin, every form of spiritual endeavour is entirely determined by the useful purpose it serves; but such forms have the power and tendency to break free from their original purpose and make themselves independent; they become purposeless and to some extent autonomous. As soon as man feels secure and free from the immediate pressure of the struggle for life, he begins to play with the spiritual resources which he had originally developed as weapons and tools to aid him in his necessity. He begins enquiring into causes, seeking for explanations, researching into connections which have little or nothing to do with his struggle for life. Practical knowledge gives place to free enquiry, means for the mastery of nature become methods for discovering abstract truth. And thus art, originally a mere handmaid of magic and ritual, an instrument of propaganda and panegyric, a means to influence gods, spirits and men, becomes a pure, autonomous, 'disinterested' activity to some extent, practised for its own sake and for the beauty it reveals. In the same way, the commands and prohibitions, the duties and taboos, which were originally just expedients to make a common life in society possible, give rise to a doctrine of ethics that sets out to realize and perfect the moral personality. The Greeks were the first people to complete this transition from the instrumental to the 'autonomous' form of activity, whether in science, art or morality. Before them there was no free enquiry, no theoretical research, no rational knowledge and no art as we understand art—as an activity whose creations may always be considered and enjoyed as pure forms. This abandonment of the old view that art is only valuable and intelligible as a weapon in the struggle for life, in favour of a new attitude which treats it as mere play of line and colour, mere rhythm and harmony, mere imitation or interpretation of reality—this is the most tremendous change that has ever occurred in the whole history of art.

In the seventh and sixth centuries B.C., the Greeks in Ionia, at the same time as they discovered the idea of science as pure research, also created the first works of a pure, purposeless art, the first suggestion of 'l'art pour l'art'. A change of this magnitude, however, does not take place within a single generation or even

in a period that can be equated with the rule of the Tyrants or with the archaic style. It may be that this change cannot be located in any period of time, that it is the eruption of a primeval impulse whose first intimations are as old as art itself. In the very earliest works of all, for all their magical, ritual or propagandist purposes, we can detect a feature here or there, some particular sketch or variation, which does seem to be free and purposeless, the pure play of a craftsman whose attention wandered for a moment from the practical task in hand. Who in the last resort can be sure how much of an Egyptian statue of a god or king is magic, propaganda or cult, and how much is pure, autonomous, aesthetic creation detached from the struggle for life and the fear of death? But whatever the precise extent of this aesthetic element in the art of prehistoric and early historic times, it remains true that until the Greek archaic period art was essentially utilitarian. Carefree play with forms, the capacity to treat an implement as an end in itself, to use art for displaying, not merely for controlling and influencing reality—all this is a discovery of the Greeks of this age. Even if there is some primeval impulse breaking through, the fact that it now gets the upper hand so that works of art are created for their own sake is very significant indeed, although the allegedly autonomous forms which arise in this way are no doubt sociologically conditioned and may serve a hidden purpose.

The autonomy of the various creative powers of man cannot be achieved without a certain formalizing of his spiritual functions; this begins with a readiness to value spiritual achievements no longer exclusively according to their usefulness for life, but according to an inner perfection of their own. If, for example, one's enemy is admired for his efficiency or his bravery, instead of all qualities that could be injurious to oneself being simply denied to him, that is a step towards the neutralization and formalization of value. The most conspicuous case of this formalization is sport, the play form of the life struggle par excellence. But art and science are also play forms, and the same is true in a sense even of morality in so far as a man's morality becomes a pure, self-sufficient achievement of his own, not influenced by any external considerations. With the separation of

is found to be portrayed differently by each of these peoples, the mind gradually comes to notice the manner of the representation; possibly it attempts sooner or later to produce something in the foreign manner, yet without having the religious beliefs of the foreigner, in fact without having any belief at all. At this point it is only a step to the conception of independent forms detached from any unitary world view. Consciousness of self—the general realization that I exist independently of the circumstances of the moment—marks man's first great effort of abstraction; the detachment of the various spiritual activities from their function in the totality of his life and the unity of his world view is a second abstraction.

The capacity for abstract thought which leads to the autonomy of spiritual forms is developed not merely by the experience of colonization, but also to a very great extent by the practice of trading for money. This abstract means of exchange and its reduction of the various goods to a common denominator, the division of the original barter of goods into two separate acts of sale and purchase, is a factor accustoming men to abstract thought and making them familiar with the ideas of a common form with various contents, of a common content in various forms. Once content and form are distinguished from one another, the notion that the form can subsist by itself as an independent entity is not far off. The further development of this idea is also linked with the accumulation of wealth in a money economy, and with the specialization of work that results from it. The liberation of certain elements in society for the creation of autonomous, that is, 'useless' and 'unproductive' forms, is a sign of wealth and of surplus energy and leisure. Art only becomes independent of magic and religion, instruction and practice, when the master caste can afford the luxury of paying for 'purposeless' art to be produced.

3. CLASSICAL ART AND DEMOCRACY

Greek classical art faces us with a difficult sociological problem; the liberalism and individualism of democracy would seem

these spiritual functions from one another and from the totality of life, man's original unity of practical wisdom, his undiscriminating knowledge, his rounded world picture, are shattered and split into ethico-religious, scientific and artistic spheres. This autonomy of the different spheres is most strikingly apparent in the Ionian natural philosophy of the seventh and sixth centuries B.C. Here, for the first time, we meet with thought forms which are more or less detached from practical considerations and aims. The pre-Greek civilizations also made many correct scientific observations, conclusions and calculations, but all their knowledge and skill was embedded in an atmosphere of magical relationships, mythical imaginations and religious dogma; it never lost sight of the practical purpose in hand. With the Greeks, on the contrary, we find for the first time a science that is not merely rational and free from religious belief and superstition, but which is also free of all thought of any possible utility. In art the boundary between useful and pure form is not so sharply drawn, nor is the change so clearly assignable to a definite locality, but here, too, we may take it that the transformation took place in the Ionian cultural field and during the seventh century. Strictly speaking, however, the Homeric poems also belong to the world of autonomous forms, since they are by no means religion, science and poetry in one, nor a simple agglomeration of the knowledge, science and experience of the time, but are pure, or almost pure poetry. At any rate, the tendency towards autonomy first manifests itself, in art as in science, at the end of the seventh century.

The answer to the question why the change took place just at this time and place is clearly to be found in the effects of colonization and in the reactions which life among foreign peoples and cultures must have had upon the Greeks. The foreigners who surrounded them upon all sides in Asia Minor made them conscious of their own native genius, and this self-consciousness, with its accompanying self-assertion—that is, the discovery and exaggeration of their individual traits—inevitably led them to the idea of spontaneity and autonomy. An eye practised in noticing the culture of different peoples gradually distinguishes the various elements out of which the world view of each people is made up. When the god of fertility, the god of thunder or the god of war

to be incompatible with the severity and regularity of the classical style. The fact is that, as a detailed investigation will show, classical Athens was not so uncompromisingly democratic nor was its classical art so strictly 'classical' as might have been supposed. In the first place, the fifth century B.C. is one of the epochs in the history of art which have made the most important and fruitful conquests in the field of naturalism. Not merely is this true of the early classical style of the Olympia sculptures and the art of Myron; the whole century shows a joy in nature which, with some short pauses, is continually on the increase. It is precisely the fact that its impulse to be true to nature is almost as strong as its desire for proportion and order which distinguishes Greek classicism from the later classicist styles derived from it. The presence of these two opposed types of artistic impulse exactly corresponds to the division that characterized social and political life at that time and to the inward inconsistency of the democratic ideal in relation to the problem of individualism. Democracy is individualistic in that it gives free reign to competition and the different forces in society, rates each person at his own individual value and spurs him on to the utmost exertions; but it is anti-individualistic in that it levels differences of class and abolishes privileges of birth. It inaugurates a type of culture which is so differentiated that individualism and community spirit can no longer be looked upon as alternatives but are seen to be indissolubly connected. In this complex condition of things, the correct sociological estimation of stylistic factors in art becomes more difficult. The various elements in society cannot be nearly as simply defined in respect of their interests and aims as could the land-owning nobility and the landless peasantry in their former relations with one another. Not merely are the sympathies of the middle class divided; not merely is there an urban bourgeoisie; taking up a middle position between the upper and lower classes, interested in bringing about a democratic levelling, but also in getting new capitalistic advantages for itself; the nobility, too, becomes plutocratic in spirit, loses its old unity and consistency of principle and becomes assimilated to the traditionless and rationalistic bourgeoisie.

Neither Tyrants nor people succeeded in breaking the power

of the nobility; the clan state was abolished and the basic demo-
cratic institutions were introduced, at least in form, but the
influence of the nobility remained little impaired. Athens of the
fifth century may seem democratic, in comparison with the
Oriental despotism, but when compared with modern demo-
cracies it looks like a citadel of aristocracy. It was governed in the
name of the people, but in the spirit of the nobility. The triumphs
and political gains of democracy were mainly achieved by men of
aristocratic origin. Miltiades, Themistocles and Pericles all come
of old noble families. Not until the last quarter of the century did
individuals from the middle class really take a leading part in
public affairs, and even then the aristocracy still retained its pre-
dominant position. It is true that they had to cloak this predomin-
ance and make frequent, though usually only formal concessions
to the bourgeoisie. Even this betokened a certain degree of pro-
gress, but the political democracy never—even at the end of the
century—led to any sort of economic democracy. The only 'pro-
gress' consisted in the displacement of the aristocracy of birth by
an aristocracy of money, of the clan state by a plutocratic rentier
state. In the case of Athens there was a further factor. She was an
imperialistic democracy, carrying on a policy which gave benefits
to the free citizens and the capitalists at the cost of the slaves and
those sections of the people who had no share in the war profits.
In fact, progress towards democracy meant at most an expansion
of the rentier class.

The poets and philosophers had little sympathy for the bour-
geoisie, whether wealthy or poor; they supported the nobility
even when they themselves were of bourgeois origin. All the
spiritual leaders of the fifth and fourth centuries, with the excep-
tion of the Sophists and Euripides, are on the side of aristocracy
and reaction. Pindar, Aeschylus, Heraclitus, Parmenides, Em-
pedocles, Herodotus and Thucydides are aristocrats themselves,
and the middle-class Sophocles and Plato identify themselves
completely with the nobility. Even Aeschylus, who was the most
favourably inclined to democracy, at the end of his life attacks the
current changes as being in his opinion too radical.[30] Even the
comedians—although comedy as such is a democratic art[31]—are
reactionary in their sentiments. And nothing is more significant

of the condition of things in Athens than that such an opponent of democracy as Aristophanes not merely constantly won first prize but also achieved great popularity.[32]

These conservative tendencies retard the movement towards naturalism but cannot stop it. That the men of the time were well aware of the connection between naturalism and progressive politics, on the one hand, and between formal rigorism and conservatism, on the other, is well seen in the case of Aristophanes; he criticizes Euripides indiscriminately and in the same breath for undermining the old aristocratic ethical ideals and the old 'idealistic' canons of art. Already Sophocles is related by Aristotle to have remarked that he portrayed men as they should be, whereas Euripides portrayed them as they were (*Poet.* 1460b, 33–5). This remark is but a different formulation of Aristotle's own observation that the statues of Polygnotus and the characters of Homer 'are better than we are ourselves' (*Poet.* 1448a, 5–15), so that this alleged dictum of Sophocles may perhaps not be authentic. However that may be, and whether the remark originated with Sophocles, Aristophanes, Aristotle or another, the conception of the classical style as 'idealistic' and of classical art as representing a better, normative world of ethically superior beings is a characteristic expression of the aristocratic frame of mind that prevailed in this age. This aesthetic idealism of the cultured nobility shows itself, above all, in the choice of subjects to be represented. The aristocracy favoured almost exclusively motifs from the old Hellenic myths of gods and heroes; up-to-date subjects from everyday life are felt to be common and trivial. They did not object to a naturalistic style in itself but because it was the obvious style for representing everyday subjects; naturalism seemed detestable to them only when it was applied, as by Euripides, to the great historical sagas, not necessarily when employed in the more popular art forms to whose trivial subjects it seemed appropriate.

Tragedy is the characteristic creation of Athenian democracy; in no form of art are the inner conflicts of its social structure so directly and clearly to be seen as in this. The externals of its presentation to the masses were democratic, but its content, the heroic sagas with their tragi-heroic outlook on life, was aristo-

cratic. From the first, it is addressed to a more numerous and varied audience than those distinguished companies at whose tables the heroic lays or the epics were recited. On the other hand, it unquestionably propagates the standards of the great-hearted individual, the uncommon distinguished man, the embodiment of the ideal of kalokagathia. It owed its origin to the separation of the choir-leader from the choir, which turned collective performance of songs into dramatic dialogue—and this separation by itself marks a trend towards individualism; but, on the other hand, tragedy depends for its effect upon the existence of a sense of community in the audience and upon its appreciation by large masses who are on the same level—it can only really succeed as a mass experience. But even the audience of Greek tragedy is to some extent a selected one; at best it consists of all the free citizens and is not much more democratic in its composition than are the classes which govern the Polis. And the spirit in which the official theatre is managed is far less popular even than the make-up of its public, for the masses that form the audience do not have any decisive influence upon the choice of plays or the distribution of the prizes. The former is naturally in the hands of the rich citizens who have to pay the cost of the performances as a 'special contribution'; the latter is in the hands of judges, who are nothing more than executive officials of the council and whose judgement is determined primarily by political considerations. The free entrance and the payment of allowances for time spent at the theatre (advantages which are customarily praised as the last word in democracy) are just the very factors which completely prevented the masses from having any influence on the fate of the theatre. Only a theatre whose very existence depends upon the shillings paid for entry will really be a 'people's theatre'. The notion, popularized by classicist and romanticist critics alike, of the Attic theatre as the perfect example of a national theatre, and of its audiences as realizing the ideal of a whole people united in support of art, is a falsification of historical truth.[33] The festival theatre of Athenian democracy was certainly no 'people's theatre' —the German classical and romantic theorists could only represent it as such, because they conceived the theatre to be an educational institution. The true 'people's theatre' of ancient

times was the mime, which received no subvention from the state, in consequence did not have to take instructions from above, and so worked out its artistic principles simply and solely from its own immediate experience with the audiences. It offered its public not artistically constructed dramas of tragi-heroic manners and noble or even sublime personages, but short, sketchy, naturalistic scenes with subjects and persons drawn from the most trivial, everyday life. Here at last we have to do with an art which has been created not merely for the people but also in a sense by the people. Mimers may have been professional actors, but they remained popular and had nothing to do with the educated élite, at least until the mime came into fashion. They came from the people, shared their taste and drew upon their common sense. They wanted neither to educate nor to instruct, but to entertain their audience. This unpretentious, naturalistic, popular theatre was the product of a much longer and more continuous development, and had to its credit a much richer and more varied output than the official classical theatre; unfortunately, this output has been almost completely lost to us. Had these plays been preserved, we should certainly take quite a different view of Greek literature and probably of the whole of Greek culture from that taken now. The mime is not merely much older than tragedy; it is probably prehistoric in origin and directly connected with the symbolic-magical dances, vegetation rites, hunting magic, and the cult of the dead. Tragedy originates in the dithyramb, an undramatic art form, and to all appearances it got its dramatic form—involving the transformation of the performers into fictitious personages and the transposition of the epic past into present —from the mime. In tragedy, the dramatic element certainly always remained subordinate to the lyrical and didactic element; the fact that the chorus was able to survive shows that tragedy was not exclusively concerned to get dramatic effect and so was intended to serve other ends than mere entertainment.

In its festival theatre, the Polis possessed its most valuable instrument of propaganda, and certainly would not think of letting a poet do what he liked with it. The tragedians are in fact state-bursars and state-purveyors—the state pays them for the plays that are performed, but naturally does not allow pieces to

be performed that would run counter to its policy or the interests of the governing classes. The tragedies are frankly tendentious and do not pretend to be otherwise. They treat questions of current politics and centre round problems that all have a direct or indirect connection with the burning questions of the day—the contrast between clan state and popular state. The punishment of Phrynichus, alleged to have been due to his choosing the recent capture of Miletus as the subject of a play, was no doubt due to the fact that his treatment of this subject did not conform to official views, not to his having confounded politics with art.[34] Nothing could have been less in line with contemporary conceptions of art than that the theatre should be divorced from all relation to life and politics. Greek tragedy was in the strictest sense 'political drama'; the finale of Eumenides, with its fervent prayers for the prosperity of the Attic state, betrays the main purpose of the piece. This political control of the theatre brought back to currency the old view that the poet is guardian of a higher truth and an educator who leads his people up to a higher plane of humanity. Through the performance of tragedies on the state-ordained festivals and the circumstances that tragedy came to be looked upon as the authoritative interpretation of the national myths, the poet once more attains to a position almost equivalent to that of the priestly seer of prehistoric times.

The inauguration of the cult of Dionysus by Cleisthenes in Sykion was undoubtedly a move in that prince's political game and intended to supersede the Adrastus cult of the noble families there. The Dionysia introduced by Pisistratus at Athens was a politico-religious festival, with the political factor incomparably more important than the religious one. But the religious institutions and reforms of the Tyrants were undoubtedly based upon genuine popular emotions and needs, and this emotional disposition of the people was partly the cause of their success. Like the Tyrants, democracy also made a great use of religion for the purpose of attaching the masses to the new state. In the formation of this liaison between religion and policy, tragedy proved an excellent mediator, taking up a middle position between religion and art, between the irrational and the rational, the 'Dionysian' and 'Apollonian' elements. The rational factor, the causal connec-

tion of the plot, is from the very first almost as fundamental to tragedy as the irrational element—religious awe. But as the classical style matured, the rational element of the plot prevailed more and more, and the irrational became less and less important. Everything that had been confused and dark, mystical and ecstatic, uncontrolled and unconscious, is at last brought into the daylight of experience; the verifiable meaning, the causal connection, the logical motive, is everywhere required to be shown. Drama, the most rationalistic kind of poetry, and that in which adequate and consistent motivation is of the utmost importance, is the most typically classical form of poetry. This shows best the great part played by rationalism and naturalism in classical art and demonstrates that these two principles are quite compatible with one another.

In the visual art of the classical era the two elements of naturalism and stylization are even more intimately linked than in drama. In the latter, tragedy with its tendency to formal rigorism is a separate form from the naturalistic mime, and the naturalism of tragedy amounts to no more than a demand for logical probability in the plot and psychological plausibility in the characters. But in the plastic and graphic art of the age, the ugly, the common and the trivial became important subjects. On the pediments of the temple of Zeus at Olympia, the chief monument of early classical art, we find, for example, an old man with a slack, pendulous paunch, and a Lapith with ugly negroid features. The choice of subjects is, therefore, by no means exclusively determined by the ideal of kalokagathia. Contemporary vase painting makes a practice of using perspective and foreshortening and now finally discards the last remnants of archaic rectangularity and frontality. Already Myron's attention is concentrated on portraying liveliness and spontaneity; his whole aim is to represent movement, sudden effort, and posture charged with energy. He tries to fix the transient in movement, the impression made by a fleeting instant; in his 'Discobolus', he chooses to represent the most rapid, tense and concentrated instant of the action —the moment directly before the release of the discus. Here, for the first time since the Palaeolithic paintings, the value of the 'pregnant moment' is fully realized; here the history of European

illusionism begins and that of the archaic 'informative' and conceptual arrangement, according to the 'fundamental aspects' of the subject, ends. In other words, the stage is reached at which no formal beauty, however well composed, however decoratively effective, is thought to justify a breach of the laws of sense experience. The conquests of naturalism are no longer incorporated into a system of unchangeable traditions and accepted only within these limits; the representation has, at all costs, to be correct, and if correctness of representation is incompatible with tradition, it is the tradition that has to give way.

The manner of life now prevailing in the Greek democracies has become dynamic, untrammelled, free of all rigid traditions and prejudice to a degree quite unparalleled since Palaeolithic times. All external and institutional limitations upon individual freedom have been abolished. There are no despots or princes, hereditary priesthood or autonomous church, sacred books or revered dogmas, overt economic monopolies or bounds set to freedom of competition. Everything favours the rise of a worldly art, steeped in the joy of life and the actual, with a keen feeling for the value of the fleeting instant; but alongside of this dynamic and progressive trend, the older forces of conservatism are still alive. The nobility, clinging to its privileges and anxious to maintain the authoritarian clan state with the old monopolistic economy, endeavours also to prolong the life of the severe, static forms of the archaic style. Thus the whole history of classical art is determined by the alternations of these two opposed styles, as one or other of them temporarily gets the upper hand. After the dynamic beginning of the century, a static period supervenes with the working out of Polycletus' famous formula; the Parthenon sculptures present a synthesis of the two tendencies, which towards the end of the century gives way to an extension of naturalism. But to draw an absolutely sharp distinction between the two styles, even at the extremes of the process, would be an illegitimate simplification of the historical reality—such is its complexity and diversity. The fact is that in Greek classical art, naturalism and stylization are inseparably linked in almost every work, though not always in such perfect balance as, for instance, in the Parthenon 'Banquet of the Gods', or—to mention a less

ambitious work—in the 'Mourning Athena' of the Acropolis Museum. Outside classical art one could hardly find a work to compare with her for complete relaxation combined with complete control, for complete elimination of any trace of effort, strain or excess, for the sense of freedom and lightness, poise and serenity. It would, however, be quite wrong to conclude that the social conditions of contemporary Athens were necessary or even ideal for the production of art of this type or rank. For the creation of high artistic value, no simple sociological recipe can be given; the most sociology can do is to trace some elements in the work of art back to their origin, and these elements may well be the same in works of very different quality.

4. THE AGE OF ENLIGHTENMENT IN GREECE

As the fifth century draws to a close, the naturalistic, individualistic and emotional elements in its art grow in extent and importance. There is a change of emphasis from the typical to the particular, from concentration to differentiation, from restraint to exuberance. In literature the epoch of biography begins, in visual art the era of portraiture. The style of tragedy approaches that of everyday conversation and takes on the impressionistic colouring of lyric poetry. The characters begin to seem more interesting than the plot; the complex and eccentric characters more attractive than those which are simple and natural. In visual art volume and perspective are emphasized and there is a preference for three-quarter views, foreshortenings and intersections. The tombstones portray family scenes that are intimate and full of feeling, while vase painting chooses for its subjects the idyllic, the delicate and the graceful.

The corresponding change in philosophy is the Sophistic movement, a spiritual revolution that in the second half of the fifth century puts the whole world outlook of the Greeks, which still rested on the assumptions of aristocratic culture, upon a completely new basis. This movement, rooted in the same urban conditions of life which gave rise to naturalism in art, now sets up

a new ideal of education totally opposed to the aristocratic ideal of kalokagathia; it lays down a scheme of training which, instead of cultivating the qualities of the body, aims to produce rational, competent and eloquent citizens. The new bourgeois virtues that now displace the noble ideals of the chivalrous contest are founded upon knowledge, logical thinking, trained intellect and facility of speech. For the first time in the history of mankind the aim of education is the production of intellectuals. One need only go back to Pindar and his chaffing of the 'learned' to realize what a gulf separates the world of the Sophists from that of the Spartan teachers of physical training. In the world of the Sophists we meet for the first time with the conception of an intelligentsia that does not form a closed profession or caste, such as were the priests of the prehistoric or early historic times, or the rhapsodes of the Homeric age, but is conceived as a reservoir always having sufficient capacity to supply suitable candidates for political leadership.

The Sophists start by postulating that there are no limits to what education can accomplish and they maintain, in contrast to the old mystical belief in breeding, that 'virtue' can be taught. Western culture, which is based on self-consciousness, self-observation and self-criticism, has its origin in their idea of education.[35] They initiated the history of Western rationalism, with its criticism of dogmas, myths, traditions and conventions. They are the discoverers of historical relativity—the recognition that scientific truths, ethical standards and religious creeds are all historically conditioned. They are the first to realize that all norms and standards, whether in science, law, morality, mythology or art, are creations of human minds and hands. They discover the relativity of truth and falsehood, right and wrong, good and evil. They recognize the pragmatic motives underlying human valuations, and thus pave the way for all subsequent endeavour in the field of humanistic enlightenment. It is to be noted that their rationalism and relativism are connected with the same trend of economy and the same general impulse towards free competition and money-making as gave rise to the Renaissance emancipation of science, the enlightenment of the eighteenth century and the materialism of the nineteenth. Their

experience of ancient capitalism aroused the same reactions in them as the experience of modern capitalism does in their successors.

Not merely is the art of the second half of the fifth century influenced by the same experience which formed the ideas of the Sophists; a spiritual movement such as theirs, with its stimulating humanism, was bound to have a direct effect upon the outlook of the poets and artists. When we come to the fourth century there is no branch of art in which their influence cannot be traced. Nowhere is the new spirit more striking than in the new type of athlete which, with Praxiteles and Lysippus, now supplants the manly ideal of Polycletus. Their Hermes and Apoxyomenos have nothing of the heroic, of aristocratic austerity and disdain about them; they give the impression of being dancers rather than athletes. Their intellectuality is expressed not merely in their heads; their whole appearance emphasizes that ephemeral quality of all that is human which the Sophists had pointed out and stressed. Their whole being is dynamically charged and full of latent force and movement. When you try to look at them they will not allow you to rest in any one position, for the sculptor has discarded all thought of principal view-points; on the contrary, these works underline the incompleteness and momentariness of each ephemeral aspect to such a degree as to force the spectator to be altering his position constantly until he has been round the whole figure. He is thus made aware of the relativity of each single aspect, just as the Sophists became aware that every truth, every norm and every standard has a perspective element and alters as the view-point alters. Art now frees itself from the last fetters of the geometrical; the very last traces of frontality now disappear. The Apoxyomenos is completely absorbed in himself, leads his own life and takes no notice of the spectator. The individualism and relativism of the Sophists, the illusionism and subjectivity of contemporary art, alike express the spirit of economic liberalism and democracy—the spiritual condition of people who reject the old aristocratic attitude towards life, with all its gravity and magnificence, because they think they owe everything to themselves and nothing to their ancestors, and who give vent to all their emotions and passions with com-

plete lack of restraint because so whole-heartedly convinced that man is the measure of all things.

The Sophistic system of ideas finds its most comprehensive and significant expression in Euripides, the only real poet of the age of enlightenment. The mythological subjects are for him a mere peg on which to hang discussions of the philosophical questions of the day and of the commonest problems of middle-class life. He discusses the relations of the sexes, marriage, the status of women and slaves, and turns the saga of Medea into something like a domestic drama of married life.[36] His heroine, in her revolt against man, is almost nearer to the female characters of Hebbel and Ibsen than to the heroines of the older tragedy. What would these have thought of a woman who roundly declares that the bearing of children requires more courage than the heroic deeds of war! But the imminent dissolution of tragedy is evident, not only in Euripides' unheroic world-view, but also in his sceptical interpretation of fate—the very reverse of a theodicy. Aeschylus and Sophocles still believed in 'the justice immanent in the course of the world', but for Euripides man is a mere plaything of chance.[37] Instead of feeling awed at the fulfilment of the divine will, the spectator is astounded at the extraordinary freaks of man's destiny and horrified at the abrupt changes of worldly fortune to which he is liable. From this outlook, which corresponds to the relativity in the Sophistic teachings, derives that pleasure in the accidental and the extraordinary which is so characteristic of Euripides and of his successors. This joy in sudden changes of fortune also explains their preference for a happy ending in tragedy. The happy endings of Aeschylus are a relic of the primitive passion play in which the martyr-death of a god is followed by his resurrection,[38] and as such are the expression of a profound religious optimism. With Euripides, on the contrary, the effect of the happy ending is by no means edifying, for this is the product of the same blind chance which plunged the hero into misfortune. With Aeschylus the note of reconciliation at the end of the play leaves the tragic quality of the events unimpaired, with Euripides it is to a certain extent weakened and dispelled. The psychological naturalism which prevails in the dramas of Euripides completes the destruction of the tragi-heroic

attitude to life. The mere fact that the question of blame and blamelessness of the different characters is repeatedly discussed hinders any experience of tragic awe. The heroes of Aeschylus are guilty in the sense that they are under a curse[39]—which is something objective and indisputable; the idea of innocent suffering and of the injustice of fate does not occur with him at all. Only in Euripides does this subjective question come to be discussed with all sorts of accusations and justifications and pettifogging debates about degrees of blame and imputability. The characters of the tragedy now take on that pathological quality which enables the spectator to consider them as guilty and not guilty at the same time. This pathological quality fulfils the requirement of satisfying the taste of that age for the extraordinary and of providing a psychological justification for the hero. In its discussion of the question of blame and the motives of the tragic action, the Euripidean drama reveals another feature of the Sophistic frame of mind—its love of the rhetorical. And this, taken together with the typical Euripidean love of philosophical epigrams, betrays a lowering of aesthetic standards, or perhaps rather an over-hasty adoption of artistically undigested material.

Euripides' personality as a poet, too, is, when compared with that of his predecessors, a thoroughly modern phenomenon—the social type that owes its existence to the Sophists. He is a man of letters and a philosopher, a democrat and a friend of the people, a politician and a reformer; at the same time, he belongs to no class and is a social déraciné like his teachers. It is true that even in the time of the Tyrants we meet with poets like Simonides who ply their trade for a living, who sell their poems to any purchaser who offers, who lead a wandering life without any established position, and are treated by their patrons alternately as guests and servants. Such men are professional literati, but are far from constituting any independent profession of letters. Not merely was there no method of publication at all equivalent to printing; there was as yet no general demand for literary output sufficient to create a free market for this. The number of those interested in literature was so small that economic independence of the poets was out of the question. The Sophists are essentially in the direct line of succession from the poets of the Tyrants' age;

they, too, are always on their travels and lead an irregular and insecure life; they are, however, by no means parasites and are dependent not on a strictly limited number of patrons, but rather on a relatively large group of customers which is impersonal and of various shades and complexions. They are thus not merely declassed; they do not attach themselves to any particular class— in fact they form a social group the like of which had not been seen before. Their outlook is democratic; their sympathies are with the disinherited and oppressed, but they earn their living as teachers of well-bred and well-to-do youths, since the poor can neither pay for nor make any use of their teachings. Thus they are the first representatives of that 'detached intelligentsia'[40] which is socially homeless; it will not quite fit into any particular class and is the exclusive possession of none. Euripides' outlook stamps him as belonging to this free and restless intelligentsia which flutters uncertainly between the classes.

Aeschylus imagined that his aristocratic ideal of personality was compatible with democracy, which, however, he deserted at a critical phase in its evolution. Sophocles unhesitatingly chooses the ideals of the nobility in preference to those of the democratic state. In the struggle between the special ties of kinship and the unlimited equalitarian forces of the state, he uncompromisingly supports the ideals of kinship. Aeschylus, in the *Oresteia*, portrays a terrifying example of individual self-help.[41] Sophocles, in his *Antigone*, embraces the cause of the heroine against the democratic state, and in *Philoctetes* expresses unconcerned distaste for the unscrupulous bourgeois cunning and heartless efficiency of Odysseus.[42] Now Euripides is a convinced democrat, but this means in practice that he attacks the old aristocracy rather than that he positively champions the new bourgeois state. His independent spirit shows itself in a sceptical attitude to the state as such.[43]

The modernity of this type of poet, of which Euripides is the first example, appears from two characteristic features of his life —his lack of real success and his genius-like aloofness from the world. In the course of fifty years, and with an output of which we have the full text of nineteen and fragments of fifty-five out of a total of ninety-two plays, Euripides won only four prizes; he

was, therefore, by no means a successful playwright—certainly not the first or only poet who was unsuccessful, but, at any rate, the first of whom we have record. The explanation is not that there were so many true connoisseurs before his day, but that there were so few poets; mere good craftsmanship in handling the poetic technique was enough to ensure them success. By the time of Euripides the position was different; the output, at least of plays, was if anything excessive and the audiences by no means consisted of connoisseurs; the supposed infallible taste of the Greek audience is another idealizing fantasy of the romantics, just like its supposed democratic character and its equation with the whole population of the Polis. The princes of Sicily and Macedonia, to whom Euripides and even the more successful Aeschylus fled from their 'appreciative' Athenians, proved to be a better audience than they. The other strikingly modern feature of the type of poet which Euripides now introduced into the history of literature is his apparently voluntary refusal to take any part whatever in public life. Euripides was not a soldier as Aeschylus was, nor a priestly dignitary as Sophocles was, but, on the other hand, he is the very first poet who is reported to have possessed a library, and he appears to be also the first poet to lead the life of a scholar in complete retirement from the world. If the bust of him, with its tousled hair, its tired eyes and the embittered lines round the mouth, is a true portrait, and if we are right in seeing in it a discrepancy between body and spirit, and the expression of a restless and dissatisfied life, then we may say that Euripides was the first unhappy poet, the first whose poetry brought him suffering. The notion of genius in the modern sense is not merely completely strange to the ancient world; its poets and artists have nothing of the genius about them. The rational and craftsmanlike elements in art are far more important for them than the irrational and intuitive. Plato's doctrine of enthusiasm emphasized, indeed, that poets owed their work to divine inspiration and not to mere technical ability, but this idea by no means leads to the exaltation of the poet; it only increases the gulf between him and his work, and makes of him a mere instrument of the divine purpose.[44] It is, however, of the essence of the modern notion of genius that there is no gulf between the

artist and his work, or, if such a gulf is admitted, that the genius is far greater than any of his works and can never be adequately expressed in them. So genius connotes for us a tragic loneliness and inability to make itself fully understood. But the ancient world knows nothing of this or of the other tragic feature of the modern artist—his lack of recognition by his own contemporaries and his despairing appeals to a remote posterity. There is not a trace of all this—at least before Euripides.[45]

Euripides' lack of success was mainly due to the fact that there was nothing in classical times that could be called an educated middle class. The old aristocracy took no pleasure in his plays, owing to their different outlook on life, and the new bourgeois public could not enjoy them either, owing to its lack of education. With his philosophical radicalism, Euripides is a unique phenomenon, even among the poets of his age, for these are in general as conservative in their outlook as were those of the classical age —in spite of a naturalism of style which was derived from the urban and commercial society they lived in, and which had reached a point at which it was really incompatible with political conservatism. As politicians and partisans these poets hold to their conservative doctrines, but as artists they are swept along in the progressive stream of their times. This inner contradiction in their work is a completely new phenomenon in the social history of art.

The remarkably complex spiritual conditions of the fourth century find their full expression in Plato—in the progressive nature of his art and the conservative character of his philosophy, in the naturalism of his dialogue, borrowed as it is from the plebeian mime, and in the idealism of his teachings, which are rooted in the aristocratic conception of life. In all Greek literature there is hardly another who champions so whole-heartedly the cultural ideals of the nobility. Kalokagathia is not more enthusiastically praised by Pindar or sophrosýne by Sophocles. The spiritual élite whom he would entrust with control of the state belongs to the old privileged upper class; the common people, in his view, have not the least claim to take part in its control. His theory of Ideas is the classical philosophic expression of conservatism, the pattern of all subsequent reactionary idealism. Any

idealism that separates the world of timeless Forms, of pure norms and absolute values from the world of experience and practice signifies something of a retreat from life into pure contemplation and as such involves giving up the attempt to alter reality.[46] Such an attitude always works out ultimately in favour of dominating minorities, who rightly see in realism an approach to reality that might be dangerous to them, whereas a dominant majority has nothing to fear from realism. Plato's theory of Ideas fulfils the same social function for Athens of the fourth century as 'German Idealism' did for the nineteenth century; it furnishes the privileged minority with arguments against realism and relativism. Plato's political conservatism largely accounts for his archaizing theory of art (*Soph.* 234B)—his rejection of the new illusionist tendencies, his preference for the classical style of the Periclean age, and his admiration for the highly formalized art of the Egyptians which seemed to be governed by immutable laws (*Laws*, II, 656DE). He is opposed to everything new in art, as to innovation in general, scenting in novelty symptoms of disorder and decadence.[46a] Plato bars poets from his Utopia, because they are engrossed in empirical reality, in sensible phenomena which are for him but illusions and half-truths, and also because they coarsen and distort the pure spiritual and normative Forms by attempting to express them in terms of sense. This first example of 'iconoclasm' in history—hostility to art is something completely unknown before Plato—these first doubts as to the possible bad effects that art might have, occur along with the first signs of an aesthetizing outlook on life in which art not merely has its place, but grows at the expense of all the other forms of culture and threatens to stifle them. Both phenomena are intimately connected. Art is not feared as long as it is a natural means of propaganda for various purposes or a form of expression restricted to one particular field of its own, but when, with the progress of aesthetic culture, joy in forms has come to imply complete indifference to their content, man begins to recognize in art a secret poison and an enemy in the camp. The fourth century was a time of war and disasters, of war and post-war profiteers, of commercial prosperity, of the rise of a new wealthy class which to some extent invested its profit in works of art and came to regard

possession of them as a matter of prestige. Thus, there arose a tendency to over-value art, and to judge all life and all its problems by aesthetic standards. Plato's rejection of art is really a rejection of this prevalent aestheticism. The theoretical recognition that art is necessarily dependent upon our senses would not by itself have led him to take up such a hostile attitude towards it.

The diffusion of aesthetic culture among new social classes led to a replacement of the old artistic ideals, which had been rooted in the traditional education of an unquestionably dominant class, by new ideals more closely related to the new standards of life. Wilamowitz-Moellendorff connects Aristotle's theory of tragedy as a purge by pity and terror with this change in the social make-up of the audience in the theatre. He interprets it as a sign that the emotional element was now getting the upper hand in drama, and the 'philistine' attitude to the theatre as if it were a device to enable people to 'escape from the wretchedness of their daily life for a few hours' and have a good cry.[47] The search for new material, the popularity of new types of subjects so characteristic of the art of the fourth century, is linked with two principal features of the new age—its extreme emotionalism, shown in a universal desire for intense stimulations of which the emotional philistinism of the new theatre is only one symptom, and its abolition of taboos, which had hitherto forbidden the representation of certain of the subjects that now became popular. The first category of new subjects of art includes portraiture and biography; the second, representations of the female nude. Another outcome of changed taste due to social displacements is the ever-increasing popularity in art of the younger and more impulsive Olympians, especially Aphrodite and Artemis, at the expense of the older and more dignified Hera and Athena.[48] Finally, the rise of a new capitalistic class of rentiers explains one of the most remarkable trends of the century—the emancipation of sculpture from architecture. Up to the end of the fifth century by far the greater part of the sculptor's production is for the architect; even when it is not definitely part of the building, a statue has to fit in with an architectural framework. Now, in proportion as private orders replace state patronage, works of statuary are of smaller size, more intimate in character and of a more readily movable type. Fourth-

century Athens did not build a single new temple, so that the sculptors there got no more big commissions from architecture; the great buildings of the age are in the East, which is consequently the scene of new developments in monumental sculpture.

5. THE HELLENISTIC AGE

In the Hellenistic age, that is, in the three centuries following Alexander the Great, the centre of gravity of artistic development is markedly shifted from Greece eastwards, but reciprocal influences are at work all the time and for the first time in the history of mankind we really have to do with a culture which is an international hybrid. It is this levelling of national cultures which gives Hellenistic art its strikingly modern character. Everywhere there is a compromise between various streams, not merely in the field of national cultures, a blurring of sharp divisions, not merely between Occidental and Oriental, Greek and the barbarian, but also between different social levels, though not perhaps between classes. In spite of the growing differences of income, the ever-increasing concentration of capital and the steady increase of the proletariat,[49] in a word, in spite of the growing opposition between classes, there is everywhere a certain social levelling that, at last, puts a definite end to the privileges of birth. This is the last stage of the trend towards the abolition of social distinctions which had been going on since the days of hereditary monarchy and authoritarian priesthood. The decisive step was due to the Sophists, who invented the completely new rationalistic conception of *areté*, independent of birth and breeding, to which every Greek without exception could attain. The next step in this levelling is taken by the Stoics, who first enunciated standards of human value that are free from all tinge of race and nationality. The Stoics' freedom from national prejudice merely expressed a state of affairs already achieved in the kingdoms of Alexander's successors, just as the liberalism of the Sophists is merely a reflection of the social conditions due to the rise of the commercial and industrial bourgeoisie of the cities.

The very fact that every inhabitant of these kingdoms could

become a citizen of any city he fancied, by merely changing his residence, signified an end of the ideals of the Polis. The citizen is now simply a member of an economic society and stands to gain by complete freedom of movement rather than by belonging to a certain traditional group. Community of interest is no longer founded upon identity of race or nationality, but on identity of the economic position of the individual. The era of cosmopolitan capitalism now opens. The state favours selection according to business ability, since it finds that the victors in the commercial struggle for life are also the most useful for the consolidation of the world state, whereas the old aristocracy, owing to its exclusiveness, to the value it sets on racial purity and preservation of its cultural heritage, is quite unsuited for the organization and administration of a state of this kind. The new state leaves the aristocracy to its fate and hastens the formation of a bourgeois upper class, without prejudice of race or caste, relying simply upon its economic power. With its economic mobility, its freedom from meaningless traditions, its rationalistic power of improvising, this class is very similar to, though not identical with the old middle class, and provides a natural cement for the economic and political consolidation of the various peoples of the world state.

This rationalism which the state now prizes above all shows itself in all fields of cultural life; not merely in the levelling of races and classes or in the abolition of all old traditions which might hinder free competition, but also in a super-national organization of scientific and artistic production, a *commercium litterarum et artium*, that unites the literary men and scholars of the whole civilized world in co-operative production upon a large scale—thus, through central research institutions, museums and libraries, exploiting to the full the principle of division of labour in the intellectual field. The rationalistic outlook everywhere leads to the replacement of traditional groups by co-operative undertakings adapted to the particular task in hand. Just as the Hellenistic state moves its officials about regardless of their origins and traditions,[50] just as capitalistic commerce emancipates its devotees from ties of birth-place and native land, so the artists and scholars are also uprooted and herded together in great international centres of culture.

Even the Sophists of the fifth century, and before them the poets and artists of the age of Tyranny, had made themselves independent of the town in which they were born and bred, and followed a roving way of life. In their case, however, this meant that they had freed themselves from one set of ties, but had failed to replace them with any others. But in the Hellenistic era, the old loyalty to the Polis gave way to a new sense of solidarity with the whole educated world. In the field of scientific enquiry this brought about a co-operation between scholars on a scale hitherto undreamt of. The assignment of tasks and the integration of results, in short the rationalization of the methods of work with a view to maximum production, appears to have been in direct imitation of the principles of rationally conducted business. Julius Kaerst observes that the 'materialization' of spiritual life, which we regard as a characteristic of our own technical age, was already a feature of that time.[51] Already he finds the personal factor set aside, tasks split up and apportioned among the collaborators regardless of personal capacity or inclination. He suggests that all this technique of organizing intellectual work by the mechanical combination of interdependent individual production was modelled upon the state administration of the time, the centralized bureaucracy and hierarchy of officials which had to be built up and maintained by these gigantic states.[52]

Such specialization and depersonalization of enquiry led inevitably to a taste for mere erudition and a temptation to eclecticism. In the Hellenistic era, apparently for the first time in the history of Western culture, both of these are very much in evidence; these are probably the features in which that age most strikingly resembles our own. Eclecticism is also a keynote of Hellenistic production in art as well as in science. Hellenistic taste, formed by the historical approach to art, with the prevalent interest in antiquities and a deep understanding for the most diverse artistic ideals of the past, resulted in an indiscriminate acceptance of stimuli. This tendency was constantly strengthened by the founding of new collections and museums. There were already collections, both princely and private, but now works of art begin to be collected systematically and according to plan. The aim is now to present 'complete' collections that exhibit the

whole development of Greek art. Where important works were missing, copies were made to fill the gaps. In their scientific planning, the collections of the Hellenistic age are the forerunners of our museums and galleries. Not that the artistic style of earlier ages was always uniform—a strictly formal art of the upper class and a less formal art of the lower class are often found together, religious art of a conservative character alongside secular art of a progressive character. But before Hellenistic times it would hardly have been possible for several different styles and fashions to emerge together in the same social milieu, and for works in the most various styles to be produced for the same social class or the same cultural stratum. The 'baroque', 'rococo' and classicistic styles of the Hellenistic age originate successively but continue to exist alongside one another, and from the very start, the powerful and the intimate, pomposity and genre, the colossal and the minute, the delicate and the graceful, all share the favour of the public. The autonomy of art discovered by the sixth century, and consistently practised by the fifth century, turned in the fourth century into aestheticism and now culminates in a highly skilful but irresponsible playing with forms and an experimenting with abstract means of expression—a license which, though still permitting some exquisite work to be done, plays havoc with the standards of classical art so that they become to a certain extent inapplicable. The connection between this dissolution of classical standards and the changes of structure of the social strata who buy works of art and determine public taste is plain to see. As these strata became progressively less uniform, the more diverse are the styles which spring up concurrently. The most important change is the emergence of the former middle class, hitherto almost without influence in this field, as a new and substantial clientèle for works of art. This class, naturally, looks on art with different eyes from those of the nobility, though often manifesting the greatest eagerness to acquire their taste. The second feature of the art market, and one of decisive importance for the future, is the existence of the kings and their courts. The demands they make upon the artist are quite different from those of the nobility or the bourgeoisie, though both nobility and bourgeoisie are ready enough to adopt their manners and ape their pompous

and theatrical style upon a more modest scale. Thus the classical tradition in art becomes mingled with the genre and naturalism liked by the bourgeois and with the luxurious 'baroque' of the courtiers. Finally, the new capitalistic organization of art production also contributed to an eclectic enrichment of styles, as it strove to profit from the aestheticism of the times, to create a demand for works of art and to stimulate periodic changes of fashion. Besides the pottery workshops, already to some extent run upon factory lines, there was the copying of masterpieces, which now begins upon a huge scale. This was no doubt carried on in the same localities and by the same persons as the production of originals; and artists who have to spend much of their time in copying are all too readily tempted to indulge in mere play with various styles and forms. The eclecticism of this age is accompanied by a mingling of different arts and art forms—another characteristic phenomenon of the late period, but one whose beginnings go back to the fourth century. This aspect is evident in the pictorial style of sculpture in which Lysippus and Praxiteles work, but it can also be observed in other directions, particularly in the drama, which, since Euripides had become overloaded with lyrical and rhetorical elements. Such trespassing is a sign of that will to conquer new fields to which portraiture, landscape and still life owed their popularity—subjects which were formerly almost unknown. The choice of these subjects shows an attachment to material things which was natural in a commercial age accustomed to thinking in terms of goods. Man, hitherto almost the sole subject of art, is now everywhere dethroned in favour of subjects drawn from the world of things. In this way the 'materialization', which we have noted in the organization of intellectual work, now shows itself in the subject-matter—not only the vogue of still life and landscape, but also the naturalistic portrayal of a person as a piece of nature, being a symptom of this trend.

The great development of portraiture is matched in literature by the ever-growing popularity of biography and autobiography.[53] The value of the 'human document' grows as insight into a man's psychology becomes a more and more indispensable weapon in commercial competition. But the increased

interest in biography is due to other factors also—the growing tendency to philosophical self-reflection and the quickening of hero-worship since Alexander the Great, and even in some degree to the increased interest in personalities manifested by the new court society.[54] The new interest in psychology gives rise now to the novel and the bourgeois comedy. Their imaginary plots— principally love stories taking place in the world of the public for which they are written and no longer in the remote world of saga —are the creation of Hellenistic literature.[55] Such is the world of Menander's comedies, which contains roughly all that still lived of the Old Comedy and of Euripidean tragedy after the disappearance of city democracy and Dionysus worship. Its characters belonged to the middle and lower classes; its plots revolve around love, money, wills, miserly fathers, scatterbrained sons, grasping mistresses, deceitful parasites, artful servants, mistaken twins and parents lost and found again. The love interest is quite indispensable. Here too it is Euripides who paved the way for the Hellenistic age. Before him love was unknown as a subject of dramatic conflict; he discovered it, but only in the Hellenistic age did it become the linchpin of the plot.[56] The love motif of bourgeois comedy is perhaps the most bourgeois feature about it, since the lovers struggle, not against gods and demigods, but against the apparatus of bourgeois society—obstructive parents, rich rivals, betraying letters and cunningly contrived wills. Surely this whole apparatus of love intrigue reflects the 'disenchantment'[57] and rationalization of life which always goes with the triumph of money economy and the commercial spirit.

At last the bourgeois has a theatre of his own in which he really feels at home. In every little town there is a modest building, and in the big cities those new palaces of stone or marble whose remains still survive. It is this we are apt to think of when we speak of the Greek theatre; they were not, however, built for Aeschylus and Sophocles, but for the despised Euripides and his later competitors—these comprising not merely Menander and Herondas, but all sorts of acrobats, flautists, jugglers and parodists, as motley a crew as were the competitors of Shakespeare centuries later.

6. THE EMPIRE AND THE END OF
THE ANCIENT WORLD

The age of Hellenistic art gradually gives way to the pre-
dominance of Roman art; after the beginning of the Empire it is
the latter and not Greek art in which all the important develop-
ments take place. The turgid 'baroque' and the delicate 'rococo'
of the Hellenistics reached a dead end and simply went on repeat-
ing worn-out formulas; but Rome of the Caesars, along with the
uniform administration of the Empire, produced something of a
more or less uniform 'Imperial art'[58] which, since it embodied all
the most progressive tendencies, came in time to set the fashion
everywhere. After the Augustan age, in which the style was still
decidedly Hellenizing, though with a smack of bourgeois sobriety
and dullness, the special Roman characteristics came increasingly
to the fore during the reign of the Flavians and Trajan until, in
the later Empire, they finally got the upper hand. From the very
first, the taste for Greek art was confined to the well-born and
cultured classes; the middle class had little interest in it, and the
masses, of course, still less. During the last centuries of the
Western Roman Empire, as the aristocracy came to lose its
dominating position and left the towns, when generals and
Caesars rose from the lowest ranks of the army and the farthest
corners of the provinces, when the most important religious
movement of the time was a movement starting with the dregs
of the people and gradually invading the upper classes, art also
took on an increasingly popular and provincial guise, and little by
little discarded its classical ideals.[58a] Artistic development, above
all in the field of portrait sculpture, now linked up with the old
Roman tradition that had lived on without a break in the masks
of ancestors which stood in the halls.[58b] To describe them simply
as 'popular art' in the strictest sense would be going too far, for
even though the patrician privilege of displaying portraits of their
ancestors in funeral processions[58c] had, in the last years of the
Republic, been extended to the plebeian families,[58d] the cult of
the ancestral portraits remained essentially a feature of the aristo-
cratic funerals and can hardly have extended to the broad mass of
the people. However that may be, the decisive difference between

the portraiture of the Romans and that of the Greeks is that the latter was almost exclusively designed for public monuments, whereas the former existed mainly to serve private needs. It is this circumstance, above all, which explains that informal and immediate naturalism of the Roman portrait which in the end prevailed even in works designed for public purposes. The development of Roman art did not, however, by any means run a uniform course. To the very end there are two different tendencies alongside of one another: the Hellenizing, idealistic, typicalizing, theatrically emotional style of the court aristocracy, on the one hand, and the native, sober, naturalistic style of the more mobile middle class, on the other. The triumph of the popular type of art over that of the élite did not take place at the same time or to the same extent in the various branches, and aristocratic art took refuge finally in an impressionistic style which must have been completely incomprehensible to the masses, before eventually surrendering to the plebeian simplicity and expressionist directness of late Roman art.

In the Augustan age, under the Greek influence which was then dominant, sculpture was the leading art; but thereafter painting comes more and more to the fore and in the end almost completely supplants sculpture. By the third century copying of Greek works of art had stopped and for the next two centuries it is painting that dominates the field of interior decoration.[59] Painting is the late Roman and early Christian art par excellence, and takes the place held by sculpture in the classical age; it is the popular art of the Romans, speaking to all in the language of all. Never before was there such a mass-production of pictures, never before was painting employed for such trivial and ephemeral purposes as in Rome.[60] Anyone appealing to the public, informing it upon important affairs, anxious to plead his cause with it, or win adherents for his interests, was well advised to use pictures for the purpose. The victorious general had posters carried around in his triumphal procession to display his warlike deeds, the conquered cities and the humiliation of the foe to the eyes of the admiring people. In the courts, prosecution and defence alike made use of pictures which gave judges and public crude but vivid illustrations of the points at issue, the circumstances of the

crime or the alibi of the accused. The faithful offered up votive pictures, depicting the danger they had gone through, and filled with a wealth of purely personal detail. Tiberius Sempronius Gracchus offered to the goddess of freedom pictorial representations showing how his victorious soldiers had been entertained by the town of Beneventum. Trajan had the tale of his conquests, baker so-and-so, the life of his shop, laboriously carved in stone.[61] In Rome the picture is news, editorial, advertisement, poster, chronicle, political cartoon, news-reel and film drama rolled into one. Their love of pictures reveals, besides pleasure in the anecdotal and interest in documentation and eye-witness accounts, a kind of primitive, childlike, insatiable desire for sights and illustrations. All these pictures are pages out of a picture-book for adults—sometimes, as in the case of the climbing spirals of Trajan's Column, an 'unrolling picture-book',[62] intended to convey the continuity of the events and achieve the same kind of effects that we now expect of the film. The demand which these pictures aimed to meet was no doubt crude and essentially inartistic. To want to experience everything yourself, to see everything with your own eyes, just as if you had been there, is rather naïve, and it is a primitive outlook which rejects as 'second-hand' anything that is depicted in the transposed form which, for a more sophisticated age, indeed constitutes the very essence of art.

It is, however, from this very 'waxwork' style or 'film' style, which no doubt originally appealed only to the uneducated with their pleasure in the actual, from this very desire to depict memorable events as vividly and as fully as possible, that the epic style emerged which is the style of Christian and Western art. The works of the ancient East and of Greece are plastic and monumental, almost without action, neither epic nor dramatic, while those of Roman and Western art are illustrative, illusionist, epic and dramatic and as full of event as a film. Ancient Eastern and Greek art consist almost solely of works of a ceremonial character, interpretations of timeless reality, single figures, whereas Roman and Western art consist mainly of history painting, the depiction of scenes in which essentially transient phenomena are caught and translated into spatial terms through skilful optical technique. Greek and Greco-Roman art solved this problem, where

they could not circumvent it, by the method which Lessing called that of the 'pregnant moment'; this compressed the whole content of the action into one single situation which, though itself without movement, is pregnant with movement. Lessing supposed that this was the method of visual art as such, but in reality it is only the method of classical Greek art and of the modern art of the last centuries. In late Roman and medieval Christian art the utterly different method is employed which Franz Wickhoff calls the 'continuous' as opposed to the 'isolating'.[63] He means the style—arising from an epic, illustrative, cinematographic impulse in art—which portrays the various stages of an action in the same framework or landscape without a break, repeating the principal figures in each phase of the action, so that the different scenes have the same effect as the familiar sequences of drawings in humorous papers and suggest the continuity of a film. It is true, the movement is only simulated and the separate scenes are analogous to the single frames of the reel rather than to the continuous pictures on the screen, but the intention is the same. Late Roman art and the modern film both fulfil a public demand for completeness and directness, but above all a demand for pictures, just because they are more explicit, more impressive, and require less of the public than any possible description in words.

The other important trend in late Roman art is impressionism; this is lyrical rather than epic, and tries to fix a single, unique optical impression in all its subjective momentariness. Wickhoff considers this method to be preliminary to and the organic complement of the 'continuous' style,[64] but so direct a connection between the two styles cannot be established. They emerge at different times and in different circumstances, both spiritual and external; the impressionism of the first century A.D. is the ultimate refinement of classical art, while the continuous style emerges only in the second century and is the first rather crude and vulgar symptom of an artistic urge essentially alien to the classical taste. The two styles have their origin in different social strata, and hardly ever occur together in the same work. The continuous method emerges only after the best period of ancient impressionism is over. Some externals of the impression-

istic technique were preserved a while as part of the tradition of the painter's craft until they too were unlearned and forgotten. The continuous method and the epic style, aiming as they do to bring out the action of the subject, do not supplement but, on the contrary, swallow up and annihilate the impressionistic technique. The continuous method expressed an essentially anti-naturalistic impulse and there is, therefore, hardly a trace of it in the two great naturalistic periods—of Greek and post-medieval art. Wickhoff's assertion that the continuous style dominates the whole of Western art from the second to the sixteenth centuries is quite inexplicable; even in the later Gothic period it is by no means common, and after the beginning of the Renaissance it is exceptional. In any case, there is no inner connection between the illusionism of the continuous method and the optical illusionism of the impressionistic style.

But impressionism, though going its own distinct way, was a factor which hastened the dissolution of ancient art. In making the figures lighter and flatter, more and more airy and sketchy, it makes them in a certain sense less material. After they have become just figures for colouristic and atmospheric effects and have lost their bodily volume, their structural solidity and their physical consistency, one is apt to imagine that the painter was deliberately pursuing some spiritual or transcendent ideal.[65] Thus a naturalistic and materialistic impressionism paves the way for its stylistic opposite, spiritual expressionism.[66] One is here reminded of the expressionism of Palaeolithic painting, which also ushered in its complete opposite (from a stylistic point of view), the geometrical style of Neolithic art. Both cases equally show how equivocal the various styles are, how readily each can serve as a vehicle for quite different world-views. The impressionism of the fourth Pompeian style, with its virtuosity of subtle suggestion, is the refined product of the urban intelligentsia of Rome; the 'impressionism' of the Christian Catacombs, on the other hand, its figures equally without weight or volume, is just as typical of the world-denying Christian who renounces everything that is earthly and material.

The art of representing the human figure in the ancient world begins and ends with 'frontality'; we can follow the changes

from the conventionality and geometrism of archaic art, through the free movement of classical art and the contortions of Hellenistic baroque back to the symmetrical, flat, solemn front view of late Roman art.[67] The course of this development starts with the subordination of art to religious cult, goes on through the reign of autonomy and aestheticism, and ends in a new form of spiritual dependence; beginning as the expression of an authoritarian social order, it leads through the periods of democracy and liberalism to become again the expression of a new spiritual authority. Whether one counts this last phase of the development as the final stage of ancient art—accepting Droysen's notion that ancient civilization abolished itself and paganism through some inner impulsion of its own—or as the first stage of a new world epoch is more or less a question of the most convenient classification and periodization. But just as we have to recognize in the colonate an early form of feudalism,[68] so also we can admit no break between late Greco-Roman art and that of the Christian Middle Ages.

7. POETS AND ARTISTS IN THE ANCIENT WORLD

There is one thing that hardly alters, at least perceptibly, from the beginning to the end of the Greco-Roman epoch—and that is the point of view from which the plastic or graphic artist is judged and valued relatively to the poet. The latter at times enjoys a quite peculiar esteem as seer and prophet, bestower of fame and interpreter of myths; the plastic or graphic artist is and remains a banausic artisan who, with his wage, gets all that he is entitled to get. Various factors account for this distinction. First of all, the sculptor or painter works for reward and makes no attempt to hide the fact, whereas the poet is looked upon as the guest-friend of his patron, even at times when he is utterly dependent upon him. Then, too, the sculptor and the painter have to work with dirty materials and tools whereas the poet goes about with clean clothes and hands—all of which counted for more than one might think in the eyes of an untechnical age. But most important of all is the fact that the sculptor or painter is obliged to be doing manual work that involves bodily effort and

the performance of many wearisome tasks, while the labours of the poet are certainly not obvious to the eye. This low estimation of people who have to work for their living, this contempt of all work done for gain, and even of productive work in general, originates in the fact that such activities—in contrast with the primeval aristocratic pursuits of government, war and sport—smack of subordination and service.[69] At a time when agriculture and stock-raising were fully developed and carried on mainly by women, war had become the principal occupation of men and hunting their chief form of sport. War and hunting both require practice, courage and skill, and therefore stand in high esteem; on the other hand, occupations involving minute, patient, exacting work are suitable for weaklings and so are without honour. This line of thought is pushed to extremes, and in time all productive activity, any occupation that earns a living, comes to be regarded as dishonourable. Such work is assigned to slaves because it is despised, not despised (as was formerly supposed) because done by slaves. The association of manual work with slaves is at most a factor that helped to maintain the primitive notions of prestige, but these notions are certainly much older than the institution of slavery.

The ancient world, impelled to bridge the contradiction between this contempt for manual work and its high estimation of art as a vehicle of religion and propaganda, finds the solution in a conceptual separation of the work of art from the personality of the artist; it reveres the creation while despising the creator.[70] Comparing this standpoint with the modern view which sets the artist above his work—abandoning the fiction that the artist's personality is completely expressed in his work—we can see the great difference between the ancient and the modern world in respect of their valuation of work as such. Even if, as Veblen asserts,[71] the primitive prestige attached to unproductive activity has never been quite lost, yet the difference between that age and ours is still immense. At all events, this prejudice went far deeper in the ancient world than in our day. As long as the warlike nobility retained its predominance in the Greek world, a primitive, parasitic, freebooters' notion of honour persisted; and when the predominance of this class ceases, another very similar

conception of prestige, derived from the athletic contests, became current. When arms were silent, such contests were considered to be the only worthy occupation for a man; this new ideal of living equally implies the idea of a struggle absorbing all the energies of the participants and requiring that they should possess independent means of existence.

For the Greek ruling class and its philosophers, fullness of leisure is the precondition of all that is good and beautiful—it is the priceless possession which alone makes life worth living. Only he who has leisure can achieve wisdom and freedom of spirit, can master life and enjoy it to the full. The inner connection between this ideal of living and the social position of the rentier class is obvious. Its kalokagathia, its all-round training of the bodily and spiritual powers, its contempt for all narrowing specialization and one-sided expertise, proclaim an essentially unprofessional ideal. When Plato, in the *Laws*, stresses the contrast between an education which enhances the whole personality and a mere training in professional skill, he expresses not only his love for the old aristocratic kalokagathia, but also his obvious distaste for the new democratic bourgeoisie, which has brought about occupational differentiation. In Plato's eyes every specialization, every sharply defined occupation, is vulgar (banauson) and such banausia is a characteristic feature of democratic society.[72]

The victory of bourgeois over aristocratic manners in the course of the fourth century and during Hellenistic times brings with it a certain revaluation of the old conception of what is honourable; but there is still no honouring of work as such, nor is work ever supposed to have an educational value as alleged by modern bourgeois ethics; it is merely something that may be excused and overlooked in a man who is good at making money. Burckhardt has already noted that in Greece the bourgeoisie no less than the aristocracy despised work, whereas in the Middle Ages work was always respected by the bourgeoisie who, far from taking over the noble conceptions of honour, in the end imposed their own notion of professional honour upon the nobility. The value which a people attaches to work is, according to Burckhardt, determined by the conditions under which it developed its particular ideal of life. The ideal of modern Western civiliza-

tion derives from the bourgeoisie of the Middle Ages, which in the end outmatched the nobility in spiritual as well as in material goods. But the valuations of the Greeks derived from their heroic age and a world that knew not utility; they were a legacy of the warlike Greek aristocracy and were never altogether discarded.[73] Only after the ideal of the athletic contest lost its power in the crisis that coincided with the end of the Polis, does a radical new valuation of work, and thus of the plastic arts, begin to emerge. But in the ancient world this change was never completely carried through.

In classical Athens the economic and social position of the painters and sculptors persisted as it was in the Heroic and Homeric ages with hardly any alteration, in spite of the enormous importance which works of art came to have in displaying the power of their proud, victorious city. Art was still looked upon as a mere handicraft, and the artist as an ordinary artisan with no part or lot in the spiritual value of knowledge or education. He was still ill-paid, without secure abode, and led a wandering life, and so was a stranger and foreigner in the city that employed him. Bernhard Schweitzer explains this relatively unchanging social position of the craftsman-artist by the invariably unfavourable economic conditions in which the artist worked all through the age of Greek independence.[74] In Greece, the city state was and remained the sole large-scale patron for works of art; as such it had almost no competition to face since, with the relatively high production costs of works of art, there was no private individual who could maintain or even start competition against it. Between the artists, on the other hand, there was keen competition and this was by no means offset by competition between the different cities. Any production for the free market which could give the artist an assured position was out of the question, either within the single city or among the cities taken as a whole.

The change in the position of the artist, so noticeable under Alexander the Great, is directly connected with the propaganda made on that conqueror's behalf. The cult of personality which developed out of the new hero-worship redounded to the advantage of the artist both as a bestower and as a recipient of fame. The demand of Alexander's successors for art, and the wealth

that was now accumulating in the hands of private individuals, led to a great increase in the consumption of art, thereby raising its economic value and the public's estimation of the artist. Finally, philosophical and literary education increasingly reached the circles of the craftsmen-artists; they began to separate themselves from the ordinary artisans and to form a group distinct from that of the tradesmen. The recorded anecdotes from the lives of the artists give us a good idea of the big change which had occurred since classical times. In the signatures to his paintings, Pharrhasius boasts of his skill in a self-complacent fashion that would have been quite impossible a short while before; Zeuxis' painting earned him a fortune greater than any painter before him; Apelles is not merely the court-painter, but also a confidant of Alexander the Great. Stories about eccentric painters gradually come into vogue and we eventually find symptoms of something like the modern adulation of the artist.[75] On top of, or rather behind all this, there is what Schweitzer terms the 'discovery of artistic genius', and which he attributes to the influence of Plotinus' philosophy.[76] Now Plotinus regards the beautiful as an essential attribute of the divine nature. According to his metaphysics, only the artist could restore to the fragmentary world of sense that completeness which it lost by becoming separated from God.[77] It is evident how greatly the artist must have gained in prestige through the spread of such a doctrine; he regains the aura of the divinely inspired seer which had surrounded his person in primitive times. He seems once again to be God-possessed, with the grace of the knowledge of hidden things, as formerly in the age of magic. The act of artistic creation becomes a sort of *unio mystica* and is separated more and more from the world of ratio. As early as the first century, Dio Chrysostom compares the artist to the Demiourgos (world creator). Neoplatonism elaborates this parallelism with increasing emphasis on the creative element in the artist's achievement.

This turn of affairs explains the division of mind characterizing the attitude of the later periods, especially of the imperial and final periods, towards the artist. During the Roman Republic and the early Empire, the current estimate of manual work and of the artist's calling was the same as in Greece of the heroic,

aristocratic and democratic periods. But in Rome, whose oldest traditions reflected the life of an agricultural people, the idea of all work being contemptible had no direct connection with the primitive conditions of perpetual warfare. For the sense of historical continuity with that age had been completely broken, since it was followed by a period in which even the richest and most distinguished Romans worked on their own land.[78] Still the warlike peasant population of Rome in the third and second centuries B.C., in spite of its intimate acquaintance with manual work, had no great leaning towards art or appreciation of the artist. Only with the change to money economy and urban culture, and with the Hellenizing of Rome, is there any rise in the status of the poet first and then gradually of the painter and sculptor also. And this change only becomes conspicuous in the Augustan age, with its conception of the poet as a 'vates' and with its patronage of the arts on a grand scale, both by the court and by private individuals. Even then the social estimation of the plastic and graphic arts, in comparison with poetry, is relatively low.[79] Amateur painting by distinguished personages is indeed increasingly common—even among the emperors, Nero, Hadrian, Aurelius, Alexander Severus and Valentinian I are all given to this fashionable hobby—but sculpture, presumably because of the bodily exertions and more elaborate apparatus it requires, continues to be regarded as an unsuitable occupation for a gentleman. And even painting is only considered respectable as long as it is not practised for gain. Successful painters refuse to take reward for their work, and Plutarch claims that Polygnotus, for example, was not ungentlemanly (banausos), because he decorated a public building with frescoes without asking for any reward.

Seneca still maintains the old classical distinction between the artist and his work—'We offer prayers and sacrifices before the statues of the gods, but we despise the sculptors who make them'[80]—and Plutarch says something very similar—'No generous youth, when contemplating the Zeus of Olympia or the Hera of Argos, will desire to become a Phidias or a Polycletus.' This is clear enough in respect of the painters and sculptors, but Plutarch goes on to say that such a youth will not wish to be an

Anacreon, a Philemon, or an Archilochus either; though we enjoy their works, they are not, he says, themselves necessarily worthy of esteem.[81] This putting the poet on the same level as the sculptor is thoroughly unclassical and shows how inconsistent the late Empire is in such matters. The poet here seems to share the low estimation of the sculptor because he, too, is a specialist, working to established rules and translating a divine inspiration into words by means of a rationalized technique. And the same division of mind which pervades Plutarch's writings is also found in Lucian's *Dream*, where Sculpture is represented as a common dirty woman, but Rhetoric as a shining ethereal being; yet Lucian, in contrast to Plutarch, asserts that in the statues of the gods we reverence their creators.[82] Any recognition of the artist's personality which appears in these dicta is evidently due to the aestheticism of the Empire, and indirectly perhaps to Neoplatonism or similar philosophical teachings. But the depreciation of the plastic and graphic artist continues and never quite disappears, showing that the ancient world, even in its latest period, still clung to the primitive valuation of 'conspicuous leisure' and, in spite of its aesthetic culture, was incapable of forming anything like the Renaissance and modern conception of genius. For only when this conception becomes current, is the form and technique through which the personality of genius chooses to express itself of any consequence. Then all that matters is that it should express itself or even merely give some indication of that which refuses to be expressed.

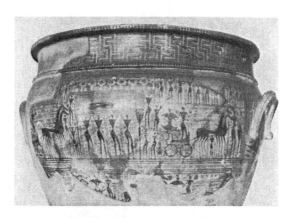

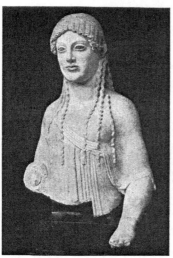 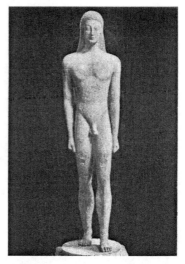

1. DIPYLON VASE. *Paris, Louvre. About 800 B.C.*—*The abstract geometric forms of the decoration are in many respects more closely connected with Neolithic art than with the artistic creations of the Ancient-Oriental urban cultures.*

2. FEMALE FIGURE. *Athens, Acropolis Museum. 6th century B.C.*—*One of the numerous 'Korai', offered as votive gifts, with the typical features of the elegant Ionian style.*

3. MALE FIGURE. *Athens, National Museum. 6th century B.C.*—*One of the earliest artistic representations of the idea of kalokagathia propagated by the Greek ruling class through its artists, poets and philosophers.*

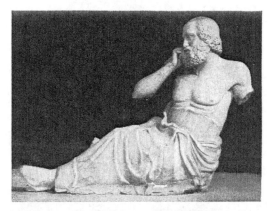

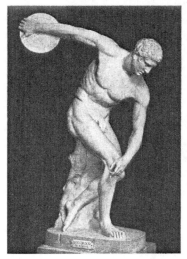
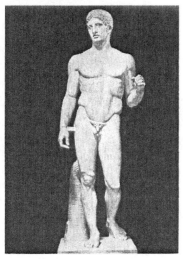

1. OLD MAN *from the East Pediment of the Temple of Zeus in Olympia. About 460 B.C.—Example of the naturalistic conception of art of early classicism which also includes the ugly and trivial as subjects for artistic treatment.*

2. MYRON: DISCUS-THROWER. *Rome, Vatican. Middle of the 5th century B.C. Roman marble copy.—The work, which attempts to capture the momentaneous impression of a fleeting movement, is the classical expression of the dynamic attitude to life of the age.*

3. POLYCLETUS: SPEAR-HOLDER. *Naples, Museum. 450–440 B.C. Roman marble copy.—The Polycletan 'canon' represents, with its equilibrium, the classical version of the aristocratic ideal of beauty.*

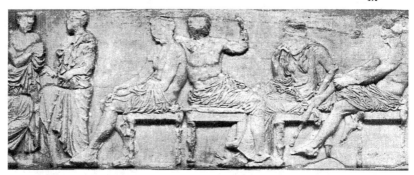

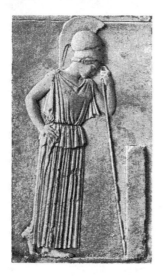
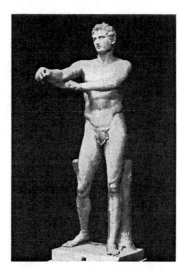

1. SYMPOSIUM OF THE GODS *from the East Frieze of the Parthenon. London, British Museum. 447–432 B.C.—The sculptures of the Parthenon are the most representative artistic monument of Athenian democracy.*

2. 'MOURNING ATHENA'. *Athens, Acropolis Museum. Middle of the 5th century.—A less pretentious but just as perfect creation of Greek classicism as the Parthenon sculptures themselves.*

3. LYSIPPUS: APOXYOMENOS. *Rome, Vatican. Late 4th century. Roman marble copy.—The new, post-classical, less severe version of kalokagathia. The aristocratic masculine ideal has lost most of its heroic features.*

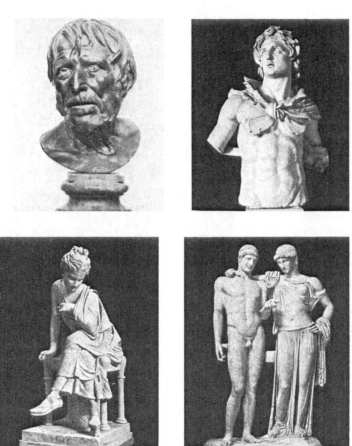

1. 'SENECA'. *Naples, Museum. 2nd century B.C. Roman bronze copy.—Hellenistic naturalism.*

2. TRITON. *Rome, Vatican. Roman marble copy.—Hellenistic baroque.*

3. SEATED GIRL. *Rome, Palazzo dei Conservatori. Roman marble copy.—Hellenistic rococo.*

4. ORESTES AND ELECTRA. *Naples, Museo Nazionale.—Hellenistic archaism.*

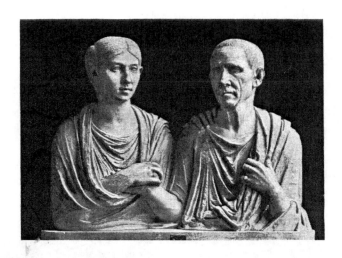

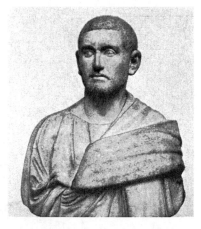

1. ROMAN MARRIED COUPLE ('*Cato and Porcia*'). *Rome, Vatican. Augustan age.—The work still bears traces of the old sacred portrait sculpture connected with ancestral worship.*

2. PUTTO. *Wall painting in the House of the Vettii in Pompeii. 4th Pompeian style. Between 79 and 63 B.C.—Roman impressionism.*

3. PORTRAIT HEAD. *London, British Museum. About A.D. 250—Roman expressionism.*

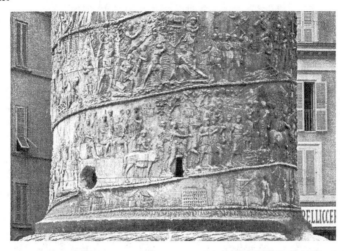

1. COLUMN OF TRAJAN (*Lower part*). *Rome. A.D. 113*—'*Continuous*' *representation of the Dacian campaign.*

2. DUCCIO: THE AGONY IN THE GARDEN. *Siena, Opera del Duomo. Part of the 'Majestas' for the Cathedral of Siena completed in 1311.—Example of the 'continuous' representation in the Middle Ages. Christ appears in the same scene twice, representing two different phases of the action.*

CHAPTER IV

THE MIDDLE AGES

1. THE SPIRITUALITY OF EARLY CHRISTIAN ART

THE unity of the Middle Ages as a historical period is quite artificial. In reality they fall into three entirely distinct cultural periods—the natural economy of the early Middle Ages; the courtly chivalry of the high Middle Ages; and the urban bourgeois culture of the late Middle Ages. At any rate, the divisions between these three epochs go deeper than those which mark the beginning and the end of the Middle Ages as a whole. Not merely is this the case, but the events that sunder these periods from one another—the emergence of a knightly nobility of service along with the change from natural economy to urban money economy, the awakening of lyrical sensibility and the rise of Gothic naturalism, the emancipation of the bourgeoisie and the beginning of modern capitalism—are of greater importance in accounting for the modern outlook upon life than all the spiritual achievements of the Renaissance,

Most of the features which are customarily regarded as being characteristic of medieval art, such as the desire for simplification and stylization, the renunciation of spatial depth and perspective, the arbitrary treatment of bodily proportions and functions, are in reality only characteristic of the early Middle Ages; as soon as the urban money economy and bourgeois way of life come to prevail they no longer hold good. The sole element of importance which does dominate the Middle Ages before and after that epoch-making change is the metaphysically based world-view. At the transition from the early to the high Middle Ages, art emancipates itself from most of the limitations imposed upon it, but it still retains a deeply religious and spiritual character, being

109

the expression of a society still thoroughly Christian in feeling and hieratic in organization. Throughout the whole period the spiritual sway of the clergy remains, in spite of heresy and sectarianism, without a rival, and the prestige of their monopoly of the means of salvation, the Church, remains essentially unimpaired.

But the transcendental world-view of the Middle Ages did not come suddenly into full flower with the coming of Christianity. The art of early Christian times had none of that metaphysical transparency which is of the very essence of the Romanesque and Gothic styles. The 'spirituality' of this art, in which scholars have tried to find all the essentials of the later medieval conceptions of art,[1] is in reality only the same indefinite sort of spirituality which inspired the last centuries of paganism. The 'spiritual' attitude of these centuries did not give rise to a complete supernatural system, displacing the natural order of things; at most, it expressed an increased interest in and susceptibility to the stirrings of the human soul. The forms of ancient Christian, as of late Roman, art are psychologically, not metaphysically expressive; they are expressionistic but not revelatory. The wide open eyes of late Roman portraits express intensity of soul, spiritual tension, a life that is strongly emotional; but it is a life which is without any metaphysical background and as such has no inner relation to Christianity. It is in fact the product of conditions which obtained long before Christianity emerged. The tension which Christian doctrine resolves was already beginning to be felt in the Hellenistic age; though Christianity soon produced answers to the questions that troubled those times, the work of many generations was needed before those answers could be expressed in forms of art—these were by no means simultaneous with the enunciation of the doctrine itself.

Early Christian art during the first two or three centuries of its existence was merely a development or even a variant of late Roman art. So great is the similarity between late pagan and early Christian work that the decisive change of style must have occurred between the classical and post-classical, not between the pagan and Christian eras. In the works of the later Empire, above all those of the age of Constantine, the essential features of early

Christian art are anticipated—its impulse towards spiritualization and abstraction, its preference for flat, bodiless, shadowy forms, its demand for frontality, solemnity and hierarchy, its indifference to the organic life of flesh and blood, its lack of interest in the characteristic, the individual and the species. In short, there is the same unclassical will to represent the spiritual rather than the sensible which is found in the paintings of the Catacombs, the mosaics of the Roman churches and the earliest Christian manuscripts. The course of development runs from circumstantial pictures of a situation in the later classical times to a concise record of facts in the latest pagan times and finally to schematic symbols, as of a seal, in early Christian art. Starting with the early Empire, we can watch step by step the process by which the idea becomes more and more important than the outward form, and the forms gradually develop into a kind of hieroglyphic script. The road that carries Christian art further and further from the realism of classical art forks in two different directions. One line of development produced the symbolism which is not so much concerned to represent as to conjure up the spiritual presence of the sacred personages by translating every detail of the scene into a code-language of salvationist doctrine. The spiritual value which the work of art is thought to gain by this translation explains the otherwise unintelligible characteristics of early Christian art—its distortion of natural size and adjustment of proportions to the spiritual significance of the objects portrayed, its so-called 'reversed perspective' which represents the principal figures when further away from the onlooker on a bigger scale than the subordinate figures in the foreground,[2] the ostentatious front view which it gives to the important figures, its summary treatment of merely circumstantial details, etc. The second line of development evolved an epical or illustrative style which aims at calling the various scenes, actions and incidents vividly to mind. In fact, the reliefs, paintings and mosaics of the early Christian epoch are either objects of devotion or else tales from the Bible and the legends of the saints. In these the artist's whole efforts are directed to a clear and distinct rendering of the action itself; for example, in the miniature from the Rossano Gospel-book, that portrays Judas bringing back the

pieces of silver, one of the front pillars supporting a canopy is partly cut away to show the high priest, although he is supposed to be sitting behind the pillar. The painter was obviously more concerned to show clearly the high priest's gesture of rejection than to draw correctly details which have nothing to do with the action.[3]

We are now presented, at least in the early stages, with a simple, popular type of art, recalling in many of its features the picture story-telling from Trajan's Column. Popular though it was in its origins, this style was increasingly adopted for official works of art at Rome, so that the early Christian art, primarily destined to suit the taste of the lower classes, was distinguished from the art of the social élite not so much by its tendency as merely by its quality. The pictures of the Catacombs, in particular, must have been almost entirely work by simple artisans, amateurs and daubers whose qualifications consisted in their religious zeal rather than in any positive talent for work; but a degeneration both of taste and technique is to be seen in the art of the old cultured classes as well. We are faced here by a break in the course of history similar to that which occurred in our own time when impressionism was abandoned in favour of expressionism; the art of the age of Constantine seems as rude, when compared with that of the early Empire, as does a picture by Rouault when compared with one of Manet. Both these historical changes originated in a change in the sentiments of an urban, cosmopolitan society, whose last vestiges of solidarity had been undermined by capitalism, and now, tormented by the fear of extinction, begins to put its trust in supernatural aid. Such a society, living in an atmosphere of impending calamity, tends to show more interest in new spiritual content than in the old refinements of form. In late Roman times, this atmosphere was no less plainly manifest in pagan than in Christian art; the only difference was that works executed for well-born and well-to-do Romans were still the creation of real artists, who would hardly have been willing to work for the poverty-stricken congregations of the Christians. Even in cases where they were not personally averse from Christian ideas and were prepared to work for a small reward or none, they would still be disinclined to work for

the Christians, who required of them that they should give up
the portrayal of heathen divinities altogether, a concession which
no artist of any repute or position would be at all likely to
make.

Those scholars who are determined to find the metaphysical
world-view of the Middle Ages in the earliest Christian art inter-
pret all its obvious defects as against classical art as being simply
due to conscious and deliberate choice; Riegl's theory of 'artistic
intention' (*Kunstwollen*) leads them to regard every failure of the
power of imitative expression as a spiritual gain and a sign of
progress. Their principle is, wherever a certain style seems in-
capable of solving a particular problem, to enquire whether this
style was really intended to solve the problem in question. Now,
this principle is undoubtedly one of the most fruitful ideas in
the doctrine of 'artistic intention'; its value, however, is that of
a working hypothesis and it should not be pressed beyond proper
limits; it is clearly absurd to interpret it in such a way as to deny
all possibility of a gap between the artist's intention and his power
of execution.[4] There can be no question that such a gap existed
in early Christian art. What has been praised in it as deliberate
simplification, masterly concentration or conscious idealizing and
intensifying of the actual is in reality often just incapacity and
poverty, just a helpless inability to render natural forms correctly,
and a primitive bungling of the drawing.

This clumsiness and ungainliness of early Christian art is not
mastered until after the Edict of Toleration, when it became the
official art of state and court, of aristocratic and educated circles.
Then it even regains—for example, in the apse-mosaic of Sta
Pudenziana—something of that very kalokagathia which, from
its hatred for the classical fidelity to sense, it had not long since
so decisively rejected. The doctrine that only the soul can be
beautiful, while the body like everything else material is neces-
sarily ugly and repulsive, is relegated to the background, at least
for some little time after the recognition of Christianity. The
Church, now rich and powerful, portrays Jesus and his disciples
as majestic and dignified persons, just as if they were distin-
guished Romans, imperial governors or influential senators. In
relation to ancient times, this art is even less of a novelty than the

113

Christian art of the first three centuries was. It should rather be regarded as marking the first of those renaissances which cropped up continually throughout the Middle Ages, becoming from now on a leitmotiv in the history of European art.

Throughout the first few centuries of the Christian era, life in the Roman Empire continued to move with but little change along the same economic and social lines, and was nourished upon the same traditions and institutions as before. When the forms of property, the organization of labour, the sources of education and the methods of instruction remained practically unchanged, it would have been remarkable had any sudden change occurred in the current conception of art. The most that can be said is that a reorientation of life undermined the original coherence of the forms of ancient culture, but these forms still remained the sole vehicle of expression available, which one had to use if one wished to be understood. Christian art had nothing else available either and employed these forms, as one does a language, not because it wanted to preserve them, but just because they 'were at hand'.[5] The old means of expression, as is so often the case with long-established forms and institutions, outlasted the spirit which had given them birth. Long after the spiritual content of life had become Christian, people still expressed themselves in the forms of the ancient philosophy, poétry and art. Thus in Christian culture there was, from the very beginning, a rift without parallel in the ancient Eastern and Greco-Roman cultures, for in these form and content were originated and developed *pari passu*; the Christian world-view, on the other hand, was compounded partly of a new, still undifferentiated psychological attitude, partly of thought forms of a refined, both intellectually and aesthetically over-ripe culture.

The new Christian ideal of life did not at first alter the outward forms of art, but did alter its social function. For the ancient world, a work of art had a significance that was primarily aesthetic, but for Christianity its significance was quite different. The autonomy of cultural forms was the first element of the ancient spiritual heritage to be lost. To the mind of the Middle Ages, religion can no more tolerate art as existing in its own right regardless of creed, than it can tolerate an autonomous

114

science. As an instrument of ecclesiastical education, art was the most valuable of the two, at least where maximum diffusion was the aim. Strabo already said, 'Pictura est quaedam litteratura illiterato'; and 'Pictura et ornamenta in ecclesia sunt laicorum lectiones et scripturae' is still the dictum of Durandus. In the opinion of the early Middle Ages, art would be superfluous if everyone could read and follow an abstract chain of reasoning; art was originally looked upon just as a concession made to the ignorant masses who are so easily influenced by impressions of sense. It was certainly not allowed to be 'a mere pleasure to the eye', as St. Nilus put it. Its didactic character is the most typical feature of Christian art, as compared with that of the ancients; Greeks and Romans used it as an instrument of propaganda often enough, but it was never for them a mere vehicle of doctrine. In this respect the roads diverged from the very start.

The art forms themselves show no radical change until the fifth century and the dissolution of the Western Empire. The old Roman expressionism now develops into a style of 'transcendental statement'.[6] The emancipation of art from reality is now complete; the total rejection of all intention to reproduce reality goes so far as often to recall the geometrical art of early Greece. The composition of the picture is once again subordinated to a principle of decorative order which, however, no longer simply expresses an aesthetic quality of rhythm, but some higher plan, some harmony of the spheres. The artists are no longer content with mere decorativeness, with even spacing of the figures, symmetrical arrangement of the groups, rhythmical balancing of gestures, pleasing composition of colours; all such principles of composition play a preliminary and subordinate rôle in the new system as it finally emerges in the nave of Sta Maria Maggiore. We have here scenes that take place in a peculiar medium without light and air, in a space without depth, perspective and atmosphere, whose flat, shapeless figures are without weight and shadow. All attempt to produce the illusion of a consistent piece of space is now altogether discarded; the figures do not act upon one another in any way and the relations between them are purely ideal. They become far more stiff and lifeless,

and at the same time far more solemn, more spiritualized, more remote from life and from this earth. Most of the devices by which these effects are achieved, above all the reduction of the spatial depth, flatness and frontality of figures, economy and simplicity of design—all these were known to late Roman and early Christian art; but now they all coalesce and form the elements of a new style of their own. Formerly they were found in isolation, or at least only employed if a particular situation seemed to require them,[7] and were always in open and unresolved conflict with naturalistic traditions and recollections; but here the flight from the world is fully accomplished and all is cold, stiff, lifeless form—although instilled with a very intense and very essential life through death of the fleshly Adam and awakening of a new spiritual man. It all reflects the words of St. Paul, 'I live, but not I but Christ liveth in me'. The ancient world and its joy in sense is now abolished; the old glory departed; imperial Rome in ruins. The Church now celebrates her triumph, not in the spirit of the Roman nobility, but in the sign of a power which pretends to be not of this world. Only now that the Church is absolute mistress, does she produce an artistic style which has hardly any connection with that of the ancient world.

2. THE ARTISTIC STYLE OF
BYZANTINE CAESAROPAPISM

During the migration of the peoples the Greek Orient suffered no cultural breakdown like the West. The urban and money economy, which had almost completely collapsed in the Western Roman Empire, continued to flourish in the East and was in fact more vigorous than ever before. The population of Constantinople rose to over a million as early as the fifth century and the reports of its wealth and grandeur by contemporaries sound like a fairy tale. For the whole of the Middle Ages, Byzantium was the wonderland of unlimited treasure, palaces glittering with gold and endless festivities: it served as an example of official splendour to the whole world. The means which made this magnificence possible flowed from trade and commerce. Constantinople was a

metropolis in the modern sense to a far greater extent than Rome: a city with an internationally mixed and cosmopolitanly minded population, a centre of industry and export, a nodal point of foreign trade and long-distance communications,[8] and, incidentally, a genuinely Oriental city at the same time, whose inhabitants would have found it impossible to understand why trade was regarded as a degrading pursuit in the West. With its monopolistic controls, even the court formed a great industrial and commercial enterprise. And the limitations placed on economic freedom by these monopolies led to the real source of private wealth being landed property, not trade,[9] in spite of the capitalistic structure of Byzantine economy. The big profits derived from commerce accrued not to private persons but to the state and the imperial household. The limitations imposed on private enterprise consisted not merely in the fact that, since the reign of Justinian, the manufacture of certain silk materials and trading in the most important food-stuffs were confined to the state, but also in the regulation which left the whole organization of production and commerce to the city administration and the guilds.[10] The claims of the exchequer were by no means satisfied, however, by the state monopoly in the most profitable branches of industry and commerce; the treasury extracted the major part of its profits from private enterprise in the form of taxes, rates, duties, patent-fees, etc. It was therefore impossible for mobile private capital ever to become effective. At the most, the autocratic economic policy of the Crown allowed the land-owner to remain unmolested and uninterfered with on his country estate, whereas in the city everything was most strictly supervised and·regulated by the central government.[11] Thanks to its regular income from taxation and its rationalized state undertakings, Byzantium worked with an absolutely balanced budget and had a supply of money at its disposal which, in contrast to the Western countries in the early and high Middle Ages, made it possible for it to suppress all particularistic and liberalistic aspirations. The Emperor's power was based on a strong mercenary army and an efficient civil service, which it would have been impossible to maintain without the state's regular income. To them Byzantium owed its stability and the Emperor

both his economic freedom of action and his independence of the great landowners.

These conditions explain why the dynamic and anti-traditionalistic tendencies usually associated with trade and communications and with an urban money economy were not able to make any headway in Byzantium. Urban life, which normally has a levelling and emancipating effect on the population, here became the source of a strictly disciplined, conservative culture. Thanks to Constantine's pro-urban policy, Byzantium acquired from the very start a different social structure from that of the cities of classical antiquity or of the high and late Middle Ages. Above all, the law which connected landed property in certain parts of the kingdom with the possession of a house in Constantinople, resulted in landowners moving to the city; and this led in turn to the development of a separate urban aristocracy, with a more loyal attitude to the Emperor than that shown by the nobility in the West.[12] This materially satisfied conservative class also weakened the mobility of the rest of the population and helped very largely to make it possible for the typical culture of an absolute monarchy, with its standardizing, conventional and static tendencies, to arise and maintain itself in such an intrinsically unstable centre as Constantinople.

Caesaropapacy was the prevailing form of government under the Byzantine Empire: that is, the union of secular and spiritual power in the hands of a single autocrat. The dominion of the Emperor over the Church was based on the doctrine of divine right developed by the Fathers of the Church and proclaimed as law by Justinian, which replaced the old myth of the divine descent of the king, now regarded as incompatible with the Christian faith. For if the Emperor was no longer allowed to be 'divine', he could still be God's deputy on earth, or, as Justinian himself liked to be called, his 'arch-priest'. Nowhere in Western Europe had the state been so much a theocracy, never in modern history has the service of the temporal lord been so essentially part of the service of God as here. In the West the Emperors were always merely secular rulers, and always had a rival, if not an open enemy, in the Church. In the East, on the other hand, they stood at the head of all three hierarchies—the Church, the

army and the government[13]—and regarded the Church merely as a 'department of state'.

The spiritual-secular autocracy of the Eastern Roman Emperor, which often made the most unreasonable demands on the loyalty of its subjects, had to be displayed in public in order to stimulate popular imagination, had to be clothed in imposing forms and shelter behind a mystic ceremonial. The Oriental Hellenistic court, with its unapproachable solemnity and a rigid etiquette which forbade any kind of improvisation, was just the right setting for such ostentatious effects. But in Byzantium the court was the centre of all intellectual and social life even more exclusively than it ever was in the Hellenistic age. The biggest and in fact the only commissions for the more exacting works of art and even the more important commissions for the Church were given by the court. Not until Versailles was art again to become so entirely centred on a court. But nowhere else was art so exclusively a royal concern and so little the art of an aristocracy as here, nowhere else has it ever again become so rigidly and inflexibly a form of ecclesiastical and political loyalty. The aristocracy was nowhere so dependent on the monarch as here, nowhere was it so absolutely an aristocracy of officials, a class of bureaucrats and functionaries specially created by the Emperor to provide employment for his favourites; it was, therefore, in no way an exclusive, isolated caste, a hereditary aristocracy, in fact it was not an aristocracy at all in the strict sense of the word. The Emperor's autocracy allowed no hereditary privileges to flourish. The aristocratic and influential class was always identical with the particular civil service in office; a man enjoyed privileges only so long as he was in official employment. For this reason, we should always speak, in connection with Byzantium, of the influential men of the Empire, instead of a nobility as such. The Senate, the political representation of the upper class, was recruited at first only from civil servants and only later, when landed property had attained a privileged position, from landowners as well.[14] But, in spite of the special favours which the landowners enjoyed as compared with the industrial and merchant class, it is no more feasible to speak of a landed aristocracy here than of any other kind of hereditary aristocracy.[15] An official

position was the indispensable link between wealth and social influence. To be reckoned as belonging to the aristocracy, the rich landowners—and only the landowners were really rich—had to buy an official title, if they could acquire one in no other way. The officials, for their part, had to try to acquire a country estate in order to make themselves economically secure. In this way, such a complete fusion of the two leading classes took place that in the end all landowners were officials and all officials landowners.[16]

It would never have been possible for Byzantine court art to become the Christian art par excellence, if the Church itself had not become an absolute authority and had not felt itself to be mistress of the world. In other words, the Byzantine style was only able to gain a footing everywhere where there was a Christian art, because the Catholic Church in the West desired to become the power the Emperor was already in Byzantium. The artistic aim of both was the same: that art should be the expression of an absolute authority, of superhuman greatness and mystic unapproachability. The endeavour impressively to represent official personalities who demanded respect and reverence of the people, a tendency which had made itself felt increasingly since the later years of the Empire, reaches its climax in Byzantine art. The method used in the attempt to achieve this aim was, in the first place, frontality, as it had been in Ancient-Oriental art. The psychological mechanism which this method sets in motion is twofold: on the one hand, the rigid attitude of the figure portrayed frontally induces a corresponding spiritual attitude in the beholder; on the other hand, by this approach, the artist manifests his own reverence for the beholder, whom he imagines, supremely, in the person of the Emperor, his employer and patron. This deference is the inner meaning of frontality even when, and in fact above all when—as a result of the simultaneous functioning of the two mechanisms—the personality portrayed is the ruler himself, when, paradoxically, the respectful attitude is assumed by the very person it is really intended to honour. The psychology of this self-objectivization is the same as when the king himself most strictly observes the etiquette which revolves around his own person. By means of frontality every figure-representation takes on to some extent the

features of a ceremony. The formalism of ecclesiastical and of courtly ritual, the solemn gravity of a way of life regulated by asceticism or by despotism, the attempt of the spiritual or the secular hierarchy to create symbols of their authority, make the same demands on art and find expression in the same stylistic forms. Christ is represented in Byzantine art as a king and Mary as a queen; they wear royal and costly robes and sit reserved, expressionless and forbidding on their thrones. The long row of apostles and saints approaches them in slow and solemn rhythms, exactly like the Emperor's and Empress's train in court ceremonies. Angels attend and form processions in strict order, exactly like the spiritual dignitaries in ecclesiastical ceremonial. The figures are forbidden by an inviolable ritual from moving freely, from stepping out of the uniform line or even looking to one side. Everything here is awe-inspiring in its regal magnificence with all human, subjective and arbitrary elements suppressed.

This ritual found paradigmatic expression in the dedicatory mosaics in S. Vitale, which, in this respect, have never been surpassed in later times. No classical or classicizing movement, no idealistic and no abstract art, has ever succeeded in expressing form and rhythm so directly and so purely. Everything complicated, everything dissolved in half-tones or twilight, is excluded here; everything is simple, clear and obvious; everything is contained within sharp, unblurred outlines and expressed without shades and valeurs. The story has been completely transformed into pageantry. Justinian and Theodora with their train present votive offerings—an unusual theme for the chancel of a church. But as the sacred scenes take on the character of courtly ceremonies in this Caesaropapist art, so the festivities of the court fit into the framework of ecclesiastical ritual without difficulty.

In architecture, especially in the interiors of churches, the same majestic and domineering spirit is expressed as in the mural mosaics. From the very beginning, the Christian church was different from the ancient temple in that it was more a parochial centre than a house of God and shifted the emphasis of the architecture from the outside to the inside of the building. But it would be wrong to see in this necessarily the expression of a

democratic principle, and to declare the church to be a more popular type of building than the temple. The shifting of attention from outside to inside had already taken place in Roman architecture and is in itself no evidence of the social function of the building. The basilican lay-out which the early Christian Church adopts from the public building of the Romans, with its division of the interior into sections of different rank and value, and especially the separation of the choir, reserved for the clergy, from the rest of the building, is more in accordance with an aristocratic than a democratic outlook. But Byzantine architecture, which completes the formal pattern of the early Christian basilica by adding the cupola, leads to a further intensification of the hierarchical relation in which the different sections of the building are sharply divided from each other. The cupola, as it were, the crown of the whole structure, emphasises the break between the different parts of the interior.

On the whole, the miniature painting of the period shows the characteristics of the same solemn, pompous and abstract style as the mosaics; on the other hand, it is more animated and spontaneous in expression, and freer and more varied in subject-matter, than the monumental mural decorations. Incidentally, two different tendencies can be discerned in this miniature painting: that of large, full-scale, luxurious miniatures, which follow the style of the elegant Hellenistic manuscripts; and that of the less pretentious books, intended for monastic use, the illustrations of which are often limited to mere marginal drawings and conform, with their Oriental naturalism, to the simpler monastic taste.[17] The comparatively modest means required for book illustration make it possible to produce for less highly placed and artistically more liberal-minded circles than the patrons who commission the expensive mosaics. Moreover, the more flexible and simpler technique allows a freer treatment, more open to individual experiment than the complicated and awkward procedure of the mosaic. The whole style of miniature painting can, therefore, be more natural and spontaneous than that of the pretentious church interiors;[18] this also explains why the writing-rooms became the refuge of orthodox and popular art during the iconoclastic period.[19]

It would be a misleading simplification of the facts, however, to deny all trace of naturalism in Byzantine art, even in the mosaics. The portraits which are part of their rigid compositions are often astonishingly lifelike and the harmonious way in which this conflict of styles is resolved is perhaps the most remarkable feature of this art. The portraits of the Emperor and his wife and of Bishop Maximian in the mosaics of S. Vitale make just as convincing an impression and are as lively and appealing as some of the best portraits of the later Roman emperors. In spite of all stylistic limitations, it was apparently no more possible to abandon truth to life, at least in the portraits, in Byzantium than in Rome. The figures could be presented in a frontal position, arranged according to abstract principles and left to become rigid with ceremonial solemnity, but in the case of portraits of well-known personalities it was found impossible entirely to ignore their characteristic personal features. We are dealing here, by the way, with what is already a late stage in the development of early Christian art, a stage in which an attempt is made to find the way to a new differentiation and to find it in the line of the least resistance, that is to say, in true to life portraiture.[20]

3. CAUSES AND CONSEQUENCES OF ICONOCLASM

The wasteful wars of the sixth, seventh and eighth centuries, which required the co-operation of the landed gentry in order to keep the army up to strength, confirmed the power of the landowners and led even in the East to a kind of feudalism. It is true that the mutual dependence of feudal lord and vassal which marked the Western feudal system was lacking here, but even here the Emperor became more or less dependent on the landowners as soon as he no longer had at his disposal the means necessary for the raising of a mercenary army.[21] The system of bestowing landed property as compensation for military service developed, however, only on a small scale in the Eastern Roman Empire. In contrast to the West, not the magnates and knights but the peasants and the common soldiers were enfeoffed here. The owners of latifundia, naturally, tried to absorb the estates

owned by peasants and soldiers which arose in this way, as they had done in the West with freehold peasant property, and here too the peasants went for protection from the often intolerable burden of taxation to the great lords, as they had to in Western Europe because of the insecurity of their tenure. For their part, at least in the early stages, the Emperors made every possible effort to prevent the accumulation of landed property, above all, of course, in order not to fall into the powerful hands of the great landowners themselves. But their main effort during their long and desperate fight against the Persians, the Avars, the Slavs and Arabs was concentrated on the preservation of the army; every other consideration had to yield to this one overriding concern. The prohibition of image-worship was only one of their emergency measures.

Iconoclasm was really not a movement inimical to art: it did not persecute art as such but only a special kind of art; it merely fought against pictures with a religious content, and even in the period of the most rabid persecution, decorative paintings were still tolerated. The campaign had in the main a political background; the attack on art as such was a comparatively insignificant undercurrent in the total complex of motives—perhaps the least significant of all. In those places where the movement started, in any case, it played the smallest possible part even though it had a not altogether inconsiderable share in spreading the idea of iconoclasm. The aversion from the pictorial representation of the numinous, as well as the dislike for anything reminiscent of idolatry, was by no means so decisive an influence on the outlook of the later Byzantines, with their delight in pictures, as on that of the early Christians. Until the time when Christianity was recognized by the State, the Church had attacked the religious use of pictures on principle and only tolerated them in cemeteries under certain specific conditions. But even here portraits were prohibited, sculpture was shunned and paintings restricted to symbolical representations. In the churches the use of works of fine art was absolutely forbidden. Clement of Alexandria emphasizes that the second commandment is directed against pictorial representations of every kind and that is the criterion for the early Church and the Fathers. But after the

reconciliation of Church and State there was no longer any fear of a relapse into idolatry and the visual arts could be put to the service of the Church, though even now not entirely without certain restrictions and prohibitions. In the third century, Eusebius still described the pictorial representation of Christ as idolatrous and contrary to Scripture. Self-contained pictures of Christ were comparatively rare even in the following century. Not until the fifth century did the production of this type of picture begin to flourish in any strength. Then, however, the image of the Redeemer became the religious representation par excellence and comes in the end to represent a kind of magic protection against the influence of the evil spirit.[22] Another root of the iconoclastic idea, and one indirectly connected with the aversion from idolatry, was the early Christian refusal to accept the sensual-aesthetic culture of classical antiquity. This spiritual motive was formulated by the early Christians in countless ways, perhaps most characteristically of all by Asterius of Amasia, who condemned all pictorial representations of the Holy, because, as he thought, no picture could avoid stressing the material and sensual in the subject portrayed. 'Do not make a picture of Christ,' he warned; 'the humiliation of the Incarnation to which He submitted of his own free will and for our sake, was sufficient for Him to endure—rather let us carry around in our soul the incorporeal word.'[23]

The campaign against the idolatry into which the veneration of images had developed in the East played a far greater part than all the factors mentioned so far. But even that was not the real cause of Leo III's worry. He was concerned not so much with the purity of religion as with the enlightening effects which he promised himself would follow from the prohibition of religious images. And even more important to his mind than the cause of enlightenment itself was his regard for those cultured enlightened circles of society which he hoped to win over to his side by the prohibition of the worship of images.[24] For in these circles a 'reformatory' outlook had spread under the influences of the Paulicians and protests were being raised against the whole sacramental system, the 'pagan' ritual and the institutional priesthood. Yet nothing seemed to them more pagan than

the idolatry which was carried on with the images of the saints, and on this matter at least the puritanical peasant dynasty of the Isaurians was in complete agreement with the cultured class.[25] A further factor which helped the spread of iconoclasm enormously was the military successes of the Arabs, who recognized no image-worship in their religion. The Mohammedan position found supporters, as the successful cause always does, and it became the fashion in Byzantium. Many people saw a connection between the enemy's successes and his religion, and thought they could learn his secret simply by following and watching him closely. Others perhaps wanted to assuage the wrath of the enemy by adopting his way of life. Most of them probably thought that the abandonment of idolatry would in any case do no one any harm. But the most important and in the final analysis the decisive motive behind the iconoclastic controversy was the fight which the Emperors were waging with their followers against the constantly increasing power of monasticism. In the East, the monks exerted nothing like so much influence on the intellectual life of the upper classes as in Western Europe. Secular culture in Byzantium had its own tradition linking it up directly with classical antiquity; it did not need the mediation of the clerics. The relationship between the monks and the common people was all the more intimate, however. These two, monks and people, formed a common front, which could, in certain circumstances, become a source of danger to the central authorities. The monasteries became places of pilgrimage to which people went with their questions, their worries and requests and to which they also brought their gifts. The greatest attraction of the monasteries was the miracle-working icons; to possess a famous image of a saint became an inexhaustible source of fame and wealth for a monastery. Naturally, the monks adopted only too gladly the popular religious customs, the cult of the saints, the worship of relics and images, in order to increase their influence as well as their income.

In his plans for founding a strong military state, Leo III felt himself hindered most of all by the Church and the monks. The princes of the Church and the monasteries were among the biggest landowners in the country and enjoyed freedom from

taxation. As a result of the popularity of the monastic life, the monks were keeping many young men back from the army, the civil service and agriculture and were depriving the treasury of considerable revenue as a result of the constant endowments and donations they were receiving.[26] The Emperor, by forbidding the worship of images, deprived them of their most effective means of propaganda.[27] This measure affected them as the producers, owners and custodians of the images, but most of all as the guardians of the magic spell which the holy icons had woven around themselves. If the Emperor intended to succeed in realizing his totalitarian ambitions, his main task was to disperse this magic and the atmosphere in which it thrived. The chief argument which 'idealist' historians put forward against such an explanation of the iconoclastic controversy is that the persecution of the monks did not begin until three or four decades after the prohibition of image-worship and that under Leo III no direct hostilities were engaged against the monks themselves.[28] As though the monks had not already been affected painfully enough by the prohibition of image-worship in itself! It was neither necessary nor possible to attack them directly before they resisted the prohibition; but as soon as this happened, direct persecution was begun with no delay.

Iconoclasm was, therefore, by no means a puritanical, Platonic or Tolstoyan movement directed against art as such. It also did not lead to a standstill but merely to a new orientation in the practice of art; and the change even seems to have had a refreshing influence on artistic production, which had become excessively formalistic and monotonously repetitive. The purely decorative tasks to which painters were now restricted brought about a return to the Hellenistic decorative style and, as a result of the new freedom from ecclesiastical considerations, made a more vigorous treatment of natural subjects possible than had previously been authorized.[29] When these subjects then developed into hunting and garden scenes, the human figure was also depicted less rigidly, with more movement, and in a less flat and 'frontal' fashion. The second golden age of Byzantine art in the ninth and tenth centuries, which continued the naturalistic achievements of this secular period and applied them to ecclesi-

astical painting, could therefore rightly be called a result of the iconoclastic movement.[30] Byzantine art soon became formally stereotyped again, however. But this time the conservative movement started not in the court, but in the monasteries, that is to say, in what had formerly been the very home of the freer, more unconventional and more popular approach. In earlier times courtly art had striven for firm, uniform and absolutely binding standards, now it became the turn of monastic art. Monastic orthodoxy won the day in the battle of the images and became conservative as a result of its victory, so conservative in fact that in essentials the icons of the Greek Orthodox monasteries were still being painted in the same manner in the seventeenth as in the eleventh century.

4. ART FROM THE AGE OF THE MIGRATIONS TO THE CAROLINGIAN RENAISSANCE

The art produced during the period of the migration of the peoples is out of date and behind the times compared with that of Christian antiquity; stylistically it had not advanced beyond the Iron Age. Never has such a profound conflict of artistic outlook been at work within such a small area, as in this epoch, when in Byzantium a strictly disciplined but technically highly skilled figurative art, and in Western Europe occupied by Germanic and Celtic tribes an abstract geometrism concentrating on the purely ornamental, was the normal form of expression. For however complicated and rich in invention this decorative art was with its multifariously entangled, plaited and spiral patterns, its animal bodies with intertwining limbs and human figures adorned with flourishes, from an evolutionary viewpoint, it did not advance beyond the La Tène period. It is, above all, its extraordinary poverty in figure-drawing—only in the Irish and Anglo-Saxon miniatures does the human figure occur at all—and then its abandonment of any attempt to give even the slightest bodily substance to the object portrayed, which make it seem so primitive. In spite of the explosive and often very expressive dynamism of its forms, it is and remains a paltry, playful, merely decora-

tive art. Its 'secret Gothic' shares with the real Gothic nothing but the tension of an abstract interplay of forces, and certainly the two styles have nothing intrinsic and concretely spiritual in common. Whether a specifically Germanic style or, what seems to be more probable, a Scythian and Sarmatic ornamental style, merely transmitted and imitated by the Germanic tribes,[31] is expressed in this lineal art, we are dealing with a phenomenon which implies the complete dissolution of the classical conception of art and which forms 'the most abrupt contrast to the artistic outlook of the Mediterranean region'.[32]

Was the art of this period of the migrations a folk art as Dehio maintains?—It was a *peasant art*: the art of the peasant tribes which inundated the West, of a people still tied to primary production. If we are going to call all peasant art 'folk art' or if folk art means comparatively simple forms of expression intended for a culturally homogeneous public, then this art was 'folk art'. But if we understand by 'folk art' an activity not carried on by professional specialists, then it can in fact hardly be described as such. Most of the products of this art which have come down to us presuppose an artistic skill far exceeding any kind of dilettantism; it is quite inconceivable that they could have been achieved by artists without a thorough professional training and long practice. The Germans probably had only a few specialized craftsmen, and manual crafts were doubtless still carried on for the most part inside the home; but the production of artistic ornaments such as those which are extant could hardly have been a mere side-line.[33]

The Germans were mostly free peasants cultivating their own fields; partly, however, they were already landlords with serfs working their land for them. There was no longer any question of 'communal farming' in this age of the migrations.[34] The conditions prevailing can only be described as undeveloped in so far as the whole culture was still on a purely agricultural level. Here too the geometric style was, as everywhere since the end of the Neolithic age, in accordance with the peasant way of life, but it did not presuppose here any more than anywhere else the outlook of a property-sharing community. The art of this period has no peculiar characteristics in comparison with the peasant art of

129

other ages and other peoples, but it is remarkable that the geo-
metric style of the Germanic peasants is not only continued in the
miniature painting of the Irish monks, but is enhanced by the
extension of its ornamental principle to the human figure. The
distance from nature of this painting reaches and sometimes even
surpasses the abstraction of early Greek geometrism. Not merely
the non-figurative ornament, not merely plant and animal, but
also human forms are turned into pure calligraphy and lose all
trace of bodily and organic substance. But how is it to be explained
that an art practised and refined over such a long period as that
of the scholarly monks employed by a scholarly public remained
stationary on the stylistic level of the migratory peoples? The
main reason is probably that Ireland was never a Roman province
and therefore had no direct share in the fine arts of classical
antiquity. Most of the Irish monks will probably never have seen
any Roman sculpture, and Roman or Byzantine illuminated
manuscripts will not have reached Ireland very often—in any
case not often enough to form the basis of an artistic tradition.
Thus the abstract formalism of the art of the migration period
did not meet here even with as much resistance as it did on the
Continent in the shape of Roman art. A further factor which
explains the 'peasant' geometrism of the Irish miniatures is con-
nected with the specific character of the Irish monastic rule,
which was different from Continental and especially Byzantine
monasticism. The Greek monasteries were situated near the cities
and took an active part in city life, commerce and international
intellectual movements; their members did only light manual
labour and had nothing in common with the rural way of life.
The Irish monks, on the other hand, were still half-peasants.
Patrick himself was the son of a landowner with medium-sized
property, the son of a 'rusticus', and he observed the very letter
of the strict Benedictine rule when founding his monasteries.
But it is remarkable that early Irish poetry, which stands on the
same cultural level as the miniature painting of the monks,
reveals such a lively feeling for nature that it is possible to speak
in relation to it not only of accurate naturalism but even of a
highly sensitive, quickly responsive impressionism. It is difficult
to understand how two such different phenomena could belong

to one and the same culture: on the one hand, the miniature paintings, in which every natural form is immediately turned into a mere ornament, and, on the other, a description of nature such as the following:

'Tiny sound, lovely sound, tender music of the universe, a cuckoo with its sweet voice in the treetops; little sunshafts are playing in the sunbeam, the young cattle have fallen in love with . . . of the mountain.'[35]

The only explanation of this discrepancy is that here too, as so often, evolution does not run parallel in all the different forms of art and that here too we have one of those historical periods the artistic manifestations of which cannot be reduced to the common denominator of a single style. The degree of naturalism in the different arts and genres of a period depends not only on the general cultural level of the period, not even if its sociological structure is uniform, but also on the nature, age and special tradition of each individual art and genre. To describe an experience of nature in words and rhythms or in lines and colours is by no means one and the same thing. An age may be successful in the one and fail in the other, may enjoy a still comparatively spontaneous and direct relationship to nature in the one art form when this same relationship has already become conventional and stereotyped in the other. The Irish, who discovered such poetic images as 'the little bird has let a whistling note resound from the tip of its shining yellow beak; the blackbird sends out a cry over Loch Lāig from the yellow bushy tree'[36] and spoke of such things as the 'footwear of swans' and the 'winter's coat of the ravens',[37] drew and painted birds of which it is difficult to say if they are supposed to represent chickens or young eagles. Absolute parallelism of stylistic approach in the different arts and genres presupposes a level of development on which art no longer has to wrestle for the means of expression, but is able, to a certain extent, to choose freely among the different possibilities of formal treatment. In the Palaeolithic age there will have been nothing in contemporary poetry—if there was any poetry at all—to compare with the highly developed naturalism in the painting of the same period. Again, in the old Irish poetry the metaphorical

power of the language produced images of natural life, for which
the art of painting, based on the ornamental style of the migra-
tion period, lacked the means of expression. In their poetry the
Irish were dependent on quite a different tradition than in their
painting. The poets will have been familiar with Latin nature
lyrics or with poems derived from Latin poetry, whereas all the
painters knew, to start with, was the geometric style of the Celtic
and Germanic peasant tribes. But poets and painters will also
have belonged to different social and cultural classes, and this
difference must have influenced their approach to nature. We
know, on the one hand, that the painters of the miniatures were
simple monks, and we may assume, on the other hand, that the
authors of both the epic poems and the nature poems were
active as professional poets, that is to say, they belonged either
to the class of the highly esteemed court poets or to that of the
probably less highly regarded bards, who were nevertheless still
reckoned members of the upper class on account of their learn-
ing.[38] The assumption that these poems had the same kind of
origin as folk poetry[39] has its source in the romantic idea that
'natural' and 'folk-like' are interchangeable concepts, whereas in
reality they are more opposites than alternatives. The same
directness of vision which we find in the Irish nature lyrics is also
evident in the following passage from the life of a saint, that is to
say, in a literary work that has obviously nothing to do with folk
poetry. The passage deals with an episode in which a child playing
on the seashore falls into the water but is saved by the saint, and
it then describes how it plays with the waves as it sits in the
middle of the sea on a sandbank:

'For the waves could reach up to him and laugh around him,
and he was laughing at the waves, and putting the palm of his
hand to the foam of the crests and he used to lick it like the foam
of new milk.'[40]

After the barbarian invasions a new society arose in the West
with a new aristocracy and a new cultural élite. But whilst this
was developing, culture sank to a low-water mark unknown in
classical antiquity and remained unproductive for centuries. The
old culture does not come to a sudden end: Roman economy,

society and art decay and disappear gradually and the transition to the Middle Ages takes place step by step and almost unnoticed. The continuity of development is best expressed in the survival of the late Roman economic structure:[41] agriculture with large-scale property and the *coloni* remain the basis of production.[42] The old settlements remain inhabited and the ruined cities are even partially rebuilt. The use of the Latin language, the validity of Roman law and, above all, the authority of the Catholic Church, which becomes a model for the political administration—all these remain intact. On the other hand, the Roman army and the old administration have to go. An attempt is made to preserve existing institutions, the financial administration, the legal and police system, in the new state, but the old posts—at any rate, the most important of them—have to be filled by new officials, and the new aristocracy grows very largely out of this new civil service.

The Germanic conquests brought about the transition within the German people itself from the old tribal state to the absolute monarchy. The newly established states led to changes which enabled the victorious kings to make themselves independent of the popular assembly of freemen and, following the example of the Roman emperors, to raise themselves above both the people and the nobility. They regarded the conquered territories as their own private property and their followers as ordinary subjects over whom they had absolute personal control. But their authority was by no means secure from the very start. Every single one of the old tribal chiefs might come forward as a rival and every member of the old aristocracy was potentially dangerous. They rid themselves of this danger by very largely exterminating the old tribal aristocracy, which must already have suffered enormous losses in the wars of conquest. The assumption that nothing at all survived of the old nobility,[43] and that, except for the Merovingians, there were no more noble families, is probably exaggerated,[44] but the survivors were certainly no longer a danger to the king. Nevertheless, under the Merovingians there must already have been a new and large ruling class. How did it come into being? And of what kind of social elements did it consist? Except for the remnants of the Germanic hereditary

nobility, it was made up above all of the members of the prob-
ably only sparsely surviving Roman senator-class living in
the occupied territories. In any case, many of the old Gallo-
Roman landowners retained their properties and privileges even
though the kings favoured the new official and military nobility.
This official aristocracy formed not only the most influential but
also the numerically most important section of the Frankish
upper class. Since the establishment of the new state, the only
way to new honours led by way of service to the kings; whoever
was in the king's service counted for more than the others, and
belonged automatically to the aristocracy. But this aristocracy
was still no real nobility, for its privileges were liable to be for-
feited and were by no means hereditary, were not based on birth
and descent but merely on office and property.[45] It was also far
from forming an ethnically uniform group; it was made up of
Gallic, Roman and Germanic elements, and represented a class
in which the Franks were given no preference at least as against
the Romans. The freedom from prejudice of the kings went so
far in this respect that they allowed and perhaps even aided and
abetted people of the lowest origins, even escaped slaves, to attain
the highest honours.[46] Such people were, at any rate, less danger-
ous to the kings' power and often more fitted to carry out the new
tasks than the members of the old families.

From as early as the sixth century, individual functionaries,
above all the highest administrative officials, the 'counts', were
rewarded, apart from their salaries, with allocations from the royal
estates. The land was certainly granted in the beginning only for
a limited number of years, then for life and only after that as
hereditary property. Gregory of Tours, our authority on the
social conditions of the Merovingian period, does not mention
any grants of land for military services, in other words, no endow-
ments of a feudal nature.[47] The Merovingian benefice is still in
the nature of a gift and not a security. But certain privileges and
exemptions were soon connected with these grants of land. For
to the extent that the state proved itself unable to protect the life
and property of its subjects, the great landowners took over this
function, arrogating to themselves in return the authority of the
state within their own territory. Thus not only the royal lands

but also the area in which the state had a say in affairs was diminished as the gifts of land increased. In the end, the king was master only on his own estates, which were often smaller than those of his most powerful subjects. Incidentally, this re-shaping of power-relationships was in full accordance with the general development, which removed the centre of gravity of social life from the towns to the country.

The country is, in contrast to the town, unsuitable for the practice of art, above all for the fine arts which have a more than purely decorative function. In the country there are no proper tasks for art, no public and none of the necessary means. At any rate, the main reason for the stagnation of art under the Mero-vingian kings is the decadence of the towns and the lack of a permanent royal residence. The transformation of urban culture into a rural culture, a process which had already begun in the later years of the Empire, is now completed. The money economy of the cities of classical antiquity reverts to the domestic and natural economy of the big estates, where an attempt is made to become entirely independent of outside forces, of cities and mar-kets. But the autarchy of the big estates is not primarily the result of the decline of the cities; on the contrary, the cities with their markets fell into ruin because the estate owners, who could not sell their produce owing to the shortage of money, prepared to produce as far as possible everything they needed for themselves and nothing more. In the end the decay of the depopulated cities went so far that the kings had to move out to their estates as they could not find or pay for the food to maintain themselves and their followers in the cities. The cities survived this crisis very largely as bishops' sees, but even if they were just able to main-tain themselves, it is, in any case, symptomatic that during the whole Frankish epoch no single important city arose in the West, whereas in the same period the Arabs founded gigantic cities like Baghdad and Cordova.[48] Even the places where the kings resided from time to time, such as Paris, Orléans, Soissons and Rheims, were comparatively small and thinly populated. No court life developed in any of them. Nowhere did a need for buildings and monuments arise. Even the monasteries were still too poor to fulfil the functions of the court and the city. There was therefore

no city, no court and no monastery where regular artistic activity might have developed.

In the fifth century there was still in existence everywhere a cultured aristocracy well versed in literary and artistic matters, but in the sixth century it disappeared almost completely; the new Frankish nobility was not in the least concerned with matters of education and culture. Not only the aristocracy but also the Church passes through a period of neglect and decay. Often even higher Church dignitaries could hardly read, and Gregory of Tours, who reports on this situation, himself writes a somewhat crude Latin—a sign that the language of the Church was already dead in the seventh century.[49] The schools run by laymen decline and are closed one by one. Soon there are no educational institutions at all, except for the cathedral schools, which the bishops have to maintain to secure a continuous supply of clergy. This was how the Church first acquired that educational monopoly to which it owes its extraordinary influence in the society of Western Europe.[50] The state becomes clericalized, in the first place simply because the Church provides and educates state officials, and the educated laity instinctively acquire the ecclesiastical outlook on life, because the cathedral and later the monastic schools are the only educational establishments to which they can send their children.

The Church still continued to give the most important commissions to artists. The bishops still had churches built, still employed builders, carpenters, joiners, glaziers, decorators and probably sculptors and painters as well. Owing to the lack of extant monuments, we can form no accurate idea of this artistic activity, but, if we may draw general conclusions from the few surviving illustrated manuscripts, it was limited to the somewhat second-hand continuation of late Roman art and the repetition of the art of the migration period. At this time no one in the West was any longer capable of representing a body plastically; everything is limited to pure surface ornament, to the interplay of lines and to calligraphy. The motifs used in decorative art are, in accordance with the prevalence of the rustic way of life, the forms of traditional peasant art: the circle and the spiral, intertwining ribbons and slings, fishes and birds, sometimes foliage and ten-

drils, and that is the sole innovation in advance of the art of the migration epoch. These are also the themes of the goldsmith's art, to which most of the examples that have survived belong. Their relatively great number shows where the artistic interests of this primitive society lay. Art meant in the first place ornamentation and finery, ostentatiously decorated utensils and precious jewels. It served—as it often still does in a sublimated form in much more highly developed cultures—merely to show off the possession of power and wealth.

With the coronation of Charlemagne the nature of the Frankish monarchy undergoes a fundamental change. The secular power of the Merovingians is transformed into a theocracy and the Frankish king becomes the protector of Christendom. The Carolingians re-establish the weakened power of the Frankish kings but they are unable to break the power of the aristocracy because they partly owe their own position to it. The counts and magnates become vassals of the kings from the ninth century onwards, it is true, but their interests are often so opposed to those of the Crown that in the long run they are unable to keep their vows to the king. Their power and their wealth do not increase, but decrease as the power of the state grows. The central government, by leaving the administration of the country to them, lays claim to the official service of a class which must reveal itself sooner or later as the enemy of the state and which as such rules and governs all the more freely since an official hierarchy with lower and intermediary ranks is almost completely lacking. The king cannot do very much against the unruly counts, above all he cannot simply dismiss them, for they are not officials in the normal sense, but people with whom the peasantry feels that it has much in common, who have been the richest and most highly respected people in the district for generations and compared with whom the new officials would appear to be intruders.[51] The king and the state are more particularly unable to prevent the peasants from making over their land to the magnates in increasing measure, in order to receive it back from them, as their protectors. The general tendency is towards the formation of latifundia and territorial principalities; and although the age of Charlemagne is still far distant from the final development of

this tendency, the royal authority is already so weak that the monarch has once again to make a show of more power than he actually possesses. Above all, he has to appear in public as the supreme head of the new spiritual-secular state and to make his court the main centre of fashion and culture of the Empire.

In Aix-la-Chapelle, where a literary academy, an artists' workshop in the palace and the best scholars of the time are all gathered in one place, Charlemagne creates, as the prototype of the European court, a home for the Muses which, despite the great interest shown in art at the Roman and Byzantine imperial courts, represents a new departure. For the first time since Hadrian and Marcus Aurelius a ruler in the West not only takes a real interest in learning, art and literature but carries out a cultural programme of his own. In setting up literary academies, however, the Emperor had in mind the renewal of intellectual culture only indirectly, his real aim was the training of staff for his administrative machine. In these academies Roman literature was, therefore, considered primarily as a collection of models of good Latin style and was studied mainly with a view to acquiring fluency in the official language. As far as the institutions themselves are concerned, it has recently been doubted whether there ever was a 'palace school' in which, as used to be thought, the children of distinguished families were educated: the assumption that such a school actually existed is now attributed to a misunderstanding of the texts in which 'scholares', as is now maintained, means not the pupils of a *schola palatina* but the Emperor's protégés, young aristocrats who, as future soldiers and officials, receive their practical training at the court.[52] On the other hand, it is beyond doubt that at the court of Charlemagne there was a literary society of poets and scholars, with regular meetings and competitions, which did in fact constitute a real academy; and we may also regard it as certain that a palace workshop was attached to the court in which illustrated manuscripts and art and craft objects were produced.

Charlemagne's whole cultural programme was part of a wider plan to revive the ideals of classical antiquity, the basic conception of which, although it was linked with the political idea of a renewal of the Roman imperium, was not merely the first com-

prehensive, but also the first creative re-assimilation of classical culture. The thesis that the Middle Ages never became aware of their distance from classical antiquity and always considered themselves its direct heirs[53] is untenable. The main difference between the Carolingian Renaissance and Christian antiquity lies precisely in the fact that it does not simply continue but that it rediscovers the Roman tradition. For the first time classical antiquity becomes a cultural experience with which is connected the consciousness of having rediscovered, in fact of having re-acquired, something that had been lost. This experience indicates the birth of Western man,[54] since it is not the actual possession but the struggle for the possession of classical culture which is his distinguishing mark. The age of Charlemagne contents itself with receiving the heritage of classical antiquity at second hand. The late Roman art of the fourth and fifth centuries and the Byzantine art of the following centuries form the storehouse of ideas and forms from which it draws its models and its inspiration. And although, in keeping with its lively mood of revival and rebirth, it has a special fondness for trying to imitate the proud and dashing attitudes of the Romans, it finds access to classical antiquity only through the refracted medium of Christian art. The most striking token of this break with classical antiquity is that the monumental sculpture of the Romans, for which the early Christians had already lost all understanding, also remains a closed book for the men of the Carolingian Renaissance. For this reason, Dehio thinks that the Carolingian assimilation of classical culture is no real renaissance but merely a continuation of late classical culture.[55] But Carolingian art does achieve one epoch-making innovation—as Dehio states himself[56]—by overcoming the flat ornamental style of the migration epoch and reintroducing the human body in its full three-dimensional reality. This characteristic is in itself reminiscent more of classical than of Christian antiquity. In Carolingian art, we encounter, however, in contrast to the purely ornamental approach of the migration period, not only a figurative art but, in contrast to early Christian times, a partially illusionistic conception of art. It revives not only the monumental and statuesque feeling but also the impressionistic conception of antiquity. Beside the imposingly conceived

and lavishly executed dedicatory pictures of the Emperors' Gospel-Books, we possess the rapid and vibrant pen-drawings of the Utrecht-Psalter which, though they have their stylistic source in Christian-Oriental models,[57] were unparalleled for impressionistic subtlety and expressionistic force in all the centuries since the end of the age of Hellenism. What is remarkable is not that this improvising method of representation was practised at the same time as the cool, imposing court style, but that, qualitatively, it was so much more impressive than the court art with its much more lavish technique, resources and format. It is obvious that a manuscript like the Utrecht-Psalter, with its simple, sketchy and uncoloured drawings, could not meet the luxury requirements of the court and that it was intended for a more modest circle, more interested in the illustrative than the ornamental side of art. The differentiation of manuscripts according to the size and technique of the miniatures, the distinction between 'aristocratic' manuscripts with whole-page multicoloured illustrations and 'popular' manuscripts with drawings mainly in the margins, which we had to make in our analysis of Byzantine art, is even more imperative here.[58] Of course, the different artistic quality of the work can be no more attributed to sociological conditions here than anywhere else; but the greater freedom of movement enjoyed by the artist in the world of unofficial art may have helped to increase the spontaneity and directness of the work. Just as the laborious, minute execution of the manuscripts de luxe leads to a static style, so the swift, sketchy manner of the 'cheaper' pen-drawings favours a dynamic, impressionistic approach.

The broad pictorial style of the whole-page miniatures, worked in thick body-colours, used to be called the manner of the palace school of Aix-la-Chapelle or Ingelheim or wherever it happened to be, and the sensitive, nimble impressionism of the Utrecht-Psalter the local style of the school of Rheims, which was more or less under Anglo-Saxon influence; not until it was established that even some of the luxury manuscripts produced with the greatest care originated in the writing-rooms of Rheims or its environs[59] did the geographical demarcation of the various styles lose the importance formerly attached to it. It is obvious that the source of the different styles must be sought more in the

different social position of the patrons than in the different nationalities of the artists themselves or the different local traditions of the workshops. Apart from certain stylistic similarities, manuscripts of the most varied kinds, some of them in the exacting pseudo-classical court style, some in the simple, sketchy, monkish manner, were prepared in one and the same writing-room.

The palace workshop was undoubtedly the main centre of artistic activity; the Renaissance movement started here and the scriptoria of the monasteries seem to have been organized from here.[60] Certainly, it was only later on that the monastic workshops acquired a monopoly in this field. In the age of Charlemagne probably just as many monks worked in the palace workshop as later laymen did in the monasteries. At any rate, in the Carolingian period many writing-rooms must have been in use; not only the relatively large number of manuscripts preserved but also their varied artistic quality suggests that. Incidentally, it is a striking fact how much better, for example, the average sample of ivory carving is than that of the extant miniatures. The more difficult technique implies a higher standard of production; obviously, the dilettanti who found no difficulty in obtaining employment in the writing-rooms were not trusted with the more valuable materials.[61] But the products of all these workshops have one feature in common, whether they are paintings, carvings or metal work: they are all comparatively small in size. At first sight this peculiarity seems incompatible with the tendency of court art to emulate the monumental style of classical antiquity, for this kind of art usually strives to attain outward as well as inward greatness. The preference for small-scale art in the Carolingian period has been linked with the still unstable and unsettled life of the time, with its nomadic character, and it has been recalled that nomadic peoples never have any monumental art but produce the smallest possible, easily portable decorative and ornamental objects.[62] The 'nomadic' character of Carolingian culture is reflected in the subordinate position of the cities and the constant shifting of the royal residence, and these factors are sufficient, if not completely to explain, at least to make more intelligible this preference for small-scale work in art.

5. THE EPIC POETS AND THEIR PUBLIC

According to Einhart, Charlemagne had the 'old barbaric songs' of bygone feuds and battles collected and recorded. These were evidently songs dealing with heroes of the migration period, Theodoric, Ermaneric, Attila and their brave warriors, which had already been worked up into more or less extensive epics in earlier times. In the days of Charlemagne the epic no longer suited the taste of cultured people; classical and learned poems were already more popular than epics. Even the king will have taken no more than a purely historical interest in the old epic songs, and the fact that he had them recorded only confirms that they were threatened with extinction. But Charlemagne's collection has also been lost. The next generation, Louis the Pious and his contemporaries, were no longer interested in these poems. The epic form had to be adapted to biblical materials and to express the clerical outlook in order not to disappear from literature altogether. Probably the collection commissioned by Charlemagne was edited by clergymen, and to judge from 'Beowulf', clerics had been occupied with the editing of heroic narratives even earlier. But the heroic poetry must have been preserved alongside monastic literature in another form, more akin to the original, before it came to life again in the courtly-chivalric epic. Above all, it must have appealed to a wider public than the purely literary poetry of the clergy and probably also to a wider public than the original heroic lay. It was suppressed by the court and the country nobility; if it survived anywhere, and it did, it can only have been among the lower classes. But however that may be, it only became popular in the centuries between the end of the heroic and the beginning of the chivalric age. And even then it did not become folk poetry in the real sense of the term; it remained in the hands of professional poets, who, despite their popularity, had almost nothing in common with the artless and impersonal way of the folk.

The 'folk epic' of romantic literary history originally had no connection at all with the common people. The prize-songs and heroic lays which are the source of the epic were the purest class poetry ever produced by a master class. They were neither created

nor sung nor spread abroad by the 'folk', nor were they intended for or attuned to the character of the folk. They were absolute art-poetry and an aristocratic art. They were concerned with the deeds and experiences of a warrior upper class, they flattered its lust for fame and glory, mirrored its heroic *amour-propre*, its tragi-heroic moral outlook, and not merely addressed the only conceivable public but also borrowed their poets from it, at least at the outset. It is true that the old Teutons had, both before and contemporaneously with this aristocratic poetry, a communal poetry, a poetry of ritual forms, magic incantations, riddles, maxims and minor social lyrics, that is to say, dancing songs, songs of labour and choral songs, which they performed at banquets and funeral ceremonies. These forms constituted the common, and very largely undifferentiated possession of the whole people, although the common performance of them was not an indispensable characteristic.[63] The prize-song and the heroic lay seem, in contrast to this communal poetry, to have been first invented in the migration period, their aristocratic character is to be attributed to the social upheavals which were connected with the successful invasion and brought to an end the relative uniformity of the cultural conditions of the previous age. Just as the structure of society became more differentiated as a result of the new conquests, extensions of property and the establishment of new states, so a class-poetry developed alongside the communal forms of poetry and the impetus for this probably came from the new elements in the aristocracy. This poetry was not only the special possession of a privileged, exclusive and class-conscious stratum of society, but, in contrast to the older communal poetry, it was also a scholarly, individually differentiated art acquired by practice, the creation of professional poets serving the ruling class.

The first poets of the migratory and heroic age to emerge as distinct personalities were probably still warriors themselves and were among the king's personal followers,[64] at least in 'Beowulf' the princes and heroes take an active part in poetry. But soon these cultured amateurs and occasional poets were replaced by professionals who, from now on, belong to the permanent staff of the court households and are for the most part no longer warriors. The *scop*, i.e. the court poet of the Western and

Southern Teutons, appears from the very outset as a specialist and an expert. The court *skald* of the Northern Teutons, however, remained a warrior whilst being a professional poet at the same time, and as the prince's confidential adviser, preserved some of the characteristics of the wise and knowledgeable singer of olden times. It appears all the more remarkable that the idea of personal authorship is more developed among the Northern Teutons than with the other Teutonic tribes, where the court singer sings some of his own songs and some by other poets without stressing the difference and without being asked by anybody about the authorship of the songs. It is only the actual performance that the listeners applaud. With the Norwegians, on the other hand, a sharp distinction is made between the poet and the reciter; they are not only familiar with but they even over-emphasize the pride of authorship and lay great stress on originality of invention. Here the names of the authors are preserved together with the works themselves: a phenomenon which does not occur elsewhere until the rise of the author-cleric and is perhaps connected, in the North, with the prestige which the poet enjoys as a warrior.

Probably even the Eastern Goths had professional poets. Cassiodorus mentions that Theodoric had sent the Frankish king Clovis a singer and harpist. We know from Priscus' description that such singers were active at the court of Attila. It is not clear from his report, however, whether they already held a really official position as poets. Nor do we know anything definite about the authority enjoyed by the professional poet with the Teutons in the heroic age. On the one hand, it is asserted that the poets and singers belonged to court society and stood in close personal relationship to the prince, but on the other hand, we are reminded that in 'Beowulf', for example, they are not even mentioned by name and that their prestige cannot, therefore, have been particularly great. What we know for certain is that the English court poet had had a firmly established official position from the eighth century onwards,[65] and this institution will have been adopted by all the Teutons sooner or later. Yet it did not last very long, for we soon hear of the wandering singer travelling from court to court and from castle to castle to entertain cultured society. But this change does not lead to such far-reaching

results as one might imagine: the poems retain their courtly character, although the princes and heroes to whom they are addressed are different on each occasion. In any case, the professional element is more strongly emphasized by the wandering singer than by the permanently appointed court singer, whose relationship to court society remains ambiguous. But we must not, on any account, confuse the wandering court singer with the common or garden vagrant and the unkempt minstrel, who appears on the scene at a later period. The distance between the two types is not narrowed until the secular singer loses the favour of the courts and has to find his public in inn parlours and fairs.

After the evening banquet at the court of Attila there followed, according to Priscus, next to the prize- and war-songs, comic performances by the clowns, who are to be considered, on the one hand, as the heirs of the ancient mimes and, on the other, as the ancestors of the medieval minstrel. Perhaps in the early stages, the provinces of the serious and the humorous were nothing like so sharply divided as later on when, as a court official, the singer became more and more distinct from the mime only to approach this style again when he became a wandering minstrel. Among the reasons for the crisis to which the court singers succumbed in the eighth and ninth centuries is to be reckoned, apart from the hostile attitude of the clergy[66] and the decline of the small courts,[67] in the first place the competition of the mimes.[68] The cultured court singer of heroic lays disappears along with the heroic spirit of his public, but heroic poetry survives the heroic age and is more long-lived than the society to which it owes its origin. After the decline of the military-aristocratic culture, it turns from an exclusive class interest into a universal art. The fact that this declension was so easily brought about, and that the same kind of poetry could be understood and enjoyed by the upper and lower classes almost simultaneously, can only be explained by assuming that the difference in cultural standards between the rulers and the ruled cannot have been anything like so great as in later ages. It is true that from the very beginning the rulers lived in a different sphere from the people, but they were not yet so conscious of the gulf that divided them from the lower classes.[69]

The romantic theory of the heroic epic as a folk art was nothing but an attempt to explain its historical element. The romantics were not yet aware of the propagandist function of art. The idea that the military aristocracy of the great heroic age could have had a practical interest in poetry was quite foreign to them. With their 'idealist' outlook on life and letters they would never have brought themselves to admit that in their poetry these heroes were merely trying to enhance the prestige of their own kith and kin, that their interest in the poetic transmission of great events was by no means purely intellectual. And as, on the other hand, the romantic theorists could not assume that the poets of the heroic ballads and epics drew their material from chronicles—an idea that has only dawned on our age—all they could do was to explain the historical themes in the epic as based on a tradition which was supposedly derived directly from the events themselves and passed from mouth to mouth and generation to generation, until it finally developed into the finished narrative of the epic poems. The survival of the heroic narratives on the lips of the people was at the same time the simplest explanation of the subterranean existence which the epic led between its two manifestations in the age of the migrations and in the age of chivalry. Incidentally, for the romantic movement, even these manifestations—the finished poems—were merely stations in the progress of a thoroughly continuous and homogeneous development. In its view, what mattered for a true understanding of the whole process were not the resting-places but the uninterrupted growth, the living tradition, the life of the saga itself.

In his folklore mysticism, Jakob Grimm went so far as to regard it as inconceivable that a folk epic could ever have been 'composed'. He thought that it composed itself and imagined its development to have been similar to the germination and growth of a plant. The whole romantic movement agreed in thinking that the epic had nothing to do with an individual, reflecting poet practising his art as a skilled craft acquired by learning, and that it was the work of the unreflecting, unconsciously and spontaneously creative folk. It characterized folk poetry, on the one hand, as a collective improvisation, on the other, as a slow, steady

organic process quite incompatible with the notion of discontinuous, deliberate steps attributable to a single individual. The folk epic was said to 'grow', by the transmission of the heroic saga from one generation to the next, and only to cease growing when it entered into literature proper. The term 'heroic saga' is used here to describe the form in which the epic is still completely in the possession of the people, and to which the epic poet owes the best part of his work. But the question is, even in the cases where the oral transmission of historical events may be taken for granted, not to what extent the poet makes use of the traditional material, but how much of this material can still be described as a 'saga'. The idea of a tradition being able to produce a long, homogeneous epic narrative without the co-operation of a consciously and deliberately creative poet, and enabling anyone exhaustively and coherently to re-tell such stories, is perfectly absurd. A finished, well-rounded and homogeneous narrative, however rough and ready the form in which it is presented, is no longer a saga but a poem and he who tells it for the first time is its creator.[70] It is, as Andreas Heusler has shown, a serious error to believe that the heroic narratives first pass anonymously from mouth to mouth as undeveloped sagas, are taken up by a professional poet and worked up into a poem. A heroic saga starts as a song, as a poem, and is re-told and added to as such; the epic is merely a later form, which in certain circumstances displaces the original shorter version, but is not fundamentally different.[71] The really artless, unliterary saga is made up of nothing but sporadic, disconnected motifs, abrupt, loosely united historical episodes, and short undeveloped local legends. These are the bricks which can be contributed by the common people, but which contain as good as nothing of what constitutes a heroic poem and an epic.

As far as the French heroic epic is concerned, Joseph Bédier not only denies the existence of the kind of saga which refers directly to historical events but even that of the heroic lays, and declares that there is no reason to assume any version of the epics to have existed before the tenth century. The problem with which he too is concerned, as all research on the sagas has been since the romantic movement, is the origin of the historical

elements of the epic. If, as he emphasizes, there has never been anything in the nature of a spontaneously self-developing saga, what has bridged the gap of the centuries between the events of the age of Charlemagne and the Charlemagne epics? How did the historical subject-matter come into the *chansons de geste*? How did the persons and events of the eighth century become known to the poets of the tenth and eleventh centuries? These questions, Bédier thinks, have never yet been answered satisfactorily, for the hypothesis that the sagas had already begun to take shape amongst the heroes' contemporaries is merely a clumsy and arbitrary attempt to overcome the dilemma presented by the problem of how it occurred to the poets to choose as the heroes of their works historical persons who had already been dead several hundred years.[72]

Gaston Paris had already denied the existence of the oral tradition, but he could only bridge the gap between the historical events and the epics by accepting the existence of the heroic lays of the Wolf-Lachmann theory.[73] Bédier, like Pio Rajna before him,[74] denies that such heroic lays ever existed, at least in the French language, and attributes the historical element in the heroic epic to the learned contribution of the clergy. He tries to prove that the *chansons de geste* arose along the pilgrim routes and that the minstrels who recited them to the assembled throng near the monastery churches were to some extent the mouthpieces of the monks. To advertise their monasteries and churches, they are supposed to have attempted to spread the stories of the saints and heroes who were buried there or whose relics were preserved there, and for this purpose made use of the minstrels and their art. The monastic chronicles contained records of these historical figures and formed, according to Bédier, the only source from which the historical bases of the epics could be derived. Thus, for example, the 'Chanson de Roland' in which the monks made Charlemagne the first pilgrim to Compostella, is supposed to have arisen originally as a local legend in the monasteries on the route to Ronceveaux and to have drawn its material from the historical records of these monasteries.[75]

The Bédier theory has been attacked on the ground that in the 'Chanson de Roland' neither St. James nor the famous place

of pilgrimage with his grave is mentioned amongst the many saints and Spanish cities which are referred to by name. Where is the alleged advertisement for the pilgrimage, the critics have asked, if the poet fails to mention the goal of the journey? This objection is not entirely sound, for what we possess is possibly only one version of a poem which had rapidly become universally popular and widely known and in which there was no longer any special point in mentioning the place of pilgrimage, Compostella, by name. But however that may be, in the French epics the traces of the clerical hand are as conspicuous as the accents of the minstrel are unmistakable. We see here all those forces working together which, in the Germanic and Anglo-Saxon sphere, had brought about the fall of the heroic ballad from the heights of a courtly art to the lower level of a popular art: monasticism and the art of miming, the poet and the public from the lower strata of society, the clerical interest and the taste for the pathetic and the piquant, all of which influences now come more and more into the foreground. Bédier is very well aware that the pilgrimages do not by a long way explain everything and he emphasizes the point that the crusades in East and West, the ideals and feelings of feudal society and of chivalry, are just as necessary factors for an understanding of the *chansons de geste* as the intellectual world of the monks and the emotional world of the pilgrims. They are unintelligible apart from the pilgrims and the monk, but they are also unintelligible apart from the knight and the burgher, the peasant and, more than any of these, the minstrel.[76]

Now, who and what is this minstrel in reality? Where does he come from? In what respects does he differ from his predecessors? He has been described as a cross between the early medieval court-singer and the ancient mime of classical times.[77] The mime had never ceased to flourish since the days of classical antiquity; when even the last traces of classical culture disappeared, the descendants of the old mimes still continued to travel about the Empire, entertaining the masses with their unpretentious, unsophisticated and unliterary art.[78] The Germanic countries were flooded out with mimes in the early Middle Ages; but until the ninth century the poets and singers at the courts kept themselves

strictly apart from them. Not until they lost their cultured audience, as a result of the Carolingian Renaissance and the clericalism of the following generation, and came up against the competition of the mimes in the lower classes, did they have, to a certain extent, to become mimes themselves in order to be able to compete with their rivals.[79] Thus both singers and comedians now move in the same circles, intermingle and influence each other so much that they soon become indistinguishable from one another. The mime and the *scop* both become the minstrel. The most striking characteristic of the minstrel is his versatility. The place of the cultured, highly specialized heroic ballad poet is now taken by the Jack of all trades, who is no longer merely a poet and singer, but also a musician and dancer, dramatist and actor, clown and acrobat, juggler and bear-leader, in a word, the universal jester and *maître de plaisir* of the age. Specialization, distinction and solemn dignity are now finished with; the court poet has become everybody's fool and his social degradation has such a revolutionary and shattering effect on himself that he never entirely recovers from the shock. From now on he is one of the *déclassés*, in the same class as tramps and prostitutes, runaway clerics and sent-down students, charlatans and beggars. He has been called the 'journalist of the age',[80] but he really goes in for entertainment of every kind: the dancing song as well as the satirical song, the fairy story as well as the mime, the legend of saints as well as the heroic epic. In this context, however, the epic takes on quite new features: it acquires in places a more pointed character with a new straining after effect, which was absolutely foreign to the spirit of the old heroic ballad. The minstrel no longer strikes the gloomy, solemn, tragi-heroic note of the 'Hilde-brandslied', for he wants to make even the epic sound entertaining; he tries to provide sensations, effective climaxes and lively epigrams.[81] Compared with the monuments of the older heroic poetry, the 'Chanson de Roland' never fails to reveal this popular minstrel taste for the piquant.

Pio Rajna mentions somewhere that he was able to reach nearly the end of his researches on the French epic without even once finding it necessary to use the word 'heroic lay'. Karl Lach-mann, on the other hand, might have said that he could not have

made a single statement of any importance about the epic without using this word. The romantics resolved the epic into the elements of the saga and the song, because they regretted the loss of the irrational forces of history in the epic of the professional poets. Our age, on the other hand, prefers to draw attention, in the epic, as in art generally, to the conscious skill and background knowledge displayed, because it understands the rational better than the emotional and the instinctive. The poems have their own legend, their own heroic history: works of poetry live not only in the form the poets give to them but also in that which they are given by posterity. Every cultural epoch has its own Homer, its own 'Nibelungenlied' and 'Chanson de Roland'. It re-composes these works by interpreting them anew from the standpoint of its own outlook on life. But these reinterpretations are better described as a gradual circling round than as a direct approaching of the works in question. The later interpretation is not necessarily the 'more accurate'; but every serious attempt to interpret a work from the point of view of a living present deepens and widens its significance. Every theory which shows us the epic from a new, historically valid standpoint is useful; for we are concerned here not so much with historical truth, with 'what really happened', as with obtaining a new, direct approach to the subject. The romantic interpretation of the heroic saga and heroic poetry made it clear that the epic poets, however original they were as artists, could by no means do entirely what they liked with their material and felt themselves much more rigidly bound by established traditional forms than the poets of a later age. Again, the song-theory made another generation aware of the cumulative composition of the epics, and, by directing attention to their source in the heroic and aristocratic prize- and war-song, made possible an understanding of their sociological constitution. Finally, the theory of the contribution of the clerics and minstrels shed new light on both the unromantically popular and on the ecclesiastical and learned elements of the genre. Only after all these interpretations had been attempted did it become possible to discover an approach from which the epic can be seen as a kind of 'hereditary poetry'[82] midway between art poetry with its freedom of movement and folk poetry with its strong traditional ties.

6. THE ORGANIZATION OF ARTISTIC PRODUCTION IN THE MONASTERIES

After the reign of Charlemagne the court is no longer the cultural and intellectual centre of the Empire. Scholarship, art and literature are now centred in the monasteries; the most important intellectual work is done in their libraries, writing-rooms and workshops. The art of the Christian West owes its first golden age to their wealth and industry. With the increasing number of cultural centres, brought about by the development of the monasteries, a more marked differentiation of artistic activity takes place. We must not, however, think of these monasteries as completely isolated from one another; as a result of their common dependence on Rome, the universal influence of the Irish and Anglo-Saxon monks, and later through the reformist congregations, they are all connected with one another though not very closely.[83] Bédier has already drawn attention to their points of contact with the lay world, their function in relation to pilgrimages and their rôle as meeting-places for pilgrims, merchants and minstrels. But in spite of these external connections, the monasteries remain fundamentally self-sufficient, self-centred unities, holding fast to their traditions longer and more uncompromisingly than the earlier more fickle courts or later bourgeois society.

The Benedictine rule had prescribed manual as well as intellectual work and even attached greater importance to manual occupations. The monastic estates, like the manor-houses, aspired to become economically as independent as possible and to produce all the necessities of life on their own land. The activity of the monks included work in the fields and gardens as well as handicrafts generally. It is true that even from the very beginning the heaviest physical toil was performed by the free peasants and by serfs attached to the monasteries and later on, apart from the peasants, by lay brothers, but especially in the early period, most of the manual crafts were carried on by the monks themselves; and precisely through its organization of handicraft work, monasticism had the deepest influence on the development of art and culture in the Middle Ages. That the production of art proceeded within the framework of well-ordered, more or less rationally

organized workshops with a proper division of labour, and that members of the upper classes could be enlisted for this work, is the merit and achievement of the monastic movement. It is known that aristocrats were in a majority in the early medieval monasteries; certain monasteries were in fact almost exclusively reserved for them.[84] Thus people who could otherwise probably never have handled a smeary paint-brush, a chisel or a trowel came into direct touch with arts and crafts. It is true that the contempt for manual labour still remains widespread even in the Middle Ages, and the idea of power still continues to be associated with that of an idle existence, but it is unmistakably evident that now, in contrast to classical antiquity, alongside the life of the seigneur, which is associated with unlimited leisure, the industrious life acquires a more positive evaluation and this new relationship to work is connected, amongst other things, with the popularity of monastic life. Even in the bourgeois evaluation of labour of the later Middle Ages, as expressed, for instance, in the regulations of the guilds, the spirit of the monastic rule still lives on. One must not forget, however, that in the monasteries work continues to be regarded partly as a penance and a punishment,[85] and that even St. Thomas still speaks of 'viles artifices' (*Comm. in polit.*, 3.1.4.). For the present there can, therefore, be no question of labour being an ennoblement of life.

Western Europe first learnt to work methodically from the monks; the industry of the Middle Ages is very largely their creation. The artisans, who, as the heirs of the old Roman craftsmen, were still plentiful enough in the towns,[86] worked within very modest limits until the revival of urban economy and contributed little to the development of industrial techniques. There were certainly specialist craftsmen on the royal palatinates and the bigger estates, where compulsory unpaid labour was used, but they were regarded as part of the royal household and domestic staff and their work was still in the nature of purely domestic labour governed more by custom than by practical considerations. The separation of manual crafts from the domestic setting first takes place in the monasteries. Here time is carefully husbanded, the day is divided rationally and the passing of the hours is measured and proclaimed by the striking of a bell.[87] The principle

of the division of labour becomes the basis of production and is practised not only within but also to some extent between the different monasteries.

Outside the monasteries the applied arts were cultivated only on the royal domains and the biggest estates and even there only in the simplest of forms. But it was precisely in this field that the monasteries excelled. The copying and illustrating of manuscripts was one of their oldest titles to fame.[88] The establishment of libraries and writing-rooms, which Cassiodorus had begun in Vivarium, was imitated by most of the Benedictine monasteries. The writers and book-illustrators of Tours, Fleury, Corbie, Treves, Cologne, Ratisbon, Reichenau, St. Albans and Winchester were already renowned in the early Middle Ages. In the Benedictine foundations, the scriptoria were big, communal workrooms, and in the other orders, the Cistercians and Carthusians, for example, smaller cells. Large-scale manufacture and small-scale, individual undertakings must have existed side by side. The work of the copyists and illuminators was, moreover, apparently sub-divided. A distinction was made, apart from the painters (miniatores), between the masters skilled in calligraphy (antiquarii), the assistants (scriptores) and the painters of initials (rubricatores). Besides the monks, the scriptoria also employed hired writers, i.e. laymen who worked partly in their own homes, partly in the monasteries. Apart from book-illustration, the monastic art par excellence, the monks also engaged in architecture, sculpture and painting, were active as goldsmiths and enamel-workers, practised silk- and carpet-weaving, started bell-foundries and book-binding workshops, glass factories and ceramic workshops. Certain monasteries developed into real centres of industry; and whereas Corbie at first occupied only four main workshops with twenty-nine workmen, as early as the ninth century, we find in St. Riquier whole rows of streets filled with the workshops of the armourers, saddlers, bookbinders, cobblers, etc., grouped according to the type of trade.[89]

Not only in agriculture, which makes excessive demands on physical strength and in which the monks, with their increasing wealth, were engaged more and more as landowners and administrators and less and less as labourers, but also in the other

branches of production the monks did only a part of the manual labour and devoted themselves more to organizing the work. They even occupied themselves much less with the copying of manuscripts than is generally supposed, and, to judge from the increase in the number of libraries, not more than a fiftieth part of the working hours of all the monks in a monastery was normally spent on the copying of manuscripts.[90] In the departments which required more physical effort, above all in the building trade, lay brothers and outside workers will have been employed in greater numbers but not so much in the minor arts. Nevertheless, in view of the constant demand of churches and courts for such craft products, it may be assumed that the monasteries were always ready to engage efficient workers and artists in this sphere of their work as well. For apart from the monks and the free or tied workers of the manors, there were also from the very outset manual workers and artists who formed the elements of a free, though small labour market. They were the travelling journeymen who found employment, sometimes in the monasteries, sometimes in the bishops' palaces and the manor-houses, and of whom there is evidence that they were regularly employed by the monks. Thus it is on record, for example, that the abbey of St. Gall and the monastery of St. Emmeran in Ratisbon enlisted many such travelling workmen to make reliquaries. It was a general practice to employ master-builders, as well as stone-, wood- and metal-workers from far and near, especially from Byzantium and Italy, to help with the building of big churches.[91] On the other hand, if the information about the strictly guarded 'secret processes' of the monasteries is based on fact, the employment of such foreign labour will have in some cases been hedged around with difficulties. Whether such secrets existed or not, the monastic workshops were by no means occupied only with the production of articles but were also very often engaged in technological research. The Benedictine monk Theophilus was able, in his *Schedula diversarum artium*, at the end of the eleventh century, to describe a whole series of inventions made in the monasteries, such as the production of glass, the burning of glass paintings for windows, the mixing of oil-colours etc.[92]

The travelling workers and artists were also trained for the

most part in the monastic workshops which were at the same time
the 'art-schools' of the age and made the training of young artists
their special concern.[93] In many monasteries, as for example in
Fulda and Hildesheim, handicraft workshops were set up which
served primarily educational purposes and guaranteed the mon-
asteries and cathedrals as well as the secular manorial estates and
courts with a constant supply of young artists.[94] The monastery of
Solignac, which was founded by St. Eligius, the most famous
goldsmith of the seventh century, achieved a particularly high
standard in its educational work. Another prince of the Church
who is said to have given great service to art as a teacher was
Bishop Bernward, the high-minded patron of architecture and
brass-founding and the creator of the bronze doors of Hildesheim
Cathedral. We often know merely the names of the other less
highly placed clerical artists, but nothing of the part they played
in medieval art. It is true that in the case of the monk Tuotilo
what was known about him became consolidated into a full-size
legend, but, as has been said, this is a mere personification of
the artistic activities of St. Gall and is simply the medieval counter-
part of the Greek legend of Daedalus.[95]

The monastic contribution to the development of church
architecture is very important. Until the growth of the towns and
the advent of the medieval cathedral workshop, church architec-
ture is concentrated almost entirely in the hands of the clergy,
although we must think of the artists and craftsmen employed
in building churches only in part as actual monks themselves.
But the directors of most of the building enterprises, including
the most important, were religious; they seem, however, to have
been more the supervisors than the architects.[96] Incidentally, the
building activities of the individual monasteries were too dis-
continuous for monks, tied to definite foundations, to choose
architecture as a full-time profession. Probably only the un-
attached, mobile laymen could do that. Of course, there are
exceptions to be noted. For example, we know that the monk
Hilduard was the 'maître de l'œuvre' of the Abbey church of
Saint-Père in Chartres. We also know that St. Bernard of Clair-
veaux placed a brother of his order, the architect Achard, at the
disposal of other monasteries and that Isembert, the 'maître de

l'œuvre' of the cathedral of Saintes, built bridges in La Rochelle and England as well as in Saintes itself.[97] However many similar cases there may have been, the minor arts which were associated with less physical exertion were more in accordance with the spirit of the normal monastic workshop than the more monumental forms of art.

The over-estimation of the part played by monasticism in the history of art originates in the romantic period and is part of that legend of the Middle Ages, the survival of which often still makes it difficult for us today to approach the historical facts without prejudice. The rise of the great medieval churches was romanticized in the same way as that of the heroic epics. The principles of that organic, plant-like growth that was stressed in folk poetry were also applied to the churches and all specific planning and consistent direction of the work were contested; the existence of an architect to whom these buildings could be ascribed was denied in the same way as that of the individual poet was denied in the composition of the epics. In other words, the intention was to ascribe the decisive rôle in the arts not to the painstaking and trained artist but to the artisan whose work was done not with conscious thought but simply in accordance with tradition. The anonymity of the artist was also a part of the romantic legend of the Middle Ages. In its ambivalent relationship to modern individualism, the romantic movement represented anonymous creativity as a special mark of greatness and dwelt with particular affection on the picture of the unknown monk creating his work solely for the honour of God, hidden away in the darkness of his cell and in no way obtruding his own personality. But, unfortunately for this romantic theory, in the cases where the names of the artists have come down to us from medieval times, they are nearly always those of monks, and the naming of the artists stops at the very moment that artistic activities pass out of the hands of the clergy into those of the laity. The explanation is simple: whether the name of the artist was to be allowed to appear on a work of ecclesiastical art was decided by religious and they naturally gave pride of place to their own professional brethren. But even the chroniclers, who were in the habit of recording such names and who were themselves exclusively

monks, had an interest in the particular mention of an artist only if he was a fellow-monk. In contrast to classical antiquity or the Renaissance, the impersonality of the work of art and the unobtrusiveness of the artists are beyond doubt. For even when the name of an artist is mentioned and the artist expresses a personal ambition in his work, the idea of individual particularity remains foreign to him and his contemporaries. But all the same, it is a romantic exaggeration to speak of a fundamental anonymity in medieval art. In miniature painting there are countless examples of signed works and at every stage of its development.[98] In connection with the architectural monuments of the Middle Ages it has been possible, in spite of the large number of works destroyed and documents lost, to establish the names of 25,000 artists.[99] One must not forget, however, that often where, in the medieval style, the predicate 'fecit' is added to a name in an inscription, it is the person who commissioned the work that is meant and not the artist who did the work, and that the bishops, abbots and other clerical gentlemen, to whom the buildings were ascribed in this way, were in most cases merely the 'chairmen of the building committee' and neither the actual architects nor the supervisors of building operations.[100]

Whatever part the clergy played in the building of their churches and however the work was divided between monks and laity, somewhere there must have been a limit to the divisibility of functions. Cathedral chapters and abbatial building committees may have made corporate decisions on the ultimate fate of building plans and the artistic problems may have been solved, as a whole, in mutual consultation by a collective body, but the individual steps in the creative process can have been carried out only by individual artists consciously pursuing aims of their own. Such a complicated structure as a medieval church could not arise like a folk song, the creation of which starts, in the final analysis, in the mind of a single unknown individual but which, as opposed to a building, grows without a plan by constant accretions from outside. It is not the idea that a work of art is the shared creation of several personalities that is romantic and scientifically unverifiable, for even the work of the single artist is made up of the contributions of several partly autonomous intellectual faculties,

the union of which is often a delayed and purely external operation. But the idea that a work of art is absolutely and entirely the creation of a group and that it needs no uniform and deliberate plan, however subject to modification, is naïve and romantic.

7. FEUDALISM AND THE ROMANESQUE STYLE

Romanesque art was a monastic art, but at the same time an art of the aristocracy. The combination of these qualities best shows how great was the solidarity between the clergy and the secular nobility. The most important posts in the medieval Church were reserved, like high-priestly office in ancient Rome, for members of the aristocracy;[101] the abbots and bishops were connected, however, with the feudal system not only by their noble birth but also by their economic and political interests. They owed their property and their power to the same social order in which the privileges of the secular nobility were rooted. There existed between the two aristocracies, if not always an explicit, at least a trustworthy alliance. The monastic orders, whose abbots had enormous wealth and legions of subordinates at their disposal, and from whose ranks the most powerful Popes, the most influential advisers and the most dangerous rivals of the Emperors emerged, kept themselves as sublimely aloof from the masses as did the secular lords. A change in their seignorial attitude to the common people first occurs with the ascetic reform movement which began in Cluny, but there can be no question of a change in the direction of a more democratic outlook until after the foundation of the mendicant orders. Set in the midst of their widespread properties, overlooking the slopes of mountains, with views reaching deep down into the countryside, with their steep, massive, bulwark-like walls, the monasteries were just as lordly and unapproachable domains as the forts and castles of the princes and barons—nothing is more understandable than that the art which was created in these monasteries was also in accordance with the character and outlook of the secular aristocracy.

The aristocracy which develops out of the Frankish army and officialdom, and is completely feudalized by the end of the ninth

century, now places itself at the head of society and becomes the real holder of supreme power. Out of the former nobility based on military service there had developed a powerful, proud and rebellious hereditary nobility in whom the memory of its descent from a professional class had long since faded, entirely disappeared in fact, and whose privileges now seemed to have existed from time immemorial. The relationship between the kings and this aristocracy became completely inverted in the course of time; originally the crown was hereditary and the sovereign could choose his advisers and officials as he liked, now the privileges of the aristocracy were hereditary and the kings elected.[102] The Germano-Romanic states of the early Middle Ages faced difficulties which had been felt as early as the later classical age, when the attempt had been made to overcome them by institutions such as the colonate, the introduction of taxation in kind and making the landowners responsible for the state revenue, that is to say, by a system similar to medieval feudalism. The lack of sufficient funds for the upkeep of an adequate administrative service and a suitable army, the difficulty of defending extensive territories against the danger of invasion, had existed since the late Roman period and new difficulties arose in the Middle Ages because of the lack of trained civil servants, the increased and prolonged danger of hostile attacks, and the necessity of introducing armoured cavalry above all against the Arabs, a reform which, owing to the costly equipment and relatively long period of training required, constituted an intolerable burden on the state. Feudalism is the institution by which the ninth century tried to overcome these difficulties, especially that presented by the creation of a mounted and heavily armoured army. For want of other means, military service was recompensed by the granting of landed property, exemptions and seignorial rights and, particularly, by special taxation and legal privileges; and these formed the basis of the new system. Benefices, i.e. occasional gifts of landed property from the royal domains as a reward for services rendered or the granting of the usufruct of such land as payment for regular official and military services, were already in existence in the Merovingian age. The feudal character of the grants and the vassalage of those invested,

in other words, the contractual relationship and the loyal alliance, the system of mutual service and obligation, the principle of mutual fidelity and personal loyalty, which now takes the place of the old system of subordination—all this is new. Feudal tenure, at first merely a usufruct granted for a limited period, became by the ninth century hereditary.

The creation of the feudal cavalry with hereditary tenure as the basis of the service relationship is one of the most revolutionary military innovations in the history of Western Europe: it transforms an organ of the central government into an almost unlimited power in the state and brings the absolute kingship of the Middle Ages to an end. From now on, the king has only so much power as is due to him on the basis of his private estates and only so much authority as he would have even if he held his property as a mere fief. There is no longer any state in our sense in the immediately succeeding epoch, no homogeneous administration, no civic solidarity, no universal, formally legal obligations.[103] The feudal state is a social pyramid with an abstract point as its apex. The king wages wars but does not rule; the great landowners rule, and no longer as officials and mercenaries, favourites and upstarts, beneficiaries and prebendaries, but as independent territorial lords, whose privileges are based not on an official authority derived from the sovereign as the source of law, but purely and simply on their actual, direct personal power. They constitute a master class claiming for itself all the prerogatives of government, the whole administrative machine, all important positions in the army and all the higher posts in the ecclesiastical hierarchy, which thereby attains an influence in the state such as probably no social class had ever possessed before. Even the Greek aristocracy in its prime secured less personal freedom for its members than the weakened royalty of the early Middle Ages had to grant to the feudal lords. The centuries dominated by this aristocracy have rightly been described as *the* aristocratic epoch in European history;[104] in no other phase of Western European development were cultural forms so exclusively dependent on the philosophy, social ideals and economic policy of a single, numerically rather weak class.

The feudal system is, in the moneyless and tradeless period

of the early Middle Ages, in which landed property is the only source of income and the only form of wealth, the ready-made solution of the problems arising from the administration and defence of the country. The ruralization of culture, which had already begun in late classical times, is now complete: the economy is wholly agrarian and life has become absolutely rural. The towns have lost their powers of attraction, the existence of the overwhelming majority of the population is limited to small, scattered, isolated settlements. Social life, trade and intercourse had died out in the towns; life had taken on more simple, more regionally localized forms. The economic and social unity, on the basis of which everything is now organized, is the manor; men have forgotten how to move in wider circles and to think in more comprehensive categories. As money and means of communication, cities and markets are mostly lacking, people are forced to make themselves independent of the outside world, and to forgo both the acquisition of others' products and the sale of their own. Thus a situation develops in which there is almost no incentive to produce goods in excess of one's own needs. Karl Buecher has described this system by the well-known term of a 'closed household economy' and has called it a perfect system of money- and barter-free autarchy.[105] As we now know, his extreme view of the situation is not wholly in accordance with the facts; the hypothesis of an absolutely self-sufficient household economy in the Middle Ages has proved to be untenable,[106] and the suggestion that we should speak rather of an 'economy without outlets' than of a 'barterless natural economy' supplies the necessary corrective.[107] But Buecher merely overstated the case for the existence of the independent estate economy in the Middle Ages, he certainly did not invent it; since no one will deny that there is in fact a tendency to autarchy in the feudal period. The general rule is to consume goods in the household where they are produced, despite the many exceptions and the fact that the buying and selling of goods never stops completely. The distinction between the early medieval production for home consumption and the later production of commodities, already suggested by Marx, is, in any case, a necessary one, and the category of the 'closed household economy' proves to be almost indispensable for the

characterization of the feudal economic system, provided one takes it as an 'ideal type' rather than as a concrete reality.

The most peculiar characteristic of early medieval economy, and, at the same time, the feature by which it exerts its deepest influence on the intellectual culture of the period, is undoubtedly the fact that all inducement to overproduce is lacking and that traditional methods continue to be used and the old rhythm of production observed without any concern for technical inventions and organizational improvements. It is, as has been said,[108] a pure 'outgoing economy', producing only so much as it consumes, in which all idea of profitability, all sense of calculation and speculation, all conception of the planned and rational employment of the forces available, is lacking. The immobility of the forms of society and the rigidity of the barriers separating the various classes is in perfect accordance with the traditionalism and irrationalism of its economy. The classes which make up the society are regarded not only as having their own intrinsic significance but as ordained by God, that is to say, it is almost impossible to rise from one class into another; any attempt to disregard the frontiers between them is equivalent to rebellion against the Divine will for man. In such an inflexible, immobile system of society, the idea of intellectual competition, the ambition to develop and assert one's own individuality, could no more come to the surface than could the principle of commercial competition in an economy without markets, without reward for extra production and without prospect of profit. In conformity with the undynamic spirit of the economy and the static structure of society, a stern, immovable, diehard conservatism also reigns supreme in the scholarship, art and literature of the period. The same inflexibility which binds the economy and society itself to tradition also retards the development of new thought in science and scholarship and delays new modes of experience in art. It introduces that stabilizing and almost stodgy trend into the development of Romanesque art which prevents any deeper change of style occurring for nearly two centuries. Just as the spirit of rationalism, the understanding of exact methods of production and the ability to speculate in figures is absolutely lacking in economic life, and just as on the whole

people have no feeling for figures, for precise timing and quantitative evaluations in everyday life, so the age lacks all the categories of thought based on the concepts of commodity, money and profit. In a word, it lacks the intellectual dynamism induced by the competitive idea. That a pre-individualistic frame of mind is in accordance with a pre-capitalistic and pre-rationalistic economy is all the more easily explained as individualism already contains within itself the principle of competition.

The idea of progress is completely unknown to the early Middle Ages; it has no understanding of the value of what is new, it strives rather to preserve what is old and traditional. And it is not merely the idea of progress as held by modern science which is foreign to its way of thinking;[109] in the comprehension of familiar truths guaranteed by authority, the age is much less concerned with originality of interpretation than with the confirmation and corroboration of the truths themselves. It regards the rediscovery of what has already been established, the reforming of what has already been formed and the reinterpretation of truth as pointless and meaningless. The supreme values are beyond question and contained in eternally valid forms; the desire to change them, merely for the sake of changing them, would be pure presumption. The purpose of life is possession of the eternal values, not mental activity for its own sake. This is a calm, firmly established age, strong in faith, never losing its confidence in the validity of its own conception of truth and moral law, having no intellectual dissension and no conflicts of conscience, feeling no yearning for the new and no boredom with the old. At any rate, it does not lend any support to such ideas and feelings.

The early medieval Church, which enjoyed the authority of the ruling class in all intellectual matters and acted as its mandatary, nipped in the bud any doubts in the absolute validity of the commands and doctrines that flow from the idea of the divinely willed nature of this world and that guarantee the authority of the established order. The culture within which every province of life stood in direct relationship to the faith and to the truths of the Gospel entailed the dependence of the whole intellectual life of society, of all its science and art, of its whole thinking and

willing, on the authority of the Church. The metaphysical-religious conception of the world, according to which all earthly things are related to the world to come and all human beings to the Divine Being and everything is the expression of a transcendent purpose and Divine intention, was used by the Church above all to create an absolutely unrivalled position for the theocracy based on the sacramental priesthood. From the primacy of faith over knowledge the Church derived the right authoritatively and unchallengeably to establish the guiding principles and the frontiers of culture. Such a homogeneous and self-contained outlook on life as that of the early Middle Ages could develop and assert itself only in the form of an entirely 'authoritarian and coercive culture',[110] and only under the pressure of sanctions such as those the Church was able to impose, being in exclusive possession of the instruments of salvation. The strict limitations which feudalism with the aid of the Church imposed on the thinking and feeling of the time explain the absolutism of the metaphysical system, which was as ruthless towards all idiosyncrasies in the field of philosophy as the social system was to all individual freedoms and which made the same principles of authority and hierarchy supreme in the intellectual and spiritual spheres as were inherent in the sociological structure of the age.

All the same, the absolutist cultural programme of the Church is not completely realized until after the end of the tenth century when, under the influence of the Cluniac movement, a new spirituality and a new intellectual intransigence make themselves felt. In pursuit of their totalitarian aims, the clergy now produce an apocalyptic mood of escapism from the world and a yearning for death; they hold men's minds in a state of constant religious excitement, preaching about the end of the world and the Last Judgement, organizing pilgrimages and crusades and excommunicating emperors and kings. In this authoritarian and militant spirit the Church achieves the final consolidation of medieval culture, which now appears for the first time, at the turn of the millennium, in its full unity and individuality.[111] Now the first great Romanesque churches arise, the first important creations of medieval art in the narrower sense of the word. The eleventh century is a brilliant period in the history of church architecture,

just as it is the golden age of scholastic philosophy and, in France, of ecclesiastically inspired heroic poetry. This whole intellectual flowering, above all the rise of architecture to its heights of achievement, would be inconceivable without the enormous growth of Church property which now takes place. The age of monastic reforms is also an age of great benefactions and endowments for the monasteries.[112] Not only the wealth of the monastic orders increases, however, but also that of the bishoprics, especially in Germany, where the kings seek to gain for themselves allies against rebellious vassals in the leaders of the Church. Thanks to their donations, the first great cathedrals now arise alongside the great monastic churches. As is known, the kings have no permanent residence during this period, but take up their quarters with their courts now in a bishop's palace, now in an abbey.[113] Owing to the lack of a capital and a residence, they also carry on no building activity on their own account, but are content merely to give their support to the enterprises initiated by the bishops. Therefore, the great episcopal churches of this period in Germany are rightly considered and described as the 'Emperors'' minsters.

These Romanesque churches are, in accordance with the influential position of their builders, imposing expressions of unrestricted power and unlimited resources. They have been called 'fortresses of God' and they are, in fact, as large, solid and massive as the strongholds and castles of the period—far too large in relation to the size of the congregations. But they were erected ·not merely to serve the faithful but to the greater glory of God and, like the sacred buildings of the Ancient Orient and unlike any architecture of later ages to the same extent, they served as symbols of supreme power and authority. It is true that the dimensions of the Hagia Sophia were equally enormous, but there was some practical reason for its hugeness since it was the principal church of a metropolis, whereas the Romanesque churches were built at best in quiet and secluded little towns—inevitably, for there were no longer any big towns in the West.

It would be very natural to connect not merely the proportions but also the heavy, broad, weighty forms of Romanesque architecture with the powerful social position of the builders, and

to consider them the expression of an inflexible sense of class-supremacy. But it would not explain anything, it would merely confuse the issue. To understand the voluminous and oppressive calm and gravity of Romanesque art, one must appreciate its 'archaism', its return to simple, stylized geometric forms, and these are due to easily intelligible circumstances. The art of the Romanesque period is more simple and homogeneous, less eclectic and differentiated than the art of the Byzantine or Carolingian epoch, because it is no longer a court art and because the cities of the West suffered a further setback after the age of Charlemagne, above all as a result of the penetration of the Arabs into the Mediterranean area and the interruption of trade relationships between East and West. In other words: the creation of art is now no longer subject to the refined and fickle taste of the court nor to the intellectual restlessness of the towns. It is in some ways coarser and more primitive than the art of the immediately preceding period, but it drags along with it much less undigested and unassimilated material than Byzantine and especially Carolingian art. It no longer speaks the language of a more or less imitative culture but that of a religious renewal.

This is once again a religiously inspired art in which the spiritual and secular elements are more or less fused into a single whole, and in which those who experience it at first hand are not always aware of the distinction between the ecclesiastical and secular purposes behind it. At any rate, they feel the gulf dividing the two spheres less acutely than we do, although there can be no longer any question in this comparatively late period of such an absolute synthesis of art, life and religion as the romantics envisaged. For although the Christian Middle Ages were much more deeply and ingenuously religious than classical antiquity, the connection between religious and social life was closer in Greek and Roman times than in the Middle Ages. At least, classical antiquity was nearer in spirit to primitive times to the extent that the state, the tribe and the family were still regarded not merely as social groups but as religious units and religious realities. The Christians of the Middle Ages, on the other hand, separated the natural forms of society from supernatural relationships.[114] The subsequent combination of the two orders in the

167

idea of the *civitas dei* was never complete enough for political groupings and blood relationships to acquire a religious character in the popular mind.

The religious nature of Romanesque art did not, therefore, result from the circumstance that all the expressions of the life of the time were conditioned by religion, for that was in fact by no means the case, but rather from the situation which had developed after the dissolution of court society, municipal administration and central government, and in which the Church had become practically the only source of commissions for works of art. In addition to that, as a result of the absolute clericalization of culture, art was no longer regarded as an object of aesthetic enjoyment but as an 'extension of divine service, as a votive offering and a sacrificial gift'.[115] From this point of view, the Middle Ages stood nearer to the conditions of primitive society than did classical antiquity. But that is not to say that the artistic language of the Romanesque was in any way more intelligible to the broad masses of the people than that of the classical age or of the early Middle Ages. If the art of the Carolingian period was dependent on the taste of a cultured court society, and was, as such, foreign to the common people, art is now the exclusive possession of a clerical élite which, even though it is broader-based than the court society of Charlemagne, does not even include the whole of the clergy. If, therefore, medieval art was a vehicle for ecclesiastical propaganda, its task could only be to put the masses of the people into a solemn but on the whole somewhat vague and indefinite religious frame of mind. The often far-fetched symbolism and sophisticated expression of the works of art depicting religious subjects were certainly often not understood and appreciated by simple Christian believers. Because the forms of the Romanesque style were more concise and less differentiated than those of earlier Christian art, they were not, therefore, by any means more in accordance with simple and popular taste.

With the rhythmic alternation of styles a new phase of abstract, rigid formalism is attained in Romanesque art—after the geometrism of early and the naturalism of later classical times, the abstraction of the early Christian and the eclecticism of the Carolingian age. Feudal culture, which is essentially anti-indivi-

dualistic, favours the general and the homogeneous in art as in other fields, and strives for a representation of the world in which everything is stereotyped, the physiognomies as well as the draperies, the large gesticulating hands as well as the small trees shaped like palm branches and the mountains stiff and sharp like tin. Both this stereotyped formalism and the monumentality of Romanesque art are best expressed in the emphasis on cubic forms and their adaptation to architecture. The sculptural works in the Romanesque churches are, as it were, mere pillars and columns, parts of the architectonic design. Not only the animals and the foliage but also the human figures fulfil an ornamental function in the total pattern of the church; according to the space to be filled up, they are bent and twisted, stretched or reduced in size. The subservient rôle of the detail is emphasized so strongly that the frontier between free and applied art, between sculpture and mere decoration, remains entirely fluid.[116] Here too the idea of correspondence with the authoritarian form of government is a very tempting one. The simplest explanation would be to connect the functional relationship of the various elements in a Romanesque building, and their subordination to the architectonic unity of the whole, with the authoritarianism of the age, and to attribute it to the principle of amalgamation, which dominates the social patterns and is expressed in collective structures such as the universal Church and monasticism, the feudal system and the 'closed household'. But such an interpretation would be rather misleading. The sculptural work in a Romanesque church is 'dependent' on the architectural design in quite a different sense from that in which peasants and vassals are dependent on their feudal lords.

Strict formalism and abstraction from reality are undoubtedly the most important, but by no means the only characteristics of the Romanesque style. For just as a mystic tendency is at work alongside the scholastic trend in the philosophy of the age, and a wild, unrestrained ecstatic religiosity finds expression in the monastic reform movement alongside a strict dogmatism, so also in art emotional and expressionistic tendencies make themselves felt alongside the dominant formalism and stereotyped abstractionism. This less restrained conception of art is not perceptible,

however, until the second half of the Romanesque period, that is to say, it coincides with the revival of trade and urban life in the eleventh century.[117] However modest these beginnings are in themselves, they represent the first signs of a change which paves the way for the individualism and liberalism of the modern age. Externally nothing much is altered for the present; the basic tendency of Romanesque art remains anti-naturalistic and hieratic. And yet, if a first step towards the dissolution of the ties which restrict medieval life is to be discerned anywhere, then it is here, in this astonishingly prolific eleventh century, with its new towns and markets, its new orders and schools, the first crusade and the founding of the first Norman states, the beginnings of monumental Christian sculpture and the proto-forms of Gothic architecture. It cannot be a coincidence that all this new life and movement occurs at the same time as the early medieval self-supporting economy is beginning to yield to a mercantile economy after centuries of uninterrupted stagnation.

In art the change takes place very slowly. It is true that figure sculpture by itself represents a new art, forgotten since the end of the classical age, but its formal idiom remains fundamentally tied to the conventions of the earlier Romanesque school of painting; and as for the proto-Gothic style of the Norman churches of the eleventh century, it is correct to consider it still as a form of Romanesque. The vertical dissolution of the wall and the expressionism of the figures show unmistakable signs, however, of a tendency to a more dynamic outlook. In the overstatements by which effects are now obtained—the displacement of natural proportions, the excessive enlargements of the expressive parts of the face and body, especially of the eyes and hands, the exaggeration of gesture, the ostentatiously deep bows, arms flung upwards, legs crossed in dancing fashion—it is no longer only a question of that phenomenon which, as has been asserted, is present in all primitive art, and merely consists in the 'parts of the body, the movement of which most clearly indicates volition and emotion, being formed in greater size and strength'.[118] We are dealing here with a definite tendency to expressionism.[119] The impetuosity with which art now applies itself to this mode of representation is inspired by the spiritual fervour and activism of the Cluniac

movement. The dynamic force of 'late Romanesque baroque' bears the same relationship to Cluny and the monastic reform movement as the solemn and passionate style of the seventeenth century does to the Jesuits and the Counter Reformation. In sculpture as in painting, in the sculpture of Autun and Vézelay, Moissac and Souillac as in the Evangelists of the Gospel-Books of Amiens and of Otto III, the same asceticism and the same apocalyptic Last Judgement atmosphere are expressed. The slender, fragile figures of the prophets and apostles, consumed by the fire of their faith, which surround Christ on the tympana of churches, the redeemed and blessed ones, the angels and saints of the Last Judgements and Ascensions, are all spiritualized ascetics, imagined, by the pious monks who created this art, as models of perfection.

Even the narrative and scenic representations of later Romanesque art are often the products of a wild, fantastic dream-vision, but in the ornamental compositions, as, for example, in the 'trumeau' of the Benedictine Abbey of Souillac, the fantastic element is worked up into the abstruseness of a delirium. Men, animals, fabulous creatures and monsters are all united in a single stream of rampant life, a chaotic swarming of intertwined bodies which is reminiscent in some respects of the maze of lines in the Irish miniatures and shows that the tradition of this old art is still alive, but it also shows all the changes that have taken place since its golden age and how the rigid geometrism of the early Middle Ages was made fluid by the dynamism of the eleventh century. What we understand by Christian and medieval art is now fully realized for the first time, and the transcendental meaning of the pictures and sculptures completely revealed. Phenomena like the excessive length or convulsive gestures of the figures can no longer be explained on rational grounds, in contrast to the unnatural proportions of early Christian art, which flowed with a certain logic from the hierarchy of the figures represented. In Christian antiquity nature was deformed by the emergence of a transcendent world, but the validity of natural laws remained fundamentally inviolate; here, on the other hand, these laws are completely annulled and with them the predominance of classical conceptions of beauty is also broken. In early Christian art the

deviations from natural reality still moved within the limits of the biologically possible and the formally correct: but now these deviations have become quite irreconcilable with the classical criteria of truth and beauty, and in the end, 'all the intrinsic and specific values of sculptural figures as sculpture came to an end'.[120] The reference to the transcendent is now so predominant that the individual forms no longer have any inherent value of their own; they are now pure symbols and signs. They express the transcendent world no longer merely in negative terms, that is to say, they not only hint at the reality of the supernatural by leaving gaps in the concatenation of the natural and by denying the independent character of the purely natural order; they now depict the irrational and the supramundane in a thoroughly positive and direct manner. If one compares the bodiless, ecstatically convulsed figures of this art with the robust and handsome figures of classical art, in the way that the relief of St. Peter in Moissac has been compared with the 'Doryphoros',[121] then the real nature of the medieval conception of art becomes clearly apparent. Compared with the art of classical antiquity, which is restricted to what is physically beautiful and which avoids in general all reference to psychological and intellectual characteristics, the Romanesque style appears as an art concerned solely with the expression of the spiritual, the laws of which conform not to the logic of sense experience, but to that of the inner vision. The special character of late Romanesque art is to be found in this visionary quality and here is to be found the explanation of the shadowy lengths, the forced poses, the marionette-like motions of its figures.

The delight of Romanesque art in pictorial illustration grows steadily; in the end it is just as strong as its interest in the decorative. The intellectual restlessness of later Romanesque art is expressed, among other things, in the constant widening of the field covered by pictorial representation, which leads to the conquest for artistic purposes of the whole range of Holy Scripture. The new subjects, particularly the Last Judgement and the Passion, are just as typical of the age as the style in which they are treated. The main theme of late Romanesque sculpture is the Last Judgement. It is a favourite subject for the tympana of

church portals. A product of the millenarian psychosis, it is at·the same time the strongest expression of the authority of the Church. The whole of humanity is brought to judgement, and either condemned or acquitted according as to whether the Church is pleading for the prosecution or the defence. To intimidate men's minds, art could have devised no more effective method than this picture of endless terror and eternal bliss. The popularity of the other great theme of Romanesque art, the Passion, is due to a new emotional tendency, although the treatment is in most cases still confined within the frontiers of the old, unemotional, solemnly ceremonial style. It stands, anyhow, midway between the earlier aversion from the representation of the suffering, mortified God and the later morbid revelling in the Saviour's wounds. For the early Christian, educated in the spirit of classical antiquity, there was always something embarrassing about the idea of the Redeemer dying on a criminal's cross. Carolingian art accepts the Oriental image of the crucifixion, but still fights against showing a tortured and humiliated Christ. Divine sublimity and physical agony are incompatible in the mind of the ruling class. Even in the Romanesque representations of the Passion, the crucified Christ does not normally hang from but stands on the cross and is usually shown with his eyes open, quite often wearing a crown and clothed.[122] The aristocratic society of this time had first to overcome its distaste for the representation of the naked body, a distaste influenced by social as well as religious considerations, before it could accustom itself to the sight of a naked Christ. But medieval art continues to avoid showing naked bodies where the subject does not make it absolutely necessary.[123] Corresponding to the heroic, royal Christ who still appears as the victor over the earthly, mortal things, even as he hangs from the cross, we have, of course, a picture of the Madonna which, instead of showing her with all her love and sorrow, as we have been accustomed to seeing her since the Gothic period, shows her as a heavenly Queen exalted above all human cares.

The delight with which later Romanesque art can become engrossed in the illustration of an epic theme is shown most directly in the Bayeux Tapestry, a work which, in spite of being designed for a church, expresses an outlook different from

that of ecclesiastical art. It tells the story of the Norman con-
quest of England in a remarkably fluent style, with many varied
episodes and with a striking love for realistic detail. A diffuse way
of presentation here makes its mark, anticipating the cyclic com-
positions of Gothic art and sharply opposed to the principles of
unity which govern the ·Romanesque conception in general.
Obviously, this is not a work of monastic art but rather the pro-
duct of a workshop which was to some extent independent of the
Church. The tradition that ascribes the embroidery to Queen
Mathilda is no doubt based on a legend, for the work was clearly
done by experienced, professionally trained artists; but the
legend, at any rate, points to the secular origin of the work. No
other monument of Romanesque art gives us such a comprehen-
sive idea of the means which the secular art of this age must
have had at its disposal. It makes the loss of similar works, on the
preservation of which obviously less care was expended than on
that of ecclesiastical art, doubly regrettable. We do not know how
extensive the production of secular art was; it will not have even
approached the output of ecclesiastical art, but it was, at least in
the late Romanesque period to which the Bayeux Tapestry be-
longs, no doubt more important than the small number of surviv-
ing examples might lead us to suppose.

How difficult it really is to discuss the secular art of this
period, on the basis of what we possess, is best shown by the por-
trait, which moves irresolutely halfway, as it were, between
religious and secular art. The individualizing image, with the
emphasis on the personal characteristics of the model, was not yet
understood. The Romanesque portrait is nothing but another
form of official memorial; we meet it either in the dedicatory
pictures of manuscripts or on sepulchral monuments in churches.
But the dedicatory picture, which often portrays the writer and
the painter as well as the person who commissioned or suggested
the manuscript,[124] paves the way, in spite of its solemnity, for the
self-portrait, a very personal genre, though for the moment it is
still treated without any emphasis on the individual features of
the person depicted. The conflict between the two styles is even
more acute in the sculptured portraits on tombs. In early Chris-
tian art the person of the deceased either did not appear at all or

only in a very restrained form; on the tombs of the Romanesque period, however, it becomes the main subject of the whole production.[125] Feudal society, thinking in class-categories, still fights against the emphasis on personal characteristics, but already favours the idea of the personal memorial.

8. THE ROMANTICISM OF COURT CHIVALRY

The rise of the Gothic style marks the most fundamental change in the whole history of modern art. The stylistic ideals that are still valid today—truth to nature and depth of feeling, sensuousness and sensitivity—all have their origin here. Tested by these standards of feeling and expression, the art of the early Middle Ages seems not merely stiff and awkward—so does Gothic work in comparison with that of the Renaissance—but it also seems crude and unpleasing. Not until Gothic times do we once more get works in which the figures have normal proportions, natural movement and beauty in the proper sense of the word. Even in the case of these works, we cannot for an instant forget that they belong to a bygone age. But in the case of some of them at least, we already begin to experience an immediate pleasure that is not merely due to education or religious sentiment. What then were the causes of so radical a change of style? How did this new conception of art, so closely akin to our own, originate? With what material, economic and social, changes is the new style connected? We should not expect the answer to these questions to reveal any sudden revolution, for great as are the differences that mark off the Gothic age as a whole from the early Middle Ages, it seems at first to be simply a continuation and completion of that eleventh-century transition period, during which the economic and social system of feudalism and the static equilibrium of Romanesque art and culture begin to totter. At any rate, the beginnings of monetary and commercial economy and the first signs of a rebirth of the bourgeoisie and of urban craftsmanship all go back to that time.

Looking at this change, it seems as if the economic revolution which in the ancient world gave birth to the culture of the com-

mercial cities of Greece is about to repeat itself; at any rate, the new face of Western Europe has more resemblance to the city-economy of antiquity than to the early medieval world. Once more the centre of gravity of social life shifts from the country to the town; once again the town is the source of all stimulation and the focus of all communications. Hitherto the monasteries were the fixed points upon which plans for a journey had to be based; now it is once again the towns where people meet and come in contact with a wider world. The main difference between the medieval towns and the *poleis* is that the latter were chiefly centres of administration, while the former were almost exclusively centres of commercial exchange. In consequence, the breaking up of the old static forms of life is more rapid and more radical than it was in the city communities of the ancient world.

The question as to what was the immediate cause of this growth of towns—which came first, increased manufacture and expanded activity of the merchants, or an increased supply of money bringing with it a movement to the towns—this question is not easily answered. It is just as likely that the market expanded because the purchasing power of the population had risen, the increased rents of land now providing for increased numbers of craftsmen, as it is that the increased rents were a consequence of the new market towns and their needs.[126] But whatever the actual course of development may have been, the decisive change from the cultural point of view is the rise of two new occupational groups—the artisans and the merchants.[127] There had, of course, been artisans and merchants before; not merely did farms and manors, monastic estates and bishops' palaces—in a word, the various households—keep their own tradesmen, but some country folk also manufactured articles for the free market, and that at a very early date. These small-scale peasant crafts, however, did not amount to a regular production and were generally only carried on at times when a man's land proved insufficient to maintain his family.[128] At this stage, exchange of goods was only occasional; people bought and sold as need arose, and there were no merchants, or only here and there for long-distance trade; at any rate, there was not any well-marked group that could be described as a mercantile class. The producers themselves

normally undertook the sale of their own products; but from the beginning of the twelfth century, we find, alongside of the primary producers, urban craftsmen who were not merely independent, but also regularly occupied as such; similarly we find specialized merchants forming a professional group of their own.

'Urban economy' in the sense of Buecher's theory of economic stages signifies, in contrast to the earlier production for own use, a production for the customer, that is, of goods that are not consumed in the economic unit in which they are produced. It is distinguished from the following stage of 'national economy' in that exchange of goods still takes the 'direct' form—i.e. the goods go direct from the producing to the consuming unit, production as a rule not being for stock or the free market, but to the direct order of definite customers personally acquainted with the producer. We are thus at the first stage of the separation of production from consumption, but still far removed from the completely abstract method of modern production by which goods have to pass through a whole series of hands before they reach the consumer. This difference of principle between the medieval 'town economy' and the modern 'national economy' still remains, even when we pass from Buecher's 'ideal type' of town economy to the actual historical facts; for although pure production to order never existed by itself, the relationship between the tradesman and consumer in the Middle Ages was far closer than nowadays; the producer was not yet faced with a completely unknown and indefinite market as he was later. These characteristics of the 'urban' way of production showed themselves in medieval art in a greater independence of the artist, on the one hand, as compared with the artist of Romanesque times, but, on the other hand, in a complete absence of that modern phenomenon, the unappreciated artist working in a total vacuum of estrangement from the public and remoteness from actuality.

The capital risk, which is the special feature of all production for stock, in contrast to production to order, was borne almost wholly by the merchant, who was, therefore, more dependent than the craftsman upon the vagaries of an incalculable market. It is he who, in this early stage, most truly represents the spirit of money economy and foreshadows the new type of society which

was to come, based on profit and money-making. It is due to him that, alongside of landed property, hitherto the only property of any consequence, a new sort of wealth, that of mobile business-capital, now emerges. Hitherto the stock of precious metals had been almost exclusively hoarded in the form of useful articles, especially gold and silver cups and plates. The small amount of coin in existence was mostly in the possession of the Church and did not circulate; nobody thought of turning it to any advantage. The monasteries, which were the forerunners of rational business management, did lend out money against extortionate interest,[129] but only as occasion might offer; financial capital, if that term should be used at all when speaking of the early Middle Ages, was not exploited. Trade now sets this dead, sterile capital once more in movement. It makes money not merely the universal means of exchange and payment, not merely the most desired form of property; it makes it 'work' and renders it productive once more by using it both for the provision of materials and tools and the speculative piling up of stocks, and also as a basis for credit and banking transactions. All this brings with it the first characteristic signs of the capitalist outlook on life.[130] The mobility of their property, the ease with which it may be exchanged, negotiated and accumulated, increasingly frees individuals from their native environment and from the social station in which they had been born. They rise more easily from one social class into another and take increasing pleasure in impressing upon their fellows their own personal ways of thinking and feeling. Money, making the measurement, exchange and abstraction of values possible, depersonalizes and neutralizes property; it makes the membership of the various social groups depend upon the abstract, impersonal and constantly varying factor of possessing the requisite amount of capital. Thus, in principle, it abolishes the rigid bounds of social castes. As soon as social prestige varies with the amount of money possessed, men are brought down to the level of simple economic competitors; and since the acquisition of this sort of property is due to highly individual gifts of intelligence, business sense, hard-headedness and powers of combination, not to birth, class or privilege, the individual achieves a self-made prestige, whereas the value of

belonging to a particular social group dwindles. In a word, intellectual quality becomes the source of prestige instead of the irrational qualities of birth and breeding.

The money economy of the towns threatens the whole feudal economic system with extinction. The manorial farm, as we have seen, was an economy without an outlet, restricting itself to production for its own use, since its products were unsaleable. As soon, however, as superfluous production could be turned to account, new life entered into this inefficient, unambitious, traditionalist economy. More intensive and more rational methods of production were explored and everything done to produce more than was needed for home consumption. As the landlord's share of the produce was rather strictly limited by tradition and custom, the new gains at first went to the peasants. However, the lord's need for money grew, not merely through the rise in prices that inevitably resulted from increasing trade, but also owing to the temptations of the many costly novelties which were increasingly coming forward. After the eleventh century there was an enormous rise in standards of living, and men's taste in such matters as clothing, armour and housing underwent a prodigious refinement. They were no longer satisfied with what was plain and useful, but required that each article of furniture or clothing should be an object of value. With their stationary income, the land-owning nobility felt oppressed by these conditions and the only way out they could see for the moment was the colonization of any still uncultivated portions of their estates. So they aimed to lease off any available land, including any which had been left untilled through the flight of a peasant, and to commute the former services in kind into money payments—both because they needed money above all else and because they gradually realized that the working of their land by serfs could hardly compete with the newer methods of an age of incipient rationalization. They come more and more to the conviction that the free workman gets through a lot more work than the serf, and that people prefer a heavier but definitely fixed burden to one which is lighter but indefinite.[131] Incidentally, they get all they can out of their critical position; by freeing the serfs they not merely get tenants who bring in more than the serfs did, but they also get cash in

considerable sums for each grant of freedom. Even so, they often fail to make ends meet and, to keep pace with the times, have to raise loan after loan, ultimately even selling off parts of their estates to the wealthy and eager townsmen.

By acquiring such landed properties, the bourgeois hopes above all to consolidate his still rather dubious social status. Landed property is to him a bridge giving access to the higher levels of society, since in that age the merchant or artisan who has left the land is still something of a problem. He is somewhere between the nobility and the peasantry, free like a nobleman, but as plebeian in origin as the lowest villain. Indeed, in a sense, for all his freedom, he ranks below the peasant, being regarded as in a way rootless and outcast.[132] Living in an age in which a personal relationship to the land was looked on as the only full justification for a man's existence, he resides upon a plot which does not belong to him, which he does not till, and which he must at any moment be ready to leave. He shares in privileges hitherto enjoyed by the nobility alone, but he has to buy them with money. He is independent in material things, often richer than many of the nobility, but ignorant how to use his wealth according to the requirements of the aristocratic manner of life—he is in fact a parvenu. Despised and envied both by the nobility and the peasantry, it was long before he succeeded in emerging from this disagreeable situation. In the thirteenth century, however, the town bourgeoisie, if still not quite respectable, is by no means negligible as a social group. From that time on, it stands as the *tiers-état* in the forefront of modern history, and leaves its own characteristic mark on Western civilization. Between the consolidation of the bourgeoisie as a class and the end of the *ancien régime* there are no important changes of structure in Western society,[133] but all the changes that do occur during this period are due to the bourgeoisie.

The immediate result of the emergence of an urban, commercial economy was, as we have seen, a move to level old social differences. But money soon creates new antagonisms. At first it served as a bridge between groups separated by birth; later it becomes a means of social differentiation and brings about class divisions within the original solidarity of the bourgeoisie. Class

antagonisms so aroused overlay, cut across or exacerbate the old differences of estate. All those individuals who follow the same occupation or hold the same type of property, i.e. all the knights, clergy, peasants, merchants and artisans, and again the richer and the poorer merchants, the owners of big and little workshops, the independent master craftsmen and their journeymen, now regard one another as social equals by birth, but as irreconcilable competitors. Such class antagonisms are gradually felt to be more powerful than the former differences of estate. Ultimately, the whole of society is brought into a state of ferment; the former social boundaries become fluid; the new boundaries are sharp enough but are constantly shifting. A new estate had pushed its way in between the nobility and the unfree peasantry, had received recruits from both. The gulf between free and unfree was narrower than formerly; the serfs had in part turned tenants and in part had fled into the towns where they had become free wage-workmen. For the first time they are in a position to dispose freely of their labour and conclude wage-contracts.[134] The introduction of payment in cash in place of the former payment in kind brings with it new, hitherto undreamt-of liberties. In addition to being able to spend his wages according to his fancy, a gain which was bound to increase his opinion of himself, the workman could get free time for himself more easily than before and spend his leisure just as he liked.[135] The cultural effects of all this are incalculable, although the direct influence of the new bourgeois element upon the culture of the time shows itself gradually and not simultaneously in all fields. Apart from certain literary types, such as the *fabliau*, for example, poetry was still addressed exclusively to the upper classes. There were plenty of poets of bourgeois origin at the various courts, but they were generally the mouthpieces and exponents of aristocratic taste. As a customer for works of visual art, the individual bourgeois still hardly counts at all; but the production of such work is now almost entirely in the hands of bourgeois artists and artisans while, through the town-corporations, the bourgeois as 'public' already exerts an important influence upon art, especially upon the form of the churches and monumental buildings of the towns.

The art of the Gothic cathedrals is an urban, bourgeois art, in

181

contrast to the monastic and aristocratic Romanesque; urban and bourgeois in the sense that laymen took an ever-increasing part in the building of the great cathedrals, while the artistic influence of the clergy correspondingly diminished;[136] urban and bourgeois because the erection of these churches is inconceivable apart from the wealth of the towns, their cost going far beyond the means of any individual prelate. And it is not merely the art of the cathedrals which shows traces of a bourgeois outlook; the whole culture of chivalry is to some extent a compromise between old feudal hierarchical sentiment and the new liberal bourgeois attitude to life. The influence of the bourgeois is most strikingly shown in the secularization of culture. Art is no longer the private language of a thin stratum of initiates, but a mode of expression that is understood almost universally. Christianity itself is no longer a religion of the clergy, but develops more and more decidedly into a mass-religion. Its moral content is emphasized at the expense of ritual and dogma;[137] it is humanized and emotionalized. The new tolerance of the 'noble heathen'—one of the few indubitable effects of the crusades—expresses the new religious feeling, freer and more inward, which is characteristic of the age. The mysticism, the mendicant orders and the heresies of the twelfth century are all symptoms of the same trend.

The secularization of culture is primarily due to the existence of the town as a centre of commerce. These centres, where people came together from far and near, where merchants from distant provinces and often from distant countries exchange wares—and no doubt also ideas—must have been the scene of a spiritual interchange quite unknown in the early Middle Ages. International trade also brought a revolution in the trade in works of art.[138] Hitherto such works, consisting chiefly of illuminated manuscripts and products of craftsmanship, only changed hands in the form of occasional presents or in the execution of direct commissions given to particular craftsmen. Sometimes, it is true, objects of art got from one country to another by way of simple theft; thus, for instance, Charlemagne carried off pillars and other pieces of existing buildings from Ravenna to Aix-la-Chapelle. But after the end of the twelfth century, a more or less regular trade in works of art was established between East and West and North and South

—though in the case of northern Europe art was almost exclusively an import. In all fields of life we sense instead of the old parochialism a universalistic, international, cosmopolitan trend of affairs. In contrast with the stability of the early Middle Ages, a large part of the population is constantly on the move; knights undertake crusades, the faithful pilgrimages, merchants journey from town to town, peasants leave their land, artists and artisans roam from one building-site to another, teachers and scholars from university to university—among the wandering scholars there emerges something of the romanticism of the tramp.

Apart from the fact that intercourse between people of different traditions and conventions commonly entails a weakening of traditional beliefs and prejudices, the kind of education a merchant required was such as to lead inevitably to his gradual emancipation from ecclesiastical tutelage. The knowledge of reading, writing and arithmetic so indispensable to the practice of trade was indeed imparted, at least at first, by clerics, but had no real connection with the stock subjects of clerical education such as grammar and rhetoric. Foreign trade presumably also required some knowledge of languages, but not of Latin. The consequence was that the vulgar tongue everywhere found its way into the schools for the laity which in the twelfth century were already to be found in every larger town.[139] But instruction in the mother tongue meant the abolition of the clerical monopoly of education and the secularization of culture; already in the thirteenth century we find educated laymen who knew no Latin.[140]

The change of social structure in the twelfth century is due in the last analysis to an over-laying and displacement of groupings based on occupations. Now, the knights were originally an occupational group, even though they later became a hereditary one. Originally they were nothing but a class of professional soldiers, drawn from very diverse social elements. Formerly the princes and barons, counts and great landlords, had been warriors and had been granted their fiefs primarily as a reward for actual war-service; but the obligations originally attaching to these grants had gradually lost their force; the number of lords of the old nobility who were really expert in war was now—perhaps always had been—too small to suffice for the needs of the inter-

minable wars and feuds of the time. He who wanted to wage war (and who did not!) had to provide himself with a force more numerous and more reliable than the old levies had been. To this was due the rise of knighthood, the knights being drawn mainly from the ranks of the manorial retainers (*ministeriales*). The retinue of any great lord included estate-managers, farm-bailiffs, domestic officials, heads of the various workshops, members of the bodyguard and the watch, these latter comprising personal attendants, grooms and sergeants. Most of the knights derived from this last category of retainers, and so were of servile origin. There was certainly a free element among the knights, not derived from the manorial retainers but consisting of descendants of the old military class who had either never received a fief or had sunk back to the level of the mere paid soldier. The retainers, however, provided at least three-quarters of the whole number[141] and the residue of freemen was not markedly distinguished from them since, before the formal ennoblement of the retainers, there was a complete absence of any 'knightly' group-consciousness among the warriors, whether free or unfree. In those days the only sharp distinction was between landlords and peasants, rich and 'poor', and the criterion of nobility consisted not in any tangible legal rights but in a noble manner of living.[142] Now in this respect there was no difference between the free and the unfree soldiers who followed one of the great nobles to war; before the constitution of the orders of knighthood they all simply counted as his servants.

Both princes and other great lords required mounted warriors and loyal vassals, and as long as there was no money economy, these could only be rewarded by the grant of fiefs; both the princes and the landlords were ready enough to part with all they could possibly spare from their estates so as to increase the number of their vassals. Grants of such fiefs for service began in the eleventh century; by the twelfth the retainers' appetite for them is almost satiated. With the capacity to hold an estate, the retainer takes the first step towards nobility. In general, the well-known process whereby nobilities are formed repeats itself. The warriors receive estates for service rendered or to be rendered; at first they certainly cannot dispose of these as they like,[143] but later the

fiefs become hereditary and their holders independent of their lords. When the fiefs become hereditary, an occupational group of retainers is transformed into a hereditary class of knights. But even after their ennoblement they are a second-class nobility— little nobles with a deeply rooted instinct of servility towards the great nobles. They by no means regard themselves as rivals of their lords—unlike the members of the old feudal nobility, who were all potential pretenders to the throne and an ever-present danger to the princes. At most, the knights change sides when better reward appears to offer; their inconstancy explains the supreme place given to loyalty in the chivalric system of ethics.

This opening of the ranks of the nobility and acceptance of the little fellow of a retainer with his little estate into the same order of knighthood as his rich and powerful lord constitutes the big social novelty of the age. The servitor of yesterday, who had been on a lower rung of the social ladder than the free peasant, is now ennobled and so moves from the company of those without rights into the other, highly desirable hemisphere of the Middle Ages, that of the privileged classes. Seen from this angle the emergence of chivalry is just another instance of the generally increased social mobility and of the same passion to rise which also transformed the serfs into bourgeois and the unfree into free workmen or independent tenants.

If, as appears, the overwhelming majority of the knights were drawn from the retainers, their outlook on life might be expected to colour the whole character and culture of the knights as a class.[144] By the beginning of the thirteenth century, the knights show a tendency to become a closed group to which access is no longer possible. Only the sons of knights could henceforth become knights. The ability to accept a fief or a high standard of living are now no longer enough for a man to be reckoned as noble; strict conditions and the solemn conferment of knighthood according to prescribed ritual have now become indispensable.[145] Access to the nobility is once more bolted and barred, and it is a reasonable assumption that the newly dubbed knights were the keenest advocates of exclusiveness. However that may be, the transformation of the knights into a hereditary and exclusive caste marks a most fateful moment in the history of the medieval

nobility and certainly the most fateful in that of chivalry. Not merely did the new knights henceforward form an integral part, indeed by far the major part, of the nobility, it is now that the chivalric ideal and the class-conscious ideology of the nobles is worked out—by the knights. At any rate, the principles of a noble manner of life and the ethics of the nobility now take on the clear and uncompromising form known to us from the chivalric epic and lyric. We often find the new members of a privileged group to be more rigorous in their attitude to questions of class etiquette than the born representatives of the group; they are more clearly conscious of the ideas which hold the particular group together and distinguish it from other groups than are men who grew up in those ideas. This is a well-known and often-repeated feature of social history; the *novus homo* is always inclined to over-compensate for his sense of inferiority and to emphasize the moral qualifications required for the privileges which he enjoys. In the present case, too, we find that the knights who have risen from the ranks of the retainers are stricter and more intolerant in matters of honour than the old aristocrats by birth. What seems to the latter a matter of course, something that could hardly be otherwise than what it is, appears to the newly ennobled an achievement and a problem. The feeling of belonging to the governing class, one of which the old nobility had scarcely been conscious, is for them a great new experience.[146] Where the old-style aristocrat acts instinctively and makes no pretensions about it, the knight finds himself faced with a special task of difficulty, an opportunity for heroic action, a need to surpass himself—in fact to do something extraordinary and unnatural. In matters in which a born grand seigneur takes no trouble to distinguish himself from the rest of mankind, the new knight requires of his peers that they should at all costs show themselves different from ordinary mortals. The romantic idealism, the self-conscious 'sentimental' heroism of chivalry are idealism and heroism at second hand, and originate primarily in the ambition and the deliberation with which this new nobility set about developing the notions of its own peculiar honour. Its zeal is only a sign of unsureness and weakness which the old nobility does not, or at least did not, suffer from as long as

uninfluenced by the new, inwardly unstable, company of the knights. This instability shows itself most strikingly in its equivocal attitude to the conventional forms of noble living. On the one hand, it clings to the superficialities and exaggerates the formalities of the aristocratic manner of life; on the other hand, it sets inward nobility of soul above the outward and purely formal nobility of birth and manners. Conscious of its subordinate position, it exaggerates the value of mere forms, but conscious also of possessing capacities equal to or even greater than those of the old aristocracy, it, at the same time, depreciates the value of such forms and of noble birth as such.

The exaltation of noble character above noble origin is also a sign of the thorough-going christianization of the feudal warrior-caste—the result of a long development leading from the rough professional warrior of the age of migrations to the knight of God of the high Middle Ages. The Church encouraged the formation of the new chivalric nobility with all the means at her disposal, consolidated its social position by a form of consecration, charging it with the protection of the weak and oppressed, recognizing it as the Army of Christ, and so raising it to a kind of spiritual dignity. The Church's real object was, no doubt, to check the process of secularization which proceeded from the towns and which otherwise might well have been accelerated by the knights, who were usually poor and relatively traditionless. The worldly tendencies in chivalry were in fact so strong that their attitude to Church doctrine, in spite of the premium set upon orthodoxy, was very much of a compromise. All the cultural innovations of chivalry, its ethics, its new conception of love and the poetry in which this was expressed, betray the same antagonism between worldly and other-worldly, sensual and spiritual impulses.

The whole system of knightly virtues is, like the ethics of the Greek aristocracy, permeated by the idea of kalokagathia. None of the knightly virtues are obtainable apart from physical strength and training—still less are they founded upon an actual denial and mortification of those bodily excellencies, as the original Christian virtues were. In the various parts of the system, which comprises those virtues that we may call the Stoic, the chivalric, the heroic and the aristocratic (in a narrower sense of the word),

the relative value of physical and bodily qualities is different, but nowhere does the physical factor quite lose all significance. The first group in fact contains—as has been remarked of the system as a whole[147]—neither more nor less than the well-known principles of ancient ethics in a christianized form. Force of character, endurance, moderation and self-control formed the basic conceptions of the Aristotelian, and later, in a more uncompromising form, of the Stoic ethics: the knights simply took this over, chiefly through the medium of medieval Latin literature. The heroic virtues, especially contempt for danger, pain and death, unqualified loyalty, the quest of fame and honour, were already highly prized in early feudal times; chivalric ethics merely softened the heroic ideal of that epoch, giving it a new emotional tinge, but retaining it in principle. The new attitude to life expresses itself most clearly and directly in the peculiarly 'chivalrous' and 'seigniorial' virtues: firstly in magnanimity towards the conquered, protection of the weak and respect towards women, in courtesy and gallantry, and secondly in the qualities that still characterize the modern gentleman, such as generosity, relative indifference to chances of profit, fairness and decency at all costs. No doubt, chivalric ethics did not remain entirely uninfluenced by the outlook of the emancipated bourgeois, but their cultivation of these noble virtues brought them into sharp conflict with the commercial spirit of the bourgeoisie. The knights felt their material existence threatened by the bourgeois money economy, and felt nothing but hatred and contempt for the economic rationalism, the calculation and speculation, the saving and bargaining, of the merchants. Their manner of life, permeated by the principle of *noblesse oblige*, their extravagance, their ostentation, their contempt for all manual work and all regular pursuit of gain, is thoroughly unbourgeois.

A more difficult task than the historical analysis of chivalric ethics is that of tracing the derivation of the other two great cultural achievements of chivalry—their new ideal of love and the new type of lyric in which this was expressed. It is obvious from the start that these cultural forms are intimately bound up with life at the courts. The court is not merely a background but the very soil out of which they grow. This time, however, it is

not the king's court but those of the princes and feudal magnates which take the lead. In particular, it is the small scale of these courts that explains the relatively free and individualized character of chivalric culture. Here everything is less solemn, less ceremonious, incomparably freer and more elastic than at the royal courts which had been the centres of culture in other days. Even at these little courts conventions were still fairly strict. 'Courtly' implies conventional, and always has done, for it is of the very essence of a courtly culture that it should set bounds to the explosive and unruly individuality of men and direct it along well-trodden paths. The representatives of this relatively free court culture still owe their special position not to any qualities that mark them off from the rest of the members of the court, but to a bearing which they have in common with the rest. In this form-governed world originality is disallowed as discourteous.[148] Membership of the court circle is in itself man's highest prize and highest honour; insistence on one's own individuality here seems like a sort of contempt for this privilege. Thus the whole culture of the epoch has its being within the bounds of more or less rigid conventions. The manner of social intercourse, the expression of emotion, indeed the emotions themselves, but also the forms of poetry and art, the descriptions of nature and the figures of the lyric, the 'Gothic curve' or the polite smile of the statues, all these are stereotyped.

The culture of medieval chivalry is the first modern form of culture based on court organization, the first in which there is a real spiritual unity between the princes, the courtiers and the poets. The 'courts of the Muses' are not merely instruments of princely propaganda or subsidized educational institutions, but organs for the fulfilment of a purpose common to those who discover and those who practise noble forms of life. Such a unity was possible only after access to the highest levels of society had been opened to poets from the lower strata, now that a very complete similarity of manners, hitherto inconceivable, had come to exist between the poets and their audiences, and now that the words 'gentle' and 'simple' had come to signify not merely differences of birth but of education, so that a man was not necessarily gentle by mere birth and rank but must become so by training

of mind and character. It is sufficiently evident that such a standard of value could only have been established by a 'professional nobility' which still remembered how its own privileged position had been achieved, not by a born nobility that had enjoyed these privileges from time immemorial.[149] Now this development of knightly kalokagathia, that is, of a new culture attributing moral and social value to aesthetic and intellectual excellence, opened a new gulf between spiritual and secular education. Leadership, especially in poetry, now passed from the clergy, with their one-sidedly spiritual outlook, to the knights; monkish literature loses the leading rôle it had formerly held and the monk is no longer the representative of the age; its typical figure is the knight as he is portrayed, for example, in the 'Rider of Bamberg', noble, proud, intelligent, the fine flower of spiritual and bodily training.

The courtly culture of the Middle Ages is distinguished above all from every earlier court culture—even from that of the Hellenistic courts, which also was strongly influenced by women[150]—by its markedly feminine character. It is feminine not merely in that the women take part in the intellectual life of the court and influence the line of poetic creation, but also in that the thought and feeling of the men is in many respects feminine. Unlike the old heroic poetry and even the French *chansons de geste*, which were written for an audience of men, the Provençal love songs and the Breton romances of Arthur are primarily addressed to women,[151] and Eleanor of Aquitaine, Marie of Champagne, Ermengarde of Narbonne and the rest of the patrons are not merely great ladies holding 'literary salons', not merely connoisseurs whose suggestions are of decisive importance; often it is actually they who speak through the mouth of the poet. The men in fact owe their aesthetic and moral education to women, while women are the source, object and audience of poetry—and this is not the whole story; not merely do the poets address themselves to women, they see the world through the eyes of women. Woman, who in ancient times had been simply the slave, the possession of man, a prize of war and conquest, whose fate even in the early Middle Ages was still much dependent on the arbitrary will of family and lord, now achieves a position which seems

at first quite incomprehensible. Even though the improved education of women might be attributed to the constant pre-occupation of their men by military service and to the progressive secularization of culture, we should still have to explain how mere education came to have such prestige as to enable the women to bear rule over society. Again, the new jurisprudence, which in certain cases allowed a daughter to inherit the throne and a widow to take over a great feudal estate, may have contributed in a general way to the increased prestige of the female sex,[152] but by itself this is hardly a sufficient explanation. The chivalric conception of love cannot be adduced in explanation for the very fact that it is not a cause but a symptom of the new position of women in society.

Love was not a discovery of the chivalric poets of the courts but it took on a new meaning through their work. In Greco-Roman literature, it is true, the love motif comes increasingly to the fore, especially after the end of the classical period, but it never takes on the importance which it has in the court poetry of the Middle Ages.[153] The action of the *Iliad* revolves around two women, but it is not a love story; put any other object of competition in the place of Helen and Briseis and the poem would not be essentially altered. In the *Odyssey* the Nausikaa episode has a certain emotional value of its own, but it is just a single episode and no more. The relations of the hero to Penelope are still altogether on the same plane as those in the *Iliad*; woman is a possession and part of the inventory of a house. The Greek lyric of classical and pre-classical times deals only with sexual love. This may be a source of the utmost joy or sorrow, but is confined to its own particular sphere and without influence on the personality as a whole. Euripides is the first poet in whom love becomes the principal motif of a complicated plot and of dramatic conflict. Old and new comedy take over this promising motif from him, and so it gets into Hellenistic literature, there taking on certain romantic and sentimental features, especially in the 'Argon-autica' of Apollonius. But here, too, love appears at most as a tender emotion or a violent passion, not as a sovereign principle of education, an ethical power and channel of the deepest experience of life as it is in the poetry of chivalry. It is well known how

much Virgil's Dido and Aeneas owe to the Jason and Medea of Apollonius and again what Medea and Dido, the two most popular love-heroines of antiquity, signified for the Middle Ages and so ultimately for the whole of modern literature. It was the Hellenists who discovered the special attraction of the love story, created the first romantic love idylls—the tales of Cupid and Psyche, Hero and Leander, Daphnis and Chloe. But apart from the Hellenistic age, love as a subject of romance has no place in literature until the rise of chivalry; the sentimental treatment of the emotion of love, the development of tension out of the uncertainty whether the lovers are going to get each other or not, are not effects which poetry strove after either in classical times or in the early Middle Ages. In the ancient world the taste was for tales of heroes and for myths, in the early Middle Ages for tales of heroes and saints; if the love motif entered into this at all there was no glamour of romance about it, since even the poets who took love seriously shared Ovid's notion that it was a disease robbing man of intelligence and sapping his will-power, making him wretched and pitiable.[154]

Characteristic of chivalric, in contrast with classical and early medieval poetry, is above all the fact that love, although spiritualized, never becomes a philosophical principle as it was in Plato and Neoplatonism; on the contrary, it retains its sensual and erotic character and precisely as such effects the rebirth of the moral personality. New in chivalric poetry is the cult of love, the notion that it is to be guarded and tended; new the belief that love is the source of all that is good and beautiful, and that every odious action or unworthy sentiment constitutes a betrayal of the loved one; new is the tenderness and inwardness of feeling, the pious awe which the lover experiences at the least thought of the lady he loves; new the unending, unsatiated and insatiable because unbounded desire of the lover; new the happiness which is independent of any consummation and remains a supreme blessedness, even in spite of complete lack of success; new finally is the softening and feminizing effect of love on the man. The very fact that the man is suitor is a reversal of the original relationship between the sexes. In archaic and heroic times, when slave hunting and seduction were everyday happenings, wooing

by the man is unknown. For the man to woo for the woman's love is equally contrary to the habits of the people; here it is the woman and not the man who sings the love songs.[155] Even in the *chansons de geste* it is the woman who makes the advances, but in chivalric circles such behaviour seems discourteous and improper. Courtesy requires that the woman should be cold and that the man should pine. The courteous and chivalric attitude is one of endless patience and utter selflessness in the man, involving the extinction of his own will and the sacrifice of his own being to the will of the woman as a superior being. Courtesy demands of the man complete acceptance of the fact that the object of his worship is wholly unattainable; self-indulgence in the pains of love, an emotional exhibitionism and masochism—all features of modern love-romanticism which here occur for the first time. The lover as longing and renouncing, love as something to which attainment and fulfilment are irrelevant and which is even enhanced by its negative character, a 'love of the remote' without any tangible or even any clearly defined object—all this ushers in the history of modern poetry.

How then can the emergence of this extraordinary ideal of love that seems so incompatible with the heroic feelings of the time be explained? Is it intelligible that a lord, a warrior, a hero, should utterly repress his proud, masterful personality, implore a woman for love, or rather for the boon of merely being permitted to declare his own love—should be willing to accept for his devotion and loyalty a smile, a gracious glance, a friendly word? The queerness of the situation is enhanced by the circumstance that for all the moral rigour of the medieval outlook, this lover openly declares his by no means chaste feelings towards a married woman, who in addition is normally the wife of his liege lord and host. The final oddity is that penniless and homeless minstrels declare their love for their lords' and patrons' wives no whit less freely and frankly than the noble lords do, begging and expecting the same favours as any prince or knight.

In attempting to solve this problem nothing is more obvious than to suppose that these views and this kind of erotic serfdom of the man were merely the outcome of the general legal conceptions of feudalism, that the courtly-chivalric conception of love

is a mere extension of the political relationship of vassalage into the field of sex relationships. This idea, that love-service is an imitation of vassal-service, was in fact put forward in the earliest days of research into troubadour poetry.[156] That particular version which makes chivalric love a mere by-product of knight-service and regards love-vassalage as nothing more than a metaphor is more recent and was first formulated by Eduard Wechssler.[157] The older idealistic theory of the origin of vassalage derives the social relationship from the ethical one, holding that the idea of fealty required both the lord's personal approval of the vassal and the vassal's confidence in and personal attachment to his lord.[158] But Wechssler's theory asserts that the vassal's 'love', whether for lord or lady, is nothing but a sublimation of his subordinate social position. These love songs, according to him, are no more than an expression of the vassal's homage to his liege, a variant of the political panegyric.[159] The fact is that chivalric love poetry derives from the ethics of fealty not merely forms and expression, images and similes, the troubadour not merely declares himself the devoted servant and loyal vassal of the beloved lady, he even goes so far as to request of her his rights as a vassal and to maintain his claim to reciprocity of loyalty and to favour, protection and aid. These pretensions are clearly just formulae of court convention. Such a transference of vows from the lord to his lady becomes particularly plausible when we take account of the long and repeated absence of barons at the wars and the important circumstance that during their absence from court and castle the powers of the liege-lord were exercised by women. Nothing was more natural than for poets in the service of these courts to sing the praises of the lady and to voice this in those ever more gallant forms which they deemed appropriate to flatter feminine vanity. Wechssler's theory, that the whole love-service, that is, the courtly cult of love and the gallant forms of the chivalric love lyric, was really not the creation of the men but of the women who employed them for the purpose, is therefore not to be rejected out of hand. The most powerful argument which has been adduced against this theory is that the oldest troubadour of all, William IX, Count of Poitiers, the first to clothe his declaration of love in the form of a vassal's homage, was not

a vassal but a mighty prince. This objection is not, however, entirely convincing, since the declaration of fealty may in the case of the Count of Poitiers have been just a poetical conceit that happened to occur to him, while in the mouth of the later troubadours it might none the less have been based on the real facts of the situation. In fact, it must have been, for otherwise a particular poetical conceit of this kind would not have taken so widespread and tenacious a hold. Even though in the inventor's case it may not have corresponded to his personal circumstances, it was at least grounded in the general conditions of the time.

Whether based on a real or fictitious relationship, the terms of the chivalric love poem seem from the very start to be fixed by established literary convention. The troubadour lyric is 'society poetry' in which even real experiences have to be clothed in the fixed forms of the prevalent fashion. In poem after poem the beloved lady is extolled in the same terms, decked out with the same qualities, represented as embodying the same virtue and beauty; all the poems employ the same rhetorical formulae to such an extent that one could take them all to be the work of one and the same poet.[160] So powerful is this literary fashion, so inescapable the conventions of the court, that one gets the impression that the poets had no more than an abstract ideal in mind, not any individual woman—that their sentiments are derived rather from literary examples than from any living person. It was, presumably, this impression in the main that led Wechssler to declare the entire chivalric love to be fictitious and to deny that there was any real experience of the emotions described in these love songs, except in the rarest instances. The praise of the lady, in his opinion, was genuine, but any love on the part of the singer was normally just a conventional falsehood, the agreed formula of praise. The ladies wanted to be sung and praised for their beauty; no one cared about the credibility of the love that this beauty was supposed to inspire. The emotional element in the wooing was 'conscious self-deception', a well-understood society pastime, an empty convention. Any expression of strong and genuine feeling, Wechssler holds, would not have been at all agreeable either to the lady or the courtiers, it would have been an offence against order and decency.[161] There could be no

question of the lady reciprocating the troubadour's love since, quite apart from difference of rank, the merest suggestion of adultery would have been heavily punished by the husband.[162] The declaration of love was intended as a rule to give the poet a pretext for complaints about her cruelty, and such complaints themselves were really conceived as praise for the lady's irreproachable chastity.[163]

To prove this fiction theory untenable, the high artistic value of the love songs is emphasized, and the old familiar argument adduced that all genuine art must be sincere and based on firsthand experience. In reality, every aesthetic quality, even the emotional value of a work of art, lies beyond such questions as whether it is sincere or insincere, spontaneous or affected, original or academic—for one can never really be sure what the artist did feel, or whether the feelings aroused by contemplation of the work really correspond to those that called forth its production. It is questioned whether the troubadour's love songs, had they contained nothing more than paid flattery, as Wechssler asserts, could possibly have commanded the interest of so large a public,[164] but we must not underrate the power of fashion in a conventionally minded court society; nor was the public really so large, even though it was to be found in all the countries of Western Europe. However, though neither the artistic value of chivalric poetry nor its success necessarily prevent us from stamping it as 'fictitious', we still cannot accept Wechssler's theory without qualifications. Knightly love is certainly a variant of vassalage and as such 'spurious', but it is not a conscious fiction or intentional masquerade. Its erotic kernel is genuine, even though in disguise. Troubadour love and love poetry lasted too long to be a mere fiction. The successful literary expression of fictitious emotions is not, as has been asserted,[165] without parallel in history; the maintenance of such a fiction for generations would certainly be.

Though the vassalage relationship permeated the whole social structure of the age, we should be at a loss were it not for the promotion of retainers to knighthood and the new and exalted position of the poet at court, to explain why this subject was so suddenly taken up, until the whole emotional content of poetry became clothed in terms of this relationship. Any true under-

standing of the new conception of love must take account of the newly constituted, often propertyless knights, and the ferment that went out from this heterogeneous social group, no less than of the general legal forms of feudalism. There were many born knights, younger sons for whom the paternal estates no longer sufficed, who now roved penniless about the world, often to eke out their living as wandering singers, but if at all possible to establish themselves in service at the court of a great lord.[166] A large number of the troubadours and minnesingers were of humble origin, but since a talented minstrel with a great noble as his patron could easily rise to be a knight, differences of birth were no longer of such great importance. Such knights, who were impoverished and uprooted, were often naturally enough the most advanced exponents of knightly culture. In consequence of their poverty and their social displacement, they felt a certain freedom from social ties and obligations that was impossible to the old feudal nobility. They could, without losing face, dare innovations which to others with firmer roots in society would have seemed fraught with the gravest objections. The new cult of love and the cultivation of the new sentimental court poetry was in the main the work of this floating element in society.[167] They clothed their homage to their lady in the form of love songs couched in courtly but not entirely 'fictitious' terms; they were the first to give a place to service to the lady alongside of service to the lord; it was they who interpreted liege-loyalty as love and love as liege-loyalty. Now in this translation of an economic and social situation into erotic terms, motives of a sex-psychological character also played their part, but these too were sociologically conditioned.

At the courts and castles there were invariably plenty of men and very few women. The lord's entourage consisted of men who were mostly unmarried. Girls of noble families were brought up in nunneries and seldom seen. The princess or lady of the castle was the centre around whom all the life of the place revolved. Knights and court singers all paid homage to this well-educated, wealthy and powerful lady who no doubt may often have been young and attractive as well. Daily contact between a host of young unmarried men and so desirable a woman in

insular seclusion from the outside world, the caresses of husband and wife which they would inevitably witness with the ever-present thought that she belonged to him wholly and to him alone—all this must have produced in so insular a world a state of erotic tension. This tension, since it had as a rule no other means of satisfaction, found expression in the sublimated form of courtly love. The beginnings of this nervous eroticism would date from the time when many of the young men now in the lady's retinue first came to court, as children into her household, and spent the most important years for a boy's development under her influence.[168] The whole system of chivalric education favoured the growth of strongly erotic ties. Till his fourteenth year a boy was entirely under the control of women, spending his childhood in the care of his mother and the subsequent years in that of the lady of the court, who supervised his education. For seven years he remained in the service of this lady, attended her about the house, accompanied her on journeys and was instructed by her in all the arts of courtly behaviour, in courtly manners and accomplishments. The whole enthusiasm of a half-grown boy would be concentrated upon this lady and his fancy would form his ideal of love after her image.

The patent idealism of courtly-chivalric love should not blind us to its latent sensualism. Nor can we fail to recognize that it grew out of a revolt against the Church's requirement of chastity. The success of the Church in repressing sexual love had at all times fallen far short of her ideals,[169] but now that the boundaries of the social groups and so also the standards of moral value became more fluid, the repressed sensuality broke out with re-doubled force and overwhelmed the manners not only of court circles but to some extent of the clergy too. There is hardly an epoch of Western history whose literature so revels in descriptions of the beauty of the naked body, of dressing and undressing, bathing and washing of the heroes by girls and women, of wedding nights and copulation, of visits to and invitations into bed, as does the chivalric poetry of the rigidly moral Middle Ages. Even such a serious work, and one written with such a high purpose, as Wolfram's 'Parzival' is full of descriptions that border upon the obscene. The whole age lives in a state of constant erotic tension;

one need only mention the strange custom—well known to us from accounts of tourneys—by which the hero wore the veil or the chemise of the beloved lady next to his skin, with the magical effects ascribed to this fetish, to get a picture of this eroticism. Nothing more sharply reflects the inner contradictions in the emotional world of chivalry than its equivocal attitude to love, which combined the highest spiritualization with extreme sensuality. But illuminating as is a psychological analysis of the equivocal nature of these emotions, the psychological facts are a product of historical circumstances which in turn require explanation and can only be explained sociologically. The psychological mechanism of this attachment to the wife of another, and of this intensification of emotion through the freedom with which it could be expressed, could never have been set in motion without the force of ancient religious and social taboos having first been weakened and the soil prepared for such an exuberant growth of erotic feelings by the rise of a new emancipated upper class. In this case, too, psychology, as so often, is only unclear, disguised, incompletely worked-out sociology. The majority of historians, however, faced with the change of style which the rise of knighthood brought about in all fields of art and culture, cannot rest content with either a psychological or a sociological explanation; they feel bound to search for some direct historical influences, some direct literary borrowings.

Many have followed Konrad Burdach in tracing the novel aspect of knightly love and troubadour poetry to Arabic sources.[170] Now there are, as a matter of fact, quite a number of motifs common to Provençal love lyrics and the Moslem court poetry, above all the same rapturous exultation in sexual love and the same pride in suffering for love. But there is no real evidence that these common features, which by no means make up the whole conception of chivalric love poetry, were taken over into troubadour poetry from Arabic literature.[171] One of the most important points which tends to discredit this notion of direct influence is the fact that the songs of the Arab poets are generally addressed to a slave and that there is no trace in them of any mingling of the notions of liege-lady and loved one—which is the very kernel of the chivalric conception.[172] The theory that

derives all this from classical Latin sources is no more tenable. Rich as are the Provençal love songs in particular motifs and in particular ideas which go back to ancient literature, above all to Ovid and Tibullus, the spirit of those pagan authors is quite alien to them.[173] Knightly love poetry is, in spite of its sensualism, thoroughly medieval and Christian; it remains, in spite of its novel tendency to portray individual feelings (in striking contrast to Romanesque poetry), far more remote from reality than Roman elegiac poetry. This latter is always concerned with a real love experience, whereas love for the troubadours, as we have seen, is to some extent a poetical pretext, a general tension of soul that is almost without any definite object. However conventional a particular occurrence on which the poet tries out the resonance of his heart-strings, his raptures, his exaltation of women, his attention to his own soul, the passion with which he tears his feelings apart in analysis of his heart's experiences—all this is genuine and utterly alien to the classical tradition.

Least convincing of all the theories of the origin of the troubadour lyric is that which derives it from the folk song.[174] On this theory the origin of the courtly love canzone was a May folk dance, the so-called 'chanson de la mal mariée'; the subject of this was always a young married woman who once a year in May threw off the fetters of marriage and took a young lover for a single day. The only connection of all this with troubadour poetry is the significance of spring—the starting with a nature-setting (*Natureingang*)[175] and the adulterous character of the love;[176] but these features, to all appearance, derive from court poetry and pass from it into folk poetry. There is no trace of a *Natureingang* older than the extant court poetry.[177] The proponents of the folk-song theory, above all Gaston Paris and Alfred Jeanroy, incidentally employ the same method by which the romantics imagined that they could prove the spontaneity of 'folk epic'. Starting from existing, relatively late examples that are definitely not folk literature, they assume the existence of an earlier folk poetry; then they derive from this arbitrarily invented, unproven and doubtless non-existent stage of development the very poems with which they began.[178] Now, it is certainly likely enough that folk-song motifs, snatches of popular wisdom,

proverbs and turns of speech found their way into chivalric poetry, which also, no doubt, caught up some of the 'poetical sanddrift' from ancient literature that was embedded in the speech of the time,[179] but the supposition that the courtly love canzone developed out of the folk song is unproved and unlikely to be proved. It is possible that there was in France before the rise of the courtly poetry some simple popular form of love lyric; but this is in any case completely lost and we are nowise justified in regarding the refinements, the scholastic complexities, the frequent intellectual and emotional virtuosity of chivalric love poetry as survivals of this lost and doubtless very naïve folk poetry.[180]

The most important external influence seems to have come from the Middle Latin poetry of the clergy. The chivalric conception of love as a whole was certainly not formulated by clerics, but secular poets may have taken over from them some of the most important features of that conception. The pre-chivalric clerical tradition of love-service, such as has been posited,[181] certainly never existed. It is true that the friendly correspondence between clerics and nuns reveals even in the eleventh century some curious sentimental relationships which hover between friendship and love, and already betray that mingling of the spiritual and sensual familiar to us in chivalric love; but these are just another symptom of the general spiritual revolution which set in with the crisis of feudalism, and reached its fulfilment in the courtly culture of chivalry. The relations between the knightly love lyric and Middle Latin clerical literature is, therefore, one of parallelism rather than of cause and effect or deliberate borrowing.[182] As far as technique went, the knightly poets certainly learnt a good deal from the clergy; in their first essays at poetry it is manifest that they had the forms and rhythms of the Church hymns in mind. There are also points of contact between chivalric love poetry and the clerical autobiographies of the age which, compared with those of the preceding age, reveal a novel and indeed modern character; but these points of similarity, above all the increased sensibility and more accurate analysis of psychical states, are also connected with the general social upheaval and the new valuation of the individual;[183]

whether found in ecclesiastical or secular literature, they go back to a common root in social history. The spiritualizing tendency of courtly-chivalric love is doubtless of Christian origin; but there is no need to suppose that troubadours and minnesingers took this over from clerical poetry—the whole emotional life of Christianity was permeated with it. The worship of women may well have been conceived on the pattern of the Christian worship of saints,[184] but the pretended origin of love-service in the service of Our Lady, a characteristic invention of the romantics,[185] is without the slightest historical basis. There is little sign of any worship of the Virgin in the early Middle Ages, and the beginnings, at any rate, of troubadour poetry go back further. Worship of the Virgin did not inspire the new conception of love, but itself gradually took on the quality of courtly chivalric love. Finally, the debt of the knightly conception of love to the mystics, primarily Bernard of Clairvaux and Hugh of St. Victor, is by no means as clear as was formerly supposed.[186]

But whatever the various factors determining or influencing it, troubadour poetry is lay poetry of a character utterly antagonistic to the ascetic, hieratical spirit of the Church. The clerical amateur now finally gives place to the secular poet, thus bringing to an end the period of nearly three centuries in which the monasteries were almost the sole homes of poetry. Even during the intellectual supremacy of the monks, the nobility had still continued to form a part of the literary public; but the appearance on the scene of the knight as poet signified, in contrast to the former more or less passive rôle of the laity, something so novel that it must be regarded as marking one of the most profound breaks in the history of literature. One must not, however, think of the social change which set the knight at the head of cultural development as more uniform and universal than it really was. Alongside of the knightly troubadour there was still the professional minstrel to whose level the knight, in so far as he has to depend on his art, may sometimes sink, but who nevertheless represents a separate social stratum. Besides the troubadour and the minstrel, there were naturally still clerics who busied themselves with poetry, though from the point of view of literary history they no longer played a leading part. And finally, there

were the historically and artistically most important group of the wandering scholars, the *vagantes*, who led a life very similar to that of the wandering minstrel and were frequently confused with him, but who none the less, in their pride of education, always took pains to keep themselves distinct. The poets of the age belonged to almost every level of society; we find among them kings and princes (Henry VI and William of Aquitaine), representatives of the great nobles (Jaufré Rudel and Bertran de Born), of the lesser nobles (Walther von der Vogelweide), of the retainers (Wolfram von Eschenbach), bourgeois minstrels (Marcabru and Bernart de Ventadour) and clergy of all degrees. Of the four hundred names of poets known to us, seventeen are women.

Along with the old heroic tales which, after the emergence of the knights, rise once more from the church doors and inns into higher social spheres, everywhere attracting the interest of the courtiers, the popular minstrels also once more came into honour. They are still ranked far below the knights and clergy, who are no more willing to be confused with them than were the poets and actors of the Dionysus theatre at Athens willing to be confused with the mimes, or the *scops* of the migration period with the jugglers. Formerly, however, the poets of different social groups had treated of different themes, and this by itself had been a criterion of social difference. But now that the troubadour handled the same subjects as the minstrel, he must try to surpass the ordinary singer by his method of handling the material. The 'dark rhyming' (*trobar clus*) which now became the fashion, with its deliberate obscurity and love of enigma, its piling on of difficulties of technique and content, is often nothing but a means of shutting off the lower, uneducated classes from the aesthetic pleasure enjoyed by the upper ranks of society and of marking oneself off from the pack of clowns and histrions. It is usually a more or less explicit will to social distinction that explains an artist's pleasure in the difficult and complicated, the aesthetic attraction of hidden meanings, far-fetched associations, disjointed and rhapsodic composition, symbols whose significance is not realized for a while and then never fully exhausted, music that is hard to memorize, 'melodies where one does not know at the

start how they would end'—in other words, the special attraction of all secret satisfactions and paradises. The importance of this quality of intellectual aristocracy in the troubadours and their pupils may be estimated when one considers that of all the Provençal poets, Dante rated highest Arnaut Daniel, the most obscure and complicated.[187]

The plebeian minstrel enjoyed, in spite of his lower rank, enormous advantages through his professional association with the knightly poet. He would otherwise never have been allowed to give public expression to his own individuality, his private subjective feelings, or, putting it in another way, to turn from epic to lyric poetry. Only the new social position of the poet made possible this poetical subjectivism, this poetry of personal confession, this self-important analysis of one's own feelings, and it was only because he now shared the social prestige of the knight that the poet began once again to claim rights of authorship and property in his work. Were it not that the profession of poetry was now followed by persons of superior social status, the fashion of referring to oneself in one's poems would not have established itself so easily. Marcabru speaks of himself in twenty of his forty-three poems, Arnaut Daniel in practically all of his.[188]

The minstrels who are now again met with at every court, and indeed are essential features of the most modest court, were masters of elocution—they sang and gave recitations. Were the poems they recited their own work? At first, like their ancestors the mimes, they probably improvised, and up to the middle of the twelfth century were doubtless poet and singer in the same person, but later on a specialization seems to have set in and at least some of the minstrels seem to have confined themselves to reproducing the works of others. At first the princely and noble poets were evidently mere pupils of the minstrels, who, as experienced professionals, undoubtedly helped them in the solution of technical difficulties. The non-noble singers were from the beginning servants of the aristocratic amateurs; later, no doubt, impoverished knightly poets also stood in a somewhat similar relationship of service to those great lords who were amateurs of the art. Occasionally even successful professional poets had recourse to the services of the poorer minstrels. In

particular the rich amateurs and the more renowned troubadours did not recite their own poetry but had it recited by hired minstrels.[189] Thus arose a remarkable artistic division of labour which strongly emphasized the social distance between the noble troubadour and the common minstrel, at least at first. This distance, however, gradually diminished and the levelling process in the end produced, especially in northern France, a type of poet very similar to the author of modern times, who no longer composed poetry for recitation but wrote books to be read. The old heroic lays had been sung, the *chansons de geste* recited, the early court epics probably read aloud, but the romances of love and adventure are now produced as reading matter for the ladies. The change whereby women became predominant in the make-up of the literary public has been termed the most important change in the history of Western literature.[190] Equally important, however, for the future was the change over to reading as the form of artistic experience. Only when poetry is read can it become a hobby, a habit, a daily necessity. Only so can it become 'literature', enjoyment of which is no longer confined to the solemn moments of life or to special festivities, but which may be drawn upon as desired merely to pass the time of day. Poetry thus loses the last remnant of its numinous character and becomes mere 'fiction', mere invention which can arouse aesthetic interest without claiming any element of conviction. That is why Chrétien de Troyes has been characterized as a poet who, far from believing in them, has no longer the slightest inkling of the real sense of the mysteries round which the Celtic sagas revolve. Regular reading turned the awed hearer into an unconcerned reader— but also, it might be, into an experienced connoisseur, and the evolution of the connoisseur finally unites hearers and readers into a group with a common interest which can properly be called a 'literary public'. The appetite of this public then gives rise, among other things, to the phenomenon of quite ephemeral literature, written to suit the fashion of the hour. The courtly love romances are the first instance of such literature.

Now reading requires a completely different technique of relation from that appropriate to recitation or reading aloud; it demands and makes possible the achievement of novel effects of

a kind hitherto quite unknown. A work intended for singing or recitation is composed mainly on the principle of simple juxta-position; it is made up of single songs, episodes or strophes that are more or less complete in themselves. Recitation can be inter-rupted at almost any point, and the effect of the whole is not seriously impaired if some parts are left out. The unity of such a work is achieved not through its formal composition but through a unity of atmosphere that pervades the whole. Such is the structure of the 'Chanson de Roland'.[191] Chrétien de Troyes, on the other hand, by means of retardations, excursions and sur-prises, achieves special effects of tension which result, not from the particular section taken by itself, but from the relationship of the various parts to one another, their sequence and contrast. Now the poet of the courtly romance of love and adventure adopts his method not merely because, as already remarked,[192] his public is harder to please than the audiences of the 'Chanson de Roland', but also because he is composing for readers and in con-sequence both can and must produce effects that are impossible to oral recitation, which lasts only for a short period at a time and is liable to be arbitrarily interrupted. These romances for reading usher in modern literature not merely because they are the first romantic love stories of Western Europe, the first poetical works in which love ousts all else, lyricism is all-pervading, and the sensitivity of the poet is the chief criterion of quality, but also because they are—to adapt a well-known conception of dramatic criticism—the first 'récits bien faits'.

The course of development during the age of the knightly troubadour and the popular minstrel leads first to a certain assimi-lation of these two different social types, but later, towards the end of the thirteenth century, to fresh differentiation between them. This results, on the one hand, in the established, salaried *menestrel* or court poet in the narrower sense, and, on the other in a type of singer who has come down in the world and become a masterless *jongleur*. As soon as the courts began to keep poets and singers with a regular official position, the wandering min-strels lose the custom of the upper classes and address themselves, as they did before their social rise at the beginning of the chivalric period, to a lower class of public.[193] The salaried court poets, on

the other hand, in deliberate contrast, develop into real men of letters, with all the petty vanities and all the pride of later humanists. They are no longer content to enjoy the favour and generosity of a great lord; they now aspire to be the teachers of their patrons.[194] And the princes no longer keep them just to amuse their guests, but as companions, confidants and advisers. They have in fact a ministerial position, as their title, '*menestrel*', shows. They are, however, held in far greater esteem than any of the retainers of the old days; in all questions of good taste, courtly manners and knightly honour they are regarded as the highest authorities.[195] They are the true forerunners of the Renaissance poets and humanists, or, at any rate, they are no less so than their antagonists, the wandering scholars (*vagantes*), to whom Burckhardt is inclined to give all the credit.[196]

The *vagans* was a cleric or scholar who roamed about singing and reciting, a runaway priest or a student who had abandoned his studies, that, is a déclassé and a bohemian. He is a product of the same economic revolution, a symptom of the same social movement which had produced the town bourgeois and the professional knight, but he already shows important signs of the social restlessness of the modern intelligentsia; he is completely without respect for Church or privileged classes, a rebel and a libertine who is in principle opposed to all tradition and convention. At bottom, he is a victim of the upset social equilibrium, a transitional phenomenon typical of times when masses of people are abandoning the social groups to which they had formerly belonged and which governed the whole life of their members, for other looser groupings that offer more freedom though less protection. With the revival of the towns and the concentration of population in them, and above all with the blossoming of the universities, a new social phenomenon emerged—the scholar-proletariat.[197] A part of the clergy, too, had lost its social security. Formerly the Church had taken responsibility for all pupils of the episcopal or monastic schools, but now that, as a consequence of the greater personal freedom and the general passion to rise in the social scale, schools and universities were crowded with poor youths, the Church was no longer inclined to find posts for all of them. These young people, many of whom could not even

complete their studies, often led a wandering life as beggars and comedians. Nothing was more natural than that they should have been always ready to revenge themselves with the gall and venom of their poetry upon a society which did so little for them.

The *vagantes* write in Latin; they are the entertainers of the spiritual, not of the temporal lords. But in all other respects the life of a wandering scholar and that of a wandering minstrel were not very different. Nor was the difference of education between them as great as is commonly supposed. After all, these unfrocked clerics and spoilt students were no more than half educated, like the mimes and *jongleurs*.[198] None the less their works, at least in their general trend, are learned poetry of a particular social class and are addressed to a relatively small and well-educated public; and although these *vagantes* were often obliged to entertain a company of laymen with poems in the vulgar tongue, they kept themselves strictly aloof from the ordinary minstrels.[199]

The poetry of the *vagantes* is not always easy to distinguish with certainty from that of the schools.[200] A number of Middle Latin love lyrics are scholar poetry, and some of these again were mere school poetry in the sense of being produced as part of the regular instruction. Many of the most fervent love songs were simply school tasks, and these cannot have had much first-hand experience behind them. Even this is not the whole story of the Middle Latin lyric. It is highly probable that at least some of the drinking songs, if not the love songs, originated in the monasteries. Again, poems like the 'Concilium in Monte Romarici' or the 'De Phyllide et Flora' are best ascribed to the higher clergy. In fact, the secular Latin poetry of the Middle Ages is something in which all ranks of the clergy probably had a hand.

The love lyrics of the *vagantes* differ from those of the troubadours mainly in that they speak of women with contempt rather than with favour, and treat sensual love with an almost brutal directness. This is merely another sign of the lack of respect with which the *vagantes* handle everything that was conventionally held in honour—not, however, as has been supposed, a sort of revenge for a chastity which they are not likely ever to have practised. In the Goliard lyrics woman appears in the same harsh light as in the fabliaux. This similarity cannot be accidental and

leads us to conclude that the *vagantes* took a direct hand in the creation of this whole anti-feminist and anti-romantic literature. At any rate, the fact that no single class escapes the mockery of the fabliaux, neither monk or knight, bourgeois or peasant, supports this conclusion. The wandering scholar occasionally entertains the bourgeois too, and even at times looks upon him as an ally in his own guerilla warfare against the ruling class, but despises him none the less. It would be quite wrong to regard the fabliaux, in spite of their irreverent spirit, their carelessness of form and their coarse naturalism, as out and out popular literature, or to suppose that they were written for an exclusively bourgeois public. The writers of the fabliaux were certainly bourgeois, not knights, and the spirit that pervades them is also bourgeois—rationalistic, without illusions, unromantic and ironical; but just as the bourgeois public took no less pleasure in the chivalric romances than in the many tales of middle-class life, so the nobility liked hearing the impudent stories of the minstrels no less than the heroic romances of the court poets. The fabliaux are not a bourgeois class-literature in the sense that the heroic lay is a class-literature of the warlike nobility or the love romances a class-literature of the courtier-knights. At any rate, they represent the bourgeois in a detached, self-critical mood, and this bourgeois self-criticism which they voiced also gives them an appeal to the higher ranks of society. The fact that the nobility

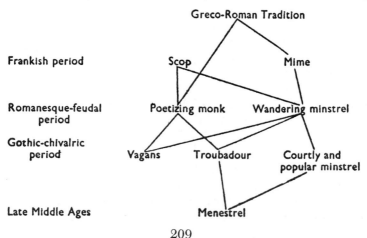

209

enjoyed the light literature of bourgeois circles does not, of course, imply that it regarded this as being on a level with the courtly romances of chivalry. It enjoys the stories in just the same way as it enjoys the efforts of mummers, strolling singers and bear-leaders.

In the late Middle Ages poetry becomes more and more bourgeois, and so does the poet, in line with his poetry and his public. As long, however, as the Middle Ages lasted, no new types—apart from the decidedly bourgeois-minded Meister-saenger—were involved, but only variations on the old ones. The family tree of these various types now appears as shown on the previous page.

9. THE DUALISM OF GOTHIC ART

The spiritual mobility of the Gothic age can in general be traced even more plainly in the works of visual art than in the creations of the poet. Not merely did the practice of the former arts remain in the hands of a more or less unitary occupational group, thus manifesting an almost continuous development, while poetical production, shifting, as it did, from one social level to another, developed in a series of jumps or stages that were often discontinuous; the bourgeois spirit, the impelling factor in the new disequilibrated society, imposed itself more rapidly and more completely in the plastic arts than it did in poetry. In the latter only a few types on the periphery of a massive production directly express the worldly, realistic enjoyment of life character-istic of the bourgeois, whereas this bourgeois spirit permeates the whole of plastic art in practically all its forms. A grand transition of the European spirit from the Kingdom of God to Nature, from the last things to the immediate environment, from tremendous eschatological mysteries to the more harmless secrets of the creaturely world, is here displayed in more striking form than in the typical poetry of the age. In visual art it is earlier apparent that the interest of the artist is about to shift from grand symbols and metaphysical concatenations to the portrayal of the immedi-ately experienced, the sensible and the particular. Organic life,

which after the end of the ancient world had lost all meaning and value, once more comes to be honoured, and the individual things of experienced reality are henceforth made subjects of art without requiring some supernatural, other-worldly justification.

There is no better illustration of this development than the words of St. Thomas, 'God enjoys all things, for each accords with His essence'. They are a complete epitome of the theological justification of naturalism. Everything real, however slight and ephemeral, has an immediate relationship to God; everything expresses the divine nature in its own way and so has its own value and meaning for art too. And though, for the present, things claim attention only as manifestations of God and are ranked —according to the degree of their participation in God—in a hierarchy, the idea that no stratum of being, however lowly, is quite without significance or spark of divinity, and so none wholly unworthy to be portrayed in art, marks a new epoch. Accordingly, in art too, the conception of a God wholly independent of the world gives way to that of a divine power working in created things. The God who 'impelled from without' corresponded to the aristocratic world-view of early feudalism; the God who is present and working in all the orderings of nature corresponds to the attitude of a more liberal world in which the possibility of rising is not entirely excluded. The metaphysical hierarchy of things still reflects a society that is built up of estates, but the liberalism of the age already voices itself in the conception that even the lowest stage of being is in its own way indispensable. Formerly an unbridgeable gulf separated the estates, but now they have contact with one another. Accordingly, as a subject of art also, the world is represented as a continuous, though elaborately graded reality.

It must be obvious that in the high Middle Ages there was no possibility of the sort of naturalism which reduces the whole of reality to a mere sum of sense impressions any more than of a total replacement of feudal forms of rule by the bourgeois manner of life, nor again of any radical abolition of the spiritual dictatorship of the Church for a free and untrammelled secular culture. In art, as in all other fields of culture, what we find is just a certain balance between freedom and restraint. Gothic

naturalism is an unstable equilibrium of world-affirming and world-denying impulses, just as the whole of chivalry is permeated by an inner contradiction, and just as the whole religious life of the period fluctuates between dogma and inwardness, between clerical creeds and lay piety, between orthodoxy and subjectivism. The same inner contradiction, the same spiritual polarity, manifests itself in all these social, religious and artistic oppositions.

The most striking manifestation of this dualism is the peculiar feeling for nature in Gothic poetry and art. Nature is no longer a dumb, soulless, material world, as it seemed—and was bound to seem—to the eye of the early Middle Ages with its Jewish-Christian idea of God as an invisible spiritual lord and creator. Belief in the absolute transcendence of God then necessarily involved a depreciation of nature, just as now the prevalent pantheism brought about its rehabilitation. Before the Franciscan movement only a fellow-man, but thereafter any creature, can be counted as 'brother';[201] this new idea of love, too, is in harmony with the liberal trend of the period. Man searches nature no longer merely for analogies of a supernatural reality, but rather for traces of his own personality and reflections of his own feelings.[202] A meadow in bloom, a stream covered with ice, spring and autumn, morning and evening, are regarded as stations in the soul's pilgrimage; yet in spite of this feeling for correspondence, an eye for the individual in nature is still lacking; the images drawn from nature are ready-made and rigidly conventional, wanting in personal variety and intimacy.[203] In the love songs stock descriptions of spring and winter landscapes occur again and again and are finally reduced to empty conventional formulae. It is, however, noteworthy that nature should have become an object of interest at all, and that it should seem in itself to be something worth describing. The fact is that man's eyes must first be opened to nature before they can discover individual features in her.

Much more consistently and clearly than in these descriptions of landscape, Gothic naturalism manifests itself in the representation of human form. In this field we meet everywhere a thoroughly new conception of art, and one radically opposed to

the stereotyping abstraction of Romanesque. Interest is now completely centred upon the individual and the characteristic—even before the time of the statues of the kings at Rheims and the portraits of the founders at Naumburg; the freshness, vitality and directness of these portraits is already to be found to some extent in the figures on the west portal at Chartres.[204] These, too, are so accurately drawn that we feel sure that they must have been studies of actual living models. The kind old man with the look of a peasant, high cheek bones, broad splayed nose and somewhat slanting eyes must have been personally known to the artist. The remarkable fact is that these figures, though still showing the old archaic clumsiness and heaviness, though as yet without any trace of the later chivalric animation, are so surprisingly full of character. Feeling for the individual is evidently one of the first symptoms of the new dynamic. It is astounding with what suddenness an art which had considered the human race only in its totality and uniformity, distinguishing men merely as saved or damned and disregarding all other individual differences as utterly irrelevant, now gives way to a completely different attitude that emphasizes and tries to seize the uniqueness in each figure.[205] It is astounding how suddenly a sense for the ordinary things of everyday life awakens, how soon people begin once more to observe, to see things 'correctly', to take pleasure once again in the accidental and trivial. The far-reaching character of the change of style is shown in the fact that, even with an idealist such as Dante, it is his eye for little characteristic details that is the source of supreme poetical quality.

What has really occurred? The essential change is that the one-sidedly spiritual art of the early Middle Ages, which rejected all imitation of directly experienced reality and all confirmation by sense, has given way to an art that makes all validity of statement, even about the most supernatural, ideal and divine matters, depend upon achieving a far-going correspondence with the natural sensible reality. The whole relationship between Spirit and Nature is thus altered. Nature is no longer characterized by absence of Spirit but rather by her spiritual transparency, her power of expressing the spiritual, though not yet by a spirituality of her own. Such a transformation could only occur following a

213

change in the conception of truth itself, which now, instead of its former one-sidedness, takes on a dual aspect—in other words, it could only occur after men had come to recognize two different ways of truth, or rather had discovered that there are two different kinds of truth. Now the idea that the representation of a state of things true in itself must, if it is to be artistically correct, conform to the particular conditions given in sense experience, so that the artistic and ideal value of a representation may be very unequal—this new idea of the relationship between values was completely unknown to the early Middle Ages, and simply means that the well-known contemporary philosophical doctrine of the 'duality of truth' is now applied to art. Nowhere else is the division of mind, which was brought about through the breach with the old feudal traditions and by the gradual emancipation of men's minds from the Church, more sharply expressed than in this doctrine, which must have seemed monstrous in any earlier age. For what could be more incomprehensible to an age of unshaken faith than that there should be two different kinds of cognition and two different sources of truth—that faith and knowledge, authority and reason, theology and philosophy, *contradict* one another, while each of these in its way may express a kind of truth? The doctrine pointed a way that was full of danger, but which was the only way out for an age already dissatisfied with unconditional belief, though not as yet very deeply impregnated with the scientific spirit, an age unwilling to sacrifice its faith to its knowledge or its knowledge to its faith, and so unable to build its culture except upon some synthesis of the two.

Idealism in the Gothic period was at the same time a naturalism which sought to represent spiritual and ideal figures, rooted in a super-sensible world, in a manner that would also be empirically correct. In this art was in line with the philosophical idealism of the age, which held that ideas were not apart from but in particular things,.thus upholding the reality both of ideas and of particulars. Translated into the terms of the historical dispute, this meant that universals were considered as immanent in the data of sense, and as not having any objective existence whatever apart from them. This moderate nominalism, as the doctrine is

called in the history of philosophy, was based on a world-view that was still thoroughly idealist and supernaturalist, but was none the less further removed from absolute idealism (i.e. the 'realism' of the dispute) than from the later extreme nominalism which denied any sort of objective existence to ideas, and only admitted the individual, concrete, non-recurrent, unique events of sense experience as having ultimate reality. This taking account of the individual thing in the search after truth was in reality the decisive step. For even barely to recognize that there are individual things, to question whether the individual existent may be substantial, is to open the door to individualism and relativism, and to imply at least a partial dependence of truth upon the temporal and mutable facts of this world.

The problem around which the dispute about universals revolved is not merely the central problem of philosophy, not merely the philosophical problem par excellence of which the fundamental oppositions in philosophy—between empiricism and idealism, relativism and absolutism, individualism and universalism, historicism and anti-historicism—are but variants; it is far more than merely a philosophical problem. It is in fact the epitome of those vital questions which put themselves as soon as any kind of culture has been developed, and about which the individual, as soon as he becomes conscious of himself as a spiritual being, is called upon to make up his mind. The moderate nominalism, which does not deny the reality of ideas, but regards them as inseparable from the things of sense experience, is the key to the whole of Gothic dualism, both to the conflicting impulses in the economic and social structure of the time and to the inner contradictions between the idealistic and naturalistic elements in its art. The doctrine of nominalism here plays exactly the same part which the Sophistic movement played in the history of ancient art and culture. Each is the typical philosophical doctrine of an anti-traditional, comparatively liberal-minded epoch. Both are philosophies of an age of enlightenment, their essence being that they treat as relative values, and thus mutable and transitory, standards which were hitherto looked upon as eternal and universally valid. They refuse to admit any such 'pure' and absolute validity independent of individual conditions.

215

The shifting of the philosophical basis of the medieval world-view by the substitution of a nominalist for a realist metaphysic can only be explained by reference to the sociological background. Realism was appropriate to an essentially undemocratic order of society, to a hierarchy in which only the peaks counted, to absolutist organizations which transcended the individual and confined life within the framework of Church and feudality without allowing any freedom of movement. Nominalism, on the other hand, reflected the dissolution of authoritarian forms of community and the triumph of a social life built out of infinite individual gradations over one based on unconditional subordination of the individual. Realism is the expression of a static and conservative, nominalism that of a dynamic, liberal and progressive outlook. Nominalism, which claims for every particular thing a share in being, corresponds to an order of life in which even those on the lowest rung of the ladder have their chance of rising.

The dualism reflected in the relationship of Gothic art to nature is also manifest in its solution of the problems of composition. On the one hand, Gothic art abandons the decorative and predominantly cumulative style of Romanesque composition, replacing this by forms more akin to the classical, based upon the principle of concentration. On the other hand, it breaks up the whole, which in Romanesque art was at least pervaded by a certain decorative unity, into a number of partial compositions, each one in the main built up according to the classical principle of unity and of subordination, but in total giving the effect of a rather indiscriminate conglomeration of subjects. There are efforts to open out the crowded Romanesque compositions and to depict scenes complete in time and place, instead of mere collections of particulars linked only in symbolical meaning or through the decorative scheme, but even so Gothic composition is still mainly additive and in this far removed from the spatial and temporal unity of classical work.

The principle of 'continuous' representation, the inclination to review, as in a film, all the particular phases of an event, the readiness to overlay the 'pregnant moment' with an epic wealth of detail—signs of an artistic approach which we first met with in

late Roman times and which never quite disappeared throughout the Middle Ages—now comes to the fore again in the cyclical type of composition. The same principle finds its crassest expression in medieval drama, which shows such a passion for change and variety that it has been termed the 'drama of movement' (*Bewegungsdrama*), as opposed to the classical 'single-place drama' (*Einortsdrama*).[206] The Passion plays, with their numerous scenes set up alongside of one another, their hundreds of performers, and their performances frequently lasting for several days on end, run through each stage of the action to be represented, dwell upon each single episode with an insatiable love for the spectacular, and show far more interest in the movement of events than in single dramatic situations. These 'film dramas' of the Middle Ages are in a sense the most characteristic, even though qualitatively perhaps the most insignificant creations of Gothic art. The new artistic urge often led to cathedrals being left unfinished or, if finished, to their giving us the feeling, of which Goethe was the first to become conscious, that they are somehow incomplete, indeed impossible to complete, because in the process of endless, interminable development. This impulse into the unlimited, this inability to be content with any conclusion, comes out all the more clearly in the Passion plays because of their extreme naïvety. It is in the 'drama of movement' of the Middle Ages that its dynamic sense of life, its unrest, dissolving traditional modes of thought and feeling, its nominalistic turning to the multiplicity of changing and transitory particulars, are most directly apprehended.

The dualism shown in the various social, economic, religious and philosophical trends of the age, in the antagonisms between consumption-economy and commercial economy, feudalism and bourgeoisie, other-worldliness and inner-worldliness, realism and nominalism, dominating the whole relationship of Gothic art to nature and the inner structure of its composition, also manifests itself in a polarity of rational and irrational elements in art, especially in architecture. The nineteenth century, which naturally sought to explain the character of this architecture in terms of its own technological frame of mind, emphasized the rationalistic features. Gottfried Semper characterized Gothic art as a

'simple translation of scholastic philosophy into stone',[207] and Viollet-le-Duc saw in it simply the application and illustration of mathematical laws;[208] both of them in fact regarded it as art governed by abstract necessity, in contrast with the irrationality of aesthetic impulses. Both of them, and indeed the whole nineteenth century, explain this architecture as a 'calculating engineer's art' that draws its inspiration from practical utility, and expresses simply what is technically necessary and structurally possible. It was believed that the principles of Gothic architecture, above all its exhilarating verticalism, could all be derived from the ribbed vault, a technical invention. This mechanistic doctrine fitted in well with the rationalistic aesthetics of the century; it was held that in a genuine work of art no single detail could be altered without impairing the whole, and a Gothic building, with its strict logic and austere functionalism, was looked on as the very prototype of an artistic whole that must be utterly ruined by any addition or subtraction.[209] It seems extraordinary that such a doctrine should ever have been applied to Gothic architecture, which, with the chequered history of its constructions, most strikingly illustrates the fact that the final form of a work of art is as much due to chance, or what in relation to the original plan looks like chance, as to any one basic idea.

Dehio regards the invention of cross-vaulting as the really creative event in the originating of Gothic, and the particular forms of Gothic architecture as merely consequences of that one technical achievement. Ernst Gall was the first to reverse the relationship, representing the new formal ideal of vertical composition as the primary factor and the technical execution of this idea as derivative, subordinate and secondary, both in time and in artistic analysis.[210] Others have even maintained since that the practical value of most of the 'technical achievements' of Gothic cannot really be put very high; that the rib in particular has no real structural function and that originally both cross-vaulting and buttresses had an essentially decorative purpose.[211] The issue in this controversy between the rationalists and the irrationalists is in the last resort the same as the issue between Semper and Riegl on the foundation of style generally.[212] One party is anxious to derive artistic form from the particular practical task in hand

and its technical solution; the other emphasizes those many cases where the artistic idea is achieved only by a certain straining of the available technical resources, the technical solution itself being to some extent the result of pursuing a certain artistic form. Both parties go to opposite extremes but fall into the same error; for if the technicism of Viollet-le-Duc has appropriately been called 'romantic mechanics',[213] the aestheticism of Riegl and Gall is no less the product of romantic illusionism as to the freedom of the artist's intention. In none of the phases of production of a work of art are artistic purpose and technique really separable; both are always but aspects of a process and only distinguishable in theory. To treat one of the two as an independent variable is illegitimately and irrationally to exalt one above the other and is a 'romantic' way of thinking. The true relationship of these two motives to one another by no means appears from their subjectively felt sequence in consciousness during an act of creation, for this sequence is influenced by so many incalculable factors as to be simply 'accidental'. As a matter of historical fact, it is just as likely that the rib vault 'was first introduced for purely technical reasons and its artistic possibilities realized subsequently',[214] as that the vision of a certain form preceded this technical invention, the architect being led by this vision in his technical calculations, even though possibly unaware of it. In such circumstances no certainty of a scientifically verifiable sort is obtainable. We may none the less assume that these principles are connected with the changing social background of the creative artist and can suggest why they may be found in agreement or in conflict with one another. In periods such as the early Middle Ages, which in general were free from social conflict, there is not, as a rule, any radical antagonism between artistic intention and technique; the art forms and the technique are employed harmoniously and say the same thing in different ways, the one factor being no more rational or irrational than the other. But in times like the Gothic age, when the whole of culture was rent by antagonisms, it often happens that the spiritual and material elements in art speak different languages and, as in the present case, the technique appears rational but the artistic aims irrational.

The interior of the Romanesque church is a self-contained, stationary space that permits the eye of the spectator to rest and remain in perfect passivity. A Gothic church, on the contrary, seems to be in process of development, as if it were rising up before our very eyes; it expresses a process, not a result. The resolution of the whole mass into a number of forces, the dissolution of all that is rigid and at rest by means of a dialectic of functions and subordinations, this ebb and flood, circulation and transformation of energy, gives us the impression of a dramatic conflict working up to a decision before our eyes. And this dynamic effect is so overwhelming that beside it all else seems a mere means to this end. So it comes about that the effect of such a building is not merely not impaired when it is left uncompleted; its appeal and its power is actually increased. The inconclusiveness of the forms, which is characteristic of every dynamic style, gives emphasis to one's impression of endless, restless movement for which any stationary equilibrium is merely provisional. The modern preference for the unfinished, the sketchy and the fragmentary has its origin here. Since Gothic days all great art, with the exception of a few short-lived classicist movements, has something fragmentary about it, an inward or outward incompleteness, an unwillingness, whether conscious or unconscious, to utter the last word. There is always something left over for the spectator or reader to complete. The modern artist shrinks from the last word, because he feels the inadequacy of all words— a feeling which we may say was never experienced by man before Gothic times.

Now, a Gothic building is not merely itself a mass in movement; it mobilizes the spectator, too, and turns an act of enjoyment into a process with definite direction and gradual accomplishment. Such a building cannot be taken in all at once from any possible view-point; from no quarter does it present a complete, restful view, disclosing the structure of the whole. On the contrary, it compels the spectator to be constantly changing his view-point and permits him to gain a picture of the whole only through his own movement, action and power of reconstruction.[215] Greek art in the age of early democracy, when social conditions were similar, had also enforced a similar activity on

the spectator. Here, too, he was shaken out of restful contemplation of the work of art and impelled to follow the movements of the subject represented. The resolution of the compact, cubic form and the emancipation of sculpture from architecture are the first steps Gothic art takes towards the rotation of the figures by means of which classical art set the spectator in motion. But the decisive step in both periods is the rejection of frontality. This principle is now finally abandoned, to appear hereafter only for two quite short periods in all, at the beginning of the sixteenth and the close of the eighteenth century. Since then frontality and the formal rigorism which it betokens has remained something archaistic and programmatic that can never again be fully realized. In this respect, too, Gothic art starts an artistic tradition unbroken until our own day, and whose importance is unequalled by any subsequent tradition.

In spite of the similarity between the Greek and the medieval ages of enlightenment and their effects on art, the Gothic style brings something completely novel and completely unclassical, yet no whit inferior, to replace the Greco-Roman tradition. In fact, it is only with the rise of the Gothic spirit that the reign of classical standards comes to an end. Romanesque art was no less transcendental than Gothic; it was indeed in many respects more highly spiritualized than any subsequent art, yet was none the less closer in its forms to ancient art than the far more sensual and secular Gothic. Gothic is in fact permeated by something which we look for in vain in Romanesque art and which, as against the Greco-Roman tradition, is completely novel. Its sensitivity, intimacy of experience and inwardness of feeling was unknown to the subtlest artist of the ancient world. Now this sensitivity is the peculiar effect of an interpenetration of Christian spiritualism and the awakening sensualism of the Gothic age. It was not the emotionalism of Gothic by itself that was new, for late classical art, too, was emotional, even melodramatic, and Hellenistic art also aimed to stir and inspire, to captivate and overwhelm the senses; the novel element consists in an intimacy of expression whereby the artist makes any work of Gothic or post-Gothic art a sort of confession of his personal faith. And here we meet once again with the antagonism that pervades all

forms of Gothic culture. The confessional character of modern art, which presupposes a unique and first-hand experience in the artist, has from Gothic times onwards had to assert itself against a burden of technique that is tending to become more and more of an impersonal routine. For no sooner has art overcome the last remnants of primitiveness and reached a stage when the mere manipulation of the means of expression is no longer an effort, then the dangers of having a ready-made technique available for all sorts of purposes begin to make themselves felt. With Gothic the lyricism of modern art, but also its cult of virtuosity, begins.

10. LODGE AND GUILD

The masons' lodge (*opus*, *oeuvre*, *Bauhuette*) of the twelfth and thirteenth centuries was a co-operative organization of the artists and artisans engaged upon the building of a large church or cathedral under the artistic and administrative direction of persons appointed or approved by the body which had commissioned the building. The function of manager (*magister operis*), who was charged with the provision of materials and labour, and that of the master mason or architect (*magister lapidum*), who was responsible for the artistic planning, assignment of tasks and co-ordination of the work of individuals, may often have been combined in the same person, but there is no doubt that as a rule they were kept in separate hands. The artistic and administrative heads had much the same relation to one another as that of the director and the producer of a film, the production organization of which presents the only close parallel to that of the medieval masons' lodge. There is, however, one important difference in that the director normally works with different personnel for each film, whereas changes in the personnel of the lodge by no means always coincided with the completion of a particular building; on the contrary, some of the workers formed a nucleus which stayed with the architect after the completion of a particular task, whereas other workers came and left while the work was in progress.

We know that the Egyptians had developed a form of artistic

group-work and that the Greeks and Romans had building corporations which were mobilized in groups for big projects; but none of these associations had the self-contained, self-governing character of the medieval lodge; an autonomous occupational group of this kind was alien to the ideas of the ancient world. Again the only thing in the early Middle Ages at all resembling the lodge was the collaboration upon a particular building of the various workshops belonging to the same monastery; but this was lacking in one of the most essential characteristics of the later associations —their mobility. It is true that the lodge of the Gothic period, when the building of churches often took a very long time, frequently remained for generations upon the same site; but if the work was completed or interrupted, they moved off under the leadership of their architect and took on new tasks.[216] The mobility which was of such fundamental significance for the whole artistic production of the age showed itself indeed not so much in the migration of the lodge as a compact group, but rather in the wandering life of the individual artist-craftsman, his habit of coming and going, of leaving one company and joining another. We find, it is true, even in the monastic workshops workmen who have been imported and taken on for a limited period only, but the majority of the workers in those workshops were monks of the monastery, who would offer strong resistance to alien and disturbing influences. The stability of purely local production, however, with its continuity and relative slowness of artistic development, comes to an abrupt end as soon as production shifts from monastery to building yard and gets into the hands of laymen. From that moment new ideas begin to be accepted from all quarters and widely disseminated.

The builders of the Romanesque period still had to rely mainly on the labour of their serfs and tenants, but once money came into use, free labour from outside the locality could be employed to a greater extent so that something of an inter-local market for labour began to emerge. Thereafter the scale and speed of building varied according to the money that could be made available; if the building of a Gothic church sometimes went on for centuries, this was due as a rule to the periodic scarcities of money. When money was to be had, the building went forward rapidly

and without a break, but if it ran out, the work had to be slowed down or stopped altogether for a time. Thus the organization of the work differed according to the means of the promoter; either the work went forward steadily and the same personnel was continuously employed with but little change, or production was kept going only with interruptions and changes of tempo, now more and now fewer artists and artisans being employed.[217]

When, with the rebirth of the towns and the introduction of a money economy in the building trade, the lay element got the upper hand, there was not at first any organization able to maintain discipline in place of the monastic workshop. In any case, the building of a Gothic cathedral was a much more lengthy and complicated proceeding than the building of a Romanesque church had been. It required a far greater variety of workpeople and a much longer time for its completion, both because of the nature of the work and often, too, owing to the financial circumstances already mentioned. This situation demanded a strict regulation of the work and one that departed from the traditional methods. A solution was found in the lodge, with its precise rules regarding the taking on, payment and training of workers, its hierarchy of architect, master-craftsmen and journeymen, its special restrictions laid upon the members' rights of intellectual property in their own work, and its unconditional subordination of the individual to the artistic requirements of the common task. The aim was to achieve a frictionless division and integration of the labour available, with the utmost possible specialization and the completest harmonization of the products of different individuals. This aim could only be attained where a real unity of spirit possessed those taking part, for only a willing subordination of personal wishes to the will of the architect and continuous and intimate contact between the artistic director and each of his fellow workers could enable the required levelling of individual differences to be achieved without impairing the artistic quality of the particular products. How could such a division of labour as this, and that in so complex a spiritual process as artistic creation, ever be attained?

There are two completely opposed but equally romantic views on this subject. The one is inclined to see in communal

organization of art production the indispensable condition for the highest achievement, while the other holds that the breaking down of tasks and the limitation of individual freedom endangers —to say the least—the production of any genuine work of art. People are accustomed to take the favourable view of communal production when speaking of medieval art, and the unfavourable view when speaking of the film, for example. Both attitudes, for all that they lead to contradictory conclusions, share at bottom the same opinion of the nature of artistic creation. Both regard the work of art as a product of a unitary, undifferentiated, indivisible, quasi-divine act of creation. The romantics of the nineteenth century personified the collective spirit of the lodge as a sort of folk soul or group soul, attributing individuality to that which has no individuality and crediting the work of a collection of people to this supposed unitary and personal group soul. The critics of the film, on the other hand, do not mistake the collective character, that is, the composite organization, of film production. Indeed they stress its impersonal or, as they put it, 'mechanical' character; but they deny all artistic quality to the product just because it is the creation of an impersonal and atomized process. They forget that the individual, independent artist's method of working is by no means as unitary and organic as the romantics imagine. Any spiritual process that is at all complex, and artistic creation is one of the most complicated of all, consists of a whole series of more or less independent functions— conscious and unconscious, rational and irrational—and their various products have to be thoroughly sifted and edited by the artist's critical intellect in much the same way as the manager of the lodge tested, corrected and harmonized the products of the individual workmen. To suppose that the faculties and functions of the human soul work as a perfect unity is as untenable and as much a romantic fiction as the pretended independent reality of folk souls and group souls apart from the individual souls. Individual souls may conceivably be portions or diffracted rays of some collective soul, but this collective soul has its existence exclusively in its components and diffractions. In the same way the individual soul normally manifests itself only in particular functions; harmony of its various attitudes is something that

—apart from states of ecstasy, which are, however, not relevant to art—is only attained after severe struggle, no free gift of the moment.

The lodge was an organization of labour appropriate to an age when Church and town corporations were practically the only purchasers of works of art. They formed a relatively small circle whose demand was only intermittent and in general soon satisfied. The artist had to change the scene of his activities frequently if he was to find employment. But he need not go alone, nor be thrown entirely on his resources when he went on his travels; the lodge to which he could belong possessed the adaptability which the times required. It settled in a place and remained there as long as there was work, moved on as soon as there was no more to do and established itself where some new employment was to be found. It offered the individual what was for those times a very great measure of security; an able workman could stay in the company as long as he wanted, but he was also free to leave it for another or, if of a stay-at-home disposition, he could join one of the big permanent cathedral companies of Chartres, Rheims, Paris, Strasburg, Cologne or Vienna. Only when the purchasing power of the town bourgeois had grown to such an extent that private individuals and not merely corporations began to form a regular market for works of art, was the artist in a position to leave the lodge and settle in a town as an independent master.[218] This point was reached in the course of the fourteenth century, but at first it was only the painters and sculptors who freed themselves from the lodge and went into business on their own account. The building craftsmen remained in the companies for nearly two centuries longer, for it was not until the end of the fifteenth century that the building orders of the private citizen offered a sufficient source of income. When this came about, the building workers also left the lodges and joined the guilds, which had long included sculptors and painters. The concentration of artists in the towns and the competition which developed between them made some collective economic organization necessary from the very start. This would naturally be effected on the lines of the guild, the form of self-government which the rest of the tradesmen had devised for themselves

centuries before. Guilds in the Middle Ages arose wherever an occupational group felt its economic existence threatened by an influx of competitors from without. The object of the organization was to exclude or at least restrict competition. The outward manifestation of its internal democracy, which in the early days was real enough, was from the very first an extremely intolerant protectionism against all outsiders. The regulations were aimed solely and exclusively to protect the producers and not in any way to protect the consumers, as the pretence was and as idealizing romantics would like us to believe—the mere prevention of free competition by itself was injury enough to the consumer's interests. As for the regulations prescribing a minimum quality in the product, these were by no means unselfish in their aim and were framed so as to give just enough latitude to ensure the members a steady market for their own products.[219] The romantics not only extolled the guilds, in contrast with the industrialization and commercialism of the liberal era, and denied that the guilds were originally monopolistic or selfish in character, they also saw in this co-operative organization of work, in the universal standards of quality and the arrangements for public inspection and control, means whereby 'handicraft was raised to the level of art'.[220] As against this idealism, Sombart quite correctly observes that 'the mass of the artisans never attained to a respectable level of artistic quality' and that art production was always something different from ordinary manufacture.[221] Even if the guild regulations did help to improve the quality of manufactures—a quality which had nothing to do with artistic merit— to the artist such regulations were just as often a hindrance as a stimulus. Yet, as compared with the lodge, the guild, anti-liberal though it was, marked a decided step forward in the matter of the artist's freedom.

Lodge and guild differed in principle in that the former was an association of employees hierarchically organized, the latter, at least at first, an association of independent entrepreneurs on equal terms. The lodge was a single collective organization in which no one was free, not even the manager or the architect, for these, too, had to work to a plan conceived and drawn up by the Church authorities, and one in which their requirements were usually

specified down to the details. In the individual workshops, on the other hand, of which the guild was composed, the master craftsmen were free not merely in the use of their time, but also in their choice of artistic means. The statutes, narrow-minded as they often were, normally confined themselves to technical specifications. Unlike the regulations to which the artists in the lodge had to conform, the guild had hardly touched on matters of purely artistic interest. They restricted the master's initiative, but, provided he kept within certain generally accepted limits, did not prescribe what he should or should not do. The personality of the artist as such was not yet acknowledged; his workshop was still organized in exactly the same way as that of any other tradesman; the painters did not regard membership in the same guild as the saddler as in any way derogatory. None the less, we have to recognize in the independent master craftsman of the late Middle Ages, working at his own risk and personally responsible for his work, the immediate precursor of the modern artist.[222]

Nothing shows the general trend of development during the Middle Ages more clearly than the increasing separation of the artist's place of work from the building site. In the Romanesque period the whole of the artist's work was executed upon the building itself. As far as the painter was concerned, the decoration of a church consisted exclusively of wall paintings which, naturally, had to be executed on the spot. But the plastic decoration, too, was done on the scaffolding, 'après la pose'; that is, the sculptor chiselled his stone after the mason had fixed it in the wall. With the institution of the lodge in the twelfth century, a change already noticed by Viollet-le-Duc took place in this respect. The lodge offered the sculptor a more convenient and better equipped place of work than the scaffolding had been. Now he generally does the whole of his work in a workshop near the church, the finished sculptures being subsequently built into the structure. The change was probably not so sudden as Viollet-le-Duc supposes,[223] but, in any case, here was a development which was to lead ultimately to the independence of the sculptor's work and a growing separation of sculpture from architecture. The gradual substitution of panel paintings for wall paintings illus-

trates the same trend. Finally, the workshop becomes completely separated from the building; sculptors and painters leave the site for their own workshops and may as often as not never have seen the church whose altar-pieces and tabernacles they had been commissioned to make.

Quite a number of the stylistic characteristics of late Gothic are directly connected with this separation of the place of work from the place where the works of art are destined to be put. With the shift of art production from the building-site to the master's workshop is linked first and foremost that most strikingly modern feature of late medieval art, the bourgeois modesty and the unmonumental and unpretentious scale of its products. The bourgeoisie, in their private capacity, at first commissioned not churches or manor-houses, not chantries or series of frescoes, but tabernacles and panel pictures—however, their orders for these latter run into hundreds or even thousands. These types of art suited both the pocket of the bourgeois and his taste, and they equally suited the small-scale production of the independent artist; in the narrow space of a town workshop, with the few assistants each master had, only works of relatively small size could be attempted. The circumstances also favoured the employment, as material, of the light, cheap, easily worked wood. Whether the choice of a more modest size and a less pretentious material was the result of a change of taste, or whether the new, more flexible, more subtle and more expressive style resulted from changed materials and conditions, is hard to say. In any case, the small scale and more tractable material in itself invited innovation and inevitably assisted the transition to a style that was more expansive, more concerned to enrich and diversify the subjects depicted.[224] The change from the large, the weighty and the imposing to the small, the slight and the intimate can indeed be observed not merely in the wooden figures of the altar-pieces, but also in the more monumental stone sculpture of the time; but this in no way proves that material may not have played some part in determining style—nothing would be more natural than for the style of wood-sculpture, in an age when this predominated, to be transferred to sculpture in stone. However that may be, the artistic trend shown in works of every size and

every material is towards prettiness, delicacy and refinement. We witness the increasing conquests of modern virtuosity, of technique all too easily acquired, of resources all too readily come by and manipulated. This virtuosity, however, is in a sense only one symptom of the process which led, in this late Gothic age, to fully fledged money economy and production for sale, to the commercialization of painting and sculpture, and to the emergence of a taste that treated pictures as mere wall decoration and statues as furniture.

One may, indeed one must, be content to establish a correspondence between the history of style and the history of labour organization; it is idle to enquire which of the two is the primary and which is the secondary. Let it suffice to point out that at the end of the Middle Ages a situation is reached where immobile artists, small-scale workshops, cheap and easily handled materials, are found along with works small in size, delicate of shape, whimsical and curious in their forms.

11. THE MIDDLE-CLASS ART OF
THE LATE GOTHIC PERIOD

The late Middle Ages not merely has a successful middle class—it is in fact a middle-class period. The urban money and commercial economy, which sets the course of the whole development from the end of the high Middle Ages, leads to the political and cultural independence and later to the intellectual predominance of the middle-class element. For this class represents the most progressive and productive trends in art and culture as well as in economic life. But the middle classes of the late Middle Ages form an extremely varied social pattern split up into the most diverse spheres of interest, the upper and lower limits of which are in constant flux. The former uniformity, the common economic aims and egalitarian political aspirations have now given way to an overriding tendency towards social segregation according to financial standards. Not only do the upper and the lower middle class, tradesmen and craftsmen, capitalists and labourers, become more and more sharply divided from each

other, but numerous transitional stages arise between the strongly capitalistic employer and the small manufacturer, on the one hand, and the independent masters and the working-class proletariat, on the other. In the twelfth and thirteenth centuries the middle classes were still fighting for their material existence and freedom; now they are fighting for the preservation of their privileges against the new elements rising from below. From a progressive class, struggling for social justice, they have become a more or less sated, conservative class.

The unrest which had upset the stability of feudal conditions in the twelfth century and had steadily increased ever since reaches its climax in the insurrections and wage-struggles of the late Middle Ages. The whole of society has now become unsettled. The middle classes strive, satisfied and secure as they are, to emulate the prestige of the nobility and imitate the aristocratic way of life; the nobility, on the other hand, also tries to adapt itself to the profit-seeking spirit and rationalistic outlook of the middle classes. The result is a far-reaching levelling down of society; on the one hand, we have the rising middle classes, on the other, the declining aristocracy. The distance between the upper strata of the middle class and the lower, less well-to-do strata of the aristocracy is gradually reduced, but the differences in levels of wealth become more and more irreconcilable—the hatred of the poor knight for the rich burgher becomes an insuperable barrier and the conflict between the labourer deprived of civil rights and the privileged master impossible to settle.

But the structure of medieval society also shows dangerous flaws even on the highest levels; the backbone of the powerful old feudal class, with its defiant attitude to the princes, has been 'broken. With the transition from the natural to the money economy, the more or less independent nobility becomes the clientèle of the sovereign monarchs. The individual landowners may have become richer or poorer as a result of the dissolution of serfdom and the transformation of feudal properties into leasehold estates or farms worked by free labour, but they no longer have the men at their disposal to use in waging wars against the kings. The feudal aristocracy disappears and is replaced by a court aristocracy which derives its privileges from its position in the service

of the king. In earlier times the princes' households were also made up of nobles, of course, but they were independent or could at any time make themselves independent of the court. The new court nobility is, however, completely dependent on the grace and favour of the king. The nobles become court officials and the court officials are ennobled. The old military nobility inter-mingles with the new patent nobility, and in the hybrid court and official aristocracy which they now form, it is by no means always the members of the old nobility who play the more im-portant part. The kings prefer to choose their legal advisers and economic experts, secretaries and bankers from the middle-class elements; in making their choice, they are guided simply by the standards of personal achievement. Here, too, the guiding prin-ciples of a money economy are overriding: the ability to compete, the indifference about the means used to reach the goal, the transformation of personal into impersonal business relationships. The new state, with its tendency to absolutism, is no longer based on the loyalty of its vassals but on the material dependence of a discharged civil service and a paid standing army. This meta-morphosis only becomes possible, however, after the principles of the urban money economy have been extended to the whole budget and the means have been acquired which are necessary to maintain such a costly system.

The structure of the nobility is changed along with that of the state, but it preserves its continuity with the past intact. Knighthood, on the other hand, as the exclusive warrior-class and upholder of secular culture, decays completely. The process is protracted and the ideals of chivalry do not lose their alluring splendour from one day to the next—least of all in the eyes of the middle classes. But behind the scenes everything is set for the fall of Don Quixote.—The decline of the knighthood has been connected with the new methods of warfare introduced in the late Middle Ages, and it has been pointed out that the heavily accoutred cavalry suffered a severe reverse whenever they met the infantry of the new mercenary armies or the foot of the peasant brigades. They flew from the English bowmen, the Swiss mercenaries, the Polish-Lithuanian national army—in other words, from every kind of weapon different from their own,

and from every kind of military force which did not observe their own rules of warfare. The new methods were not, however, the real reason for the defeats suffered by the knights: they were merely a symptom, for they were simply the expression of the rationalistic approach of the new middle-class world to which the knights found it impossible to accommodate themselves. The gun, the anonymity of the infantry, the strict discipline of the mass armies—all these innovations were mechanizing and rationalizing warfare and making the personal and heroic attitude of the knights out of date. The battles of Crécy, Poitiers, Agincourt, Nicopolis, Varna and Sempach were not lost for technical reasons, but because the knights, instead of forming a real army, were merely incoherent, undisciplined bands of adventurers, putting personal renown above the victory of the common cause.[225] The well-known thesis of the democratization of military service by the invention of firearms and the use of paid infantry, which deprived the knights of their profession, is only tenable in a limited sense. It has been rightly argued against this theory that the knights' weapons were by no means made obsolete by the introduction of the blunderbuss and the musket, quite apart from the fact that the infantry fought mostly with pikes and bows and not with firearms.[226] The late Middle Ages even saw the climax in the development of the heavy armour worn by the knights, and right up to the Thirty Years War the cavalry remained a factor of often decisive importance alongside the infantry. Incidentally, it is not correct to say that the infantry was made up exclusively of men from the countryside; we also find men of the middle class and the nobility in its ranks. Knighthood became an anachronism not because its weapons, but because its 'idealism' and irrationalism had become out of date. The knight did not understand the motive forces behind the new economy, the new society and the new state; he still persisted in regarding the middle class with its money and 'narrow-minded' commercial outlook as an anomaly. The men of the middle class knew much better where they stood with the knights. It amused them to join in the masquerade of the knightly tournaments and the 'courts of love', but they treated all such activities as mere sport; in their business activities they remained

hard-headed and free from illusions in a world which was the very opposite of chivalrous.

The middle class mixes far more with the old urban patrician families than with the feudal nobility. The 'newly rich' gradually come to be regarded as equals by the old-established patrician families and finally become completely assimilated by inter-marriage. Not every rich member of the middle class is a patrician to begin with, but commoners had never moved up into the ranks of an aristocracy on account of their financial position so easily as they do now. The old urban nobility and the new capitalists share the municipal administration between them and form the new governing class, the distinguishing mark of which is that its members are qualified to be elected to the council. The families whose members have no seat there, but are regarded by those qualified to become members as of equal standing by reason of their financial status, and who can marry into patrician families, are also considered as belonging to this class. This rank of notabilities which carries on the administration of the cities directly or indirectly now forms a strictly closed class; its way of life is thoroughly aristocratic in character and its authority is based on almost as exclusive a monopoly of the offices and dignities of government as that once enjoyed by the feudal aristocracy. But the real purpose behind the ascendancy of this class is to guarantee for its members a monopoly in economic affairs. For, wherever big export business is carried on, they dominate the market if only because they alone own stocks of raw materials. They develop from tradesmen into merchants and manufacturers and now make others work for them. They simply provide the raw materials and a fixed wage for the work. The original equality of all craftsmen organized in the guilds yields to a graded differentiation according to political influence and financial means.[227] First of all, the poorer masters are forced out of the greater guilds, then these, too, shut themselves off from those trying to rise from below and prevent the poorer apprentices from becoming masters. The small tradesmen gradually lose all influence on the city administration, particularly on the way economic burdens and privileges are distributed, and, in the end, they acquiesce in the lot of a dispossessed petty bourgeoisie. The

journeymen sink to the level of life-long wage earners, and, forced out of the guilds, they amalgamate into new associations of their own. Consequently, from the fourteenth century, there develops a distinct working class, excluded from the chance of ever rising in the social scale, and this class forms the basis of the new methods of production which are already very similar to those used in modern industry.[228]

Whether it is permissible to speak of a capitalist system in the Middle Ages depends on how one defines capitalism. If one understands by a capitalist economy the slackening of corporate ties, the gradual emergence of production from the limitations as well as from the security of the corporation, in other words, if one means simply managing and doing business on one's own account, inspired by the competitive spirit and the profit motive, then one must certainly include the high Middle Ages in the capitalist era. But if one regards this definition as inadequate and the exploitation of outside labour and the control of the labour market by those who own the means of production, in a word, the transformation of labour from a form of service into a mere commodity, as the most essential factors, then the beginnings of the age of capitalism must be dated from the fourteenth and fifteenth centuries. On the other hand, it is hardly possible to speak of a real accumulation of capital, of great wealth in the modern sense, even in the late Middle Ages, nor is it any more feasible to speak of a consistently rational economy, based entirely on the principles of efficiency, methodical planning and expediency. But the trend towards capitalism is unmistakable from this period onwards. The individualistic spirit in economic life, the gradual breakdown of the corporative principle, the depersonalization of human relationships, gain ground everywhere; however much of the full concept of capitalism remains unfulfilled, the age already bears the marks of the new economy and is dominated by the middle class, as representing the capitalist method of production.

In the high Middle Ages, the urban middle class still took no direct part in cultural life: as artists, poets and thinkers the middle-class elements were merely the agents of the clergy and nobility, merely the executants and mediators of principles not

235

rooted in their own philosophy. In the late Middle Ages this situation undergoes a fundamental change; chivalric ways of life, the tastes of court society, ecclesiastical traditions, still remain in many respects the standards of middle-class art and culture, but the middle class has now become the real upholder of culture; most of the commissions for works of art are given by individuals belonging to the middle class, and no longer by kings and prelates as in the early Middle Ages, or by courts and municipalities, as in the Gothic period. It is true that the nobility and clergy do not surrender their rôle as founders of churches and builders of palaces, but their influence is no longer creative—the inspiration for new works of art now comes mostly from the middle class. The conception of art held by such a complex and divided social organism as this could naturally not be homogeneous: one must not assume, for instance, that it was absolutely in accordance with popular taste. For however differently the artistic aims and standards of the middle class developed from those of the clergy and nobility, they were not completely simple and popular, that is, immediately intelligible without any cultural background at all. The taste of a middle-class merchant may have been more 'vulgar', more realistic and more earthy than of a connoisseur of the high Gothic period, but it was hardly less differentiated and hardly less foreign to the simple everyday experience of the common people. The forms of late Gothic painting and sculpture created to accord with middle-class taste were often even more precious and playful than the corresponding forms in the art of the high Gothic.

Popular taste is expressed more in literature, which now, as nearly always, penetrates into lower levels of society than painting and sculpture, the products of which only wealthy people can afford to buy. Here, too, the popular element consists merely in the fact that most of the literary genres reveal less bias and less regard for the moral and aesthetic prejudices of the knightly caste, but there is no real folk poetry in any of this literature; nowhere does the unsophisticated idea of art of the common people, independent of the literary tradition of the upper classes, come into its own. The medieval fable has always been regarded by literary historians and folklore specialists as the direct

expression of the folk spirit. According to the romantic theory, which was universally recognized as valid until quite recently, the fables originated in oral tradition and rose from the depths of the simple, unlettered folk into the sphere of literature, leaving a late and partly inaccurate deposit of the original forms created by the folk. But in reality the opposite process seems to have taken place. We do not know of any popular fables older than the *Roman de Renart*; the French, Finnish, Ukrainian stories which we possess are all derived from the literary fable, and the medieval verse fables are probably dependent on that source as well.[229] But the case of the late medieval folk song is similar: it is the late descendant of the lyric verse of the troubadours and wandering scholars—a simplified and popularized form of the literary love song. It was spread abroad by the lower ranks of the minstrelsy who 'struck up the music for the dances, sang the very songs which are usually called the folk songs of the fourteenth, fifteenth and sixteenth centuries and were also sung in chorus by the dancers themselves. . . . Much of what was being developed in the Latin poetry of the time passed into folk song through their mediation.'[230] The fact that the so-called 'folk books' of the late Middle Ages are nothing but popular prose versions of the old courtly novels of chivalry is too well known to need stressing here. Only in one literary genre, the drama, do we find anything approaching folk poetry in the late Gothic period. Even here there is no question of the work being the original creation of the 'folk', but it is, at any rate, the continuation of a genuine popular tradition, transmitted since the days of the early classical age in the mime and then continued in the religious and secular drama of the Middle Ages. It is true that along with the miming tradition many themes of art-poetry, above all of Roman comedy, penetrated into the medieval theatre, but most of these themes were so deeply rooted in popular soil that the common people were for the most part merely receiving back their own cultural property. The religious theatre of the Middle Ages is, on the other hand, entirely a popular art and not only because its audience but also because the actors themselves came from all levels of society. The members of the companies are clerics, merchants, craftsmen, partly also simple members of

the crowd, in a word, dilettanti, as opposed to the actors in the secular theatre, who are professional mimes, dancers and singers. The dilettante spirit, which was never able to make any headway in the plastic arts until recent times, made its mark in the poetry and drama of the Middle Ages in all the changes in the sociological structure of cultural life. Even the troubadours were merely dilettanti to begin with, and only gradually developed into professional poets. After the decline of courtly culture, the majority of these poets, whose livelihood was based on more or less regular employment at court, became unemployed and gradually disappeared. The middle class was for the moment neither rich nor literary-minded enough to take them all on and feed them. The place of the minstrels is now taken once again partly by amateurs who continue their ordinary civic pursuits and devote only their spare time to poetry and the drama, into which they introduce the spirit of their own craftsmanship, in fact they emphasize and exaggerate the technical elements of literary creation, as if thereby to compensate for the dilettantism which does not really fit into their solid workmanlike way of life. They unite, as do the actors in the religious drama, in guildlike organizations and subject themselves to a mass of regulations, instructions and prohibitions, which are reminiscent in many respects of the statutes of the guilds. And this workmanlike spirit is expressed not only in the poetry and drama of the non-professional dilettanti, but also in the works of those professional poets who, wholly in the spirit of craftsmanship, call themselves 'masters' and 'mastersingers' and consider themselves infinitely superior to the lower ranks of the minstrelsy. They invent for themselves artificial, above all metrical difficulties, in order to put the rabble of uneducated minstrels in the shade with their virtuosity and learning. This literary poetry, which holds fast to the tradition of the already antiquated courtly-chivalric poetry both in form and content, is not only the form furthest removed from the naturalistic style of the late Gothic period, and, therefore, the least popular artistic form, but it is also the least fruitful genre of the age.

The naturalism of high Gothic art corresponded to some extent to the naturalism of Greek classicism; the depiction of reality still moved within the limits of strict forms and abstained

from entering into details which might endanger the concentrated unity of the composition. The naturalism of the late Gothic period now explodes this formal unity just as the art of the fourth century B.C. and of Hellenism had exploded it, and concentrates on the imitation of reality with an often brutal and ruthless disregard for the formal structure. The special quality of the art of the late Middle Ages does not consist in naturalism itself, but in the discovery of the independent value and status of this naturalism, which now often contains its purpose within itself and is no longer—or no longer wholly—subservient to a symbolical and supernatural meaning. Supramundane connections are not lacking here either, but the work is in the first place a copy of nature and not a symbol using natural forms as a means serving an extraneous purpose. Nature is not yet of absolute significance in herself, but already interesting enough to be studied and depicted for her own sake. In late medieval middle-class literature, the fable and the farce, the prose novel and the short story, an absolutely secular, spicy and coarse naturalism already finds expression, in sharpest conceivable contrast to the idealism of the chivalric novels and the sublimated feelings of the aristocratic love lyric. Here for the first time, we meet with real, lifelike characters—and the supremacy of the psychological approach in literature begins to make itself felt. No doubt it is possible to find accurately observed characters even in earlier medieval literature—the 'Divine Comedy' is full of them—but both in the work of Dante and, for example, in that of Wolfram von Eschenbach the psychological individuality of the characters is not in the foreground, but rather their symbolical significance; they do not contain their meaning and *raison d'être* in themselves but reflect a meaning far beyond the confines of their individual existence. The main difference between the character descriptions of late medieval literature and the method of the earlier period is that the writers do not come across the peculiarities of their characters by chance, but look for them, collect them and spy them out. This psychological alertness is, however, more than anything else a product of urban life and commercialism. The concentration of many different people in one town, the richness and frequent alternation of the various types one meets day by day,

sharpens the eye for peculiarities of character, but the real incentive of psychological observation comes from the fact that knowledge of human nature, the correct psychological assessment of one's business partner, is among the most essential requisites of the merchant. The urban and financial conditions of life which force man out of his static world of custom and tradition into a more dynamic reality, into a world of constantly changing persons and situations, also explain why man now acquires a new interest in the things of his immediate environment. For this environment is now the real scene of his life, it is within this environment that he has to prove his worth; but to do so, he must know its every detail. And thus every detail of daily life becomes an object of observation and description; not only human beings, but also animals and trees, not only living nature, but also the home and the furniture in the home, costumes and tools, become themes of artistic interest in themselves.

The man of the late medieval middle-class epoch looks out on the world with different eyes and from a different standpoint than his forefathers whose interests were confined to the next world. He stands, as it were, on the edge of a road on which colourful, inexhaustible, relentlessly onward-flowing life unfolds itself and he not only finds everything that happens there extremely interesting, but he also feels himself involved in all this life and activity. The 'travel landscape'[231] is the most typical pictorial theme of the age and the pilgrim procession of the Ghent altar is to a certain extent the basic form of its world-view. Again and again the art of the late Gothic period depicts the wanderer, the traveller, the walker, everywhere it tries to arouse the illusion of a journey, everywhere its characters are driven by an urge to be always on the move, always on the road.[232] The pictures pass in front of the beholder like the scenes of a constantly moving procession—and the beholder is spectator and participant at the same time. And this aspect of the 'side of the road', which eliminates the sharp division between stage and auditorium, is precisely the special, one might say the 'film-like', expression of the dynamism of the age. The spectator himself stands on the stage; the auditorium is simultaneously the scenery on the stage. Stage and auditorium, aesthetic and empirical

reality, come into direct contact and form one continuous world: the principle of frontality has been completely abolished, the aim of artistic representation is the absolute illusion. The onlooker no longer stands over against the work of art like the inhabitant of another world, he has been drawn into the sphere of the representation himself, and this identification of the surroundings of the scene represented with the medium in which the onlooker is himself, first produces the complete illusion of space. Now, when the framework of the picture is regarded as the frame of a window through which one looks out onto the world, which induces the onlookers to regard the space in front of and behind the 'window' as one continuous medium, now for the first time the space occupied by the picture achieves depth and reality. The fact that the artist of the late Middle Ages is able to represent real space—space in our sense—an achievement beyond the powers of classical antiquity and the early Middle Ages, is due to the 'film-like' view of things produced by the new dynamic attitude of life itself. But it is, above all, this new feeling for space to which late Gothic art owes its naturalistic character. And although late medieval art still forms its illusion of space somewhat inaccurately and inconsistently, compared with the Renaissance grasp of perspective, the new feeling for reality which inspires the middle class is already manifest in this new method of representation.

Meanwhile, courtly-chivalric culture did not cease to continue exerting its influence, and not merely indirectly but in its own forms, which enjoyed a second rich blossoming in certain centres, above all at the Burgundian court. Here we can and must still speak of a courtly aristocratic culture, in contrast to the culture of the middle class. Here literature still lives and moves within the forms of the chivalric way of life and art still serves the official purposes of court society. Even the painting of the van Eycks, which strikes us as so middle-class, develops in the midst of court life and is intended for court circles and the upper middle class associated with these circles.[233] But the remarkable thing, and this is the most striking expression of the victory of the middle-class spirit over the spirit of chivalry, is that even in court art, and indeed even in its most luxurious form, miniature

painting, middle-class naturalism gains the upper hand. The Books of Hours produced for the Dukes of Burgundy and the Duke of Berri not only represent the beginning of the picture of manners, that is, the most bourgeois genre of painting, they form to some extent the origin of the whole of middle-class painting, extending from the portrait to landscape.[234] Not only the spirit but also the outward forms of the old ecclesiastical and courtly art gradually disappear: the monumental mural painting is forced out of existence by panel painting and aristocratic book illumination by the new graphic arts. This means not only the victory of the cheaper, 'more democratic' but, at the same time, that of the more intimate, spiritually more middle-class forms. Painting first becomes independent of architecture in the shape of the panel-picture and only as such does it become part of the movable furniture of the middle-class home.

But panel painting is still the art of the well-to-do man with fastidious tastes; the art of the small folk, of the little man, if not also of the peasant and the proletariat, is the print. The woodcut and the engraving are the first popular, relatively cheap products of the fine arts. The technique of mechanical reproduction makes possible here what is obtained in literature by the use of large audiences and repeated performances. The graphic arts are the popular complement of the aristocratic art of book illumination; the illustrated broadsheets and block-books, sold at fairs and outside church doors, mean the same to the middle-class folk as the illuminated manuscripts do to the princes and magnates. The popularizing tendency in art is now so strong that the coarser and cheaper woodcut wins the day not only against the art of book illumination but also against the more refined and more expensive copperplate-engraving.[235] It is hardly possible to estimate the influence of the spread of these prints on the development of modern art. But one thing is certain: if the work of art loses that magic, that 'aura' which it still possessed in the earlier Middle Ages and shows a tendency corresponding to the 'disenchantment of reality' produced by middle-class rationalism, this is also partly connected with the loss of the unique quality of the individual work of art by reproducing it mechanically.[236] Another concomitant of the technique and exploitation of the print

is the progressive depersonalization of the relationship between the public and the artist. The mechanically reproduced illustrated sheet, circulating in many copies and distributed almost exclusively by the middleman, is very much in the nature of a mere commodity, compared with the original work. And although the workshop routine of the age already tends towards the 'production of commodities' with its apprentice work and copying of originals, the print, with its many identical copies of one and the same representation, is the first perfect example of production for stock in a field where work was previously only done to order. In the fifteenth century workshops arise, in which manuscripts are copied in factory style and are illustrated with hurried pen drawings, and where the finished copies are offered for sale as in a bookshop. Even painters and sculptors begin to work for stock, and the principle of impersonal commodity-production thus comes to dominate the whole of art. For the Middle Ages, which, from the very outset, did not lay the emphasis on the personal genius of the artist but on the craftsmanship involved in artistic creation, the mechanization of production was not so difficult to reconcile with the nature of art as it is for the modern age and as it would have been for the Renaissance if the medieval tradition of craftsmanship in art had not kept its conception of genius within comparatively narrow bounds.

NOTES

I. PREHISTORIC TIMES

1. This antithesis also forms the background of the discussion, of funda-
mental importance for archaeology, in which ALOIS RIEGL (*Stilfragen*, 1893)
examines Semper's doctrine that art takes its rise from the spirit of technics.
For GOTTFRIED SEMPER (*Der Stil in den technischen und tektonischen Kuen-
sten*, 1860) art is no more than a by-product of craft and the quintessence of
those decorative forms which result from the individual quality of the
material, from the methods according to which it is treated and the practical
purpose for which the object to be produced is intended. In opposition to this
view, Riegl emphasizes that all art, even ornamental art, has a naturalistic
imitative origin, and the geometrically stylized forms in no way stand at the
beginning of the history of art, but are a comparatively late phenomenon, the
creation of an already highly cultivated artistic feeling. As the result of his
investigations, he opposes to the mechanistic-materialistic theory propounded
by Semper, which he calls 'the transfer of Darwinism to a field of cultural
life', his own doctrine based on 'art-creating thought', according to which
artistic forms by no means simply follow the dictates of the raw material and
the tool, but are found and achieved precisely in the struggle of the purposive
'artistic intention' (*Kunstwollen*) against these material conditions. The
methodical idea which Riegl here introduces in his discussion of the dialectic
of the mental and the material, of the content and the means of expression,
of the will and the substratum of the will, and with which he essentially
supplements Semper's theory, even if he does not entirely invalidate it, is of
basic significance for the whole theory of art.

The adherence to one or the other of the two ideologically divided schools
of thought finds expression everywhere in the archaeological theorizing of
individual scholars. ALEXANDER CONZE ('Zur Gesch. der Anfaenge griechi-
scher Kunst', *Sitzungsberichte der Wiener Akademie*, 1870, 1873.—*Sitzungs-
berichte der Berliner Akademie*, 1896.—*Ursprung der bildenden Kunst*, 1897),
JULIUS LANGE (*Darstellungen des Menschen in der aelteren griech. Kunst*,
1899), EMMANUEL LOEWY (*Die Naturwiedergabe in der aelteren griech.
Kunst*, 1900), WILHELM WUNDT (*Elemente der Voelkerpsychologie*, 1912),
KARL LAMPRECHT (*Bericht ueber den Berliner Kongress fuer Aesthetik und
allg. Kunstwiss.*, 1913), all tend, as conservative academicians and university
teachers, to connect the nature and the beginnings of art with the principles

245

of geometric ornamentalism and technical functionalism. And if they do, in fact, like Loewy or Conze in his later period, admit the priority of naturalism, they attempt, nevertheless, to limit the significance of this admission by trying to prove the existence even in the monuments of primitive naturalism of the most important stylistic characteristics of so-called 'archaic' art, such as frontality, the lack of perspective and spatial depth, the forgoing of group formations and the integration of the pictorial elements.—ERNST GROSSE (*Die Anfaenge der Kunst*, 1894), SALOMON REINACH (*Répertoire de l'art quartenaire*, 1913.—'La Sculpture en Europe', *L'Anthropologie*, V–VII, 1894–6), HENRI BREUIL (*La Caverne d'Altamira*, 1906.—'L'Age des peintures d'Altamira', *Revue préhistorique*, 1906, I, pp. 237–49) and his followers, G. H. LUQUET ('Les Origines de l'art figuré', *Jahrb. fuer praehist. u. ethnogr. Kunst*, 1926, pp. 1 ff.—*L'Art primitif*, 1930.—'Le Réalisme dans l'art paléolithique', *L'Anthropologie*, 1923, XXXIII, pp. 17–48), HUGO OBERMAIER (*El hombre fósil*, 1916.—*Urgeschichte der Menschheit*, 1931.— *Altamira*, 1929), HERBERT KUEHN (*Kunst und Kultur der Vorzeit Europas*, 1929.—*Die Kunst der Primitiven*, 1923), M. C. BURKITT (*Prehistory*, 1921. —*The Old Stone Age*, 1933), V. GORDON CHILDE (*Man Makes Himself*, 1936), recognize, on the other hand, without reserve, the primacy of naturalistic art and stress precisely the 'unarchaic' tendency in it, its absolute naturalness and vitality.

2. ADAMA VAN SCHELTEMA (*Die Kunst unserer Vorzeit*, 1936) is perhaps in the most difficult situation of all, since ideologically he is one of the most reactionary but in matters of scholarship one of the rather competent archaeologists.

3. E. B. TYLOR: *Primitive Culture*, 1913, I, p. 424.

4. LÉVY-BRUHL: *Les Fonctions mentales dans les sociétés inférieures*, 1910, p. 42.

5. WALTER BENJAMIN: 'L'oeuvre d'art à l'époque de sa reproduction mécanisée', *Zeitschrift fuer Sozialforschung*, 1936, V, p. 45.

6. On the interpretation of Palaeolithic art as magic see H. OBERMAIER in *Reallexikon der Vorgesch.*, 1926, VII, p. 145, and *Altamira*, pp. 19–20.— H. OBERMAIER-H. KUEHN: *Bushman Art*, 1930, p. 57.—H. KUEHN: *Kunst und Kultur der Vorzeit*, pp. 457-75.—M. C. BURKITT: *Prehistory*, pp. 309–13.

7. ALFRED VIERKANDT: 'Die Anfaenge der Kunst', *Globus*, 1907.— K. BETH: *Religion und Magie*, 2nd edit., 1927.

8. G. H. LUQUET: 'Les Origines de l'art figuré', *IPEK*, 1926.

9. CARL SCHUCHARDT: *Alteuropa*, 1926, p. 62.

10. GORDON CHILDE: *Man Makes Himself*, p. 80.

11. KARL BUECHER: *Die Entstehung der Volkswirtschaft*, I, 1919, p. 27.

12. HERBERT KUEHN has dealt in detail with the antithesis of the magical and animistic world-view in relation to art in his *Kunst und Kultur der Vorzeit*, 1929.

13. H. HOERNES-O. MENGHIN: *Urgeschichte der bildenden Kunst in Europa*, 3rd edit., 1925, p. 90.

14. GORDON CHILDE, op. cit., p. 109.

15. HENRI BREUIL: 'Stylisation des dessins à l'âge du renne', *L'Anthropologie*, 1906, VIII, pp. 125 ff.—Cf. M. C. BURKITT: *The Old Stone Age*, pp. 170–3.

16. HEINRICH SCHURTZ: 'Die Anfaenge des Landbesitzes', *Zeitschr. fuer Sozialwiss.*, III, 1900.

17. Cf. H. OBERMAIER-H. KUEHN: *Bushman Art.*—H. KUEHN: *Die Kunst der Primitiven.*—HERBERT READ: *Art and Society*, 1936.—L. ADAM: *Primitive Art*, 1940.

18. WILHELM HAUSENSTEIN: *Bild und Gemeinschaft*, 1920. First appeared under the title 'Versuch einer Soziologie der bildenden Kunst' in the *Archiv fuer Sozialwiss. und Sozialpolitik*, Vol. 36, 1913.

19. Cf. FR. M. HEICHELHEIM: *Wirtschaftsgeschichte des Altertums*, 1938, pp. 23–4.

20. H. OBERMAIER: *Urgeschichte der Menschheit*, 1931, p. 209.— M. C. BURKITT: *The Old Stone Age*, pp. 215–16.

21. HORNES-MENGHIN, op. cit., p. 574.

22. Ibid., p. 108.

23. Ibid., p. 40.

24. FR. M. HEICHELHEIM, op. cit., pp. 82–3.

25. HOERNES-MENGHIN, op. cit., p. 580.

II. ANCIENT-ORIENTAL URBAN CULTURES

1. Cf. LUDWIG CURTIUS: *Die antike Kunst*, I, 1923, p. 71.

2. J. H. BREASTED: *A History of Egypt*, 1909, p. 102.

3. A. ERMAN: *Life in Ancient Egypt*, 1894, p. 414.

4. ROEDER: 'Aegyptische Kunst'. In Max Ebert's *Reallexikon der Vorgeschichte*, VII, 1926, p. 168.

5. LUDWIG BORCHARDT: *Der Portraetkopf der Koenigin Teje*, 1911.

6. A. ERMAN, loc. cit.

7. Ibid.

8. Cf. TH. VEBLEN: *The Theory of the Leisure Class*, 1899, III: 'Conspicuous leisure'.

9. S. R. K. GLANVILLE: *Daily Life in Ancient Egypt*, 1930, p. 33.

10. MAX WEBER: *Wirtschaftsgeschichte*, 1923, p. 147.

11. Cf. W. M. FLINDERS PETRIE: *Social Life in Ancient Egypt*, 1923, p. 27.

12. H. SCHAEFER: *Von aegyptischer Kunst*, 1930, 3rd edit., p. 59.

13. Ibid., p. 68.

14. F. M. HEICHELHEIM: *Wirtschaftsgesch. des Altertums*, 1938, p. 151.

15. L. CURTIUS, loc. cit.

16. Cf. W. SPIEGELBERG: *Gesch. der aegypt. Kunst*, 1903, p. 22.

17. GEORG MISCH: *Gesch. der Autobiographie*, I, 1931, 2nd edit., p. 10.

NOTES

18. Cf. W. Spiegelberg, op. cit., p. 5.

19. Cf. H. Schaefer, op. cit., p. 57,

20. W. Hausenstein has already pointed out the connection between frontality and the social structure of 'feudal and hieratic' cultures.—*Archiv fuer Sozialwiss. u. Sozialpolit.*, 1913, vol. 36, pp. 759–60.

21. Richard Thurnwald: 'Staat und Wirtschaft im alten Aegypten', *Zeitschr. f. Sozialwiss.*, 1901, vol. 4, p. 699.

22. J. H. Breasted, op. cit., pp. 356, 377.

23. Ibid., p. 378.

24. Eduard Meyer: 'Die wirtschaftl. Entwicklung des Altertums', *Kleine Schriften*, I, 1924, p. 94.

25. J. H. Breasted, op. cit., p. 169.

26. Flinders Petrie, op. cit., p. 21.

27. H. Schaefer, op. cit., p. 62.

28. Roeder, loc. cit., p. 168.—Cf. H. Schaefer, op. cit., p. 60.

29. O. Neurath: *Antike Wirtschaftsgesch.*, 1926, 3rd. edit., pp. 12–13.

30. Walter Otto: *Kulturgesch. des Altertums*, 1925, p. 27.

31. Eckhard Unger: 'Vorderasiatische Kunst'. In Max Ebert's *Reallexikon der Vorgeschichte*, VII, 1926, p. 171.

32. Bruno Meissner: *Babylonien und Assyrien*, I, 1920, p. 274.

33. Ibid., p. 316.

34. G. Glotz: *La Civilisation égéenne*, 1923, pp. 162–4.

35. H. Hoernes-O. Menghin: *Urgeschichte der bildenden Kunst*, 1925. p. 391.

36. G. Rodenwaldt: *Die Kunst der Antike*, 1927, pp. 14–15.

37. L. Curtius sees in Cretan art 'the first revelation of a new European spirit, which . . . differs, with its passionate mobility, in the sharpest possible manner from Oriental art', *Die antike Kunst*, II, p. 56.

38. Cf. G. Karo: *Die Schachtgraeber von Mykenai*, 1930, p. 288.— G. A. S. Snijder: *Kretische Kunst*, 1936, pp. 47, 119.

39. Cf. D. G. Hogarth: *The Twilight of History*, 1926, p. 8.

40. Hoernes-Menghin, op. cit., pp. 378, 382.—C. Schuchhardt: *Alteuropa*, 1926, p. 228.

41. G. Rodenwaldt: 'Nordischer Einfluss im Mykenischen?' *Jahrbuch des Deutschen Archaeolog. Instit. Beiblatt*, XXXV, 1920, p. 13.

42. On the questionableness of Cretan taste cf. G. Glotz, op. cit., p. 354. —A. R. Burn: *Minoans, Philistines and Greeks*, 1930, p. 24.

III. GREECE AND ROME

1. H. M. Chadwick: *The Heroic Age*, 1912, pp. 450 ff.—A. R. Burn: *The World of Hesiod*, 1936, pp. 8 ff.

2. H. M. Chadwick, op. cit., pp. 347–8, 365.—George Thomson: *Aeschylus and Athens*, 1941, p. 62.

3. 'There is one thing which the best prefer to everything else: the

eternal fame to transitory things'—as Heraclitus still says. Fragment No. 29 in H. DIELS: *Die Fragmente der Vorsokratiker*, I, 1934, 5th edit., p. 157.

3a. Incidentally, even in prehistoric times, not all genres seem to have been performed chorically.

4. H. M. CHADWICK, op. cit., p. 87.

5. W. SCHMID-O. STAEHLIN: 'Gesch. der griech. Lit.', I, 1, 1929, p 59. In I. Mueller's *Handbuch der Alterstumswiss.*

6. Ibid., p. 60.

7. Ibid., p. 664.

8. Cf. O. NEURATH: *Antike Wirtschaftsgesch.*, 1926, 3rd edit., p. 24.

9. SCHMID-STAEHLIN, op. cit., I, 1, p. 157.

10. Cf. HERMANN REICH: *Der Mimus*, 1903, I, p. 547.

11. E. A. GARDNER: 'Early Athens'. In *The Cambridge Ancient History*, III, 1929, p. 585.

12. G. THOMSON refers to V. GROENBECK: *Culture of the Teutons*, 1931, in his exposition of this theory (op. cit., p. 45).

13. H. M. CHADWICK, op. cit., p. 228.

14. Ibid., p. 234.

15. A. R. BURN: *Minoans, Philistines and Greeks*, 1930, p. 200.

16. PAUL CAUER: *Grundfragen der Homerkritik*, 1909, 2nd edit., pp. 420–3.

17. SCHMID-STAEHLIN, op. cit., I, 1, pp. 79–81.

18. U. V. WILAMOWITZ-MOELLENDORFF: *Die griech. Lit. des Altertums*, 1912, 3rd edit., p. 17.

19. BERNHARD SCHWEITZER: 'Untersuchungen zur Chronologie und Geschichte der geometrischen Stile in Griechenland'. *Athen. Mitt.*, XLIII, 1918, p. 112.

20. Cf. W. JAEGER: *Paideia. The Ideals of Greek Culture*, 1939, p. 184.

21. WILAMOWITZ-MOELLENDORFF: *Einleitung in die griech. Tragoedie*, 1921, p. 105.

22. Cf. EDGAR ZILSEL: *Die Entstehung des Geniebegriffs*, 1926, p. 19.

23. J. BURCKHARDT: *Griech. Kulturgesch.*, IV, 1902, p. 115.

24. LUDWIG CURTIUS thinks that, from the sixth century, 'the inscription placed on the base of every important piece of Greek sculpture mentioned, apart from the name of the patron and the name of the god to whom the statue was dedicated . . . the name or names of the artists', *Die Antike Kunst*, II, 1, 1938, p. 246.

25. W. JAEGER, op. cit., p. 230.—Cf. C. M. BOWRA: 'Sociological Remarks on Greek Poetry', *Zeitschr. f. Sozialforsch.*, 1937, VI, p. 393.

26. B. SCHWEITZER: *Der bildende Kuenstler und der Begriff des Kuenstlerischen in der Antike*, 1925, p. 45.

27. T. B. L. WEBSTER: *Greek Art and Literature 530–400 B.C.*, 1939—thinks that sensualism is the particular stylistic trend of the court of Polycrates, intellectualism that of the court of Pisistratus.

28. PERIEGESIS, V, 21.

NOTES

29. J. D. BEAZLEY: 'Early Greek Art', *Cambridge Ancient Hist.*, IV, 1926, p. 589.

30. G. THOMSON, op. cit., p. 353.

31. GILBERT MURRAY: *A History of Ancient Greek Lit.*, 1937, p. 279.

32. VICTOR EHRENBERG: *The People of Aristophanes. A Sociology of Old Attic Comedy*, 1943—does not succeed, either, in making the poet a friend of democracy.

33. Cf. ADOLF ROEMER: 'Ueber den literarisch-aesthetischen Bildungsstand des attischen Theaterpublikums', *Abh. der philos.-philol. Klasse der kgl. bayr. Akad. d. Wiss.*, 1905, vol. 22.

34. Cf. J. HARRISON: *Ancient Art and Ritual*, 1913, p. 165.

35. W. JAEGER, op. cit., p. 285.

36. Ibid., p. 342.

37. M. POHLENZ: *Die griech. Tragoedie*, 1930, I, pp. 236, 456.

38. G. THOMSON, op. cit., p. 347.

39. W. JAEGER, op. cit., p. 345.

40. The term comes from ALFRED WEBER: 'Die Not der geistigen Arbeiter'. In *Schriften des Vereins fuer Sozialpolitik*, 1920.

41. WILAMOWITZ-MOELLENDORFF: *Griechische Tragoedien*, II, 1907, 5th edit., p. 137.

42. T. B. L. WEBSTER: *Introduction to Sophocles*, 1936, p. 41.

43. G. MURRAY, op. cit., p. 253.

44. E. ZILSEL, op. cit., pp. 14–15.

45. Ibid., p. 78.

46. Cf. K. MANNHEIM: 'Wissenssoziologie'. In Vierkandt's *Handwoerterbuch der Soziologie*, 1931, p. 672.

46a. P.-M. SCHUHL: *Platon et l'art de son temps*, 1933, pp. 14, 21.

47. WILAMOWITZ-MOELLENDORFF: *Einleitung in die griech. Tragoedie*, 1921, p. 111.

48. L. WHIBLEY: *A Companion to Greek Studies*, 1931, p. 301.

49. K. J. BELOCH: *Griech. Gesch.*, 1925, 2nd edit., IV, 1, pp. 323–5.— M. ROSTOVTZEFF: *The Social and Economic History of the Hellenistic World*, 1941, I, pp. 206–7; II, pp. 618, 755.

50. O. NEURATH, op. cit., p. 49.

51. JUL. KAERST: *Gesch. des Hellenismus*, II, 2nd edit., 1926, pp. 166–7.

52. Ibid., p. 163.

53. GEORG. MISCH: *Gesch. der Autobiographie*, I, 1931, 2nd edit., pp. 96 ff.

54. Ibid., pp. 105, 113, 179.

55. WILAMOWITZ-MOELLENDORFF: *Die griech. Lit.*, pp. 185–7.

56. E. BETHE: 'Die griech. Poesie'. In GERCKE-NORDEN, *Einl. in die Altertumswiss.*, I, 3, 1924, p. 38.

57. The word in the sense intended here comes from Max Weber.

58. FRANZ WICKHOFF: *Roemische Kunst*, 1912, p. 23.

58a. ARNOLD SCHOBER: 'Zur Entstehung und Bedeutung der provinzial-

NOTES

2. OSKAR WULFF: 'Die umgekehrte Perspektive und die Niedersicht'. In *Kunstwissenschaftliche Beitraege A. Schmarsow gewidmet*, 1907.—*Die Kunst des Kindes*, 1927.

3. WILHELM NEUSS: *Die Kunst der alten Christen*, 1926, pp. 117–18.—Illustration in H. PIERCE–R. TYLER: *L'Art byzantin*, II, 1934, plate 143.

4. Cf. E. V. GARGER: 'Ueber Wertungsschwierigkeiten bei mittelalterlicher Kunst'. *Kritische Berichte zur kunstgeschichtlichen Literatur*, 1932–3, p. 104.

5. M. DVOŘÁK: *Idealismus und Naturalismus i. d. got. Skulptur u. Malerei*, 1918, p. 32. Here in connection with later Carolingian art.

6. RUDOLF KOEMSTEDT: *Vormittelalterliche Malerei*, 1929, passim. Cf. for the following, pp. 14–18 and 20–3.

7. Ibid., p. 40.

8. HENRI PIRENNE: 'Le mouvement économique et social'. In *Histoire du Moyen Age*, edited by G. Glotz, VIII, 1933, p. 20.

9. STEVEN RUNCIMAN: *Byzantine Civilization*, 1933, p. 204.

10. LUJO BRETANO: 'Die byzantinische Volkswirtschaft', *Schmoller's Jahrbuch*, 1917, 41st year, Vol. 2, p. 29.

11. *Georg Ostrogorsky:* 'Die wirtsch. u. soz. Entwicklungsgrundlagen des byz. Reiches', *Vierteljahrsschr. f. Sozial- u. Wirtschaftsgesch.*, 1929, XXII, p. 134.

12. RICHARD LAQUEUR: 'Das Kaisertum und die Gesellschaft des Reiches'. In *Probleme der Spaetantike*, 17. Deutscher Historikertag, 1930, p. 10.

13. J. B. BURY: *History of the Later Roman Empire*, 1889, I, pp. 186–7.

14. GEORG GRUPP: *Kulturgesch. des Mittelalters*, III, 1924, p. 185.

15. It is only from the sixth century onwards that a 'weakening of state authority by the aristocratic families' makes itself felt.—H. SIEVEKING: *Mittlere Wirtschaftsgesch.*, 1921, p. 19.

16. G. OSTROGORSKY, op. cit., p. 136.

17. CHARLES DIEHL: *La Peinture byzantine*, 1933, p. 41.—Cf. ÉMILE MÂLE: *Art et artistes du moyen âge*, 1927, p. 9.

18. CH. DIEHL: *Manuel d'art byzantin*, 1925, I, p. 231.

19. N. KONDAKOFF: *Hist. de l'art byz. considéré principalement dans les miniatures*, 1886, I, p. 34.

20. R. KOEMSTEDT, op. cit., p. 28.

21. L. BRENTANO, op. cit., pp. 41–2.

22. Cf. E. J. MARTIN: *A History of Iconoclastic Controversy*, 1930, pp. 18–21.

23. Quoted by KARL SCHWARZLOSE: *Der Bilderstreit, ein Kampf der griech. Kirche um ihre Eigenart und ihre Freiheit*, 1890, p. 7.

24. G. GRUPP, op. cit., I, p. 352.

25. CARL BRIKMANN: *Wirtschafts- und Sozialgesch.*, 1927, p. 24.

26. O. M. DALTON: *Byzantine Art and Archaeology*, 1911, p. 13.—CARL NEUMANN: 'Byz. Kultur u. Renaissancekultur', *Historische Zeitschr.*, 1903, vol. 91, p. 222.

NOTES

roemischen Kunst', *Jahresber. des Oesterr. Archaeolog. Inst.*, 1930, XXVI, pp. 49–51.—*Silvio Ferri: Arte romana sul Reno*, 1931, p. 268.

58b. Cf. GUIDO KASCHNITZ-WEINBERG: 'Stud. zur etrusk. u. fruehroem. Portraetkunst', *Mitt. des Dtschen Arch. Inst. Roem. Abt.*, vol. XLI, 1926, pp. 178 ff.

58c. TH. MOMMSEN: *Roemisches Staatsrecht*, 1887, 3rd edit., I, p. 442; III, p. 465.

58d. A. ZADOKS-JITTA: *Ancestral Portraiture in Rome*, 1932, p. 34.

59. HERBERT KOCH: 'Spaetantike Kunst'. In *Probleme der Spaetantike*. Vortraege auf dem 17. Deutschen Historikertag, 1930, pp. 41–2.

60. G. RODENWALDT: *Die Kunst der Antike*, 1927, p. 67.

61. TH. BIRT: *Zur Kulturgesch. Roms*, 1917, 3rd edit., p. 138.

62. Ibid.

63. F. WICKHOFF, op. cit., pass., especially pp. 14–16.

64. Ibid.

65. Cf. MAX DVOŘÁK: 'Katakombenmalereien. Anfaenge der christlichen Kunst'. In *Kunstgeschichte als Geistesgeschichte*, 1924, pp. 16–17.

66. On the expressionism of late antiquity: RUD. KAUTZSCH: *Die bildende Kunst der Gegenwart und die Kunst der sinkenden Antike*, 1920.

67. Cf. H. KOCH, op. cit., pp. 49, 53.—G. RODENWALDT, op. cit., p. 87.— M. DVOŘÁK, op. cit., p. 21.

68. MAX WEBER: 'Die sozialen Gruende des Untergangs der antiken Kultur'. In *Ges. Aufsaetze zur Sozial- und Wirtschaftsgesch.*, 1924, pp. 307–8.

69. TH. VEBLEN: *The Theory of the Leisure Class*, 1899.

70. E. ZILSEL, op. cit., p. 35.

71. VEBLEN, op. cit., p. 36.

72. J. BURCKHARDT, op. cit., IV, pp. 125–6.

73. Ibid., pp. 123–4.

74. B. SCHWEITZER: *Der bildende Kuenstler*, p. 47.

75. J. P. MAHAFFY: *Social Life in Greece from Homer to Meander*, 1888, p. 439.

76. SCHWEITZER: *Der bild. Kuenstler*, pp. 60, 124 ff.

77. *Enneades*, V, 8, 9.

78. O. NEURATH, op. cit., p. 68.

79. E. ZILSEL, op. cit., p. 26.

80. LACTANTIUS: *Div. Inst.*, II, 2, 14.

81. PLUTARCH: *Pericles*, 2, 1.

82. L. FRIEDLAENDER: *Darstellungen aus der Sittengesch. Roms*, III, 10th edit., 1923, p. 103.—B. SCHWEITZER: *Der bild. Kuenstler*, p. 30.

IV. THE MIDDLE AGES

1. MAX DVOŘÁK: 'Katakombenmalereien. Die Aufaenge der christlichen Kunst'. In *Kunstgeschichte als Geistesgeschichte*, 1924.

NOTES

27. K. SCHWARZLOSE, op. cit., p. 241.

28. LOUIS BRÉHIER: *La Querelle des images*, 1904, pp. 41–2.—E. J. MARTIN, op. cit., pp. 28, 54.

29. Cf. O. M. DALTON, op. cit., pp. 14–15.—O. WULFF: *Altchristliche u. byz. Kunst*, 1918, II, p. 363.

30. CH. DIEHL: *La Peinture byz.*, p. 21.

31. C. SCHUCHARDT: *Alteuropa*, 1926, pp. 265 ff.

32. VITZTHUM-VOLBACH: *Die Mal u. Plastik des Mittelalters in Italien*, (1924), pp. 15–16.

33. GEORG DEHIO: *Gesch. der deutschen Kunst*, I, 4th edit., 1930, p. 15.

34. ALFONS DOPSCH: *Die Wirtschaftsentwicklung der Karolingerzeit*, 1912–13.—*Wirtsch. u. soz. Grundlagen der europ. Kulturentwicklung*, 1918–24.

35. KUNO MEYER: *Bruchstuecke der aelteren Lyrik Irlands. Abhandlungen der Preuss. Akad. d. Wiss.*, 1919, Philos.-Hist. Klasse, Nr. 7, p. 65.

36. Ibid., p. 66.

37. Ibid., p. 68.

38. Ibid., p. 4.

39. ELEANOR HULL: *A Text Book of Irish Lit.*, I, 1906, pp. 219–20.

40. Quoted from P. W. JOYCE: *A Social History of Ancient Ireland*, 1913, II, p. 503.

41. A. DOPSCH: *Wirtsch. u. soz. Grundl.*, I, pp. 103, 185–7.

42. FERDINAND LOT: *La Fin du monde antique et le début du moyen âge*, 1927, p. 421.

43. Ibid., p. 411.

44. A. DOPSCH: *Wirtsch. u. soz. Grundl.*, II, p. 98.

45. HENRI PIRENNE: *A History of Europe from the Invasions to the XVI Cent.*, 1939, p. 69.

46. SAMUEL DILL: *Roman Society in Gaul in the Merovingian Age*, 1926, p. 215.

47. Ibid., p. 224.

48. F. LOT: 'La Civilisation mérovingienne'. In *Hist. du Moyen Age*, edit. by G. Glotz, I, 1928, p. 362.

49. Ibid., p. 380.

50. H. PIRENNE: *A Hist. of Europe*, p. 58.

51. Ibid., pp. 111–12.

52. F. LOT: *La Fin du mond ant.*, p. 438.

53. GASTON PARIS: *Esquisse hist. de la litt. franç. au moyen âge*, 1907, p. 75.

54. C. H. BECKER: *Vom Werden und Wesen der islamischen Welt. Islamstudien*, I, 1924, p. 34.

55. DEHIO, op. cit., p. 62.

56. Ibid., p. 60.

NOTES

57. H. GRAEVEN: 'Die Vorlage des Utrechtpaslters', *Repertorium fuer Kunstwiss.*, 1898, XXI, pp. 28 ff.

58. ROGER HINKS: *Carolingian Art*, 1935, p. 117.

59. GEORG SWARZENSKI: 'Die karoling. Mal. u. Plastik in Reims', *Jahrb. d. kgl. Preuss. Kunstsammlungen*, XXIII, 1902.

60. LOUIS RÉAU-GUSTAVE COHEN: *L'Art du moyen âge et la civilisation franç.*, 1935, pp. 264–5.—R. HINKS, op. cit., p. 109.

61. DEHIO, op. cit., p. 63.

62. R. HINKS, op. cit., pp. 105, 209.

63. ANDREAS HEUSLER: *Die altgerm. Dicht.*, 1929, p. 107.—Cf. the same in JOH. HOOPS: *Reallex. d. german. Altertumskunde*, I, 1911–13, p. 459.

64. HERMANN SCHNEIDER: *German. Heldensage*, I, 1928, pp. 11, 32.

65. H. M. CHADWICK: *The Heroic Age*, 1912, p. 93.

66. KOBERSTEIN-BARTSCH: *Gesch. d. deutschen National-Lit.*, I, 1872, 5th edit., pp. 17, 41–2.

67. RUDOLF KOEGEL: *Gesch. der deutschen Lit.*, I, 1, 1894, p. 146.

68. A HEUSLER in Hoops' *Reallexikon*, I, p. 462.

69. W. P. KER: *Epic and Romance*, 2nd edit., 1908, p. 7.

70. H. SCHNEIDER, op. cit., p. 10.

71. A. HEUSLER: *Die altgerm. Dicht.*, p. 153.

72. JOSEPH BÉDIER: *Les Légendes épiques*, I, 1914, p. 152.

73. ROMANIA, XIII, p. 602.

74. PIO RAJNA: *Le origini dell'epopea francese*, 1884, pp. 469–85.

75. J. BÉDIER, op. cit., III, 1921, pp. 382, 390.

76. Ibid., IV, 1921, p. 432.

77. WILHELM HERTZ: *Spielmannsbuch*, 1886, p. IV.

78. HERMANN REICH: *Der Mimus*, 1903, passim.

79. EDMOND FARAL: *Les Jongleurs en France au moyen âge*, 1910, p. 5.

80. WILHELM SCHERER: *Gesch. d. deutschen Lit.*, 1902, 9th edit., p. 60.

81. Ibid., p. 61.

82. H. SCHNEIDER, op. cit., p. 36.

83. CH. H. HASKINS: *The Renaissance of the 12th Cent.*, 1927, p. 33.

84. ALOYS SCHULTE: *Der Adel und die deutsche Kirche im Mittelalter*, 1910.

85. ERNST TROELTSCH: *Die Soziallehren der christl. Kirchen und Gruppen*, 1912, p. 118.—G. GRUPP, op. cit., I, p. 109.

86. A. DOPSCH: *Die wirtsch. u. soz. Grundl.*, II, p. 427.

87. LEWIS MUMFORD: *Technics and Civilization*, 1934, p. 13.—Cf. WERNER SOMBART: *Der moderne Kapitalismus*, II, 1, 1924, 6th edit., p. 127. —HEINR. SIEVEKING: *Wirtschaftsgesch.*, II, 1921, p. 98.

88. Cf. for the following: J. W. THOMPSON: *The Medieval Library*, 1939, pp. 594–9, 612.

89. P. BOISSONADE: *Le Travail dans l'Europe chrét. au moyen âge*, 1921, p. 129.

90. G. G. COULTON: *Medieval Panorama*, 1938, p. 267.

NOTES

91. Jos. KULISCHER: *Allg. Wirtschaftsgesch.*, I, 1928, p. 75.

92. Ibid., pp. 70–1.

93. VIOLLET-LE-DUC: *Dictionnaire raisonnée*, I, 1865, p. 128.

94. K. TH. V. INAMA-STERNEGG: *Deutsche Wirtschaftsgesch.*, I, 1909, 2nd edit., p. 571.

95. JULIUS V. SCHLOSSER: *Quellenbuch zur Kunstgesch. des abendlaendischen Mittelalters*, 1896, p. xix.

96. WILHELM VOEGE: *Die Anfaenge des monumentalen Stiles im Mittelalter*, 1894, p. 289.

97. *Recueil de textes relatifs à l'histoire de l'architecture et à la condition des architectes en France au moyen âge, XII–XIII^e siècles.* Publ. par V. Mortet-P. Deschamps, 1929, p. xxx.

98. F. DE MÉLY: *Les Primitifs et leurs signatures*, 1913.

99. F. DE MÉLY: 'Nos vieilles cathédrales et leurs maîtres d'oeuvre', *Revue Archéologique*, 1920, XI, p. 291; 1921, XII, p. 95.

100. MARTIN S. BRIGGS: *The Architect in History*, 1927, p. 55.

101. A. SCHULTE, op. cit., p. 221.

102. HEINRICH V. EICKEN: *Gesch. u. Systemder mittelalterl. Weltansch.*, 1887, p. 224.

103. E. TROELTSCH: *Soziallehren*, p. 242.

104. JOHANNES BUEHLER: *Die Kultur des Mittelalters*, 1931, p. 95.

105. KARL BUECHER: *Die Entstehung der Volkswirtschaft*, I, 1919, pp. 92 ff.

106. GEORG. V. BELOW: *Probleme der Wirtschaftsgesch.*, 1920, pp. 178–9, 194 ff.—A. DOPSCH: *Wirtsch. u. soz. Grundl.*, II, pp. 405–6.

107. H. PIRENNE: *Le mouvement écon.*, p. 13.

108. W. SOMBART: *Der mod. Kapit.*, I, 1916, 2nd edit., p. 31.

109. J. BUEHLER, op. cit., pp. 261–2.

110. E. TROELTSCH, op. cit., p. 223.

111. Cf. OSWALD SPENGLER: *Der Untergang des Abendlandes*, I, 1918, p. 262.

112. H. PIRENNE: *A Hist. of Europe*, p. 171.

113. G. DEHIO, op. cit., p. 73.

114. E. TROELTSCH, op. cit., p. 215.

115. G. DEHIO, op. cit., p. 73.

116. Ibid., p. 144.

117. A. FLICHE: 'La Civilisation occidentale aux X^e et XI^e siècles'. In *Hist. du Moyen Age*, edit. by G. Glotz, II, 1930, pp. 597–609.

118. ANTON SPRINGER: *Die Psalterillustrationen im fruehen Mittelalter. Abhandlungen der kgl. Saechs. Ges. d. Wiss.*, VIII, 1883, p. 195.

119. H. BEENKEN: *Romanische Skulptur in Deutschland*, 1924, p. 17.

120. G. V. LUECKEN: 'Burgundische Skulpturen des 11. u. 12. Jahrh.', *Jahrb. der Kunstwiss.*, 1923, p. 108.

121. G. KASCHNITZ-WEINBERG: 'Spaetroemische Portraets', *Die Antike*, II, 1926, p. 37.

122. G. DEHIO, op. cit., pp. 193–4.

NOTES

123. Julius Baum: *Die Mal. u. Plast. des Mittelalters in Deutschland, Frankreich und Britannien*, 1930, p. 76.

124. J. Prochno: *Das Schreiber- und Dedikationsbild in der deutschen Buchmalerei*, I, 1929, passim.

125. G. Dehio, op. cit., p. 183.

126. Max Weber: *Wirtschaftsgesch.*, 1923, p. 124.

127. K. Buecher, op. cit., p. 397.

128. Ibid., pp. 139 ff.

129. R. Genestal: *Le Rôle des monastères comme établissements de crédit*, 1901.

130. Cf. for the following: Georg Simmel: *Philosophie des Geldes*, 1900, passim, and E. Troeltsch: *Soziallehren*, p. 244.

131. Alfred Rambaud: *Hist. de la civ. franç.*, I, 1885, p. 259.

132. H. Pirenne: *Medieval Cities*, 1925, p. 229.

133. Cf. Charles Seignobos: *Essai d'une hist. comparée des peuples d'Europe*, 1938, p. 152.—H. Pirenne: *Med. Cities*, p. 200.

134. P. Boissonade, op. cit., p. 311.

135. W. Cunningham: *Essay on Western Civ. in its Econ. Aspects. Ancient Times*, 1911, p. 74.

136. Albert Hauck: *Kirchengesch. Deutschlands*, IV, 1913, pp. 569–70.

137. Gioacchino Volpe: 'Eretici e moti ereticali dal XI al XIV sec. nei loro motivi e riferimenti sociali', *Il Rinnovamento*, I, 1, 1907, p. 666.

138. Cf. for the following: J. Buehler, op. cit., p. 228.

139. H. Pirenne: *Hist. of Europe*, p. 238.—*Med. Cities*, p. 240.

140. J. W. Thompson: *The Literacy of the Laity in the Middle Ages*, 1939, p. 133.

141. Hans Naumann: *Deutsche Kultur im Zeitalter des Rittertums*, 1938, p. 4.—On the difference between the German and French situation in this respect: Louis Reynaud: *Les Origines de l'influence franç. en Allemagne*, 1913, pp. 167 ff.

142. Marc Bloch: 'La Ministérialité en France et en Allemagne', *Revue hist. de droit franç. et étranger*, 1928, p. 80.

143. Viktor Ernst: *Mittelfreie*, 1920, p. 40.

144. Paul Kluckhohn: 'Ministerialitaet und Ritterdichtung', *Zeitschr. f. Deutsches Altertum*, vol. 52, 1910, p. 137.

145. Marc Bloch: *La Société féodale*, II, 1940, p. 49.

146. Alfred v. Martin: 'Kultursoziologie des Mittelalters', *Handwoerterbuch d. Soziologie*, edit. by A. Vierkandt, 1931, p. 379.—J. Buehler, op. cit. p. 101.

147. Gustav Ehrismann: 'Die Grundlagen des ritterlichen Tugendsystems', *Zeitschr. f. Deutsches Altertum*, vol. 56, 1919, pp. 137 ff.

148. Hans Naumann: 'Ritterliche Standeskultur um 1200'. In *Hoefische Kultur*, 1929, p. 35.

149. Hennig Brinkmann: *Die Anfaenge des modernen Dramas*, 1933, p. 9, note 8.

NOTES

150. ERWIN ROHDE: *Der griech. Roman*, 1900, 2nd edit., pp. 68 ff.

151. H. O. TAYLOR: *The Medieval Mind*, 1925, I, p. 581.

152. EDWARD WECHSSLER: *Das Kulturproblem des Minnesangs*, 1909, p. 72.

153. Cf. for the following: ALFRED KOERTE: *Die hellenistische Dichtung*, 1925, pp. 166–7.

154. WILIBALD SCHROETER: *Ovid und die Troubadours*, 1908, p. 109.

155. E. K. CHAMBERS: 'Some Aspects of Medieval Lyric'. In *Early English Lyrics*. Chosen by E. K. Chambers and F. Sidgwick, 1907, pp. 260–1.

156. M. FAURIEL: *Hist. de la poésie provençale*, 1847, I, pp. 503 ff.—E. HENRICI: *Zur Gesch. der mittelhochdeutschen Lyrik*, 1876.

157. E. WECHSSLER: 'Frauendienst und Vasallitaet', *Zschr. f. franz. Spr. u. Lit.*, vol. 24, 1902.—*Das Kulturproblem des Minnesangs*, 1909.

158. JACQUES FLACH: *Les Origines de l'ancienne France. II. Les Origines communales, la féodalité et la chevalerie*, 1893.

159. E. WECHSSLER: *Das Kulturproblem*, p. 113.

160. FRIEDRICH DIETZ: *Die Poesie der Troubadours*, 1826, p. 126.

161. E. WECHSSLER: *Das Kulturproblem*, p. 214.

162. Ibid., p. 154.

163. Ibid., p. 182.

164. I. FEUERLICHT: 'Vom Ursprung der Minne', *Archivum Romanicum*, 1939, XXIII, p. 36.

165. ALFRED JEANROY: *La Poésie lyrique des troubadours*, I, 1934, p. 89.

166. P. KLUCKHOHN, op. cit., p. 155.

167. M. FAURIEL, op. cit., I, p. 532.

168. Cf. for the following: I. FEUERLICHT, op. cit., pp. 9–11.—E. HENRICI, op. cit., p. 43.—FRIEDRICH NEUMANN: 'Hohe Minne', *Zschr. f. Deutschkunde*, 1925, p. 85.

169. H. v. EICKEN, op. cit., p. 468.

170. KONRAD BURDACH: *Ueber den Ursprung des mittelalterlichen Minnesangs, Liebesromans und Frauendienstes*. Sitzungsber. der Preuss. Akad. d. Wiss., 1918.—The elements of this theory are already to be found in SISMONDI: *De la litt. du Midi de l'Europe*, I, 1813, p. 93.

171. A. PILLET: 'Zur Ursprungsfrage der altprovenzalischen Lyrik', *Schriften der Koenigsberger Gelehrten Ges.*, 1928, Geisteswiss. Hefte, No. 4. p. 359.

172. JOSEF HELL: *Die arabische Dichtung im Rahmen der Weltliteratur*, Erlanger Rekoratsrede, 1927.

173. Cf. D. SCHELUDKO: 'Beitraege zur Entstehungsgesch. der altprovenz. Lyrik. Klassisch-lateinische Theorie', *Archivum Romanicum*, 1927, XI, pp. 309 ff.

174. ALFRED JEANROY: *Les Origines de la poésie lyrique en France au moyen âge*, 3rd edit., 1925.—GASTON PARIS: 'Les Origines de la poésie lyrique en France au moyen âge', *Journal des Savants*, 1892.

175. G. PARIS: *Les Origines*, pp. 424, 685, 688.

176. G. PARIS: *Les Origines*, pp. 425–6.

177. WILHELM GANZENMUELLER: *Das Naturgefuehl im Mittelalter*, 1914, p. 243.

178. HENNIG BRINKMANN: *Entstehungsgeschichte des Minnesangs*, 1926, p. 45.

179. WERNER MULERTT: 'Ueber die Frage nach der Herkunft der Troubadourkunst', *Neuphilolog. Mitteilungen*, XXII, 1921, pp. 22–3.

180. K. BURDACH, op. cit., p. 1010.

181. H. BRINKMANN: *Entstehungsgesch d. Minnesangs*, p. 17.

182. F. R. SCHROETER: 'Der Minnesang', *German-Roman. Monatsschrift*, 1933, XXI, p. 186.

183. FR. V. BEZOLD: 'Ueber die Anfaenge der Selbstbiographie und ihre Entwicklung im Mittelalter'. In *Aus Mittelalter u. Renaissance*, 1918, p. 216.

184. E. WECHSSLER: *Das Kulturproblem*, p. 305.

185. A. W. SCHLEGEL: *Vorlesungen ueber dramatische Kunst*, I, 14.

186. ÉTIENNE GILSON: *La Théologie mystique de Saint Bernard*, 1934, p. 215.

187. BÉDIER-HAZARD: *Hist. de la litt. franç.*, I, 1923, p. 46.

188. E. WECHSSLER: *Das Kulturproblem*, p. 93.

189. EDMOND FARAL: *Les Jongleurs en France au moyen âge*, 1910, pp. 73–4.

190. ALBERT THIBAUDET: *Le Liseur des romans*, 1925, p. xi.

191. KARL VOSSLER: *Frankreichs Kultur im Spiegel seiner Sprachentwicklung*, 1921, 3rd edit., p. 59.

192. Ibid.

193. EMILE FREYMOND: *Jongleurs et ménestrels*, 1883, p. 48.

194. JOSEPH BÉDIER: *Les Fabliaux*, 1925, 4th edit., pp. 418, 421.

195. E. FARAL, op. cit., p. 114.

196. HOLM SUESSMILCH: *Die lateinische Vagantenpoesie des 12. und 13. Jahrhunderts als Kulturerscheinung*, 1917, p. 16.—Cf. *Wolfgang Stammler's* review in *Mitteilungen aus der hist. Lit.*, 1920, vol. 48, pp. 85 ff., and GEORG V. BELOW: *Ueber hist. Periodisierung*, 1925, p. 33.

197. *Carmina Burana*, edit. by Alfons Hilka and Otto Schumann, II, 1930, p. 82.

198. J. BÉDIER: *Les Fabliaux*, p. 395.

199. HENNIG BRINKMANN: 'Werden und Wesen der Vaganten', *Preussische Jahrbuecher*, 1924, p. 195.

200. Cf. for the following: HILKA-SCHUMANN: *Carmina Burana*, II, pp. 84–5.

201. MAX SCHELER: *Wesen und Formen der Sympathie*, 1923, pp. 99–100.

202. W. GANZENMUELLER, op. cit., p. 225.

203. ALFRED BIESE: *Die Entwicklung des Naturgefuehls im Mittelalter und in der Neuzeit*, 1888, p. 116.

204. WILHELM VOEGE: 'Die Bahnbrecher des Naturstudiums um 1200', *Zschr. f. bild. Kunst*, N.F., XXV, 1914, pp. 193 ff.

205. HENRI FOCILLON: 'Origines monumentales du portrait français'. In *Mélanges offerts à M. Nicolas Jorga*, 1933, p. 271.

206. ARNULF PERGER: *Einortsdrama und Bewegungsdrama*, 1929.

207. GOTTFRIED SEMPER: *Der Stil in den technischen und tektonischen Kuensten*, I, 1860, p. 19.

208. VIOLLET-LE-DUC: *Dictionnaire raisonnée de l'arch. franç. du XI au XVIᵉ siècle*, I, 1865, p. 153.

209. 'Dans un bel édifice de commencement du XIIIᵉ siècle . . . il n'y a pas un ornement à enlever', VIOLLET-LE-DUC, op. cit., I, p. 146.

210. ERNST GALL: *Niederrheinische und normannische Architektur im Zeitalter der Fruehgotik*, 1915.—*Die got. Baukunst in Frankreich und Deutschland*, I, 1925.

211. VICTOR SABOURET: 'Les voûtes nervurées', *Le Génie civil*, 1928.
—POL ABRAHAM: *Viollet-le-Duc et le rationalisme médiéval*, 1934, pp. 45, 60.—H. FOCILLON: *L'Art occidental*, 1938, pp. 144, 146.

212. Cf. DAGOBERT FREY: *Gotik und Renaissance*, 1929, p. 67.

213. POL ABRAHAM, op. cit., p. 102.

214. PAUL FRANKL: 'Meinungen ueber Herkunft und Wesen der Gotik'. In *Kunstgeschichte und Kunstwissenschaft*, edited by Walter Timmling, 1923, p. 21.

215. Cf. LUDWIG COELLEN: *Der Stil in der bildenden Kunst*, 1921, p. 305.

215a. RICHARD THURNWALD: 'Staat und Wirtschaft im alten Aegypten', *Zschr. f. Sozialwiss.*, 1901, IV, p. 789.

216. CARL HEIDELOFF: *Die Bauhuette des Mittelalters in Deutschland*, 1844, p. 19.

217. G. KNOOP-G. P. JONES: *The Medieval Mason*, 1933, p. 44–5.

218. Cf. HANS HUTH: *Kuenstler und Werkstatt der Spaetgotik*, 1923, p. 5.

219. H. V. LOESCH: *Die Koelner Zunfturkunden*, 1907, I, pp. 99 ff.

220. OTTO V. GIERKE: *Das deutsche Genossenschaftsrecht*, I, 1868, pp. 199, 226.

221. W. SOMBART: *Der mod. Kapit*, I, p. 85.

222. WILHELM PINDER: *Die deutsche Plastik vom ausgehenden Mittelalter bis zum Ende der Renaissance*, 1914, pp. 16–17.

223. W. VOEGE: *Die Anfaenge des monum. Stils*, p. 271.

224. W. PINDER, op. cit., p. 19.

225. F. J. C. HEARNSHAW: 'Chivalry and its Place in History'. In *Chivalry*, edit. by Edgar Prestage, 1928, p. 26.

226. MAX LENZ: Review of Lamprecht's *Deutsche Geschichte*, 5th vol. In *Historische Zeitschr.*, vol. 77, 1896, pp. 411–13.

227. W. SOMBART, op. cit., p. 80.

228. KARL KAUTSKY: *Die Vorlaeufer des neuern Sozialismus*, I, 1895, pp. 47, 50.

229. BÉDIER-HAZARD, op. cit., p. 29.

230. W. SCHERER, op. cit., p. 254.

231. W. PINDER, op. cit., p. 144.

NOTES

232. H. SCHRADE: 'Kuenstler und Welt im deutschen Spaetmittelalter', *Deutsche Vierteljahrsschrift fuer Litwiss. u. Geistesgesch.*, 1931, IX, pp. 16–40.
233. J. HUIZINGA: *The Waning of the Middle Ages*, 1924, p. 237.
234. H. KARLINGER: *Die Kunst der Gotik*, 1926, 2nd edit., p. 124.
235. G. DEHIO, op. cit., II, p. 274.
236. WALTER BENJAMIN: 'L'oeuvre d'art à l'époque de sa reproduction mécanisée', *Zschr. f. Sozialforsch.*, 1936, V, 1, pp. 40–66.

INDEX

INDEX

262

INDEX

INDEX

266

269